The Heart of the Mission

THE HEART OF THE MISSION

Latino Art and Politics in San Francisco

Cary Cordova

PENN

UNIVERSITY OF PENNSYLVANIA PRESS

PHILADELPHIA

This book is made possible by a collaborative grant from the
Andrew W. Mellon Foundation.

Published by
University of Pennsylvania Press
Philadelphia, Pennsylvania 19104-4112
www.upenn.edu/pennpress

Printed in the United States of America on acid-free paper
10 9 8 7 6 5 4 3 2 1

Library of Congress Cataloging-in-Publication Data
Names: Cordova, Cary, author.
Title: The heart of the Mission : Latino art and politics in
San Francisco / Cary Cordova.
Description: 1st edition. | Philadelphia : University of
Pennsylvania Press, [2017] | Includes bibliographical
references and index.
Identifiers: LCCN 2017005484 |
ISBN 978-0-8122-4930-9 (hardcover)
Subjects: LCSH: Hispanic American art—California—San
Francisco—20th century. | Hispanic American artists—
California—San Francisco—20th century. | Hispanic
Americans—California—San Francisco—Ethnic identity—
History—20th century. | Mission District (San Francisco,
Calif.)—History—20th century.
Classification: LCC N6538.H58 C67 2017 |
DDC 704.03´680979461—dc23
LC record available at https://lccn.loc.gov/2017005484

For Solomon, an *ofrenda*,
For Jennifer, the artist,
For John, *mi amor,* and
For Feliciano, *mi corazón*

Contents

Color plates follow page 168.

Introduction

In 2002, a *San Francisco Bay Guardian* reporter coined the term "Mission School" to describe an innovative and lively arts movement in the city.[1] Almost immediately, the term filtered into elite art institutions. The San Francisco Museum of Modern Art, the Whitney Biennial, the Commonwealth Club, and a host of galleries and artists used the term to describe a vibrant arts scene in San Francisco's Mission District. Questions and commentary abounded: Who were these artists? What aesthetics did they share? How were they related intellectually? The newspaper and journal articles, the panel discussions, and even a documentary film sought to classify this diverse group of artists.[2]

The Mission School identified a talented, hip, multiethnic group of artists who came of age in the 1990s, including Barry McGee, Margaret Kilgallen, Chris Johanson, Aaron Noble, Rigo 23 (Ricardo Gouveia), and Isis Rodríguez. Some of these artists participated in the 1994 Clarion Alley Mural Project (CAMP), a spirited effort to revive a disreputable alley through murals, which then became the Mission School's launching pad (Figs. 0.1, 0.2, and 0.3).[3] Aesthetically, they found inspiration in folk and outsider art, graffiti and street art, cartoon art, music raves, and hip-hop. Thematically, several of the artists were critical of unfettered capitalism.[4] As a whole, they represented a new local aesthetic to place San Francisco in the international vanguard.

While enthusiasm for the Mission School grew, few commentators discussed the complexity of its roots in the Mission, a neighborhood that Latino artists had made their base since the late 1960s. The inspirational environs featured Latino arts organizations, including Galería de la Raza, the Mission Cultural Center, Precita Eyes, Brava Theater, and many more (Fig. 0.4). CAMP obviously drew inspiration from the neighborhood's famous Balmy Alley murals and even incorporated the work of local Latino artists, such as Jesús "Chuy" Campusano (Fig. 0.2) and Isis Rodríguez (Fig. 0.3). However, contemporary art critics showed little acknowledgment of the neighborhood's historic mural movement or its longstanding tradition of Latino arts.

If anything, critics and writers sought to differentiate this "generation" of artists more emphatically. Rebecca Solnit described the avant-garde CAMP as "a mural project whose styles are entirely different from the Mission's dominant

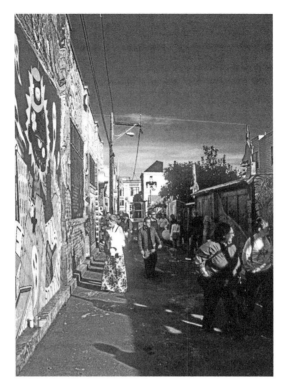

Figure 0.1. Clarion Alley Mural Project (CAMP) block party, October 2002. Mats Stromberg painted the mural on the left of a monstrous head floating over city buildings while ghosts, perhaps former residents, take flight into the air. Photograph by author. Image courtesy of the artist.

daughter-of-Diego-Rivera style."[5] No doubt, Rivera's San Francisco murals influenced many, yet the ease of representing his aesthetic dominance illustrated a more pervasive simplification of the neighborhood's profoundly diverse, innovative, and complex cultural production. The "Mission School" appellation blanketed over decades of neighborhood history and placed generations of Latino artists outside the bohemian enclave they had created.

This act of cultural displacement echoed the simultaneous physical displacement of Latino residents. In the 1990s dot-com gold rush, real estate investors, tech companies, and a variety of residents seeking affordable housing all landed on the Mission District as a lower-rent space to enjoy a diverse, bohemian atmosphere. Spilling over from nearby Silicon Valley, Internet companies and employees who wished to show their youthful, countercultural independence from traditional American business practices could project that image by locating in an area traditionally "foreign" to more established businesses. As one reporter noted,

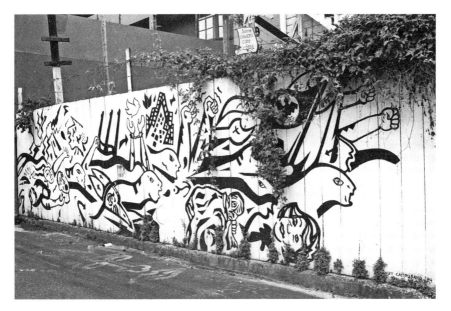

Figure 0.2. Jesús "Chuy" Campusano, *Chains and Flames*, 1994. This Clarion Alley mural paid homage to Picasso's *Guernica*, but also represented the violence of gentrification. Aaron Noble restored the mural c. 2000. Photograph by author, 2003. Image courtesy of Andres and Sandra Campusano.

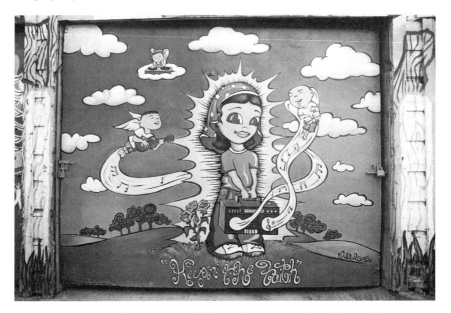

Figure 0.3. Isis Rodríguez, *Keepin' the Faith*, c. 2002. In this Clarion Alley mural, Rodríguez portrayed a Latina hipster with a boom box as the Virgin of Guadalupe. The image evolved from her "Little Miss Attitude" series and crafted a more contemporary representation of the Virgin than Rodríguez's 1993 mural in the same space. Image courtesy of the artist.

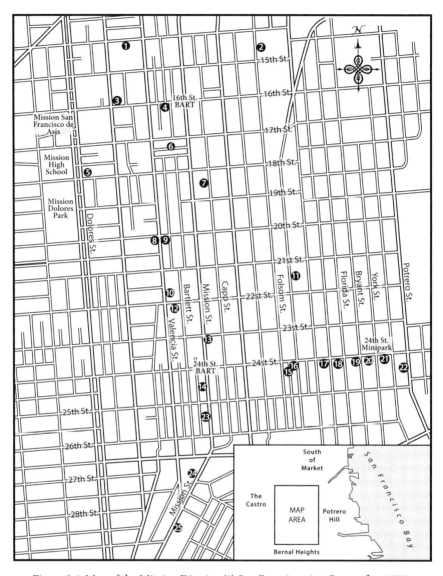

Figure 0.4. Map of the Mission District. (1) San Francisco Art Center, first 1970 location of Galería de la Raza, 425 14th Street; (2) Mexican Museum, 1975– 1982, 1855 Folsom; (3) Raza Silkscreen Center, c. 1971–c. 1980, 3174 16th Street (moved to 938 Valencia); (4) American Indian Center, c. 1958–1969, 3053 16th Street (moved to 3189 16th Street in 1971); (5) Artes Seis, 1969–1970, 3692 18th Street; (6) Clarion Alley Mural Project, 1994–, Clarion Alley between Mission and Valencia; (7) Casa Hispana de Bellas Artes, 1966–1983, 362 Capp Street; (8) Encantada Gallery of Fine Arts, 1997–2013, 904 Valencia Street; (9) La Rondalla, Mexican restaurant, c. 1951–2016, 901 Valencia Street;

"Technology companies have recently seized upon the Mission District as the newest hub of dot-com culture, attracted by its gritty mix of Latino families, free-spirited artists and cause-oriented nonprofits."[6] The Mission District also made economic sense for Internet companies; not only were property values lower than other parts of the city, but many of these companies claimed artist status and moved into "live/work lofts" to enjoy tax exemptions originally designed to retain artists in the community. The real estate laws created to make the neighborhood more hospitable to artists thus became a tool for their displacement.[7]

The lack of any substantive regulations to intervene in San Francisco's real estate boom produced a disastrous situation for the city's poorest residents.[8] According to one source, "The gap between rich and poor in San Francisco increased 40 percent between 1994 and 1996."[9] Over the next several years, San Francisco's income inequality continued to rise, while affordable housing vanished. The influx of wealth increased property values and propelled a wave of profit-motivated evictions and citywide rent hikes. Thousands of longtime residents found themselves forcibly evicted or voluntarily fleeing the city. Not only did many low-income and middle-class residents confront losing their home, but they also grappled with the historical amnesia that easily swept away all traces of their presence and influence.

This book argues for the Mission District as an important historical and geographical intersection for an influential and largely undocumented pan-Latino arts movement from the 1960s to the present. The proliferation of Latino cultural organizations in the Mission was not accidental. Synthesizing a range of cultural influences, Mission District artists of the 1960s and 1970s sought a new visual and cultural language. This ad hoc mobilization spurred an artistic

Figure 0.4. (*continued*) (**10**) New Mission Gallery, 1962–1963, 1083 Valencia Street; (**11**) Fantasy Records, c. 1960–1971, 855 Treat Avenue (home to San Francisco Mime Troupe after 1975); (**12**) Gaceta Sandinista, c.1975–1979, 3265 22nd Street; (**13**) *Homage to Siqueiros* mural, 1974–, inside Bank of America, 2701 Mission; (**14**) Mission Cultural Center, 1977–, 2868 Mission; (**15**) Balmy Alley Murals, 1972–, Balmy Alley between 24th and 25th Streets; (**16**) Casa Nicaragua, 1970s–1980s, 3015 24th Street; (**17**) Precita Eyes Mural Arts & Visitors Center (founded 1977 at 348 Precita), c.1998–, 2981 24th Street; (**18**) St. Peter's Church, 1878–, 1200 Florida; (**19**) Galería de la Raza, 1970–, 2851 24th Street; (**20**) Roosevelt Tamale Parlor, 1922–2015, 2817 24th Street; (**21**) Brava Theater, 1996–, 2781 24th Street; (**22**) El Tecolote, c.1970–c.1975, 1292 Potrero Avenue (later moved inside Mission Cultural Center); (**23**) *Latino America* mural, 1974–1980s, outside Mission Model Cities, 2922 Mission; (**24**) Cesar's Latin Palace, c.1977–2013, 3140 Mission Street; (**25**) El Club Puertorriqueño, c.1960s–, 3247–3249 Mission.

renaissance, creating spaces for generations of Latino artists to interact, debate, and create. Recalling his first visit to the neighborhood in the 1970s, writer Alejandro Murguía noted, "I was sure there wasn't a place in the world I'd rather be, not Paris or New York. At that moment it seemed to me that I was standing in the artistic center of the universe. . . . It wasn't so much San Francisco that I fell in love with; it was the Mission, La Misión."[10] The neighborhood's history of cultural production, coupled with its political activism, not only contributed to the formation of a community identity, but also propelled the Chicano civil rights movement and influenced the direction of a widespread Latino cultural renaissance. The fact that this cultural production persisted outside the purview of the American art world is indicative of its outsider status.

Although this text focuses on an arts movement that emerged in the 1960s and 1970s, it is also grounded in an earlier history of Latinos in the city. Understanding the transformation of ideologies and aesthetics that occurred in the late 1960s requires a sense of the "before."[11] This book thus begins with the presence of Latinos in San Francisco prior to 1965, principally with the settlement of the Latin Quarter (now North Beach) in the 1930s and 1940s and the subsequent cultivation of a "Beat" counterculture in the 1950s, in order to lay the groundwork for the political and artistic mobilization that followed in the Mission District.

Relying heavily on oral histories, this work uses the personal experiences of artists and activists to illustrate the social transformations of Latino art and politics in a particular place from the 1940s to the 1990s. More than thirty-five artists and activists have shared their memories with me. Others revealed their stories in the records of archival collections, including the Smithsonian Institution's Archives of American Art. Listening to these recollections, reading their words, not only offered evidence of diverse individual experiences in larger historical trajectories, but also steered me away from the easy synthesis of top-down histories. Having to connect the lives of my interviewees with the creation of their art, the work of their peers, the history of Latino social movements, and the history of San Francisco proved a challenge. My comparative analysis of these experiences led me to identify shared trajectories, just as my methodology sensitized me to issues of dissension, difference, and exclusion. Ultimately, there is no glib statement to define decades of creativity. However, there is in this book a desire to show how the Mission emerged as an influential physical space for a profoundly creative and politically active Latino arts community.

Regional Histories and (Trans)National Identities

Bay Area writer José Antonio Burciaga made fun of regional distinctions in his short essay, "A Mixed Tex-Cal Marriage." Referring to himself as a Chicano

from Texas marrying a Chicana from California, he wrote, "we thought we had a lot in common. . . . But, as we were soon to discover, the vast desert that separates Texas and California also differentiates the culture and style of Chicanos."[12] Burciaga described how the couple's clashes in food, music, fashion, landscape, and language made him realize he was in a "mixed" marriage. Although the distinctions are intentionally silly, his essay emphasizes the diversity of Chicanos and Latinos.

The nation as a whole experienced a dramatic shift in the representation of Latinos following the 1965 Immigration Act.[13] Increased migration, alongside more public demonstrations for civil rights, contributed to a greater visibility of Latinos in the United States. In particular, increases in migration from the Caribbean and Central America challenged earlier demographic majorities. Whether cities formerly had Mexican, Puerto Rican, or Cuban majorities, or some other mix, the integration of new immigrants required a continuous renegotiation of power and identity. The diverse dynamics of Latino, Chicano, Puerto Rican, Central American, and Cuban identity formation in such places as Los Angeles, New York, Miami, and Washington, D.C., show how local demographics and cultural context participate in the fluidity of Latino identities.[14] Capturing this complexity, Agustín Laó-Montes wrote, "Latinidad is both a category deployed within a variety of dominant spaces and institutions (state, corporate, academic) to label populations as well as a form of self-identification used by individuals, movements, and organizations to articulate a sense of community."[15] While national similarities exist, the impact of local histories and politics generated divergent expressions of Latinidad, both from within and outside the Latino community.

In San Francisco, fluctuations in the demographics constantly produced new majorities and new political considerations. In the 1960s, the Latino population was predominantly Mexican and Mexican American, but the large number of Central Americans, especially from Nicaragua and El Salvador, minimized the strength of any national majority.[16] In the 1970s and 1980s, as immigration shifted the balance of power from a preponderance of those who identified as Mexican or Mexican American to a more diverse and substantially more complicated international grouping, San Francisco residents redefined their social ties and networks. Most notably, collectively aligning as Latino or as "Raza" (the people) provided a means of responding to diverse social, economic, and political concerns, but these terms never subsumed national identifications with Mexico, El Salvador, or Nicaragua. I use *Latino* as a term of political and cultural solidarity, but also acknowledge the term's capacity to homogenize groups of people across race, gender, class, and politics, with ties to many regions and nations.

Moving between regional, national, and transnational perspectives is key to dismantling reductive, dehumanizing stereotypes and essential for documenting cultural diversity and political dissension. Tracing how Latinos have sought to represent themselves is critical in this process, as well as inseparable from how they have been represented. Ultimately, acknowledging the history of local communities in the larger national landscape is imperative for understanding the inclusions and exclusions that have played out in forming a national pan-Latino identity.

The Heart of Latinidad

While the Mission District exists as a physical place, with zoned borders and zip codes, its meaning is also fluid. Many have tried to document its allure. Artist Guillermo Gómez-Peña, born and raised in Mexico, has lived in various parts of the United States since 1978, but moved to San Francisco in 1995. In his 2007 "Mexican Bus Tour" of the Mission, a semihistorical, artistic meditation on place, Gómez-Peña asked:

> Why do people come here? Are we seduced by the promise of bohemia in a country of restricted imagination, in an era of constrained freedoms? Are we then seeking freedom of the imagination, attracted by the mythical possibility of reinventing ourselves overnight? Of exercising all the selves and identities we wish to become without having to confront conformity every step of the way? Or are we part of the wave of international exiles escaping failed revolutions and interventionist wars from San Salvador to Baghdad? Are we part of the wave of sexual and artistic misfits escaping orthodoxy in our distant homelands? Or are we merely taking a ghetto cruise?[17]

As Gómez-Peña proposed, the "imagined Mission" cultivated space for diverse individuals, especially those drawn to a life outside the mainstream or exiled from a former homeland.

The pervasive description of the Mission District as *el corazón*, or the heart, of the city's Latino community offers a double meaning: the Mission is the physical heart of the community, but also the symbolic center of Latino cultures (Fig. 0.5). Through its people, churches, restaurants, *taquerías*, nightclubs, and galleries, the Mission projects complex and contradictory visions of Latino culture. The area represents an oasis of pan-Latino food, art, and culture apart from, but also designated for, the rest of the city. The construction also implies

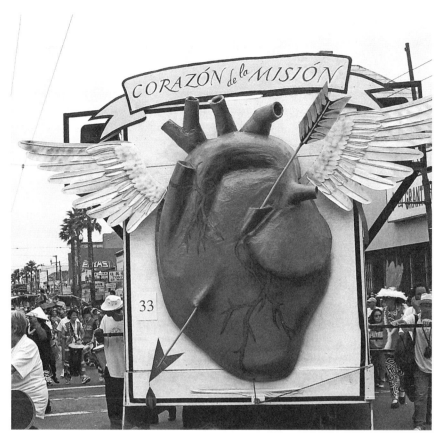

Figure 0.5. *Corazón de la Misión* (*Heart of the Mission*) float in San Francisco's Carnaval parade, May 27, 2007. Drawn from images of the sacred heart, this iconography also circulates in the form of *milagros* (small tokens with healing powers), or as one of the playing cards in a traditional Lotería game. The title *Heart of the Mission* refers to the neighborhood's physical centrality as well as its spirit. Photograph by author.

that these institutions will stay segregated in this location, as opposed to challenging larger social norms and structures.

The multiethnic diversity of San Francisco's Latino population has played a critical role in mapping the heart of this community's identity. Unlike many other areas of California, the Mexican population has not dominated San Francisco's demographics. In fact, the historic strength of its Central American populations has consistently propelled organizing around a pan-Latino identity, as opposed to a Mexican American or Chicano identity. In cultivating a panethnic identity,

Latino communities have sought to subsume national differences for the sake of more political and cultural power as a whole.[18] As San Francisco activist Elizabeth Martínez explained, "In the end, the most common, popular identification is by specific nationality: Puerto Rican, Mexican, Guatemalan, Colombian and so forth. But those of us who seek to build continental unity stubbornly cling to some broadly inclusive way of defining ourselves. In my own case, that means embracing both 'Chicana' and 'Latina.'"[19] Embracing a Latino identity will not erase national or ethnic differences, class divisions, and racial categories, but it does serve as an effective tool to assemble political strength.

Starting in the 1960s, the Mission District gained definition as a predominantly Latino neighborhood, though this label obscured the multiethnic diversity of its residents. City leaders promoted the Latinidad of the Mission as part of a larger narrative of charming ethnic neighborhoods, including Chinatown, Japantown, and Little Italy. However, this approach minimized historic segregation and social inequalities that activists, artists, and writers sought to illuminate and protest.

Artists often seek to persuade, provoke new perspectives, and challenge the status quo. Mary Romero and Michelle Habell-Pallán wrote that "formats such as art performance, music, and local sports organizations are crucial because they open spaces, counter-sites, and conditions of possibility where Latinas and Latinos can publicly imagine new ways of constructing racial, ethnic, gendered, and economic identities. In the construction of new subjects for political identification, new movements for social equality can be articulated."[20] Art offers a language to grapple with cultural borders, both via its content and in the context of its creation. Gómez-Peña declared that he makes "art about the misunderstandings that take place at the border zone. But for me, the border is no longer located at any fixed geopolitical site. I carry the border with me, and I find new borders wherever I go."[21] Art is never neutral, and its origins map cultural shifts and the dynamics of power.

Looking at the lives of Latino artists in San Francisco after World War II provides a meaningful model for considering the transformations and expressions of Latino identities through a particular place and in relation to changing social movements. Only after much research did I realize that in documenting the role of Latino artists in San Francisco I also was tracing the history of the Left, not just in the United States, but around the globe. I do not wish to suggest that all residents of the Mission have been Latino and leftist, but I do wish to emphasize the importance of this perspective in community organizing and arts production. Moreover, this is not to say that all Latino artists support leftist politics (though clearly, many do), but rather, to argue that leftist politics have dominated the construction of Latino art in the Bay Area.

In using the term *global Left,* this work emphasizes a transnational perspective. By this I refer not to the spectrum of electoral politics in the United States but rather to a broader, international, and slightly more intangible vision of liberation from oppression.[22] I define the global Left as an admittedly amorphous amalgamation of social theories focused on overturning oppression and infused with the idealism of the Cuban Revolution, the international student movements of 1968, the Chilean socialism of Salvador Allende, and the Sandinista politics of Nicaragua. Marxist in spirit and global in vision, its most definitive characteristic is an overarching concern for human rights.

Artists seldom represent their art as a solution to social problems, but often see ways their art can contribute to social change. As Rupert García noted, "Art plays many roles in the struggle, but art is not going to win: art and culture never overcome repression. People do that, but art can contribute."[23] The mobilization of artists in the Mission was rarely divorced from struggles for social change, even when abstract in appearance. As June Gutfleisch, former Neighborhood Arts Program director, stated, "In retrospect, it was always 'art for art's sake' at one level, but in Northern California and, certainly, in the city of San Francisco, the arts were never really separated from politics."[24]

Beyond making art, many of the artists discussed here have lived as teachers, activists, and even soldiers. Jokes have circulated about the large number of Latin American revolutionaries who have lived in the Mission, and these quips are not always far from the truth. In the 1970s, poets Alejandro Murguía and Roberto Vargas left the Mission to fight with the Sandinistas in Nicaragua. Artist Romeo G. Osorio joined the Farabundo Martí National Liberation Front (FMLN) in El Salvador. In the Mission, a formal distinction between art, even the most abstract art, and politics, especially the most revolutionary politics, rarely existed.

This book does not pretend to chronicle all the events and people who have contributed to the making of the Mission. But I do intend to show how the Mission became a space where Latino activists and artists could mobilize as a community and organize for and against issues that impacted that community. They came together in a shared sense of identity and politics in order to amass power and retain a cultural history. Efforts to affirm a pan-Latino identity among diverse cultures not only sought to unify the community, but also to fortify the neighborhood against gentrification.

Putting the "Place" in Displacement

Displacement is a pivotal theme in this text. The construction of the Mission School as nonderivative of earlier artistic work in the Mission highlights the ways dominant cultures can simultaneously appropriate and disempower other

cultures. As Coco Fusco noted, the avant-garde bears a long history of "appro-
priating and fetishizing the primitive and simultaneously erasing the original
source."[25] C. Ondine Chavoya described this "Orphans of Modernism" phe-
nomenon in his analysis of the Chicano arts collective Asco (1972–1987). He
argued that artists of color in particular must balance the "value of the avant-
garde as a model" versus the "pattern of exclusionism in the construction of the
Euro-American avant-garde."[26] Though the label *Mission School* had no mali-
cious intent, its facile application is emblematic of the disjuncture between com-
munity art in the Mission and the vision of mainstream arts institutions. In
discussing his coining of the term *Mission School,* critic Glen Helfand explained
that "the title emerged almost organically from interview subjects, and as a label,
it has been received calmly as well as with understandable derision. To give a
name to an identity or style is never completely accurate, and it can easily be
misused."[27] While some critics debated the adequacy of Mission School as an
aesthetic term, none suggested that the title also signaled the avant-garde usur-
pation of another community's history.

At times, scholars have implicated artists in the process of gentrification.
The "bohemian" appeal of the artist's life generates a hipster atmosphere, which
spurs development and increases property values.[28] In the Mission, this trope is
troublesome, since many longstanding artists came out of working-class, Latino
communities. Although the presence of a strong arts scene encouraged a bohe-
mian migration, the increase in artists is also related to the politics of racial
segregation, socioeconomics, and chain migration. Some artists, such as René
Castro from Chile and Martivón Galindo from El Salvador, came to the Bay
Area because they could not live safely in their home country. Other migrants,
such as Romeo G. Osorio and Victor Cartagena, became professional artists
partly as a result of their migration experience. Like other migrants, these
artists found spaces where they could connect with friends and family mem-
bers, speak Spanish, find work, and continue their religious and cultural
practices. To blame artists in the Mission for gentrification would suggest that
they were somehow above the issues facing the rest of the community. Rather,
art provided a critical way to express experiences of exile and alienation and to
protest exploitation of labor, racism, poverty, and gentrification. In fact, many
of the artists and activists discussed here have been fighting gentrification
since the late 1960s.[29] More accurately, as Solnit observed, "it is clearly not tal-
ented individual artists but the widespread ambience created by cafés, night-
clubs, galleries and those who hang out in them—by a visible bohemia, along
with 'lifestyle' commodities—that seeds gentrification."[30]

Romanticizing the Mission arts scene, however, obscures the very serious so-
cioeconomic issues confronting the neighborhood, especially in the shape of pov-

erty, deindustrialization, education, lax government, and, subsequently, drugs and gangs. In the late 1960s, average income in the Mission was substantially below the city average, the unemployment rate was high, if not the highest in the city, and the student dropout rate from Mission High varied from around 20 to 30 percent, with only 5 percent of graduates continuing on to college.[31] Not surprisingly, artists who experienced the difficulties of life in the Mission firsthand subsequently wove those concerns into their art and teachings. Neighborhood arts institutions sponsored events and programs that responded to "local" politics, which easily encompassed an international spectrum of issues. Thus, a shared aesthetic did permeate the neighborhood, even though no single style dominated.

Many of the neighborhood artists worked and socialized in similar circles and identified not only as artists but as "cultural workers," meaning that they saw their work as tied to invigorating and politicizing the community, challenging social norms, and catalyzing social change. San Francisco muralist Miranda Bergman put it this way:

> We, as conscious artists, must combat the torrent of mind-control with a real alternative—murals, songs, dance, poetry that contain different values and have educational content as well as beauty. As Mao Tse Tung said, besides a military army, a revolutionary struggle needs a "cultural army, which is absolutely indispensable for uniting our own ranks and defeating the enemy." If we want the planet to exist, for nature to flower, and for people to know harmony and economic security, we know that our life is one of real struggle.[32]

San Francisco has a rich tradition of "cultural workers," perhaps most notably documented in the artist-activism of the 1930s Depression. Cold War politics blacklisted this history, but the radical politics of the 1960s rekindled appreciation for the local impact of Diego Rivera, Frida Kahlo, and the WPA muralists.[33] The rise of civil rights movements across the country sparked enthusiasm for art with a message, and artists in the Mission took this charge to heart. Nevertheless, whether grappling with the troubles of a poor neighborhood or countering the destructiveness of the San Francisco Redevelopment Agency, its residents rarely experienced peace of mind.[34] The constant threat of displacement cast a heavy shadow over the neighborhood.

The Pull "South of the Border"

While geographic location and local economy are critical factors in the politics of gentrification, the contested status of various Latino neighborhoods, such as

New York's El Barrio, Los Angeles's Silverlake, and Chicago's Pilsen neighborhood, have shown that the Mission District's situation is hardly singular. In fact, the story echoes the complex histories of Harlem, North Beach, and the Paris Latin Quarter. This situation underscores a double bind, since the more that Latinos develop signifiers of a pan-Latino identity, whether out of a sense of community or good business practice, the more likely they are to invest the region with the "colorful" and "festive" aura of nonconformity that Americans associate with traveling south of the border. In many ways, the Mission's "tropicalizing of cold urban space," as Mike Davis described it, visually and culturally projects an atmosphere of a desirable urban bohemia apart from the mainstream.[35] Thus, *The New York Times* Travel section used a delightful tropism to sell the neighborhood's bohemian Latinidad: "Sidewalk vendors sell yucca flowers and avocados, blue-haired anarchist daddies push strollers, young men loiter at the corner, Central American housewives and vegan lesbian tattoo artists shop for fresh handmade tortillas."[36] The 2005 article smoothed over any conflict and perpetuated the idea of a quaint atmosphere for tourism or even gentrification.

Popular consumption of Latino cultures historically has served as a means of depoliticizing and "othering" the cultures, much in the vein of literary critic Edward Said's notion of orientalism. As Frances Aparicio and Susana Chávez-Silverman observe, "The etymological correlative within the Latino context [to Said's orientalism] would be 'tropicalism,' the system of ideological fictions with which the dominant (Anglo and European) cultures trope Latin American and U.S. Latino/a identities and cultures."[37] Thus, the Mission's identity as a Latino barrio also has served as a signifier of foreignness, difference, and bohemianism apart from American art and culture. People from both within and outside the community have represented the Mission as a localized vision of Latin America, or a "tropicalized" borderland, physically and culturally indicative of Latino identity.[38]

Latino markets, murals, and galleries conveyed the culture of a foreign land for people seeking an alternative lifestyle within the United States. Some residents opted to live in the Mission District as an expression of their nonconformity. As Ann Powers recalled, "I had to find the bohemia that was still forming, as I was. In the 1980s, that meant moving to the Mission District, a bilingual neighborhood where kids with fresh tattoos lived across the hall from Latin American political refugees."[39] More recently, white antigentrification activist Kevin Keating observed, "Unfortunately, people like me who want to get as far away from the mainstream as we can without actually leaving the United States altogether end up gravitating to neighborhoods like Manhattan's Lower East Side, Alphabet City, and San Francisco's Mission District and then we end up initiat-

ing the whole process of gentrification."[40] These remarks underscore how the cultivation of "foreignness" within American culture has been part of the Mission District's appeal.

The construction and consumption of Latinidad in the mainstream culture is integral to the creation of stereotypes and tropicalism, but it is also a critical factor in how Latinos view themselves. Narrow categorizations have produced limited depictions of Latinos in the mainstream media; at the same time, these tropicalizing visions have provided a platform for resistance. Much of the cultural production of the Mission has revolved around the reappropriation of negative dominant ideologies, the deconstruction of longstanding stereotypes, and the playful rejection of harmful social forces.

Along these lines, though escalating property values since the 1990s have produced enormous stress in the community, gentrification also has served as a significant source of cultural production. The sea change launched massive protests, subversive graffiti, and minor property destruction, which then made headlines in newspapers across the country.[41] Indirectly and directly, the impact of technology and gentrification has stimulated new generations of Latino artists, including Adrian Arias, Jaime Cortez, Paul S. Flores, John Jota Leaños, Leticia Hernández-Linares, Veronica Majano, Dolissa Medina, Jessica Sabogal, and Rio Yañez, who have used various media to document the community, protest inequalities, and create new aesthetics.

Indeed, CAMP also serves as evidence of the ways in which the Mission continued to inspire community organizing and art. Aaron Noble, Rigo, Michael O'Connor, Mary Gail Snyder, Sebastiana Pastor, and Aracely Soriano began painting the murals in 1992 in response to the rapid change and development they were witnessing in the Mission.[42] Ultimately, the CAMP murals were seeded in a long history of cultural activity to protect the neighborhood and affirm a community. The point here is not to undercut the meaningfulness of CAMP and the Mission School artists, but to argue that this seemingly new movement drew inspiration from a longstanding, vibrant, activist, arts-based community history.

A Roadmap to the Heart of the Mission

As I pursued this investigation, I expanded my project to acknowledge an earlier history of Latino artists and musicians in San Francisco during the 1940s and 1950s. The 1940s boom in Latin nightclubs in San Francisco's North Beach reflected the new visibility of Latinos in national popular culture. The rise of celebrities such as Carmen Miranda and Desi Arnaz put Latin Americans in the global spotlight.[43] While this entertainment propelled a rich music scene, it also

represented Latinos apart from mainstream American culture. This earlier history is integral to understanding the later development of the arts in the Mission, especially in thinking about how American popular culture has represented Latinos and how Latinos have sought to represent themselves.

Thus, Chapter 1, "Real Life and the Nightlife in San Francisco's Latin Quarter," focuses on the disconnections between the staged visions of Latinos versus the everyday existence of Latino communities in San Francisco. I provide an early history of Latinos in San Francisco and a discussion of the many physical spaces that came to represent Latinidad prior to the emergence of the Mission District. At that time, the Latin Quarter, North Beach, the South of Market area, and other pocket communities served as early spaces for Latino settlement and as significant sites for the construction of local Latino identities. Still, increasing property values spurred the displacement of many low- and middle-income Latino residents. Simultaneously, popular representations of Latinos in film and on stage became more visible in American mass culture and local entertainment venues. In San Francisco, the Latin nightclub scene propelled a strong and creative music culture, if directed toward Anglo audiences. This staging of Latino identities in the Latin Quarter nightclubs of the 1940s and 1950s masked the physical displacement of Latinos from the very same neighborhood. By foregrounding this earlier period, I also wish to emphasize the long-rooted presence of Latinos in San Francisco.

Chapter 2 examines the marginalized participation of Latino artists in the San Francisco Beat culture of the 1950s and early 1960s. Many Latinos participated in or were drawn to the city by the counterculture. In this chapter, I focus on the experiences of three Mexican American artists—José Ramón Lerma, Luis Cervantes, and Ernie Palomino—to document the aesthetic and political interests of Latino artists in San Francisco at that time. In general, the expression of ethnic identity was a low priority but still a significant factor in the trajectory of these three artists.[44] The stories of Lerma, Cervantes, and Palomino also show how the impact of returning veterans to San Francisco propelled the physical desegregation of the arts, if not the cultural desegregation. This longer history also makes more visible a complex tension facing American ethnic groups caught between constructing an identity in order to retain a cultural history and performing an identity to entertain and exoticize their difference.

In Chapter 3, I document the experience of Latinos in San Francisco at the height of the Chicano movement and convey the ways in which San Francisco translated the politics of "El Movimiento" to its regional concerns. Inspired by the national civil rights movement, activists and artists of the 1960s rallied together to preserve neighborhoods, prevent displacement, and unite in a com-

mon history. Nationwide, artists formed coalitions and built multiple cultural organizations. The creation of a Latino arts enclave in San Francisco's Mission District was both unique and emblematic within this national mobilization. In San Francisco, the stories behind the creation of Casa Hispana de Bellas Artes, Artes 6, and the Galería de la Raza reveal multiple tensions and shared agendas. As a whole, the movement in San Francisco reflected the overarching desire to create a "Raza movement" and "Raza art"—a culture and art reflective of pan-Latino identities in the United States—as opposed to the Mexican American orientation of the Chicano movement.

In Chapter 4, I stress the importance of the 1968 Third World Strike at San Francisco State College as a mobilizing force for community organizing in San Francisco's Mission District. This student-led strike was instrumental in establishing ethnic studies in colleges and universities across the nation. I argue that the event also sparked a transnational political consciousness for many people at a time of heightening globalization. The chapter uses the experience of three Chicano artists—Yolanda López, Rupert García, and Juan Fuentes—to contextualize the significance of the Third World Strike in shaping their political consciousness and their art. Though the Chicano movement is often described as a nationalist Mexican American movement, the art of López, García, and Fuentes demonstrates that the Chicano movement also generated a globally conscious art.

Chapter 5 examines the history of the community mural movement in the mid-1970s Mission District. I show the importance of murals as cultural texts, consciously formed to entertain, influence, and solidify local and transnational communities, by focusing on two key works of the period. In *Homage to Siqueiros*, a trio of male muralists claimed the mantle of the "Mexican Masters" and painted an expansive mural that indicted their patron, the Bank of America, and conditions across the Americas. In *Latino America*, the female muralists rejected the Chicano movement's emphasis on Mexican masters and declared a new feminist, collaborative iconography. Though the murals and mural process were dissimilar in terms of gender, approach, and aesthetics, the muralists joined in their desire to unite the local Latino community through their depictions of a shared homeland, or an imagined Latin America. The murals also sought to mark the landscape and prevent gentrification.

Chapters 6 and 7 are devoted to the ways that San Francisco artists and writers articulated, and even directly participated, in the liberation struggles in Nicaragua and El Salvador. Starting with the galvanizing impact of the 1972 earthquake in Managua, Nicaragua, and the 1973 coup in Chile, Chapter 6 follows the experiences of three cultural workers—Nina Serrano, Alejandro Mur-

guía, and Roberto Vargas—who sought victory for the Sandinista revolutionary movement in Nicaragua. As poets and as soldiers, they challenged U.S. political interests at home and abroad. Their perspective reflects the way that Nicaragua's precarious political position shaped the aesthetics and the politics of cultural production in the Mission, from the creation of the Pocho Che and Tin Tan literary collectives to the formation of the Mission Cultural Center and the work of the Neighborhood Arts Program.

Not surprisingly, as the number of refugees seeking asylum from El Salvador increased, the work of Mission artists sought to encompass this struggle, too. Chapter 7 explores the experiences of Salvadoran artists before, during, and after the civil war. Partly copying the local activism that had supported the Sandinistas in Nicaragua, San Francisco Salvadorans built transnational support networks for the FMLN in El Salvador. The political situation abroad propelled a wave of Bay Area cultural production that directly and indirectly grappled with revolution, human rights, terror, mourning, and, later, healing. The radical orientation of the artists had as much to do with Bay Area politics as it had to do with the large Salvadoran exile community. This chapter analyzes the local consequences of U.S.-El Salvador relations and documents the way Bay Area artists and activists grappled with the violence, disenfranchisement, and healing.

Chapter 8 uses the history of Día de los Muertos, or Day of the Dead, to examine the cumulative impact of AIDS in San Francisco and the wars in Central America. While the late 1960s and early 1970s represented a period of hope for cultural workers in the Mission District, the 1980s signaled a darker outlook for a left-oriented social movement. The election of Ronald Reagan, the appearance of AIDS, the heightened violence in Central America, and the threat of nuclear war all challenged the idealism of the early seventies. As Día de los Muertos provided an emotional outlet for mourning, it also became a public event and political tool that could be used to speak out against the Reagan administration's policies on AIDS and Central America. Discussion of the subsequent commodification of Día de los Muertos and the rising property values of the Mission District also bring this book full circle, back to the subjects of consumption and physical and cultural displacement.

Full Circle

Though this work moves from the 1930s to the 1990s, many of the issues remain the same. The dramatic displacement of Latinos out of the Mission District in the 1990s has not been that different from the discreet displacement of Latinos out of the Latin Quarter in the 1950s. In both instances, mainstream culture

romanticized Latin culture while displacing its originators.[45] However, while historical parallels may exist with the contemporary situation, the story of Latino artists in San Francisco also illustrates the formation of a formidable, diverse, complex, politicized artist community, well trained to fight displacement. The fact that the displacement of Latinos out of the Mission District generated such intense publicity and concern is a testament to the neighborhood's history of community organizing and arts activism.

Ultimately, I drew inspiration for this book from my concerns about displacement in all its forms. I hoped to show the longstanding activism and cultural production of Latino artists in San Francisco and to start the process of acknowledgment and integration in American (art) history. This work started as a meditation on a place, but it became an *ofrenda*—the traditional activity of creating an altar for Día de los Muertos, or the Day of the Dead, to celebrate the spirits of the dead and to remember what it means to be alive. And yet, as Richard Montoya of the comedic theater collective Culture Clash cautioned, "We've really got to fight the tendency to make it a eulogy for the Mission, because the Mission is not dead. Even if it's an artist that's come and gone, that artist in many ways is still here. . . . The Mission is a place where our jazz is still being composed, for *Chicanismo*. This is our Art Blakely, our Dizzy Gillespie, this is our bebop. This is where we find our Dead Sea scrolls. In a way we're taking a moment to reflect on our losses but also say, man, what an amazing place the Mission still is."[46] Montoya's point is well taken. To this day, the Mission continues to serve as a rich site for the intersection of Latino cultures and as a critical physical space for artistic activity. The cultural production in the Mission is far greater and more expansive than I can do justice to here. But perhaps this text will serve as a seed for recognition and integration. This work is in many ways a return to the people who have educated me, and a tribute to the people who continue to make art and dream of changing the world.

Chapter 1

Real Life and the Nightlife
in San Francisco's Latin Quarter

Strolling out of Chinatown, you walk into another kind of
world . . . the Latin Quarter! A world of intriguing little
bookstores, Bohemian restaurants and Spanish, Basque,
Mexican and Italian shops.
—San Francisco tourism brochure, 1940[1]

Prior to World War II, the Latin Quarter served as one of San Francisco's larger
Latino neighborhoods. Residents enjoyed Spanish mass at Nuestra Señora de
Guadalupe church, access to two Spanish-language bookstores, and a variety
of Latin American folk art stores, cafés, and restaurants that catered to those
craving a taste of home, or to those seeking a foreign experience.[2] The Teatro
Verdi offered regular showings of Spanish-language films and advertised its
location on Broadway, between Stockton and Grant, as "*el Corazón del Barrio
Latino*" (The Heart of the Latino Barrio).[3] Encompassing an area around Broad-
way and Powell Streets, the neighborhood is now seen as part of North Beach
or Chinatown (Fig. 1.1). While the city still celebrates the history of neighboring
Little Italy and historic Chinatown, few residents are familiar with the area's
Latino history.

In his 1940 guidebook, Leonard Austin reported, "Recent immigrants have
settled in other parts of the city . . . but North Beach still remains the center of
the Mexican population."[4] He described the vibrancy of the many Mexican
shops and cantinas, but also pointed out smaller Mexicano or Latino neighbor-
hoods on Fillmore Street, in the South of Market area, in the Mission, and in
Butchertown, now known as Bayview. Latinos living in these earlier neighbor-
hoods formed social networks and contributed to the cosmopolitan growth of the
city. However, economic and social pressures drove many Latinos out of these

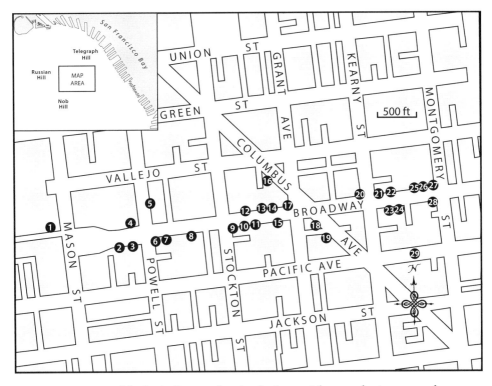

Figure 1.1. Map of the Latin Quarter showing Latino social spaces, businesses, and other popular sites, 1930s–1960s. (1) Nuestra Señora de Guadalupe church, 1912–1991, 906 Broadway; (2) Spanish Cultural Center club rooms (Casino Pan America, 1940; La Marimba, 1941; Beige Room, 1951–1957; Copacabana, 1957–1967; Tropicoro, 1967), 831 Broadway; (3) Unión Española / Spanish Cultural Center, 1939–1984, 827 Broadway; (4) Aurelio Rodriguez Photography Studio, 1935–1950, 802 Broadway; (5) Luz Garcia's Club Sinaloa, 1930s–c. 1976, 1416 Powell Street; (6) La Mexicana, grocery, 1930s–1960s, 799 Broadway; (7) Xochimilco, Mexican restaurant, 1940s, 787 Broadway; (8) Basque Boardinghouses (Hotel de España, Globo Hotel, Jai Alai, Hotel Pyrenees, Hotel Español / Martin's Español), c. 1908–1950s, 719–785 Broadway; (9) El Chico Club, 1950s, 681 Broadway; (10) Caliente Club, 1940s–1950s, 675 Broadway; (11) Tijuana Cantina, 1950s–1960s, 671 Broadway; (12) The House That Jack Built, late 1950s (founded c. 1930s), 670 Broadway; (13) La Moderna Poesia / Sanchez Spanish Books and Music, 1930s–1950s, 658 Broadway; (14) Teatro Verdi, 1915–1954, 644 Broadway; (15) Nuestra America Books and Music, 1930s–1950s, 621 Broadway; (16) Mambo Café, 1950s, 347 Columbus; (17) El Cid Cafe, c. 1960–c. 1981, 606 Broadway; (18) City Lights Pocket Bookshop, 1953–, 261 Columbus; (19) Vesuvio's (Beat hangout), 1949–, 255 Columbus; (20) Finocchio's (female impersonators), 1936–1999, 506 Broadway; (21) Vanessi's, 1936–1986, 498 Broadway; (22) El Matador, c. 1953–1977, 492 Broadway; (23) Mona's Candlelight (lesbian bar), 1948–1957, 473 Broadway; (24) Chi Chi Club, 1949–1956, 467 Broadway; (25) Club 440 / Mona's (lesbian bar), 1939–1948, 440 Broadway; (26) Casa Madrid, 1960–late 1970s, 406 Broadway; (27) El Patio (Mexican), 1930s–1950s, 404 Broadway; (28) Basin Street West (jazz club), 1964–1973, 401 Broadway; (29) International Settlement (block of "international" clubs), 1940s–1957, 500 Pacific block.

neighborhoods and prompted some to move to the Mission District.[5] These longtime city residents joined an influx of immigrants in the post–World War II period that contributed significantly to the Latinization of the Mission District. The change in physical location created a lack of continuity in the city's Latino history.

Prior to the Mission, Latino-themed businesses and social spaces in the Latin Quarter made the neighborhood one of the more visible Latino enclaves in the city. In the 1940s and 1950s, a row of restaurants and nightclubs on Broadway promoted live music, floor shows, and dancing, often accompanied by the rhythmic sounds of the mambo, rumba, or flamenco. The promotion of a Latin nightlife gave Latino musicians and performers important cultural and commercial opportunities in the 1940s and 1950s. Even so, these entertainment spaces relied on celebratory expressions of Latino culture that were often at odds with the realities of Latino lives. Gradually, the commodification of Latino cultures and nightlife participated in and overshadowed the steady displacement of Latino residents.

"Real Life" in San Francisco's Latino Communities

In the first half of the twentieth century, the Latin Quarter served as the public space for all things Mexican in San Francisco. Clarence Edwords, author of a 1914 culinary tour of San Francisco, cited the area around Broadway and Grant Streets in North Beach as the place to learn "something about conditions in Mexico." Edwords wrote: "Here you will find all the articles of household use that are to be found in the heart of Mexico. . . . You will find all the strange foods and all the inconsequentials that go to make the sum of Mexican happiness, and if you can get sufficiently close in acquaintance you will find that not only will they talk freely to you, but they will tell you things about Mexico that not even the heads of the departments in Washington are aware of."[6] As Edwords observed, a visible and politicized Mexican community existed in the Latin Quarter. Some even adopted the term "Little Mexico" to describe the population that resided at the base of Telegraph Hill and along Broadway around Montgomery and Kearny streets.[7]

However, the descriptions often displayed little appreciation for Mexican culture. The only two Mexican restaurant reviews featured in Edwords's book were damning, reporting that "the cooking was truly Mexican for it included the usual Mexican disregard for dirt," and on the other, "they were strictly Mexican, from the unpalatable soup (Mexicans do not understand how to make good soup) to the 'dulce' served at the close of the meal."[8] In the writings of Edwords and most city records, neither Mexicans nor Mexican food ranked

high in public esteem, but these passing observations did confirm the presence of a Mexican population in the Latin Quarter.

Though the Latin Quarter served as the nominal public space for Mexican culture, Latino residents made their home in residential spaces throughout the city. Referring to 1930s San Francisco, Austin wrote, "There are no distinct colonies of South Americans. They settle in the neighborhoods where they can find the Spanish language spoken in shops and restaurants operated for the Spaniard and the Mexican. Thus we find them living in North Beach, in the Mission and about Fillmore Street."[9] Austin's comment indicated the sometimes hazy lines of racial segregation prior to World War II. The interspersal of small communities, or colonias, was typical of Mexican settlement in many major U.S. cities in the early twentieth century.[10] Segregation perpetuated these colonias, but city residents had not fully crystalized the more formal lines of neighborhood segregation that defined urban life after World War II. California and the entire Southwest bear a long history of alternating between suppressing and romanticizing the region's Mexican heritage.[11] The 1848 Treaty of Guadalupe Hidalgo initiated a long period of subjugation of Mexican residents, many of whom, through physical, economic, and cultural force, lost their land and experienced various forms of disenfranchisement from their U.S. citizenship.[12] In *The Annals of San Francisco*, the sensationalist 1855 sourcebook on San Francisco's Gold Rush, the authors declared: "Hispano-Americans, as a class, rank far beneath the French and Germans. They are ignorant and lazy, and are consequently poor. . . . The Mexicans seem the most inferior of the race. . . . The most inferior class of all, the proper 'greaser,' is on par with the common Chinese and the African; while many Negroes far excel the first-named in all moral, intellectual and physical respects."[13] Such negative representations contributed to various forms of violence directed at Mexican Americans, including lynchings and rapes.[14] Social devaluation was even evident in the pricing at a nineteenth-century bordello, the Municipal Crib, which charged half as much for Mexican women as for Anglos and African Americans (twenty-five cents versus fifty cents).[15] Stereotypes of Mexicans and Mexican Americans portrayed them as undesirable and among the lowest class of Latin Americans.

The migration of Mexicans fleeing the revolution during the 1910s contributed to negative public representations of Mexicans and Mexican Americans; these new immigrants, tending to have little cultural capital in terms of U.S. education, economics, and English language skills, were delegated the least attractive jobs and lowest social status.[16] Over the course of the 1920s and early 1930s, Mexican migration into the United States continued to increase. The Cristero movement played a role. In 1926, the Cristeros, as self-labeled

"followers of Christ," rejected the Mexican government's open hostility to the Catholic Church. The ensuing execution of priests and other pious Catholics horrified people around the world and spurred acts of solidarity.[17] Though Austin did not refer to the Cristeros by name, he did describe the recent settlement of many Catholics in San Francisco as a product of discrimination in Mexico.[18] The long-standing Nuestra Señora de Guadalupe (Our Lady of Guadalupe) church served as the most welcoming place in San Francisco for these religious refugees (Fig. 1.2).

The grandeur of the church offers some indication of the many parishioners who stepped through its doors to attend regular Spanish services. An earlier church was built in 1880 but destroyed in the 1906 earthquake and fire. Its 1912 replacement dominated the street with two towering cupolas and an enormous carved frontispiece in the style of California's oldest missions. The motif reflected a trend toward Spanish colonial revival architecture and underscored the "Spanish" heritage of its parishioners. The building is now hidden behind the 1950s construction of the Broadway tunnel, a major thoroughfare through the base of Russian Hill that substantially displaced its parishioners.

In name, Our Lady of Guadalupe church paid homage to the indigenous Mexican representation of the Virgin Mary, thereby speaking directly to the

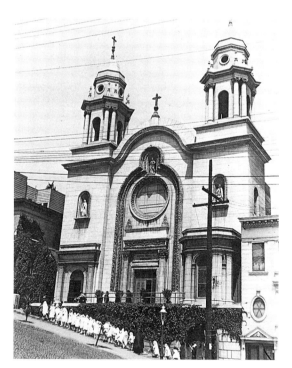

Figure 1.2. Nuestra Señora de Guadalupe, or Our Lady of Guadalupe Church, August 12, 1924. According to the original caption, the class outside was about to participate in "forty hours devotional service" in Spanish. This two-day ritual, also known as Quarant'Ore, encouraged additional expressions of faith, rather than strict attendance for forty hours. Image courtesy of the San Francisco History Center, San Francisco Public Library.

religious beliefs of its Mexican parishioners. In fact, the yearly celebration of the virgin on December twelfth may be the longest-running Mexican-oriented event in the Bay Area, though it is hard to pinpoint the date of the first celebration.[19] By providing services in Spanish, the church attracted diverse immigrants of Spanish-speaking countries. The pastor of the church from 1889 to 1944, Monsignor Antonio M. Santandreu, was from Barcelona and could speak directly to the needs of his many Basque and Spanish parishioners.[20]

People of Mexican origin were in the majority, but they did not easily dominate the Latino population. The 1930 census—the only census to distinguish Mexicans as a race—reported a little over 11,000 people with Mexican origins. However, the Latino population also included close to 4,500 people of Central and South American origins and 2,400 foreign-born of Spain. In total, Latinos formed a tiny fraction of the city's total population of 634,594, but studies have emphasized the census's long history of undercounting Latinos.[21]

The 1930 census did not separate Central Americans from South Americans, but enough evidence shows that Central Americans figured significantly in this population. As a shipping center, San Francisco developed close ties with the west coast of Central America. Over the course of the late 1800s, San Francisco became a coffee industry headquarters, serving Folger's, Hills Brothers, and MJB, fomenting a continuous economic relationship with strong coffee-producing countries such as Guatemala and El Salvador. In addition, in the 1920s and 1930s, the large multinational United Fruit Company developed a frequent line of exchange between the two coasts.[22] The growth of direct shipping routes between San Francisco and Central America assured continuous cultural, economic, and migratory exchanges.

The shipyards, canneries, and factories that grew along San Francisco's waterfront attracted a large labor pool. Many of the Central American and Mexican workers set up residence in the nearby Latin Quarter and South of Market area. Subsequently, the demand for labor during World War II precipitated an increase in Latin American immigration. In 1950, the city counted 5,600 Mexican-born residents (4.6 percent of the foreign-born) and 6,855 Central and South American-born residents (5.6 percent of the foreign-born).[23] The numbers are deceptive; they did not count the many American-born members of these communities.[24]

Large-scale migrations in the wake of social revolutions proved relevant in facilitating community expansion. New immigrants formed communities, which then offered assistance to friends and family members in terms of acculturation and employment.[25] Many people did not relinquish their ties to their home nation. The impact of these transnational communities had repercussions for both sides of the U.S.-Mexico border. Austin declared, "Every revolutionary

upheaval south of the border has thrown into this country the leaders of the losing side and many came to San Francisco to be regarded here with not a little awe." Somewhat hyperbolically, but perhaps not without basis, Austin added, "Visitors to the Mexican cafes in North Beach would be accustomed to seeing distinguished and mysterious gentlemen murmuring over their chocolate or wine, then suddenly one night they would be gone, never to be seen again. A few days later we would read of a revolution in Mexico."[26] Austin's description of Mexican revolution planned in San Francisco cafés may ring with poetic exaggeration, but, in a very real way, the city has served as an American base for various revolutionaries in Latin America from William Walker to the Sandinistas to the Zapatistas.[27] The romanticizing of revolutionaries contrasted sharply with the everyday experience of Mexican and Mexican Americans.

Romancing the Latin, Displacing the Mexican

The *Latin Quarter* label perpetuated the invisibility of Mexicans in the city. Settlers in San Francisco during the mid-1800s christened the Latin Quarter as a site of convergence for populations of Italian, Spanish, and Latin American descent. Such ethnic divisions fulfilled the city's (and the nation's) proclivity for residential segregation, but also promoted the cultivation of these cultures as an amalgamation of "Latin" identities. The conglomeration of a single Latin identity built community networks among diverse groups, though ethnic animosities persisted. Reportedly, "once an ill-concealed and profound antagonism existed between [Spanish-speakers] and their Italian neighbors."[28] Though Latin Americans were linked verbally with their "Latin" counterparts in Europe, this did not eliminate cultural tensions and exclusions. The emphasis on a harmonious grouping of Latin cultures, as designated by the *Latin Quarter* appellation, also served to deemphasize the less prestigious Mexican American community.

The Latin label connoted a genteel quality. Identifying as Latin (or Spanish) became a tool to evade negative stereotypes and facilitate upward mobility. Austin encouraged his readers to see through the Spanish sham, writing that "the so-called Spanish restaurants here are really Basque or Mexican."[29] Throughout California and the Southwest, notions of Spanish "culture" served to colonize and commodify the West. Cities underwent enormous facelifts to emulate an idealized Spanish décor and project a fabricated past.[30] By the 1940s, as Carey McWilliams noted, "the Spanish heritage is now enshrined throughout the Southwest. It has become the sacred or templar tradition of which the Mexican-Indian inheritance is the secular or profane counterpart."[31] So-called Spanish architecture not only invented an idealized past, it also silenced the presence of any Mexican or indigenous people.

The most obvious examples of Spanish revival architecture in San Francisco emerged in the Mission District. The presence of the original Mission San Francisco de Asis, more commonly known as the Mission Dolores, inspired various homages to the "mission style" in the local architecture. Similarly, Spanish street names, such as Valencia and Guerrero, harkened back to a displaced gentry. The Spanish colonial revival architecture of the 1920s and 1930s popularized the "mission" aesthetic.[32] For instance, after the 1906 earthquake, the clergy rebuilt the brick basilica adjacent to Mission Dolores in a style imitative of the original, surviving adobe structure, though with more Churrigueresque ornamentation (deliberately dense and overwhelming flourishes). When the nearby, nondescript Mission High School burned down in 1922, locals replaced it with an intricately decorated Moorish building with a red-tiled roof. Residents also sought to represent the area's historic Spanish past in various public spaces, from schools to department stores to community events. In the 1930s, the Mission Merchants Association promoted California Mission Days, sponsored the creation of small decorative arches and towers on Mission Street, and circulated street banners of a dancing Spanish señorita.[33] Such efforts contributed to the post–World War II barrioization of the Mission District. The neighborhood physically and culturally signaled a mild acceptance of "Spanish" cultures, at least more than many other parts of the city.

While the Spanish colonial revival style blossomed, Mexican people fell further out of favor. In the 1930s, the U.S. repatriated more than half a million Mexican and Mexican American citizens to Mexico in order to remove the threat of these workers taking jobs from "American" citizens.[34] Artist Luis Cervantes remembered his father's struggle to obtain a job in South San Francisco during the Depression: "There was a prejudice against Mexicans in reference to who should get a job and who shouldn't. Noncitizens, get at the end of the line."[35] Even when the demand for wartime labor prompted the United States to create the Bracero Program, which just within the war years recruited nearly 220,000 Mexican workers to come to the United States (mostly to work in California agriculture), the program prohibited any access to citizenship.[36] Public representations of Mexicans as undesirable citizens contributed to local and national efforts to physically and socially isolate Mexicans and Mexican Americans.[37] In general, Mexican migrants and Mexican Americans, like other marginalized ethnic groups, learned to suppress their cultural heritage in order to advance in school and in public life.

This general hostility helps explain the destabilizing of Latino communities in the Latin Quarter and South of Market area. Austin described the presence of small Hispanic "colonies" in the Mission as a result of displacement from the city's increasingly expensive Latin Quarter.[38] Later, when the larger North

Beach area emerged as the hangout of the Beats and the center of nightclub life during the 1940s and 1950s, property values and displacement increased even more.[39] One of the results was the creation of reconstituted Latino communities farther inland, most notably in the Mission District.

By the mid-1950s, the demographic shift in the Latin Quarter was well underway. When artist José Ramón Lerma returned to San Francisco from Korea in 1954, he found an apartment in North Beach near Our Lady of Guadalupe church. "They called it 'Mexican Town,'" he recalled. "And there were a number of old Mexicans, who would have been my father's generation, who were seamen, and had lived there for a while."[40] The ensuing destruction of Mexican Town was aided by the disruptive construction of the Broadway tunnel through the base of Russian Hill in 1950 and new demands on real estate—particularly the pressures of a growing Chinatown.[41] Gradually, the history of Mexican Town, Little Mexico, and the Latin Quarter vanished from the city's physical and cultural representations, displaced with popular representations of Little Italy, Chinatown, and North Beach.

While economic and social pressures redefined the Latin Quarter, city redevelopment projects reshaped the South of Market area. The construction of the Bay Bridge and adjoining freeways in the 1930s displaced many Mexican American residents from their waterfront community.[42] The Golden Gate Bridge (completed in 1937) spanned a less populated area, but the foot of the Bay Bridge (completed in 1936) cut directly into the homes of South of Market residents. Community activist and artist Francisco Camplís recalled, "Then the bridge came—the Bay Bridge, as well as the Golden Gate—and they razed all the homes around there, and threw all that community out. . . . And what that did was of course break up the families first, and then friends, and then networks that they had of support."[43] Similarly, another former South of Market resident recalled, "la casa donde viviamos, la vendieron a Bay Bridge" (They sold the house where we were living to the Bay Bridge).[44] Many renting tenants had their homes sold out from under them. Numbers are elusive, but oral histories suggest several residents moved inland toward the Mission, where a Spanish-language community already existed.[45] Little official recognition of these barrio communities exists in general histories or physical markers, but the residents who experienced this displacement carried the memory and were more conscious of how easily their communities could be dislodged.

The Lively Latin Nightlife: Staging Latino Identities

World events in the 1930s and 1940s increased the visibility of Latin Americans in U.S. popular culture. The likelihood of war in Europe heightened the value

of U.S. alliances with Latin America. President Franklin D. Roosevelt's "Good Neighbor" policy filtered from diplomatic circles into American life, reframing how Americans thought about Latin America (and how Latin Americans thought about the United States). In 1940, with President Roosevelt's support, Nelson Rockefeller spearheaded the creation of a Motion Picture Division in the State Department "that would concentrate its efforts on seeing that Hollywood films that heretofore had, by and large, presented negative stereotypical images of Latin Americans would now present Latin Americans in more favorable images."[46] In the process, Latin America became subject to U.S. fantasy.

Hollywood and Broadway played major roles in disseminating these positive, colonialist images of a tropical Latin American playground for American consumers. *Down Argentine Way* (1940), *The Gang's All Here* (1943), and *Holiday in Havana* (1949) were among a string of films selling Latin America as a haven for fun and sex. On Broadway, such musicals as *Panama Hattie* (1940) and *Too Many Girls* (1939) affirmed the depiction of Latin America as a desirable female. Stars such as Carmen Miranda, Desi Arnaz, and Rita Hayworth represented the friendly, sexy Latin America, often through song and dance.[47] As Alberto Sandoval-Sánchez noted, "In the 1930s and 1940s, Latin America became a postcard, a photograph, a tourist attraction, a night club, a type of theme park where fantasy and fun were guaranteed and escapism assured while U.S. national security interests were guarded."[48] Though popular culture portrayed Latin America as an ally of the United States, it also depicted Latin America as an object for American exploitation.

Like Hollywood and Broadway, San Francisco's club scene was wedded to this Good Neighbor nationalist agenda. Notably, each also provided an important intersection for Latino artists and musicians to perform. The rise of 1940s nightclubs such as Joaquin Garay's Copacabana at Fisherman's Wharf, Luz Garcia's Club Sinaloa, and the Casino Pan America along San Francisco's Broadway strip in North Beach turned Hispanic identities into entertainment (Fig. 1.3). Of course, these clubs drew inspiration from popular Latin clubs in New York, Havana, Rio, and elsewhere, both in name and aura, and perhaps gained authenticity by their location "on Broadway." Here, tourists and residents could enjoy "spicy Mexican food and spicy rumba music" at Julian's Xochimilco, the "fiery floor shows" at Casa Madrid, or the menu of "Chef Rogelio Torres, who once cooked for the King of Spain," at The House That Jack Built.[49]

The Marimba club marketed itself as "The Spirit of Latin America," and showcased the talents of the famous Hurtado Brothers Marimba Band in its early 1940s floor shows.[50] Originally from Guatemala, various incarnations of the Hurtado Brothers, mostly under the direction of Celso Hurtado, traveled around the world over the course of several decades. Many San Franciscans

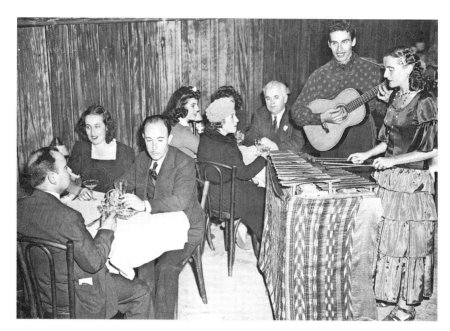

Figure 1.3. Entertainment at the Casino Pan America nightclub, 831 Broad-
way, on July 22, 1942. The original caption described Chico and Juanita as
"strolling serenaders," who "charm the guests with their guitar and marimba
music." The writer also observed how the diners "seem to enjoy the mellow
Latin-America tunes that this versatile pair is offering for approval." This
space at 831 Broadway served as home to multiple nightclubs, including the
Marimba, the Beige Room, the Copacabana, and the Tropicoro. Image
courtesy of the San Francisco History Center, San Francisco Public Library.

learned of the group through their performances at the 1915 Panama-Pacific
International Exposition and the 1939 Golden Gate International Exposition.
More stable Latin Quarter gigs at La Marimba and La Fiesta in the 1940s provided
economic support and visibility (Fig. 1.4).[51] While Latin music was not limited
to the Broadway strip, the locale was unquestionably center stage for most
Latin musicians and performers in the city.[52]

Even if many of these clubs experienced short life spans, organizations like
the Unión Española helped cultivate neighborhood continuity. The Unión Es-
pañola building, also known as the Spanish Cultural Center, served as a social
space for educational programs and cultural activities.[53] Located a block from
Our Lady of Guadalupe Church, the center frequently made its 831 Broadway
address available to nighttime entertainment: Tenants included the Marimba Club
(c. 1941), the Casino Pan America (c. 1942), the Beige Room (c. 1951–1957), the
Copacabana Club (c. 1957–1967), and the Tropicoro Club (c. 1967). The presence

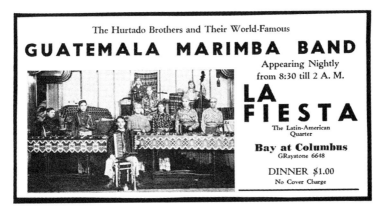

Figure 1.4. Card-stock advertisement for regular performances of the Hurtado Brothers at La Fiesta in the "Latin-American Quarter," c. 1940. Image courtesy of the private collection of David Harvey.

of the Beige Room is striking, as this club gained a reputation for welcoming gay, lesbian, and transgender performers and clientele. For instance, legendary drag performer José Sarria started performing at the Beige Room before moving his act to the nearby Black Cat. A native San Franciscan raised by his Colombian mother, Sarria transformed into an activist while working at the Black Cat, which in the 1950s served as one of the most policed gay bars in the city. In 1961, Sarria ran for election to the city's Board of Supervisors, making him the first openly gay candidate for U.S. public office.[54] Sarria's time at the Black Cat and the Beige Room spotlights some of the crossover that existed amongst Latino and queer communities in these bohemian spaces.

Henri Murger's 1849 novel *The Bohemians of the Latin Quarter* (the inspiration for Giacomo Puccini's opera *La Bohème*) solidified the idea of the Latin Quarter as the artist's garret—an exotic place for the marginalized but creative poor and intellectual outcasts.[55] San Francisco tour book authors drew on this famed history to promote its sister enclave: "The Latin Quarter is bohemian. Long have artists had homes and studios on Telegraph and Russian hills and in vicinity of Columbus Ave. and Montgomery St. Here also are the California School of Fine Arts and the Rudolph Schaeffer School of Design. . . . For five blocks, between Montgomery and Mason Sts., it is crowded with restaurants and night spots—not all expensive. Elsewhere in [the] quarter are other good restaurants, continental cafes, [and] interesting night clubs."[56]

In part, it was this global stereotype that helped transform San Francisco's Latin Quarter into the home of the North Beach counterculture during the 1950s. As the location of the California School of Fine Arts and as the home of

"Latin" culture, North Beach was perfectly positioned to become one of many American doppelgangers of the old Parisian haunts. As in Greenwich Village in New York, the French Quarter in New Orleans, and Ybor City in Tampa, Florida, American bohemianism and the ethnic "other" were intimately connected.[57]

Latin Quarter businesses promoted elite Spanish and South American cultures over less prestigious Mexican and Central American cultures. In San Francisco, a strong flamenco entertainment sector grew at various North Beach restaurants, including the Old Spaghetti Factory, the Sinaloa, and Casa Madrid.[58] El Matador became one of the most popular nightclubs of the late 1950s, with its reputation heightened by its charismatic proprietor Barnaby Conrad, whose prolific writing on Spanish bullfighting authenticated the club. The place became a celebrity hotspot. One source reported, "The last time we were there John Steinbeck was carrying on a spirited literary discussion with Barnaby, while Jane Russell, an ardent aficionada, came in to lay a rose at the feet of the Manolete painting. José Ferrer was sipping a specialty concoction known as a Picador, next to Henry Fonda and Deborah Kerr."[59] This collection of Spanish restaurants and nightclubs produced an imaginary Spain where residents and tourists could experience the fantasy of elite Mediterranean life and culture.

Flamenco was not new to North Beach, but growing interest in producing flamenco as spectacle for tourists heightened its visibility and also tended to package the event as Latino performances for white American audiences, rather than Spanish-speaking audiences. The popularity of flamenco in the 1950s was a global phenomenon; as Michelle Heffner pointed out, during Franco's totalitarian regime in Spain, "the version of flamenco tailored to 'tourist' performances emphasized a charming but nonthreatening portrait of Spain."[60]

While flamenco increasingly relied on tourism, its popularity also provided greater economic opportunities and more venues for performers. Widely recognized dancers, such as Isa Mura, Cruz Luna, and Ernesto Hernandez, popularized the flamenco tradition locally and maintained strong networks with Spain and elsewhere around the globe. Though Spanish culture dominated Latin Quarter entertainment, Cruz Luna's background suggests a multiplicity of cultures shaped flamenco in San Francisco: Born in Spain, Luna moved to San Antonio, Texas, when he was four, studied flamenco in Mexico City when he was fourteen, and came to the Bay Area when he was fifteen. In 1960, Luna opened Casa Madrid, where he performed and brought flamenco dancers from around the world.[61]

A block away from Broadway, nightclub proprietors promoted the "International Settlement," giving name to a series of clubs that celebrated exotic lands, including La Conga, the Hurricane, Pago Pago, and Arabian Nights. Their

efforts tapped into the emerging market of servicemen on leave during World War II and coordinated with city planning interests in cleansing the area of its illicit Barbary Coast history.[62] The preponderance of orientalist landscapes in this area, along with the well-documented popularity of downtown's Forbidden City, underscores some of the parallel mixed messages that Latinos and Asian Americans experienced as participants in these nighttime fantasies.[63]

The presence of so many entertainment venues spurred opportunities for musicians and facilitated a strong culture of music from around the world. The jazz scene gained strength with the African American musicians who migrated to the shipyards in San Francisco and Oakland during World War II. In the 1950s and 1960s, "small clubs were flourishing all over the city, including the Blackhawk [Tenderloin District], where Art Tatum played one of his last residencies; the Jazz Workshop [North Beach], where Cannonball Adderley recorded with his quintet; the Club Hangover [Downtown], where Earl Hines performed; Earthquake McGoon's [Downtown/North Beach], where Turk Murphy's trad-jazz band played for 20 years; and Bop City [The Fillmore], where Dexter Gordon and Sonny Criss once played."[64] North Beach, with its many small clubs and restaurants—including the Jazz Workshop, Club Fugazi, and Enrico's—became a prominent space for jazz outside predominantly African American neighborhoods. White audiences could come into contact with African American music without the anxiety of entering the Fillmore or the Tenderloin, yet with the aura of nonwhite bohemian adventure.

Latino musicians moved in and out of Latin, Anglo, and African American spaces, often in accordance with the way they were racialized in the United States. Afro-Cuban conga player Armando Peraza first came to New York in the late 1940s, where he played with Machito, Dizzy Gillespie, and Charlie Parker. In the early 1950s, he came to San Francisco and started working with African American vocalist Slim Gaillard at the Blackhawk and Bop City. Though Peraza barely spoke any English at that time, he managed to integrate into American life through music. However, he was barred from establishments that lighter-skinned Latinos could enter. He recalled a trip to see the orchestra of Mexican bandleader Merced Gallegos at the Palomar Ballroom downtown: "As I was going inside, the security guard stopped me and told me I couldn't go in. I was told black people weren't allowed. But there was this guy by the door named Noel García, who was playing conga in the band. He said: 'That's Armando Peraza' and invited me in. I sat in with the band."[65] The tendency to categorize Afro-Latinos as black not only impinged on their social mobility, but also incorrectly promoted the vision of Latinos as of a single olive-skinned hue.

Nevertheless, Peraza also moved in music circles more closely identified as "Latin." For example, Merced Gallegos, at the behest of events manager Jesse

Carlos, hired Peraza to play in his *tardeadas* (Mexican afternoon jams) at Sweets Ballroom in Oakland, but had to arrange payments under the table to avoid union backlash. Gallegos and other musicians also reserved "after hours" to subvert the culture of segregation, as when Gallegos and Duke Ellington played together at the Sinaloa Club.[66] While segregation scripted everyday life, music was multicultural, and musicians like Peraza pushed the boundaries of racialized spaces.

Just as race scripted access to opportunities, so, too, did gender. When Peraza formed his own band, the Afro-Cubans, he included Cuban vocalist Israel del Pino, Mexican American brothers Manuel and Carlos Duran (piano and bass, respectively), and Juanita Silva, who he referred to as "the first woman to play hand percussion in California."[67] The band played a cross-pollination of Cuban and Mexican music in regular performances at downtown's Cable Car Village.[68] Manuel and Carlos Duran, along with their guitarist brother Eddie Duran, proved a considerable force in the San Francisco music scene, working collaboratively and independently with high-profile band leaders, such as Cal Tjader, Stan Getz, and Vince Guaraldi. The band's inclusion of Silva is striking because so few sources documented the participation of Latina musicians in this vibrant music community. The absence of female musicians was more likely a product of oversight rather than actualities, as Sherrie Tucker documented hundreds of all-girl jazz bands in the 1930s and 1940s.[69] Even when women were present, the lack of jobs, recording contracts, promotion, and music reviews minimized visibility.

Peraza's movements around the Bay Area also highlight the peripatetic mobility of Latin musicians, although North Beach remained the center of "Latin" music. The experience of Benny Velarde, a Panamanian raised in San Francisco, reveals the importance of the North Beach scene. Velarde played bongos with the Alonzo Palio Quartet at the Jai Alai Club in North Beach in the early 1950s, joined Cal Tjader at the Macumba Club downtown, and in the late 1950s or early 1960s formed his own band, which played four nights a week at the Copacabana on Broadway for nearly a decade.[70] Velarde also booked a number of high-profile entertainers to play at the Copacabana, including Tito Puente, Tito Rodriguez, and Charlie Palmieri.[71] Velarde's experience is an interesting counterpart to Peraza's, since the majority of Velarde's venues had a more patently "Latin" orientation.[72] Latino musicians played where they could get paid, often crossing lines of segregation based on their ability to pass into white and black spaces. Zina Escovedo described how her father Pete Escovedo and his brothers Coke and Phil formed the Escovedo Brothers Latin Jazz Sextet and "played all over town, carrying their own instruments on the bus to get to

their next gig and earn their $50. They played in famous places like the Matador, Jazz Workshop, The Tropics and The Basin St. West."[73] While the Jazz Workshop mostly showcased African American jazz musicians, including Cannonball Adderley, Miles Davis, and John Coltrane, the recollections of the Escovedos spotlight the presence of Latino musicians.[74]

Across the nation, Latin music drew life from the 1950s mambo dance craze. San Francisco proved no exception, as indicated by the popularity of a Pérez Prado concert that drew 3,500 people in 1951.[75] Prado's release of "Que Rico El Mambo" and "Mambo No. 5" in 1949 helped him earn the title "King of Mambo." The mambo craze, like rumba of the 1930s and samba and conga of the 1940s, firmly established Latin music in popular culture, and by 1954, "the mambo's audience was the entire country."[76] For conga player Peraza, the impact was high. "All these people from the Arthur Murray Studios used to come out and dance to our music. We also had stars like Rita Hayworth, Ricardo Montalbán and José Ferrer from Hollywood who would stop by."[77]

Just as New York musicians Mario Bauza, Machito, and Tito Puente were producing a radical new mix of Latin sounds all along the East Coast, a similar fusion was occurring along the West Coast.[78] Latin music in San Francisco started transmitting its own "West Coast" sound. According to musicologist John Storm Roberts, "One of the major developments of the 1960s, in fact, was the emergence of California as a most important crossover center. Herb Alpert was *sui generis*, but in jazz Tjader and in rock Carlos Santana were only the best known of a floating group of musicians who were together to make San Francisco the focus of a further blending of rock, jazz, black, and Latin elements during the 1970s."[79]

Tjader, a Swedish American musician raised in the Bay Area by vaudevillian parents, played a fundamental role in raising the profile of Latin jazz (Fig. 1.5). Tjader studied jazz as a teen, then worked as a drummer with Dave Brubeck, and partly found his entrée into Latin music when he began working with British pianist George Shearing. Both Shearing and Tjader described encounters with Latin musicians in New York as inspirational, but they made San Francisco their base.[80] According to Dave Brubeck, Peraza's participation at a set at Ciro's in San Francisco in 1950 "was Cal's first exposure to [Cuban] music. Then he brought his bongos and learned a lot from Armando."[81] Shearing's appreciation of the Latin sound led him to form a quintet with Tjader on the vibraphone, backed by legendary percussionists Willie Bobo on timbales, Mongo Santamaría on conga, and Peraza on the bongo. The Shearing quintet of 1954–1955 is widely regarded as the launching pad for West Coast Latin jazz.[82] Loosely defined,

Figure 1.5. Cal Tjader's Afro-Cubans performed at the Club Macumba, shortly after it first opened in the summer of 1954. From the left are Edgardo Rosales on maracas, Tjader on timbales, Carlos Duran on bass, Bayardo "Benny" Velarde on the conga, and Manuel Duran on piano. A short time later, Tjader opted for suits and ties over the puffy shirts shown here. The band name expressed a love of Cuban music, but did not last, perhaps because none of the members hailed from Cuba. Later that year, they adopted the name "Cal Tjader's Modern Mambo Quintet," which fit more with growing fandom for the mambo. Photograph courtesy of Robert C. Tjader.

West Coast Latin jazz emerged in the late 1940s and early 1950s as a product of smaller combos playing jazz standards with Latin percussion and syncopation.[83] Shearing and Tjader made this sound audible to the world in a series of spectacular recordings featuring various Latino musicians from their San Francisco gigs.

Creative energy in the clubs and on the streets gave San Francisco a higher profile in the world. Frequent tours led musicians to share their San Francisco sound, as well as bring new influences to the city. The Broadway club scene served as an important presence in developing the West Coast Latin music scene, though it represented a steadily "disappearing" population. As the clubs and cafés popularized the area, it became increasingly unaffordable for its

oldest residents. However, in giving a location for musicians to come together and jam, the scene bubbled with creative energy and gave strong roots for the music that followed.

Listening Outside: A New Generation Taking Heed and Taking Root

The reputation of North Beach as a center for Latin music remained strong through the late 1960s. Musician and music scholar John Santos recalled, "I used to stand outside Andre's on Broadway and other North Beach clubs. I was too young to get in! To hear [Luis Gasca] and other great groups in that era."[84] This listening at the door was part of Santos' musical education.

However, economic and social pressures were changing the dynamics of the North Beach community. In part, the nightclub era was coming to an end, at least in its traditional format. Television encouraged people to stay at home, so entertainment-based businesses had to think of new ways to attract audiences.[85] In North Beach, the approach was to turn the area into a red light district. Topless clubs and nude dance shows displaced the dinner clubs of the past.[86]

By the 1970s, much of the North Beach Latin music scene had relocated to the Mission District. A case in point was Cesar's Latin Palace. Local music impresario Cesar Ascarrunz, a native of Bolivia, had adapted quickly to the Bay Area scene. Ascarrunz toured Los Locos del Ritmo all around the Bay Area in the early 1960s, playing at Zack's in Sausalito, Lucky Pierre's on Broadway, and at the Circulo Pan-Americano in the Mission District. According to Los Locos conga player Dennis "Califa" Reed, the band never rehearsed, just improvised out of a shared knowledge of Latin music, including the tunes of New York musicians.[87] Los Locos was a springboard for Ascarrunz; the savvy entrepreneur would become an important figure in San Francisco's Latin music scene. After briefly forming another band at El Cid, Ascarrunz created Cesar's Latin Palace in North Beach. Its move to the Mission District in the late 1970s affirmed the demographic and cultural shift that had transpired in these two neighborhoods.

Without fanfare, the term *Latin Quarter* disappeared from use. North Beach, the neighborhood that Austin once called the Mexican quarter, garnered an entirely Italian-American identity through tourism. Representations of North Beach continued to evolve, also drawing on its Beat counterculture bohemianism and its red light district appeal.[88] Rarely, if ever, have these popular depictions incorporated the Latin Quarter history.

Simultaneously, however, the Mission District became the principal site of Latino settlement in San Francisco. Latin music was not new to the Mission

District, although the venues historically reflected a more intimate, familial at-
mosphere than the North Beach clubs. El Club Puertorriqueño, founded in
1912, initially migrated from the Latin Quarter to the Excelsior District in the
1920s and then to the Mission in the 1960s or 1970s. John Santos fondly recalled
the Mission location as the place where his grandfather Julio Rivera used to play.
In addition, Latin dances were held at multiuse venues, such as the Polish Hall
and St. Peter's Church.[89] Mariachi José Santana, the father of Carlos Santana,
came from Mexico with his family in the early 1960s and found work down-
town at the Sinaloa Club and in the Mission at the Mariachi Club and the
Centro Social Obrero.[90] Santos and artist Emilia "Mia" Galaviz de Gonzalez
separately remembered dance parties at their family homes in the Mission in
the 1950s and 1960s. According to Galaviz de Gonzalez, "It was like a little
nightclub in the house, downstairs in the basement . . . it was a total dress-up—
high heels, flippy skirts, mambo, cha-cha-cha, drinking . . . our own mambo
club."[91] Though the music scene in the Mission existed on a smaller scale than in
North Beach, change was at hand. Pete Gallegos recalled that "on any given
Saturday night you could walk within a ten-block distance and hear any
Latin [music] you wanted during the late sixties and early seventies."[92] Places
such as Club Elegante, El Señorial, and El Tenampa added to the Latinization
of the Mission.

Perhaps the most impressive addition to the Mission District music scene
was the relocation of Fantasy Records. Founded downtown in 1949 as Circle
Records, Fantasy was originally a small record press geared toward engineer-
ing improvements in the manufacturing of plastic. However, with its release
of the first Dave Brubeck albums, the newly christened Fantasy Records label
emerged as one of the premiere jazz recording studios on the West Coast.[93] Jazz
scholar Ted Gioia declared, "If San Francisco could ever lay claim to a truly in-
digenous jazz style, it sprang from the *sui generis* modernism fostered by the
Blackhawk and Fantasy Records."[94] By the early 1960s, Fantasy Records had
moved to the Mission District, perhaps to take advantage of lower rents.

The recording tastes of Fantasy Records were geared to the eclectic, perhaps
a product of its history as a custom press for a vast array of music, including
Chinese, Hawaiian, and Dixieland sounds. Founders and brothers Max and Sol
Weiss poked fun at their success. In 1956, Max declared, "We have the golden
touch. Our *Jazz at the Black Hawk* LP, in which we conscientiously tried to pick
the worst Brubeck sides possible, has outsold anything we have this year. Cal
Tjader is selling thousands of LPs a month even though we recorded him only
because we knew the mambo craze was over."[95] Regardless of the Weiss brothers'
business savvy, Fantasy Records was *the* recording studio for jazz and Latin jazz
artists in the Bay Area.

Poet Juan Felipe Herrera remembered standing outside Fantasy Records and listening to legendary musicians playing just steps away from his home.[96] Echoing into the streets of the Mission was the music of Santamaría, Tjader, and Francisco Aguabella, among a host of jazz greats.[97] Their musical stylings set the stage for the evolution of strong Afro-Cuban rhythms in the Bay Area, both among themselves and for the next generation that stood listening outside, ready to launch its own arts revolution.

Rocking into the Mission

In the late 1960s, the Mission District served as center stage for the "Latin rock explosion." Patricia Rodriguez recalled, "In every corner in the Mission in the seventies Santana was playing, Malo was playing, whoever was playing in the street."[98] Though Santana and Malo put California's Latin sound on the music map in the 1970s, the roots for this evolution were firmly planted before the 1960s. Indeed, Santana drew his band members from veterans of this scene, including Peraza and the Escovedo brothers. Their work continued to inspire generations of musicians, most obviously the later career of Sheila E., the daughter of Pete Escovedo, who became a drummer and keyboardist with Prince. San Francisco's vibrant music scene created a rich soundtrack for Latino arts and activism.

The music flowed into the streets and beckoned the attention of a wider audience. In the context of the national civil rights movement, the music served as a rallying cry for action and an emblem of a shared, local, pan-Latino culture. Jim McCarthy declared, "The blending of cultures that characterized the Mission district and the highly charged political consciousness and activism of the late 1960s and early '70s established a robust platform upon which the music known as Latin rock was launched."[99]

Reflective of this enthusiasm, local musicians began playing impromptu drumming sessions in Dolores Park, a public green space across from Mission High School. The sounds of conga drums traveled through the air and spoke a cultural politics for the neighborhood. While some took pleasure in the new beat, members of the Dolores Heights Neighborhood Association did not, prompting police to arrest drummers Santos and Raul Rekow (of Santana fame) in 1975 for noisemaking. Supervisor Dianne Feinstein then spearheaded a "bongo ordinance" to silence the drums and demanded that police crackdown on participants. Over the next two years, supporters of the *congueros* protested their opposition to this legislative silencing (the city finally dropped the charges against Santos and Rekow, but continued to push for the ban).[100] These events spiraled into major controversies over who had a right to occupy public space in the city.

While the public drama over conga drumming was new, the tensions over belonging were not. Latinos had been fighting for space and sound well before the 1960s and 1970s. The many Latin nightclubs in the city, especially in what had been the Latin Quarter, had served as pivotal sites for generating Latin music and creating a Latino community in the city. The young drummers in Dolores Park pounded out new sounds, but also paid homage to the talents of percussionists like Peraza, Santamaria, and Aguabella. Peraza captured some of the dramatic flair of his earlier performances when he recalled, "I used to paint my fingers with fluorescent paint, put fluorescent paint on my congas . . . and when I played it looked like the whole thing was on fire."[101] No wonder this generation of Afro-Cuban musicians inspired the "Beat generation" to play congas and bongos in the city streets.[102] Yet as North Beach became the home of the Beats, celebrations of this history minimized the contributions of Latino musicians and residents.

In the 1950s and 1960s many people, Latinos included, migrated to San Francisco because they were drawn to representations of a more accepting culture for social misfits, radicals, queers, and artists. Beat writers and artists recast San Francisco as a bohemian city and desirable destination for anyone who felt on the fringe of the mainstream. The city became a magnet for creative people of all backgrounds. Later, singer Scott McKenzie helped spur the summer-of-love hippie migration with his 1967 hit, "San Francisco (Be Sure to Wear Flowers in Your Hair)." The song gave voice to "a whole generation, with a new explanation," thereby affirming the growing generation gap. As Timothy Gray writes, "Some laughed at McKenzie's song and others were angry with it, but looking back there is no denying that it had a huge effect on migration patterns of American teenagers."[103] Chapter 2 examines this transitionary moment in San Francisco's history, focusing especially on the bounded participation of three Latino artists in the city's growing counterculture.

Chapter 2

Freedom in the Beats: Latino Artists and the 1950s Counterculture

Luis Cervantes, a Mexican American originally from Santa Barbara, moved to San Francisco shortly after he completed his World War II service with the U.S. Army Corps of Engineers. He found full-time work with a mattress upholstery company and started taking art classes in the early 1950s at San Francisco State and the College of Marin.[1] When sculptor and teacher Seymour Locks asked Cervantes to help hang a show at the San Francisco Art Institute in the late 1950s, a new world opened to Cervantes: "I hadn't heard of the Art Institute. And when I walked into that place and walked around the campus, I said, 'this is the place I want to go.' And the reason why was the sense of freedom, of liberation."[2]

Cervantes quickly adapted to the spirit of his new school. Fellow artist Ernie Palomino witnessed the expression of some of Cervantes's newfound freedom with dismay: "He had a whole show of ceramic pieces in San Francisco in a gallery [similar to Fig. 2.1], and one of his pieces fell to the floor and broke into a million pieces. Then after that he started throwing his pieces around the room and breaking all of them. . . . People in there didn't know what to think about the whole thing that was taking place. . . . I didn't know what to think. I just was shocked."[3] Cervantes's willingness to destroy his art echoed the avant-garde Destructivism of the period, a movement that tested the definition of art and troubled traditional norms. The act of destruction was a way of rejecting commodification and turning artwork into a performance or "happening."[4]

As Cervantes's story demonstrates, Latino artists and musicians in 1950s San Francisco were not necessarily seeking to join a pan-Latino arts community but the avant-garde milieu of the Bay Area. An important facet of arts activity in San Francisco over the course of the late 1940s and through the 1960s was the evolving bohemian counterculture, perhaps most notably embodied in Beat and jazz cultures. The term *Beat* was multidimensional, evoking the beaten or alienated spirit of a nuclear age, but also linked to bebop rhythms in jazz and

Figure 2.1. Luis Cervantes with one of his clay sculptures at the San Francisco Art Institute, c. 1961. Image courtesy of Susan Cervantes.

the spiritually inspired beatific.[5] While some responded affirmatively to the label, others objected, even if they were deeply entrenched in the scene. Nancy Peters described how poet Lawrence Ferlinghetti "never considered himself a beat writer," but "saw the group as part of a larger, international, dissident ferment."[6] For San Francisco art critic Thomas Albright, "the art that grew from this ferment did not form a coherent or even incoherent 'school' or 'style.' . . . What these artists shared was a loose constellation of attitudes and ideas— almost just a mood."[7] Not everyone agreed on the term, but *Beat* reflected a spirited arts movement evolving in the city.

Beat and bohemian culture stimulated the creative interests of many Latinos in San Francisco, in spite of their marginalized position as participants. North Beach cafés and nightlife attracted many hopeful Latino writers, musicians,

radicals, and visual artists. Chon Noriega attributed the failure to connect these worlds partly to the overpowering impact of later history. According to Noriega, "The connection between the Beat and Chicano art movements, one that can still be heard, for example, in any poem by José Montoya . . . never made it into the history books, as scholars of each movement articulated self-contained and *sui generis* borders."[8] The narrowness of both Beat and Chicano movement histories has contributed to the absence of Latinos in 1950s American (art) history.

The life experiences of Luis Cervantes (1923–2005), José Ramón Lerma (1930–2016), and Ernie Palomino (1933–) illustrate some of the challenges that Mexican American artists faced in this period. All three trained at the California School of Fine Arts (renamed the San Francisco Art Institute in 1961) in the 1950s. Their training centered on the dominant aesthetic of the time: abstract art and Bay Area figurative abstraction.[9] All three played with the possibilities of funk sculptural assemblage, especially Palomino and Cervantes. Lerma was partial, but not limited, to abstract expressionism, Palomino was obsessed with bric-a-brac assemblage, and Cervantes was keen on piled-high ceramics and tightly organized mandala paintings. Both Lerma and Cervantes called themselves "third-generation abstract painters" to emphasize their place in an established lineage of American art.[10] This terminology did not so much describe an aesthetic as the period they came into maturity as artists. Stylistically, the three artists shared little aside from a love of art and their experience as Mexican American art students at the California School of Fine Arts.

Each of the artists wrestled with the ways their ethnicity informed and inspired their work, but also limited their social mobility. While activists sought to dismantle segregation in housing, the military, and schools, many understandably considered the art world a lesser priority. However, this very reasoning helped the art world remain under the radar. Without watchdogs, the institutions and critics could propound their preference for quality, which in its vagueness also disguised racism and sexism. Male artists unquestionably had greater access and opportunity than their female counterparts. Women, especially women of color, struggled against even more limited access and gendered expectations.[11]

Palomino, Cervantes, and Lerma were by no means the only Latino visual artists working in the city at that time, but access to their stories gives insight into this historical moment and its implicit pressures, limitations, and possibilities. As Mexican Americans, they never quite fit the Anglo-centric expectations of the art world and Beat culture, and as abstract artists they never quite fit the political interests of the Chicano movement. As veterans they benefited from government support for their education but also struggled with indelible

memories of war. Their experiences show how the influx of World War II and Korean veterans was a critical, if male-dominated, force spurring the desegregation of San Francisco's art institutions.[12] Tracing the experiences of these and other Latino artists working in and outside the San Francisco avant-garde, and in and outside the Chicano movement, offers a way of reckoning with the historical categories that they transgressed.

Beat Migrations: Looking for Community in the Counterculture

Though the Beats gave visibility to San Francisco's counterculture scene, they were not single-handedly responsible for its growth. The city already had a reputation as a place where "anything goes," beginning as far back as the California Gold Rush era. Over the first half of the twentieth century, the city earned a reputation for tolerance of the queer, the avant-garde, and the transgressive.[13] Many soldiers stayed after World War II because the city served as a liberated space to pursue same-sex relationships, unlike their places of origin.[14] By the early 1960s, as Josh Sides described, "San Francisco moved from being one of many sites of homosexual activity in metropolitan America to being the nation's gay capital."[15] Its history as a strong town for union labor also drew people sympathetic to working-class struggles.[16] San Francisco was not free of racism and homophobia—the history of segregated spaces and police raids of gay bars testify to this—but it cultivated an image of tolerance, creative energy, and physical beauty that, along with employment, drew people.

Popular culture of the 1950s heightened San Francisco's bohemian reputation. Films and books on Beat culture put a spotlight on San Francisco as an ideal location to connect with the counterculture. In fact, Hollywood quickly coopted the lifestyle of the Beats for mass consumption, turning the Beats into misguided juvenile delinquents for the amusement of American middle-class audiences. Films such as *The Beat Generation* (1959), *The Beatniks* (1960), and *The Subterraneans* (1960), and the television program *The Many Loves of Dobie Gillis* (1959–1963) ridiculed Beat culture while simultaneously depicting a lifestyle that attracted widespread interest.[17] Though simplistically stereotyped by black clothing, berets, bongos, and bad poetry, Beat culture also became a semiotic for rejecting Cold War conformity. FBI Director J. Edgar Hoover's declaration that America's three greatest enemies were Communists, eggheads, and beatniks anointed the culture with counterculture authority.[18] Popular depictions of nontraditional lifestyles spurred a "Beat migration" of hopeful writers, artists, musicians, poets, and gays to San Francisco, all seeking that "sense of freedom, of liberation" that Cervantes felt at the San Francisco Art Institute.[19]

"Beat migrants" René Yañez and Nina Serrano shared similar stories of their desire to come to the Bay Area. Yañez was magnetically drawn to the scene from San Diego: "I was very attracted by the Beat thing when I was growing up. . . . I came up one time and I loved San Francisco. At that time, North Beach was like a little village . . . Italian restaurants and coffee houses, and it was very European, very hip, and I thought this is for me, and then I got drafted!"[20] After serving in Vietnam, Yañez returned to San Francisco and played a seminal role in the Latino arts movement of the 1970s as co-curator of Galería de la Raza.

While beatnik films inspired Yañez's migration, it was a book that launched Serrano's move from Madison, Wisconsin: Jerry Stoll's *I Am a Lover*.[21] The Latina theater activist and poet stated in 2003, "Even today if you saw this book, you would love it! It's a book of gorgeous photographs of the Beat movement in San Francisco and all their cafes, and it was interspersed with gorgeous poetry. . . . I saw pictures and poetry, and I said, 'Oh I have to have that!' "[22] The draw of the Beats was the promise of a glamorous intellectual lifestyle, living in cafes, exchanging ideas, and finding a community of artists. Unfortunately, the realities of North Beach in the early 1960s did not match Serrano's fantasies. In her poem "Poets in San Francisco," she wrote, "There is a place where poets meet and love each other / Once I thought it was San Francisco / but when I got there their coffeehouses / turned into dress stores."[23] The commodification of North Beach led Serrano to turn her attention to the Mission, where she participated in an artist community that drew inspiration from the Beats, but also from the Chicano civil rights movement and radical theater.

The influence of the Beats reverberated in the writings of Bay Area Chicano authors. José Montoya, reflecting on the moment, wrote, "The Beat poets emerged about that time, and that really blew it wide open for me. And being in the Bay Area where I could see those guys. *Me los apuntaban* [people pointed them out], 'That's Alan Ginsberg, that's Ferlinghetti, that's Kerouac.' So then *dije, 'Chale* with the short story [so then I said to hell with the short story].' "[24] Subsequently, Montoya turned to the provocative rhythms of poetry. Montoya's 1972 work *El Sol y Los De Abajo* reverberates with the Beats and the late-1960s bilingual poetry of Alurista (Alberto Baltazar Urista Heredia, an activist and a leading literary figure of the Chicano movement). Similarly, Tomás Ybarra-Frausto noted how poet Raúl Salinas's early poems "show influences from two distinctly American sources: the music of jazz and the literature of the Beats."[25] Many Chicano poets embraced Beat style, easily reappropriating the bongo rhythms of Afro-Cuban jazz that had inspired the Beat writers and translating them into new bilingual forms.

Artist Rupert García remembered Beat culture reaching out into his hometown in California's Central Valley: "I think I started really thinking about

existentialism probably when the beatniks were out. . . . Even in Stockton it was kind of like hovering about, and so it was kind of fashionable, in a way."[26] Beat culture reverberated in small towns and urban cities alike and contributed to an expansive interest in the counterculture.

Though Beat culture appealed to many people, its master narrative is dominated by Anglo American males. While more recent scholarship has demonstrated the strong presence of African Americans, Native Americans, and women, the movement is still more commonly signified by names such as Kerouac, Ginsberg, and Burroughs.[27] In fact, Beat culture in 1950s San Francisco was remarkably diverse. Steve Watson pointed to its arbitrary borders in his remark, "By the strictest definition, the Beat Generation consists of only William Burroughs, Allen Ginsberg, Jack Kerouac, Neal Cassady, and Herbert Huncke, with the slightly later addition of Gregory Corso and Peter Orlovsky. By the most sweeping usage, the term includes most of the innovative poets associated with San Francisco, Black Mountain College, and New York's downtown scene."[28] In this larger sense, visual artists and musicians also contributed to the Beat scene.

In many ways, Beat culture emerged by emulating the outsider status of Mexican American, African American, and Filipino *pachucos* and zoot suiters of the 1930s and 1940s, but with the advantage of Anglo social privileges.[29] As Robert Holton wrote, "alienated from the white mainstream, the Beats found models to emulate in all kinds of excluded groups, most notably perhaps African Americans."[30] Similarly, Manuel Luis Martinez wrote that "the Beats appropriate (some more cynically than others) the figure of the Mexican and the African American because the ethnic subaltern represents a liminality."[31] Beat culture glommed onto the racialized "other" as a way to counter mainstream authority.

As the Beats attained notoriety, they also cultivated a following from the marginalized groups that had served as sources for the counterculture. However, the situation was a catch-22 for people of color, as these groups could never be full participants in a culture rooted in the privileged rebellion of white youth. While Beats actively sought to rebel and disengage from the society that advocated conformity, the racialized "other" rebelled because that society rarely sought their inclusion. Thus, Latino artists also viewed their inclusion in Beat culture with skepticism.

Neither Cervantes nor Lerma considered themselves Beats, though others did.[32] Lerma saw Beats as privileged in a way that could not be reconciled with his experience: their use of heavy drugs and their leisure time to sit in cafés did not accord with his working-class background. For someone like Lerma, who grew up in a large Mexican American family of farmers, his decision to pursue abstract art in San Francisco was counterculture enough.[33]

Cervantes also felt outside the Beat milieu. Initially intrigued, Cervantes read Kierkegaard and Camus in order to understand the existentialism of the movement. He sensed a kinship with the Beats, evident when he described the impact of the atomic bomb: "The scions of Japanese cities evaporating before our eyes created a doom and gloom to our Beat spirits that left our ashes glowing hot."[34] Gradually, however, Cervantes came to see himself as less concerned with angst and more interested in the luminescence of life. He said, "I was beyond the politics of that. Although I was on the artists' sides . . . I wasn't Beat."[35]

More contemporary scholarship has recognized how Beat writers appropriated the work of African American writers and musicians, but most scholarship that recognizes any participation or influence of Mexicans or Latinos is dedicated to their experiences south of the border. For example, John Lardas wrote, "During the late 1940s and early 1950s, Mexico held a special place in the Beats' imagination. It was a place for introspection and decadence, where myth and reality converged in stifling heat and the haze of marijuana smoke."[36] Any evidence of Latinos or Latino culture engaging or integrating with Beat culture within the United States has attained little notice, in spite of the importance of the North Beach, or Latin Quarter, location. This perpetual blindness led Juan Felipe Herrera to demand attention in his poem, "Ferlinghetti on the North Side of San Francisco," (c. 1980), in which he called for Ferlinghetti to start "looking south" and recognizing the new generation of writers emerging in San Francisco's Mission District. Herrera wrote to Ferlinghetti, "still no one has seen you taking your beat to the *mission*.taking your rap on alienation & your sketch pad half-full of mex landscapes.& nights" to the place where "one thousand fingers tear out from silent flesh & shoot red verses through the walls.flying.across grant street.unlocking the syllables of the moon."[37] The tone of the poem expressed frustration, not just at Ferlinghetti, but at a pervasive romanticizing of Mexico while disregarding Latino landscapes closer to home.

The absence of Latinos in Beat culture is part of a larger problem of invisibility in American culture. As Ed Morales stated, "Latinos are made invisible through negation."[38] Yet, as Martinez wrote, "much can be learned from juxtaposing the work of the Beats and their fellow-travelers with the work of postwar Mexican Americans, not merely as opposing cultural productions, but as participating equally, fully, sometimes in complicity, at other times at odds, in the production of an 'American' discourse."[39]

Though Beat scholars tend to mark the end of the movement as 1960, the ramifications of Beat culture did not stop there.[40] In San Francisco, artists such as Manuel Neri, Peter Rodriguez, Jorge Castillo, Louis (a.k.a. Luis) Gutiérrez, Ricardo Gomez, Victor Moscoso, Alex Gonzales, Juan Sandoval, Anthony Prieto,

and Rolando Castellón all contributed to the expanding arts scene of the 1950s.[41] In fact, people of all ethnic backgrounds were participating in the booming arts scene, in San Francisco and across the country, inspired by the artist's lifestyle, creativity, and increasing economic opportunities.[42] As Albright noted, "In the Beat period, basically a mere five years between 1955 and 1960, an immense wave of anti-establishment energy crested and broke in a dozen different directions."[43] Latino, Asian American, and African American artists were participating in this cresting wave of radical energy, though they rarely if ever signaled or organized themselves by their ethnicity.

Training American Artists: Palomino, Lerma, and Cervantes in the Avant-Garde

In the mid-1950s, the prominence of abstract art was well established. In 1949, *Life* magazine published its feature on Jackson Pollock, asking of this emerging talent, "Is he the greatest living painter in the United States?"[44] On one hand, Pollock's fame perpetuated an understanding that only the alienated Anglo American male could represent the scale and diversity of American art. On the other, Pollock democratized art—his down-to-earth persona and Beat spirit were emotionally and intellectually accessible to many people.[45] His success served as a model for many generations to emulate or reject.

Palomino, Lerma, and Cervantes, like many artists coming of age in 1950s America, were inspired by the creative possibilities emerging in art in the postwar period. All three attended the California School of Fine Arts and were readily open to the experimental aesthetic of the San Francisco school of abstract expressionism. Per Susan Landauer, "Although the individual styles of artists varied greatly, by the end of the 1940s a discernible San Francisco look had emerged, the product of mutual influence and a shared sensibility that valued toughness over taste. In general, the painting emphasized rough surfaces and broad areas of color."[46] This look pointed to the teaching presence of Clyfford Still, who made an indelible impression on the culture of the school in the late 1940s.[47] Over the course of the 1950s, practitioners in the Bay Area figurative movement, including David Park, Elmer Bischoff, Richard Diebenkorn, and Nathan Oliviera, cultivated a West Coast aesthetic that integrated abstract art with recognizable human figures and landscapes.[48] Alternatively, the funk movement—spearheaded by Peter Voulkos, William T. Wiley, Robert Arneson, and Wayne Thiebaud—produced a vast array of enigmatic, largely ceramic, sculptural assemblages inspired by Dada, surrealism, and the Beat movement.[49] The arts scene reflected an array of international, national, and regional aesthetics that tended to give the Bay Area art scene a unique feel.

Palomino, Lerma, and Cervantes adopted the aesthetic culture of the city as their own. While none of the three artists called themselves Beats, they recognized the era and associated physical locations as formative in their development. The environs inspired them as artists and even led to their participation in the founding of separate galleries. From 1959 to 1961, Lerma, Howard Foote, and John Dunlop oversaw the short-lived Russian Hill Gallery, located near the Spatsa Gallery. Cervantes admitted finding inspiration in Lerma's Russian Hill Gallery, which he referred to as a place that "blew me away for showing work that other galleries would not touch. It opened me up."[50] From 1962 to 1964, Cervantes, Palomino, and Joe White ran the New Mission Gallery. Both galleries lasted only a couple of years, but were two early examples of Mexican American co-owned galleries in the city.

Naturally, these artists drew on the proliferation of provocative new galleries in the city. The Six Gallery, located near the intersection of Fillmore and Union Streets, had the highest profile as the place where Ginsberg first read his poem "Howl" in October 1955.[51] Lerma adopted the Six Gallery as a hangout and had his first group show there the following year.[52] Cervantes declared, "At that time on Union Street was the galleries—the Six Gallery—and it was just exciting . . . just incredible!"[53]

The Marina/Cow Hollow neighborhoods around Union Street offered an escape from the high rents and tourist economy of North Beach.[54] By the early 1950s, North Beach had already become too expensive for many young bohemians.[55] As an alternative, a number of students at the California School of Fine Arts, located on Chestnut Street in Russian Hill (bordering North Beach), set up living quarters in the not-too-distant Marina District.[56] Multiple galleries set up shop, too, including the Spatsa Gallery, the East-West Gallery, the John Gilmore Gallery, the Green Gallery, the Fredric Hobbs Gallery, the Artist Co-op, the Batman Gallery, and the Rose Labowe Gallery.[57]

Many of the galleries deliberately eschewed the growing commercialism of the art market. For instance, the Six Gallery, Bruce Nixon stated, "wasn't a commercial venture in any way: no artist made money there, although none of them really seemed to care very much."[58] Dimitri Grachis, artist and owner of the Spatsa Gallery, recalled that "the Union/Fillmore Street area in the fifties was nothing like it is today. In the fifties the buildings were about 40% full and rents were very reasonable. I was paying $350.00 a month rent. The reasonable rent attracted many creative and adventurous people to the area—artists, poets, writers, actors, musicians."[59] Allen Ginsberg, Bruce Conner, and Michael McClure all lived in the neighborhood at one time or another.

Gradually, however, Marina/Cow Hollow transitioned into an upscale boutique neighborhood.[60] Intimations of this drastic change began in the late 1950s,

especially after the publication of Jack Kerouac's *On the Road*. According to
Bruce Nixon, "Bay Area bohemia . . . suddenly found itself in a national spot-
light; people who had lived and worked and partied together, merrily undis-
turbed in their pursuit of rebellion, were now the subjects of local Gray Line
tours. The scene was devastated by this unexpected and often unwelcome tidal
wave of publicity."[61] Galleries could only survive if they became more commer-
cial. Dimitri Grachis closed the Spatsa Gallery in 1961, stating, "My gallery,
once an absorbing experience, was now becoming a competitive arena. The
younger artists were expecting more, and there was a growing market that,
though selective, was willing to pay for the visual experience. I was never a com-
petitive person, so I closed the gallery, happy that I still had both my ears, and
moved to Burlingame."[62] The flourishing arts community that once existed in
the Union-Fillmore street nexus vanished. Upscale galleries now exist in the
neighborhood with little resemblance to their counterculture origins.

The physical location of the New Mission Gallery was a natural result of its
founders living in the Mission and turning their home into a studio, but the
exhibits were very much a product of the Beat scene in the Marina/Cow Hollow
enclave. The New Mission Gallery featured many of the artists that had formed
connections at the California School of Fine Arts and at the Union/Fillmore
Street galleries: Joan Brown, Howard Foote, Wally Hedrick, Seymour Locks,
Manuel Neri, Palomino, and many others.[63] However, Cervantes bristled at re-
viewer John Coplans's representation of the gallery as a beatnik hangout: "It was
condescending."[64] Though the proprietors emulated the liberated approach of
other Beat galleries, they rejected the pejorative *beatnik* label coined by local
columnist Herb Caen. In the early 1960s, they had little desire to represent
themselves as Beats, when that culture was increasingly the subject of ridicule.[65]

The artists named their first exhibition at the New Mission Gallery "The
Panama Canal Anniversary Show," but the title had little to do with the artistic
content and much more to do with the free-form spirit of the curators, who
drew the name from a calendar of historical events. According to Cervantes,
"because it was a group show, it was just tons of people, wall to wall. And so, it
just started to snowball, and after about three months, we had our first review
in *Artforum* . . . it drew a lot of people from all over."[66] Coplans described the
new gallery as "an important event in the cultural life of San Francisco. . . . This
gallery frees art to be seen, experienced, and valued as art without the hierar-
chies of commercial promotion or the restricted ideas of culture of museum
curators intervening."[67]

The New Mission Gallery opened for practical reasons: Palomino and White
were studying art at San Francisco State and needed a place to show their work.

After Palomino and White showed their art, they were less invested in the space, so Cervantes and his new partner in the arts and in life, Susan Kelk, continued the venture. Under the name Susan Cervantes, she became a leader in the Mission District community's mural movement. In the early 1960s, she was just finding where she fit in the city. Luis Cervantes credited Kelk for cultivating the amount of press the gallery received. According to Kelk, "we were getting reviews all the time about the exhibits, we were getting reviews in *Artforum* all the time, cause *Artforum* was just coming out."[68]

Likely, meeting Kelk also sensitized Cervantes to the difficulties women faced in showing their work, and he tried to respond. He recalled, "Very few women were involved in the arts. Or they were ignored. And some of them were really good. And so, a few here, there, let's get them all together, and we'll call it the 'All Chick Show.' The show featured Brown, Doreen Chase, and Kelk, among others. However, Deborah Remington refused, stating, 'I'm not a chick.'"[69] Still, the show was a landmark in featuring only women artists, and the gallery signaled the Mission District's new relevance as a site of avant-garde bohemianism.

The New Mission Gallery was likely the first contemporary visual arts gallery in the Mission, but hardly the last. Even so, its history was not documented much beyond its *Artforum* reviews. Too far removed physically to be a part of the Beat scene, and too avant-garde to reflect the late-1960s pan-Latino arts movement of the Mission, the gallery has largely fallen through the cracks of subsequent histories. Moreover, its founders contributed to maintaining the gallery's low profile. Cervantes developed a strong distaste for "the art world." While he continued to paint and participate in various events as an artist and muralist in the Mission, he was reluctant to promote himself as an artist.[70] Running a gallery was even more demanding, and in Cervantes's mind, less rewarding: "There was something about the art business that I hated. . . . The money and then the attitude. So I said to Susan, 'Let's close it down and turn it back into our studio.' And so that's what happened."[71]

Ernie Palomino

New Mission Gallery cofounder Palomino has argued that it was the oppressive culture of the California School of Fine Arts that drove him away from the school. Nearly three decades later, he recalled the 1956–1957 experience with little enthusiasm: "I had to get rid of my drapes, you know. Sharkskin shirts, one-button rolls, and put on a torn-up jacket that I had bought at the Salvation Army. And put on a corduroy shirt . . . and run around with all these beatniks."[72] After only a year of attendance, Palomino returned to Fresno. He remarked, "I

couldn't take it anymore. I missed my friends too much and, and I missed the low-riders . . . and the people that I used to hang around with, the musicians."[73]

The context of Palomino's remarks, at a conference on Chicano art in the early 1980s, reframed his San Francisco experiences. He distanced himself from the Eurocentric training of his education, outfitted himself in the authenticity of *pachuco* clothing, dismissed any Beat culture influence, and obscured his continuing involvement in the avant-garde through the early 1960s. His account blanketed over any frustration he might have felt at not having his scholarship renewed, which he ascribed to his inability to fit in with the culture of the school. Palomino sensed school administrators were bothered by "the fact that I hadn't socialized. Hadn't really socialized into their clique of students."[74]

While Palomino did withdraw from the California School of Fine Arts, he continued to participate in the arts scene. Up until at least 1966, he moved back and forth between Fresno and San Francisco, enrolled in art classes at San Francisco State, cofounded a contemporary art gallery, created multiple assemblage sculptures, and filmed his most avant-garde work, *My Trip in a '52 Ford* (1966).[75]

The experimental 16-millimeter, 26-minute *My Trip in a '52 Ford*, submitted to cap his graduate work at San Francisco State, featured Palomino's sculptures as characters. The film opens with Palomino driving through the streets of San Francisco in his '52 Ford. Bouncy jazz and honking horns serve as the soundtrack. But there is an immediate change of pace when the '52 Ford becomes *Mary Go*, a fading automobile abandoned in the hot sun. Jazz musician Dick Conte supplies the narrator's smooth voiceover, explaining that "time had demobilized Mary '52 Ford into a lump of junk." But *Mary Go*'s voice offers a counter-narrative when she says, "At last, I'm free. All my life I've wanted to be free. . . . My reincarnation shall create beautiful children." Her radiator is reborn as a "grotesque truck" by the name of *George Go* (Fig. 2.2). Viewers then encounter *Mary Go*'s other children, including the bureau-inspired prostitute *Dorothy Dresser*, the awkward housewife *Carol Chair*, the dwarfish appliance *Steve Stove*, and the godlike hood ornament *Wild Bird*.[76] The brief appearance of *Gran-ma Go* is notable because she first appeared in a 1962 issue of *Artforum* as *Mrs. Go*, which shows that the Go family narrative was fermenting at least four years before Palomino began filming.[77] The *Artforum* issue also showed *Relaxing Clay*, a mixed media sculpture that was destroyed but that inspired Palomino's papier-mâché creation, *Carol Chair* (Fig. 2.3). The correlation suggests that Palomino did not necessarily imagine the familial connections of his assemblages in the initial creation, but over time.[78]

Palomino's interest in found art stemmed from his upbringing: "[My parents] lived more or less in a world of used items and those items had to be recycled,

Figure 2.2. Ernie Palomino, *George Go*, c. 1966. Photograph courtesy of the Jacinto Quirarte Collection, Collection #UA 99.0003, UTSA Special Collections. Image courtesy of the artist.

so I found the idea fascinating when I discovered it in art."[79] He gravitated to the art of assemblage as an enthusiastic inventor and as someone skilled in re-use and recycling. His provocative, piled-high assemblages hint at the subsequent definition of a Chicano "*rasquache*" aesthetic of making do with anything and everything.[80]

Palomino breathed life into his assemblages through the possibilities of film. The incompatible assemblages comprise a conflicted family and, more symbolically, a conflicted world. All of the characters move through life with

Figure 2.3. Ernie Palomino, *Relaxing Clay*, c. 1963, mixed media. This sculpture was destroyed, but Palomino remade it in papier mâché as his character *Carol Chair* in his 1966 film *My Trip in a '52 Ford*. Photograph courtesy of the Jacinto Quirarte Collection, Collection #UA 99.0003, UTSA Special Collections. Image courtesy of the artist.

little capacity for self-reflection. For instance, the homemaker *Carol Chair,* a chair piled with clay, asks the dope-head *Steve Stove,* "Could you be so intense that you can't make sense?" *Steve Stove* responds only in incoherent Beat poetry, leading *Carol Chair* to answer herself: "Basically, I believe you're an aesthetic. Perhaps your hollow body was once filled with beautiful aesthetic ideas, but the fiery kiln burned you hollow, leaving an empty grotesque shell. Among our family, you are the queerest."[81] The exchange underscores Palomino's impatience with insensible, drugged-out, avant-garde philosophies, but also reflects his inability to be understood as an artist in a more traditional sphere.

The film's surreal depiction of familial relations among inanimate objects becomes more profound in relation to Palomino's biography. In a letter to the author, he recalled, "My parents died that year, 1966, and I was making a (comeback) to a new reality of being without family, as I was an only child. I believe these images of the (Go family) were answers to questions about (who am I)."[82] Palomino's memory points to his use of the film to meditate on life and death, starting from the moment the film opens with the sound of a stalling car. Toward the end of the film, Palomino turns the camera on a salvage yard. Viewers watch the crushing and cutting of auto parts as Mary Go says, "Soon we shall be one again." The act of dismantling, smashing, and combining of parts dramatizes the theme of sameness in life and death.

This spiritual oneness is reiterated in the film's final scene via an interaction between two humans. Palomino plays Jesse Wong, a "young Chinese student," while fellow artist Joe White plays Bill Chair, whom the narrator refers to as a "Negro custodian," but who otherwise appears white. Palomino grew up in Fresno's Chinatown, so his decision to pass as Chinese also may reflect a sense of solidarity from that experience.[83] The fact that neither man visibly matches their assigned racial category challenges viewers to consider their expectations, especially since Palomino ends the film with Wong's declaration, "We're the same, Bill Chair!" This emphasis on a shared humanity reflects Palomino's dissatisfaction with superficial constructions of race. He cited the influence of Dadaism on this scene, remarking "nothing that you see can be labeled.... Nobody is really white, nobody is really brown. Everybody is a human being. It doesn't matter what year the car is—it's still a piece of junk. The only escape is through art and music."[84]

It was after this period that Palomino more vehemently rejected the colonizing impact of his artistic training and chose to diminish its relevance. Palomino later referred to his art work of the 1950s and early '60s as *gabacho* art. A negative term for "white," *gabacho* emphasizes the oppressiveness of a vast pantheon of Eurocentric art that many people of color encountered in arts education.[85] When Palomino went on to become a participant in the Chicano arts

movement, a professor of art at California State University in Fresno, and a co-founder of "La Brocha del Valle" (The Brush of the Valley) community mural movement, he also sought to overturn the arts education that had devalued his culture and all Third World cultures.[86] This form of discarding earlier work contributed to a more pervasive cultural disconnect between the Beats and the Chicano movement. Although *My Trip in a '52 Ford* is now referred to as one of the first Chicano films, the avant-garde premise of the film distanced the work from more politically accessible films, such as Luis Valdez's *I am Joaquin* (1969). Yet, in so many ways, *My Trip in a '52 Ford* perfectly expressed the intellectual and aesthetic ferment that helped generate the Chicano Movement.

José Ramón Lerma

While Palomino claimed to have walked away from his early training, José Ramón Lerma never did. When Lerma first came from his parents' small farm in Hollister, California to study at the school in 1950, he was caught off guard by the nontraditional subject matter: "I was very focused on what I was doing at that time as a young man, and well, the whole thing of coming into the Art Institute, or the California School of Fine Arts, and finding non-objective painting. . . . It kind of blew my mind, but it also kind of left me depressed."[87]

Lerma's past training had centered on the European modernism of Pablo Picasso and the social realism of Diego Rivera, which jarred with the work he experienced at the school. In particular, his memorable encounter with a large, tri-color Hassel Smith painting confused him but also intrigued him, marking a transitional moment in his development as an artist. Increasingly, Lerma gravitated to the new aesthetic, but with his own spin: over time, he played with geometric and organic designs and collages, juxtaposed found objects in bric-a-brac structures, developed miniature abstract paintings to challenge notions of scale, and introduced sand into his painting. In 1956, according to fellow artist William T. Wiley, Lerma "was doing thick paint abstract expressionist type paintings when I first saw his work—very lyrical—calligraphic—and a feeling of landscape, dance, movement, beautiful masterful works."[88] One untitled painting from this year was emblematic of this poetic style (Plate 1). Brown earth and a gray blue sky on the horizon indicate a landscape, but the swirl of colors and brush strokes transformed the space into an abstract experience. Many of Lerma's paintings from this period evoked landscapes, not unlike Richard Diebenkorn and other Bay Area figurative painters, but also referenced particular memories.[89]

Part of Lerma's maturation as an artist emerged from his experience as a soldier in Korea. Lerma first enrolled at the California School of Fine Arts in

1950, but not having enough money to stay in school, he was drafted into Korea in 1951. When he returned in 1953, he had a stronger sense of himself and a more considered response to the art that had earlier confused him. According to Lerma, "I came back from Korea a very different person. First of all, I was angry . . . [the military] is not good for human beings, although there's a lot of discipline. . . . But they have to do that in order to train you as a killer."[90] Still grappling with his anger and frustration, he re-enrolled in the California School of Fine Arts and began to investigate the possibilities of art through paint, collage, and assemblage.

The second time around, the school proved ideal. Lerma's teacher Dorr Bothwell was influential: "She made me see things, and when I started seeing things, then the abstract came very easy in the sense that I was free."[91] Lerma drew on the emotions of his time in Korea to reinvigorate his art: in particular, his heightened sense of mortality inspired him to convey the most dramatic colors of the world.[92] One experience in particular profoundly shaped his psyche. He was stationed in an area known as the Punchbowl, where the U.S. military lit a series of flares to better see the enemy. Instead, they cast a light across the valley where all the U.S. soldiers were stationed. According to Lerma, "I stood there mesmerized by the brilliant green colors lighting up the valley, like the color you see in your dreams. It was so beautiful. It was both funny and sad at the same time."[93]

In the late 1950s, Lerma pictorially documented the Punchbowl in a series of works on paper. In one of these untitled works from 1959, a pastel convoy truck is visible in the distance, partly illuminated by the light emanating from the top of a pitch black explosion (Plate 2). A rainbow of color cascades down from the blackness, recalling the brilliant lights in the sky that Lerma witnessed in Korea. Despite the darkness of the memory, the colors across the sky also unlocked his creativity. As Gilberto Osorio poetically writes, "The flashing landscape became a gigantic expressionist painting, revealing in its core the essence of the teaching of that post war generation of artists at the California School of Fine Arts."[94] Both Lerma's paintings and his drawings incorporated this colorful yet deadly memory. For Lerma and others, the experience of war visually and psychically reinforced the existential appeal of abstraction.

As a gay man, Lerma found a means of self-expression in abstraction that was not too revealing. Lerma's homosexuality informed his art, but any markers of this identity also could stay hidden, especially from his conservative Catholic family. Lerma did not participate in shows that might claim him as a gay artist and none of his artist statements drew on this aspect of his life, but he also did not hide his homosexuality from those who knew him. Chicano writer Oscar Zeta Acosta described Lerma in his book, *Autobiography of a Brown Buffalo*

(1972). Unfortunately, all of the references are laced with homophobic slurs, but Acosta also explained that "we permitted him our holy heterosexual company" because of Lerma's ability to "keep the beast in his pockets" and because he had Jack Jefferson's recommendation (an artist and teacher at the San Francisco Art Institute).[95] Such attitudes highlight why Lerma veered away from direct representation of his homosexuality, but also illustrate that this aspect of his life was not a secret in 1960s San Francisco.

Abstraction became a space to safely reckon with his personal experiences without becoming overly vulnerable. In the early 1960s, Lerma created several abstract works that hint at the inner conflict he may have felt in relation to being gay, Catholic, and an artist. His painting *Sacred Heart* (c. 1962) drew on the classic iconography of a pierced heart with flames fluttering above, but the impasto brush strokes also made the imagery illegible. Other paintings, such as *First Crucifixion* (c. 1962), played similarly with the iconography of the cross (Fig. 2.4).[96] Traumatic family circumstances may have triggered the religious themes. Lerma's mother, a strong, independent woman raised in an intensely Catholic family, suffered a psychological breakdown in the late 1950s or early 1960s. According to Lerma, "She tried to kill my baby sister."[97] The paintings of Catholic imagery at the same time his mother was fighting mental illness take on an intensely personal and mournful dimension.

Lerma's lack of detachment was reflective of a more subtle barrier to his artistic success. At the time, the introduction of "content," or personal identity, into painting automatically troubled the necessary detachment of abstract expressionism. As Ann Gibson wrote, "Original art was by definition art that put distance between itself and the specificities of immediate cultural influences."[98] Lerma understood how any personal narrative in his work perpetuated his outsider status and ultimately resigned himself to this fate. In a 1996 interview he explained, "My abstract art is Mexican and there's nothing I can do about it. And that kept me out of the mainstream abstract because that is a little more detached."[99] Thus, Lerma developed a consciousness of his outsider status, but instead of being deterred, he increasingly relied on his Mexican American identity as a source of inspiration.

Luis Cervantes

Cervantes experienced a similar trajectory to Lerma. He was inspired by a teacher at San Francisco State who said, "Look into your roots, into your blood lines for inspiration."[100] He started playing with Politec paint, "from Mexico, sold in the Mission," because he learned that Diego Rivera had used the paint in his murals.[101] Cervantes liked the paint because it dried quickly—"one can

Figure 2.4. José Ramón Lerma, *The First Crucifixion*, 1961, oil on canvas, 24 × 24 inches. Photograph by Jed A. Jennings. Image courtesy of the artist, his family, and the private collection of Si Rosenthal and Emily Brewton Schilling.

get a lot done with Politec"—but also because the hot colors paid homage to famed Mexican muralists of the 1930s and 1940s such as Rivera, David Alfaro Siqueiros, José Clemente Orozco, and Rufino Tamayo.[102] He created a series of mandala paintings that mimicked the experience of being at the top and center of ancient pyramids (Plate 3).[103] The patterns echoed the repetition of Mexican Talavera tile and indigenous geometric design pervasive in textiles and rugs. His son Luz Cervantes wrote, "Even though he was influenced by abstract expressionism he created his own visionary style by merging Mexican-American and Pre-Columbian cosmology, philosophy and concepts into his artwork."[104]

Such markers of ethnic identity underscored the challenge that Cervantes and Lerma faced in the art world, since any personal revelation undercut the quest for detachment. Unlike Anglo painters who appropriated indigenous iconography into their work as an act of rebellion and a form of primitivism, Cervantes applied these symbols as intimate expressions of his identity.[105]

Cervantes' mandala paintings also corresponded with the psychedelic iconography of the op art movement. Albright wrote of Cervantes that "he was one of the earliest (c. 1965) to concentrate on the mandala form; in his work, the mandala occupied fields that emphasized repeated geometric patterns in intense Op art colors."[106] The mandala could easily correspond to indigenous and contemporary aesthetics and was indicative of Cervantes's comfort with these elements of his painting. Cervantes drew inspiration from the light and sound shows in the Bay Area art scene in the mid-1950s, especially through the work of his mentor, Seymour Locks. Cervantes recalled a class on "light movement, space, and color," in which Locks handed out all sorts of toys and asked the class to explore sound: "Toot, toot, or bang, bang, or whatever. And everybody was just sort of reticent. So he says, 'okay, I'm going to put the light out.' And in the dark, we all started to jam."[107] Locks then led the class in a similar exercise with light: "We brought in a whole bunch of flashlights, and in the dark, we flashed them around, and then he would put things in front, maybe like a bottle, and it would throw the image on the walls and things like that."[108]

Not long thereafter, Cervantes began to connect the art of manufacturing light and sound with the everyday beauty of light and sound in life. A trip to the beach was transformative: "I could feel the sunlight on me. . . . And I could feel the weight of my body . . . and the waves . . . fish jumping out, and the seagulls were floating around. . . . It was like the illumination of the outside connected with some internal illumination inside and bonded. And from that moment on, it was like I was a different person."[109] He associated the "Zen" moment with his gradual transition from amorphic sculptures to highly formal painting. When financial circumstances forced Cervantes to leave the Art Institute, he continued to balance these two aesthetics, both by painting and by developing "found art" sculptures in the studio he shared with Palomino and White. Gradually, however, his work became far more structured and deeply tied to the resonance of light, or what he called "geometric abstraction." The term is well-suited to one of his earliest paintings, *A Gift for the Darkness*, which he subsequently exhibited at the San Francisco Museum of Modern Art (Plate 3). Of the painting, Cervantes stated, "My concern is with the inner light, the different qualities that you can express. That is the reason it is symmetrical and starts from the center."[110]

The luminescence of Cervantes's paintings also drew energy from his desire to restore the beauty of life after the trauma of serving in World War II. Like Lerma in Korea, Cervantes was deeply affected by his experience as an American soldier in Europe. In Antwerp, he saw an intersection of cobblestone streets blown apart by a rocket blast: "It had raised the ground up and separated the cobblestones." The memory left a haunting impression. For Cervantes, "Some of the things that I do are sort of based on those little square things. . . . It was an art form that was created by this blast. It looked beautiful, but at the same time, it was just this disastrous thing."[111] The geometric simplicity of Cervantes's style might be read as minimalist abstraction, but it also resonated with the deeply personal, emotional content of his experience as a soldier. The experience of war was a driving force behind the subject matter of Cervantes and other emerging artists of the period.[112]

Persistence and Change: The 1950s and Beyond

The life stories of Cervantes, Palomino, and Lerma exemplify their commitment to art, though the context of their creativity changed over time. In the 1950s and early 1960s, each was moving in and out of various Bay Area art schools. Taking a cue from the Beat galleries on Union Street, Lerma, Cervantes, and Palomino founded their own galleries.[113] Palomino became a professor of art at California State University, Fresno. Over the course of the 1970s and 1980s, both Cervantes and Palomino contributed significantly to the community mural movement—Cervantes by virtue of his common-law marriage to Susan Kelk Cervantes and her leadership of the Precita Eyes mural center and Palomino by virtue of his mural activism in California's Central Valley.[114] Lerma remained devoted to creating and showing new work in various Bay Area galleries but distanced himself from the cultural nationalism of the Chicano movement and the Latino-centered arts movement in the Mission. The experiences of these three artists underscore the importance of the 1950s as a springboard for future activity, although they received little support at the time and their efforts subsequently were obscured by the dramatic arts awakening of the late 1960s.

Palomino, Lerma, and Cervantes experienced a persistent awareness of their "outsider" status throughout their time in the avant-garde scene of the 1950s and 1960s. The personal resonance of abstraction led Lerma and Cervantes to persist in abstract painting, despite limited opportunities for recognition. This commitment was not the result of an unwitting desire to participate in a colonizing art form, but a struggle to make that art form their own. As David Craven

argued, "Any visual language in the arts should thus be understood as a lo-
cus for competing cultural traditions along with diverse aesthetic concerns
and divergent ideological values." Craven aligned himself with Latin Ameri-
can critics Juan Acha and Marta Traba, who dismiss reading abstract expres-
sionism in Latin America only as a form of U.S. cultural ascendancy and
dominance.[115]

The Chicano movement forced a new assessment of artistic responsibility
for all generations of Latino artists in the United States. While Palomino grav-
itated to a community that could support his sense of difference, Cervantes and
Lerma remained more ambivalent. Cervantes said, "I wasn't interested in what
was happening in painting Pancho Villa and all these kinds of images that are
supposedly Mexican or Latino or whatever. And my work was so far off the
wall . . . I wanted to create work . . . more spiritual in quality."[116] Cervantes
maintained relations with younger artists and participated in the founding of
Galería de la Raza, but he never fully integrated into the new Latino arts move-
ment, or the more mainstream business of the art world.

Lerma was even more separatist from the Chicano movement in his empha-
sis on producing "American" art. Lerma did not deny his background as the
son of two Mexican immigrants, but he disliked the prevalence of pictorial
representation and didacticism in Chicano art. Lerma also quibbled with the
desire of others to claim him as an early "Chicano" artist: "I personally feel
that for me to be called a Chicano artist . . . stifles me."[117] Lerma found aes-
thetic inspiration in his ethnic heritage, but he kept his distance from Chicano
and Latino arts groups. Similarly, these groups were alienated by his abstract
aesthetic. Jim Scully wrote diplomatically that "in [Lerma's] work 'Latino' and
'American' are not discrete cultures but interwoven strands of a singular cultural
complex. He is not an ethnic artist—in the sense of one devoted to memorializ-
ing, reconstructing, or asserting an ethnicity—but an artist of the contemporary,
whatever that may involve."[118] These tensions highlight the generational split
that gradually emerged between artists who came of age in the 1950s versus those
who came of age in the 1960s.[119]

Many Latino artists participated in the expansive intellectual and aesthetic
community of the 1950s and early 1960s. Some of them, guided by these expe-
riences, became significant participants in the Mission District arts scene of the
late 1960s and 1970s. The rise of alternative art galleries provided a model for
San Francisco's ethnically separatist art galleries. Though the influence of the
Beats is pervasive in San Francisco, this is recognized more in the context of
the Haight-Ashbury's Anglo-centric hippie culture than in the making of the
Third World arts movement.[120] Perhaps the greatest problem with these cultural
borders is the perceived absence of Mexican American artists working in the

1950s. While these artists may not be iconic "Chicano heroes" overturning the avant-garde, they do reflect a history and presence that challenges the Anglo-centrism of American art and Beat culture.

In San Francisco, the Beats movement did not spontaneously appear, nor did it just vanish. Likewise, Latino artists did not suddenly appear in the late 1960s. Latino artists had been working in the United States for generations, but the identity and visibility of Latino artists was about to undergo a massive shift.

Chapter 3

La Raza Unida: Pan-Latino Art and Culture
in 1960s San Francisco

Artist Yolanda López once remarked that "one of the illusions . . . is that when we all declared ourselves Chicanos that we were homogeneous in our outlooks, that we all had the same political line, that there was a commonality as to where we were going and how we were going to do it. And that was not so."[1] The Chicano movement of the late 1960s linked Mexican Americans across the country in a political struggle. However, diverse politics and demographics shaped the movement's emphasis. Community organizing in locations where Mexican Americans did not dominate the Latino population—including San Francisco, New York, Miami, and Washington, D.C.—challenged the nationalist perspective of the Chicano movement with the need for a broader "Latino" or "Raza" orientation.

Art Historian Shifra Goldman stated, "The term *raza* (our people) used in northern California refers to the mix of peoples from Central and South America, the Caribbean, and Brazil, as well as Mexicans and Chicanos."[2] The term's emphasis on *people*, rather than *nation*, spurred its popularity, as did its implicit incorporation of all indigenous people of the Americas. For instance, Rolando Castellón described *Raza* as "a term used to describe The New Race discovered in America by Christopher Columbus."[3] The term *Raza* has a long history in the Bay Area, prominent since at least the 1930s, and more inclusive than the *Raza de Bronze* recorded in Chicano movement documents.[4] In prioritizing this Raza identity, San Franciscans facilitated local organizing but at times found themselves out of step with the Mexican American focus of the Chicano movement.

The Chicano movement promoted art as a valuable tool to share its objectives. As the Chicano manifesto "El Plan de Aztlán" (1969) stated, "We must insure that our writers, poets, musicians, and artists produce literature and art that is appealing to our people and relates to our revolutionary culture."[5] Many

Chicano artists heeded this call and produced art to solidify a collective ethnic identity and politically mobilize the community.[6] This understanding of Chicano art cultivated familiar and sometimes didactic iconographies—including illustrations of Mexican revolutionaries, farmworkers, and Mayan and Aztec figures—in order to construct a shared politics. Many who embraced this aesthetic looked on abstract art as "bourgeois" and emblematic of Western colonization.[7]

San Francisco's affinity for abstract and avant-garde art, Spanish and Latin American literature, and pan-Latino festivals became a significant point of departure within the Chicano movement. The city's aesthetic openness set this community apart. Similarly, the diversity of the population propelled activists to rely more on community organizing through a Raza or Latino perspective. San Francisco artists created organizations, mostly in the Mission District, that reflected this aesthetic and cultural openness, including Casa Hispana de Bellas Arts, the Mexican American Liberation Art Front (in Oakland), Arte del Barrio, Artes 6, and the Galería de la Raza. The origins of these art organizations illuminates some of the period's aesthetic and political debates, highlights some of the challenges these artists experienced among each other and in a larger context, and contextualizes the institutional origins of a Latino arts renaissance in the Mission.

Often, the rest of the city perceived a homogenous group of "Latinos," but nothing was further from the truth. Taking a cue from Yolanda López, profound debates and provocative divisions contributed to the intellectual and aesthetic ferment in San Francisco and elsewhere. The growth of Pan-Latino organizations, such as Casa Hispana and Galería de la Raza, became important physical spaces to articulate transnational solidarities, cross-cultural convergences, and deep divisions.[8]

Bellas Artes in the Mission

Casa Hispana, according to its mission statement, was created in response to a need to represent the richness of "Hispanic" cultures to audiences throughout the Bay Area. Founded in 1966 by a group of Latin Americans, Casa Hispana initially had few, if any, Chicano members. Amílcar Lobos, a Guatemalan poet and actor, served as the first director of the predominantly male group (Fig. 3.1).[9] Motivated by an interest in Spanish-language theater, the collective quickly grew to advocate for art in various forms from all parts of Latin America and Spain, including music, dance, visual art, poetry, and drama. Casa Hispana launched a Latino Youth Arts Workshop, a bilingual publishing collective (Casa Editorial), and multiple "Hispanic" festivals, including the first public celebration

Figure 3.1. This c. 1973 photograph features several members of Casa Hispana in a celebratory moment, just prior to the publication of Amílcar Lobos' book, *Quetzal* (1973). From left to right: Maruja Cid, Lobos, Rolando Castellón, Leland Mellot, and Carlos Pérez. Photograph courtesy of Joe Ramos.

of Día de los Muertos in San Francisco.[10] And as the seed organization for the widely influential Galería de la Raza, Casa Hispana played a critical role in the establishment of Chicano and Latino arts in the Bay Area.

Casa Hispana lasted nearly two decades (1966–1983), and the organization and its programs expressed wide appreciation for Hispanic culture and high art. Perhaps appearing less radical than many of its contemporaries, the organization did not seem to fit the nationalist ideology or aesthetics of the Chicano movement. Indeed, the Hispanic title may explain why Casa Hispana earned little scholarly attention.[11] Alicia Gaspar de Alba emphasized that "the artists who affiliated with the Chicano Art Movement did not identify themselves as Mexican Americans, Latinos, or Hispanics, but as *Chicanos* whose work expressed resistance to the hegemonic structures of mainstream America."[12] Casa Hispana de Bellas Artes did not exude this Chicano-centrism, though the organization emerged with the Chicano movement and drew on a similar wave of energy.

Casa Hispana members held their first meetings at La Rondalla, a popular Mission restaurant, then found more formal accommodations in the Mission

Neighborhood Center at 362 Capp Street. An office of the Mission Adult Center was acceptable for meetings and classes, but less than ideal for exhibits or public performances. More often, Casa Hispana relied on the outdoor courtyard and the hospitality of other institutions, including UC Berkeley, the Julian Neighborhood Theatre, and San Francisco State University.[13] As a result, community outreach was expansive, but the Mission provided an important climate for its activities.

For Carlos Loarca, the Mission made sense "because we all spoke Spanish. We were all from Latin America."[14] Artists turned to the Mission because it was affordable and because of its increasingly visible Latino-ness.[15] In 1960, San Francisco counted 51,602 Hispanics, or 7 percent of the city's population. In 1970, the numbers practically doubled to 101,901 Hispanics, 14 percent of the city's population.[16] By 1970, Hispanics comprised 45 percent of the Mission District population, a dramatic increase that affirmed the neighborhood's public reputation as *el corazón*, or the heart, of San Francisco's Latino community.[17]

The Mission's cheaper rents and the steady increase of goods and services geared to Spanish-speaking immigrants and natives attracted a high concentration of low-income residents in the postwar period. The Mission's real estate market provided primarily rented apartment space, and postwar "white flight" contributed to an extended period of economic decline.[18] Marjorie Heins reported, "according to the 1960 U.S. census, twenty percent of the Mission's residents had incomes under $3,000."[19] Quality of housing was poor, unemployment high, and city concern low. As Heins observed, "the Mission district acquired many of the characteristics of a ghetto."[20] These factors help explain why the Mission became a critical space to articulate a Raza, or pan-Latino identity.

Early on, Casa Hispana members began planning cultural festivals as a means of affirming a shared Latino identity, showcasing artistic talents, and connecting with the community. One of the first programs honored Día de la Raza on October 12, 1966.[21] Sometimes cast as a Latin American Columbus Day, the event is more a tribute to the peoples of the New World than homage to a controversial European explorer.[22] Casa Hispana's Día de la Raza grew into a major annual festival—the Raza/Hispanidad festival—with multiple associated events, including poetry readings, film viewings, lectures, art exhibits, and theater.[23]

From the late 1960s onward, the gradual creation or expansion of several major public festivals in the Mission—including Carnaval, Cinco de Mayo, Día de los Muertos, and Festival de las Americas—emphasized the pan-Latino identity of the neighborhood. For instance, Laurie Kay Sommers discussed how Cinco de Mayo steadily shifted from a Mexican-American event to a Raza event.[24] In keeping with Raza identity, Casa Hispana established an annual September

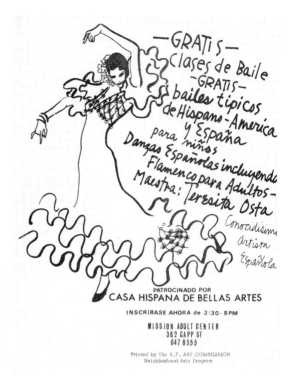

Figure 3.2. Poster for Casa
Hispana flamenco classes
taught by Teresita Osta, c.
1969. Printed by the San
Francisco Art Commission
Neighborhood Arts
Program. Image courtesy of
Don Santina.

event to celebrate independence days, including those of Brazil, Chile, Costa
Rica, Guatemala, Mexico, Nicaragua, and El Salvador. These events height-
ened cross-cultural solidarity but did not necessarily submerge nationalities:
organizers differentiated traditions by national origin within an event.[25]

Most of Casa Hispana's events drew together diverse artistic talent. Pro-
grams regularly included actors, dancers, singers, musicians, poets, and paint-
ers. The many flamenco events symbolized Casa Hispana's interest in Spanish
culture and showcased the many talented flamenco dancers and singers in the Bay
Area (Fig. 3.2).[26] According to artist Carlos Loarca, "We would have the pro-
gram, for example, with the paintings. . . . And then in the theatre come the
flamenco to dance. . . . And there were a couple of guys that dance tango and
sing songs. . . . And that's how it started."[27] Cross-pollination of artists was an
important aspect of Mission District life. Regardless of specialization, artists
experimented in multiple mediums and exposed each other to a wide array of
possibilities.

Casa Hispana staged a series of Spanish-language dramas, including works
by Federico García Lorca, Alejandro Casona, and Rubén Darío.[28] The inclusion

of Lorca and Casona signaled Casa Hispana's appreciation for leftist Spanish culture, while the inclusion of the Nicaraguan Darío, who lived all over Latin America and who wrote of various countries in his poetry, underscores its pan-Latino approach. Part of Lorca's and Casona's appeal likely stemmed from their role as supporters of a theater for the people. In the early 1930s, with the establishment of the Second Republic in Spain, both Lorca (1898–1936) and Casona (1903–1965) had the opportunity to oversee government-sponsored traveling troupes; Lorca became director of La Barraca (The Hut), while Casona became director of El Teatro del Pueblo (Theater of the People). Both playwrights approached difficult topics with an airy humor. They used farce and drama to challenge social norms. These playwrights championed theater for everyday people, part of the Casa Hispana mission. In fact, Casa Hispana offered most programs for free or for a minimal fee.

The choice of playwrights also demonstrated Casa Hispana's political affinities. As incisive social critics, both Lorca and Casona later became targets of Francisco Franco's totalitarian regime. Lorca was assassinated in 1936 and Casona fled into exile in 1937.[29] Darío's political reputation was in constant flux, as both the Somoza regime and Sandinista rebels of Nicaragua attempted to co-opt his writings in support of their political agenda.[30] However, in the context of the Mission District's later history, Darío clearly emerged as a voice for the Left: the Sandinista headquarters in San Francisco, Casa Nicaragua, developed a Rubén Darío prize; muralists invoked Darío's image in their anticapitalist paintings; and activist poets for the Sandinistas read his work at public readings.[31] While Chicanos may have considered Casa Hispana ideologically conservative, its programming illustrated an expanding cadre of Latino intellectuals supportive of a global Left.

Over the course of the 1970s, Casa Hispana continued to produce theatrical events that evoked this political/cultural orientation, including poetry by the Chilean Pablo Neruda, drama by the Colombian Enrique Buenaventura, screenings of *La Hora de los Hornos* by the Argentinean Fernando Solanas, and sponsored performances by other, similarly minded California theater troupes, such as San Juan Bautista's El Teatro Campesino, Oakland's Los Topos, and San Francisco's Teatro Cena.[32] Casa Hispana organizers clearly sought, at the very least, to unify, radicalize, and inspire the neighborhood.

Casa Hispana, the Visual Arts, and the Neighborhood Arts Program

Though Casa Hispana started as an events-oriented organization, organizers quickly showed interest in the visual arts. Loarca, who had designed stage sets

and played guitar, began to pursue possibilities for art exhibitions. His training with established artist Elio Benvenuto provided a key connection when Benvenuto became director of the annual Civic Center Art Festival. Not only did the relationship between Loarca and Benvenuto help open a new door for the artists, but the connection had the backing of the newly formed city-funded Neighborhood Arts Program (NAP).[33] As its name suggests, the NAP encouraged expanded access to the arts through the development of neighborhood-based arts programs. Casa Hispana stood out as one of the first organizations to benefit from NAP, and these connections likely helped Casa Hispana to feature the work of six of its members at the 1967 San Francisco Art Festival: Loarca, Julio Benitez, Waldo Esteva, José Luis Leiva, Lazo Radich, and Miguel Roumat.[34] Loarca led the way in establishing a regular presence for Casa Hispana visual artists to exhibit their work at the annual Civic Center Art Festivals, one of the preeminent art shows in the city at that time (Plate 4).[35]

The creation of NAP also symbolized increasing pressure within the city to recognize art and artists working outside Eurocentric ideals. The NAP gained support because it counterbalanced a controversial proposal for a performing arts center. Residents in poorer neighborhoods, such as the Fillmore and the Mission, along with other concerned citizens, considered funds for more elite art institutions a slap in the face. These groups demanded increased funding for social services, but the lack of access to art in low-income and/or nonwhite communities mattered, too.[36] In 1965, after massive protests, voters rejected two-to-one a $29 million "culture bonds" initiative to improve the War Memorial Opera House and create a new performing arts center. However, the issue did not end there. The San Francisco Art Commission, under the leadership of Harold Zellerbach, continued to push for a performing arts center that would boost San Francisco's reputation and draw new business to the city.[37] Art Commission director Martin Snipper recalled that Zellerbach "responded [to the NAP] because he thought of it as a way of minimizing the opposition to cultural activities that would result in a more positive response to the Performing Arts Center."[38] In part, the NAP acted to alleviate the pressures of social unrest. Subsequently, the NAP received funding from the incipient National Endowment for the Arts (NEA) and prompted the NEA to fund a pilot project of neighborhood arts programs in fifteen other cities.[39]

When Casa Hispana first sought a home in the Mission, it turned to the San Francisco Art Commission. Snipper remembered their request: "A group of Latinos came to see me about giving assistance to them and starting an art center in the Mission, and I said, 'The last thing the Mission needs is an art center. But if you created a Latin cultural center, I'd be glad to help you.'"[40] Presumably, Snipper did not see an art center as relevant for a neighborhood struggling

with so many social problems and envisioned a cultural center as more so-cially responsible. However, it was through city funding that Casa Hispana was able to survive.[41] The NAP facilitated that relationship and served as an impor-tant link for arts groups around the city.

Casa Hispana's visual arts programming escalated with the addition of Francisco Camplís. In late 1967 or early 1968, Camplís ran across a poster in Potrero Hill advertising drawing classes in the Mission. As Camplís recalled, "I was taking classes with this Charles Farr and doing gringo stuff. I really didn't have a sense of Mexicano stuff, which is I think what I was leaning towards."[42] With high hopes, he went to enroll in his first class at Casa Hispana, but was disappointed to discover the class was canceled for lack of an art teacher. How-ever, in a gesture symbolic of the institution's openness, a Casa Hispana repre-sentative convinced Camplís he should teach the class instead. Taking those words to heart, Camplís became a regular drawing instructor at Casa Hispana and, eventually, the art director.[43]

Like his colleagues, Camplís wanted to make art more accessible to the com-munity. He saw his job as twofold: "[I] didn't see a lot of *exhibits* involving Raza, or where Raza participated, and two, I didn't see a lot of *art activities* where we were participating. So, I thought, that's what Casa Hispana had to do."[44] One of his first orders of business was to hold an art competition, The First Annual Latin American Artists Competition, in September 1968. A competition could help Camplís locate artists for future shows, as well as perform community outreach. According to Loarca, a then-unknown East Bay artist took first place: Esteban Villa won for his painting *La Novia*.[45] The event established an impor-tant connection with Villa, who at that time was just beginning his role in the Mexican American Liberation Art Front (MALA-F) in Oakland. Delighted with the response, Camplís planned more events to integrate Raza into the arts.

Though Casa Hispana took on a leadership role for Latino artists in the Mis-sion, the programming perpetuated a focus on male artists. For instance, all six Casa members included in the 1967 Art Festival were men. The 1968 ex-hibit at the Sheraton Palace, copresented by Casa Hispana and the Mexican American Political Association, showed an effort to be more inclusive. Three women—Zulema Sanda Di Marco, Ginger Leonis, and Sonia Nevel—showed work with six men—Camplís, Jaime Cortez, Raul Mora, José Montoya, Ray-mundo Zala Nevel, and Villa.[46] However, this show is an anomaly, since few other events featured women.

In hindsight, Camplís reflected that among the visual artists "I would have to say, yeah, we did focus on the men, we did emphasize the men, and probably didn't take the women seriously."[47] Women did forge positions for themselves at Casa Hispana—Isa Mura and Teresita Osta taught flamenco, Maruja Cid

helped organize exhibits, and in 1975, Maria "China" Tello became executive director. Of Tello, Don Santina has said that "she is one of those treasures of the Latino community: writer for *El Tecolote*, activist at Casa Hispana, activist at Centro Legal, immigration consultant; respected by all. Often overlooked because she doesn't blow her own horn."[48] Social norms encouraged men and women to downplay the contributions of women. As Emma Pérez wrote, "Women's activities are unseen, unthought, merely a shadow in the background of the colonial mind."[49]

Feminist historians have sought to reconceptualize the past and reestablish the places and spaces of women in history, however limited that may be, but even their subjects can reject these efforts. For instance, Maruja Cid recalled "noticing that I was really the only female" at NAP meetings, but also stated that she was "not into that female stuff," such as the women's liberation movement.[50] A tireless activist in the Mission, Cid rejected any framing of herself as a *female* activist. When asked if she ever felt excluded as a female, she remarked, "No, but I don't. But you see, I automatically don't. We're all here to liberate."[51] Cid's political vision of herself as part of an organic liberation movement tended to deemphasize gender as a category of analysis.

Cid came into contact with Casa Hispana through her work for the NAP. In 1968, NAP director June Dunn hired Roberto Vargas and Cid as community liaisons for the Mission. Both Vargas and Cid proved to be powerful community advocates. Vargas already had a high local profile as one of the cofounders of Horizons Unlimited, a youth education retention and job training program. In addition, he traveled in the same circles as some of the other Casa Hispana poets.[52] Cid was newer to neighborhood activities but energetic. Though she considered herself an amateur dancer, her appreciation for dance carried over into her arts activism and her support for flamenco. Cid recalled in a later interview how well she and Vargas worked together: "Roberto was more interested in the contemporary part of the arts . . . and I worked more in the traditional line through Casa Hispana. But this didn't mean that we were completely separate; many times we worked together. . . . Of course, he brought on the rock groups and I brought on the flamenco."[53]

Vargas and Cid provided a yin and yang support system for the arts in the Mission. As NAP organizers for the Mission, Vargas and Cid also became exporters of "Latino" culture to other parts of the city.[54] Thus, the various forms of artistic activity happening in the Mission became symbolic throughout the city of Latino life and culture. Both acted as a conduit between groups, sharing information and strengthening local networks, but also representing different choices in terms of the representation of local Latino identities. In fact, Cid recalled how Vargas "at first . . . really resisted the flamenco and things like

that."[55] One can only imagine how community members such as Vargas responded to Casa Hispana's 1971 Día de la Raza celebration, which featured an honorary reading in Spanish of the letters of Christopher Columbus.[56] Cid observed that Vargas softened over time, as did others, but Casa Hispana's willingness to promote Spanish drama, dance, and literature proved alienating for many in the late 1960s and early 1970s.[57]

In general, the art work of Casa Hispana included an amalgamation of different styles, including variations in abstraction, figuration, and surrealism.[58] But if the artists could not articulate a shared aesthetic, then what characteristics did they share? Were the artists only united in their experience of segregation? Was the ability to speak Spanish sufficient to unite Guatemalans, Mexicans, and Chileans in the United States? What room could be made for the artists born in the United States, who had been educated not to speak Spanish? These questions became the focus of intense discussions.

Around late 1968, Casa Hispana began a program to consider the relationship between art and national or ethnic identity. Francisco Camplís and Maruja Cid initiated a discussion series in artist homes devoted to "Brown Art," or "The Latin American Artist in the United States." The objective was "to explore the American influence on the Latin American artist," as well as "the possibility of expressing the Mexican-American and Latin American experience through art, abstract art, art with political themes, ad infinitum."[59] The terms used for prefacing the description are notable: while *Brown*, *Latin American* and *Mexican American* appear, *Chicano* and *Raza* are absent. The language employed in Casa Hispana's materials, including its Hispanic-rooted appellation, indicate a conservative position in a broader Left dialogue. The panel discussion illustrates that more militant or nationalist ideals impacted Casa Hispana. Part of the impetus also can be attributed to the formation of the Mexican American Liberation Art Front across the Bay in Oakland.

Carnalismo Across the Bay: The Mexican American Liberation Art Front

By the end of 1968, Casa Hispana visual artists had built important connections with artists across the Bay. In particular, exchanges with the artists of MALA-F shaped political and aesthetic shifts in both groups. MALA-F started as a group of East Bay artists who intended to overturn the forces of assimilation and oppression that they experienced as Chicanos. The group modeled a more politically vocal and Chicano outlook; even the acronym had a touch of acerbic rebelliousness, interpreting *La Mala-efes,* as "the Bad Fs."[60] The name also linked the group to revolutionary art fronts of the 1930s.[61]

Similar to Casa Hispana, the group began with informal meetings every Friday to discuss methods to reestablish their history, promote their creativity, and gain greater visibility in their communities. René Yañez recalled the intensity of the initial meetings at his house on Manila Street in Oakland, "discussing the Chicano movement and the art and how it should serve, and they were very, very exciting meetings. Lot of debate, lot of discussions, sometimes it was up to 50, to 75 people in these discussions."[62]

Formerly of San Diego, Yañez had moved to Oakland in 1966 after having served in Vietnam. As an artist, he aspired to participate in the Bay Area's Beat community (Fig. 3.3). On his arrival, he found himself amid a variety of late 1960s social movements. While attending Merritt College and the College of Arts and Crafts, Yañez first encountered the Black Panthers: "I was just astonished. I mean, they were advocating armed revolution at the school!" When Yañez learned that free speech leader Mario Savio served drinks at a local bar, he made himself a regular customer so he could hear Savio talk.[63] His experiences with the Black Panthers in Oakland, the Free Speech movement in Berkeley, and various other social movements in the Bay Area contributed to the lively debates about Chicano art and liberation.

According to Esteban Villa, the group started with painters, but gradually included poets and other community intellectuals.[64] An article announcing the group's formation describes their objective as follows: "Now they see the social conditions and needs of the Chicanos and have committed themselves to the struggle for their liberation."[65] MALA-F curated an art exhibition entitled "New Symbols for la Nueva Raza," which announced the formulation of a new iconography, no longer subject to past discourses (Fig. 3.4). The message drew other artists from around the Bay Area. Rupert García remembered seeing an advertisement for a MALA-F exhibition: "I remember reading this thing and I just tingled. I said this is amazing. . . . I about died, man. I died because I came alive as a consequence of just understanding what this meant. . . . It was a cultural statement that said, it seemed to me, that there was a need to create a space to exhibit our perception as manifested in paintings and drawings and sculpture and what else, because other established galleries and such weren't going to do it."[66]

Camplís remembered making the trip across the Bay to Armando Valdez's bookstore (a house turned into a community space called La Causa) because he heard that was "where the visual artists, musicians, writers and poets and also students and academicians would frequently meet and discuss Chicano movement ideas, ideology, etc."[67] Camplís was struck by the militancy of the group and inspired by the passion. For him, contact with the artists of MALA-F propelled him into dialogues he had never considered. Camplís recalled, "It was

René Yañez
paintings
la causa
1560, 34th ave.
oakland, calif .
opening- fri. 6:30
may 24 to june 31

Figure 3.3. René Yañez, solo exhibition poster, c. 1968. Yañez looks directly at the viewer in a confident pose but with an abstract visual intervention in the center. The poster lists Armando Valdez's bookstore, La Causa, as the location of the show. Image courtesy of René Yañez.

Figure 3.4. Artist unknown, *New Symbols for la Nueva Raza*, c. 1969. Poster for an art exhibition of the Mexican American Liberation Art Front in Oakland. Artists included Manuel Hernandez, Malaquías Montoya, Esteban Villa, and René Yañez. Image courtesy of René Yañez.

like Casa Hispana, but more Chicano and more militant. . . . In San Francisco, I think we were pretty much naïve, I know I was, about the Chicano art. . . . And so we'd have discussions and we're listening and finding out what's Chicano art, and how do you define it."[68] Camplís started inviting members of MALA-F to workshops at Casa Hispana and included MALA-F artists in local exhibits— "we had stuff from Oakland, which were the more militant stuff, and then [in San Francisco] we'd have a vase of flowers and stuff like that."[69] In May 1969, the *Casa Hispana de Bellas Artes Newsletter* (perhaps authored by Camplís) advocated visits to a MALA-F exhibition at La Causa.[70]

Encounters with MALA-F contributed to a new artistic direction for Camplís. The late 1960s signaled a change in the content and medium of his art, from representational still-life or avant-garde paintings to "Raza art." Around this time, Camplís began to experiment with photography, partly inspired by the need to document the Chicano experience (Fig. 3.5). His photographs and his interest in the human figure led to his series of black-and-white portraits of Chicanas entitled "Mi Raza Linda" (Fig. 3.6). He was driven to redefine notions of female beauty. More subtly, his work protested the absence of Chicana women in popular culture. His work emerged as a corrective, but the gaze of his camera

Figure 3.5. Francisco Camplís, photograph from the Chicano Moratorium, August 29, 1970. Francisco Camplís Papers, CEMA 47. Galería de la Raza Archives, CEMA 4. Image courtesy of the artist and the California Ethnic and Multicultural Archives. Department of Special Research Collections, UC Santa Barbara Library, University of California, Santa Barbara.

Figure 3.6. Francisco
Camplís, untitled photo-
graph from the "Mi Raza
Linda" series, late 1960s.
Image courtesy of Francisco
Camplís.

made some uncomfortable, especially after he turned to nude photography. Whether, as one article noted, he was "exploding a taboo in Chicano art" or exploiting his Chicana sisters became a point of tension.[71] This point of differ- ence explains how Camplís at times felt excluded from the community he was trying to serve; still, this period marked his growing interest in women as the subject of his art.

In 1974, Camplís produced his first short film, *Los Desarraigados* (*The Up- rooted*). The film depicted the experience of Mexican women workers in a factory during an immigration raid at a time when the Immigration and Naturalization Service mounted widespread raids and sweeps.[72] The film protested the human impact of this policy, particularly in terms of women. The next year, Camplís published his seminal essay, "Towards the Development of a Raza Cinema."[73] As Rosa-Linda Fregoso noted, Camplís "called on filmmakers to create 'a culture by and for us.' Inspired by the works of Latin American filmmakers . . . Cam- plís urged the making of 'revolutionary,' 'decolonizing films,' as well as the de- velopment of a vernacular aesthetics."[74] His transition to socially conscious art

focused on Chicano or Raza identity was complete, not just because of his encounters with MALA-F, or Casa Hispana, but in relation to both.

Los Desarraigados also serves as a unique lens on local Chicana art history. Camplís based the short story on news accounts and on fellow artist Graciela Carrillo's firsthand experience in a raid in Los Angeles. While Carrillo did not appear in the film, other local Chicana artists did, including Patricia Rodriguez, Irene Pérez, Ester Hernandez, and Lorenza Camplís, the wife of Francisco Camplís. Cindy Rodriguez, the daughter of activist-writer Dorinda Moreno, wrote the theme song, "America."[75] The film coincided with a time when female artists started rejecting the pervasive *carnalismo* (brotherhood) of the Chicano movement by forming separate organizations.

Though male artists adopted the ideology of *carnalismo* as inclusive, the ideology reinforced the exclusion of women from the movement. MALA-F subscribed to *carnalismo* as a guiding force of its activities. According to one of its mission statements, "[MALA-F] are also practicing '*carnalismo*' in its truest sense by offering any help they can to Chicano artists, writers, and poets. They feel that together La Raza can work for the liberation of their minds."[76] As Carlos Muñoz describes it, "*carnalismo* (the brotherhood code of the Mexican-American youth gangs) would mold the lives of the students and become a central concept in this proposed nationalist ideology. From the ranks of this new breed of youth would come the poets, the writers and the artists necessary for forging the new Chicano identity."[77] The philosophy heightened the importance of "low culture" and defined the barrio—the home of *carnalismo*—as a source of creative inspiration and cultural significance. As Fregoso pointed out, the ideology also spurred the proliferation of a male-dominated aesthetic: "In poetry, mural paintings, and theatre, Chicano movement cultural workers systematically figured the *pachuco* (urban street youth) the *pinto* (ex-convict), and the Aztec warrior as the new Chicano subjects of the counterdiscourse of Chicano liberation."[78]

While the radicalism of Casa Hispana and MALA-F inspired Camplís as a filmmaker and an artist, the male-dominated *grupos* often alienated women. In 1974, Carrillo, Rodriguez, Pérez, and Hernandez formed their own *grupo*, Las Mujeres Muralistas (discussed in Chapter 5). Dorinda Moreno started a women's theater group, Las Cucarachas.[79] Though women created separate spaces to counter the exclusivity of male *grupos*, *Los Desarraigados* spotlights how women artists continued to participate under the radar in a variety of collaborative projects with men.

The flourishing debates on the meaning and definition of Chicano art cultivated various aesthetic inclusions and exclusions. Yañez grew increasingly disillusioned with his participation in MALA-F. Yañez recalls, "I went through different phases. I did comic books, I did light shows, I did painting, mixed

media. . . . One time I wanted to do a light show—a Chicano light show—and it led to debate, like, 'oh, no, no, you can't do that. You see, it's got to be painting or silk screening.'"[80] Yañez, as someone always searching for a new approach, opted to break away from MALA-F: "at a certain point I decided to move to San Francisco, to the Mission District, mainly because I saw a large Chicano, Latino audience that I felt that I wanted to communicate to."[81]

Two factors catalyzed Yañez's break from MALA-F: his romantic relationship with Graciela Carrillo, who lived in the Mission, and his desire to attend the San Francisco Art Institute.[82] MALA-F members Esteban Villa and José Montoya left for teaching positions in the art department at Sacramento State in 1969 and 1970, respectively, where they spurred the creation of the Royal Chicano Air Force (RCAF) art collective. The RCAF gradually represented another wide-ranging group of associates, including Ricardo Favela, Max Garcia, Armando Cid, Juanishi Orozco, Rudy Cuellar, and Louie "The Foot" Gonzalez."[83] The collective was first named the "Rebel Chicano Art Front," but the resulting acronym drew amusing parallels to the Royal Canadian Air Force and inspired the humorous Chicano aviator logo.[84] With the formation of the RCAF, MALA-F ceased to exist.

From Casa Hispana to Galería de la Raza: Arte de los Barrios, Artes 6, and Art for the People

In early 1969, a group of Casa Hispana artists decided to create a major exhibition of Mexican-American art in San Francisco. With Francisco Camplís at the helm, they formed Artistas Latinos Americanos (ALAS) and embarked on the process of producing "Arte de los Barrios."[85] The show partly represented a response to the lack of available exhibit space for up-and-coming Latino artists. The Mission Adult Center, where Casa Hispana operated, offered limited space. The artists eagerly exhibited their work in almost any place with walls, indicated by the wide range of exhibit spaces used in 1968: the *Sun Reporter* building, the San Francisco Art Festival, the Redwood City Community Art Auction, the Sheraton Palace Hotel, and the Guarantee Savings and Loan Association.[86] Most locations lacked the cachet of prestigious galleries and museums and proved less than ideal in terms of space. Camplís remembered hunting for library exhibit spaces: "We hung [paintings] up wherever we could. Sometimes they had the bookshelves and we just laid them on top of the bookshelves, leaning. And so that was an exhibit venue."[87] The limited exhibit spaces highlights how few doors were open to Latino artists in San Francisco's mainstream art institutions.[88]

Organizers of "Arte de los Barrios" modeled their event on the success of "Fiesta de los Barrios," an arts celebration held in Los Angeles's Lincoln Heights

on Cinco de Mayo weekend in 1969, which drew 10,000 attendees. Activists created "Fiesta de los Barrios" as a follow-up to the East Los Angeles student strikes, or "Chicano Blowouts," in which thousands of students walked out of Los Angeles high schools to protest inadequate education. They especially demanded more representation of Chicano history and culture in a school system dominated by Chicano students. In turn, activists envisioned "Fiesta de los Barrios" as a way to celebrate the artistic talents and richness of Chicano culture.[89] According to Shifra Goldman, one of the event organizers, the Los Angeles celebration included an art exhibit featuring "a thousand works of art from the public schools, the High Schools, all the way through professional, each organized in categories, granted prizes."[90] Goldman recalled, "I've come across young people who said, 'That was my beginning. I put my work into the High School division,' or whatever it was, 'at the Fiesta de los Barrios, and you gave me a prize ... and that really got me started.'"[91] Increasingly, the opportunities to share works of art enabled people who otherwise never dreamed of pursuing a life in art.

The creation of "Arte de los Barrios" indicated how, despite substantial regional differences, artists in Los Angeles and San Francisco participated in each other's communities and quickly replicated successful community events. The San Francisco organizers modeled their event on "Festival de los Barrios," but envisioned a larger geographical scale. Camplís and Ralph McNeill promoted "Arte de los Barrios" as the first California-wide exhibition of Latino artists. Popular response turned the event into a Western United States exhibition, with works from Texas, Arizona, and Colorado. Held at the Mission Adult Center from October 12 to November 12, 1969, the exhibit of approximately one hundred paintings, photographs, and mixed media traveled to Oakland, East Los Angeles, Fresno, and Tulare, Arizona.[92]

The curation and organization of such a show proved challenging. Camplís urged the participation of other artists as an opportunity for "wider exposure, recognition of talent, promotion of the visual arts in the San Francisco Spanish-speaking community, and monetary rewards."[93] His promises represented the optimistic tone of the show. Camplís recalled several works of art were misplaced, including his own: "It was nonprofessional, it was done more *con the Corazon* [with the heart]. And it was done without funds."[94] The show included images of Mexican revolutionaries alongside the abstract works of Luis Cervantes and Rolando Castellón. For Camplís it often boiled down to the militancy of barrios versus the formal art training of San Francisco: "We could see some strong Chicano stuff. And they saw a vase of flowers." But the exchanges were exciting and provocative.[95]

The aesthetic diversity confused Thomas Albright, who reviewed the show at the Oakland Museum: "I wish someone would fill me in on the distinctions

that prevail in current usage of these terms [Chicano and Latino], along with Mexican-American, Spanish-speaking [sic], Spanish-surname, barrio and others, all of which sometimes appear simultaneously and without parentheses on a single press release. At any rate, such distinctions may help account for the extreme diversity one finds in the exhibition, which is sometimes colored by ethnic traditions but not at all defined by them, and ranges from hard edge through psychedelic, pop, abstract expressionism and elsewhere."[96] While Albright accepted a lack of coherence among Beat artists, he had trouble applying a similar lens to Latino artists.[97] William Wilson of *The Los Angeles Times* vented his frustration: "Suddenly bothered, I went outside to smoke. Sure, this art is about Chicanos but is it Chicano art? Subject matter aside, it is hardly different from a community art association show in Anaheim or Sherman Oaks. If a group of people have a homogenous identity it has a distinctive artistic language, a style. There is nothing homogeneous about the look of 'Arte de los Barrios.' "[98] Both Wilson and Albright puzzled over the variety of aesthetics. The reviewers sought cohesion, while the curators conveyed diversity. Their reactions indicated the pressure on Chicano artists, and ethnically identified artists in general, to convey a shared aesthetics and politics.

Artes 6: "A Mexican Uprising"

Symbolic of the Latino community's aesthetic openness was the creation of Artes 6, a predecessor of Galería de la Raza, and a humorous homage to San Francisco's Beat culture. The name, Artes 6 (pronounced "Artes Seis"), reflected its six original members and paid tribute to the famous Beat hangout, the Six Gallery. The artists translated the counterculture gallery into Spanish to signal their ethnic alliance and their avant-gardism. Artes 6 opened in a storefront on Dolores and 18th Street in the Mission on June 14, 1969, with an exhibition of its members: Francisco Camplís, Antonio Gabriel, Ralph "Rafael" McNeill, Manuel Palos, Miguel "Mike" Ruiz, and Pilar Sanchez.

The location, next to Dolores Park and near Mission High School, appealed as a place where the artists "felt they could contribute the most for their people."[99] Perhaps the art would attract students and open a dialogue with the next generation. The publicity flyer, entitled "Mexican Up-Rising!" suggested Artes 6 exerted a more pronounced Chicano militancy than its peer Casa Hispana. However, the new gallery retained a degree of inclusiveness evidenced by cofounding member Ralph McNeill, a French American painter, who appeared translated onto the flyer as "Rafael" and whom Camplís called, "our honorary Raza."[100]

The artists declared, "Few people are aware of the artistic activities and climate of creativity surfacing in the Mission."[101] Their enthusiasm inspired

others. Rupert García learned about Artes 6 when he ran into Camplís hanging a show at San Francisco State University. The two hit it off, leading García to visit the gallery shortly afterward: "So I go down to 18th and Dolores and I go to the Artes 6 and we have the meeting and I meet these other artists. And, wow! Wow! I mean, it was beautiful."[102] The SFSU student quickly found a home at Artes 6, participating in a group show just four months after the gallery opened.[103] García later ascribed the moment he met Camplís as the moment when he became involved in "a very important cultural milieu out of the Mission District."[104]

In spite of all the enthusiasm, Artes 6 only lasted from June 1969 to June 1970 (Fig. 3.7).[105] The long, narrow space proved awkward. Moreover, Camplís does not remember a single high school student visiting the premises.[106] Artes 6 remained connected with Casa Hispana, and conversations in both locations began to steer toward accommodating more artists and developing more public outreach. While Camplís focused on Artes 6, fellow artist Rolando Castellón became director of the Visual Arts Board for Casa Hispana. Castellón then found a space on 14th Street and Valencia.[107] The location was a little out of the way for pedestrian traffic, but the building already served as a painting studio. Fredric Hobbs had relocated his Beat gallery from the Marina/Cow Hollow area to the 14th Street location and was willing to rent out his space to the new group of up-and-coming artists. Thus, Artes 6, named for the Beats, took up residence in a former home of the Beats.[108] The artists christened their new space Galería de la Raza.

Galería de la Raza

The sheer number of artists—between fifteen and twenty-five, all men—involved in the founding of Galería de la Raza is telling in terms of the institution's appeal. Rolando Castellón was elected the first director, and other men took part in varying degrees, including, in alphabetical order, Camplís, Jesús "Chuy" Campusano, Luis Cervantes, Jerry Concha, García, Robert González, Louis Gutiérrez, Loarca, Ralph Maradiaga, McNeill, Jay Ojeda, Carlos Pérez, Joe Ramos, José Romero, Mike Rios, Mike Ruiz, Gustavo Ramos Rivera, Peter Rodriguez, Manuel "Spain" Rodriguez, Manuel Villamor, and Yañez.[109]

The lengthy list of founders demonstrates a more pervasive frustration with mainstream art institutions. As Yañez recalled, "What I found out, taking portfolios around, slides around, people weren't used to Chicanos or Latinos approaching a gallery. They would go, 'Wait a minute.'" In another instance, Yañez stated, "When I worked at the Neighborhood Arts Program one time, I went to a gallery association meeting, and they were very resistant, even to look at slides, look at work, and these instances came up with other people, 'yeah, I experienced that same thing.' . . . 'well, why don't we start our own gallery, instead of

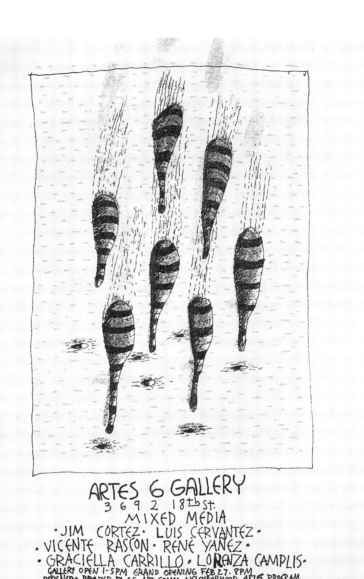

Figure 3.7. Graciela Carrillo, *Artes 6*, February 1970. René Yañez recalled that Carrillo created the abstract illustration for this poster, though it says, "Designed and printed by the San Francisco Art Commission Neighborhood Arts Program." Image courtesy of René Yañez.

knocking on doors and the doors, they're not even answering.' "[110] Galería de la Raza provided a social and physical space for Latino artists to reject the exclusionary politics of established art institutions.

Galería de la Raza formed without city assistance. In fact, initially, the artists each agreed to contribute a set fee to cover rent and bills. However, as the Galería evolved, and as the cooperative structure proved difficult to manage, it required more sustainable financial assistance and more top-down leadership.[111] The NAP and the San Francisco Art Commission became important mechanisms in its growth and long-term survival. As one artist stated, the NAP "acted as a legal liaison to bring Raza artists together, to make them aware of one another's existence. The Program also helped with funds for the gallery's founding."[112] Galería de la Raza fit well with the NAP mission to sponsor art-making in local communities. Of course, it also struggled when this funding was jeopardized, especially in the 1980s. Mapping this sometimes-difficult course fell to Ralph Maradiaga and René Yañez, who gradually assumed the leadership of Galería de la Raza.

Though a comprehensive list of the artists in the first show at Galería de la Raza in July of 1970 is not in the archives, photographer Joe Ramos offers some documentation of opening night and the diversity of work on the walls (Fig. 3.8). Especially notable was the large-scale quote on the back wall, which presided over the exhibit and communicated the curatorial theme: "A Chicano is a Mexican-American with a non-Anglo image of himself." The words were taken from a column by Rubén Salazar published in *The Los Angeles Times* just a few months prior.[113] Entitled "Who Is a Chicano? And What Is It the Chicanos Want," Salazar's questions served as guideposts for considering the art. In exhibiting their work together, the artists showed the diversity of Chicano interests and aesthetics, but also displayed their political solidarity as Chicanos. The link underscores the ways that Galería de la Raza was a more Chicano-oriented space than Casa Hispana, with a majority of Chicano members.

Though the Galería maintained a relationship with Casa Hispana in its first few years, the first show in July 1970 reflected the artists' desire to break away from high art and Spanish culture.[114] Moreover, the artists were determined to reject any use of the term *Hispanic,* especially in their name. According to Rupert García, "At this time, we were adamantly contra anything European. And of course, Casa Hispana, that killed it. We said no, it had to be something that doesn't so obviously make the connection."[115] Nonetheless, like its precursor, Galería de la Raza promoted a Raza identity to show solidarity with the Mission District population. As García recalled, "We realized that we couldn't say Chicano. That that did not reflect the multiplicity of Latinos. So we figure, okay,

Figure 3.8. This photograph by Joe Ramos offers a look inside Galería de la Raza's first location on 14th Street on opening night, July 1970. Artist and cofounder Ralph Maradiaga stands in the center. On the back wall is a quote from Ruben Salazar's February 1970 column in the *Los Angeles Times*: "A Chicano is a Mexican-American with a non-Anglo image of himself." Salazar was killed by police in the August moratorium a month later. Image courtesy of Joe Ramos.

'la raza,' the people. So 'The Peoples' Gallery' or 'The Gallery of the People.'"[116] Tomás Ybarra-Frausto connected the gallery's name with the writings of José Vasconcelos, who argued in his 1925 book *La Raza Cosmica* that the intermingling of peoples across Latin America would submerge difference into a glorious cosmic race joined together by a shared culture and history. Per Ybarra-Frausto, "This utopian vision of cultural coherence and predestined greatness found ready acceptance among Bay Area cultural activists who were searching for a point of unity among the diverse Latino communities living in the barrios of the Mission District."[117]

However, the appeal of a Raza sensibility did not necessarily translate to the politics of the larger Chicano movement. García and Camplís encountered intense resistance in their attempt to convey the value of a multiethnic Raza political coalition at a meeting in Los Angeles. People at the meeting demanded to know why San Franciscans chose the name Galería de la Raza. García recalled, "They just booed us out. I said, 'Francisco, man, let's get out of this place. All

they're talking about it is a pure Chicanismo.' "[118] García's experience showed that the Raza ideology was not without its critics, particularly among supporters of a more nationalist Chicano ethos. The confrontation also showed how San Francisco cultural workers attempted to cultivate support for Raza ideologies in a much wider sphere. Street murals, silkscreens, poetry, political writing, and theater reverberated with the emerging Raza ideology, emphasizing a shared Latin American past, a celebrated indigenism, and a desire to overturn all oppression, regardless of geographical borders.

Early exhibits at Galería de la Raza reflected an expansive interest in Latin American and Third World cultures, largely through the lens of a global Left and often in opposition to U.S. policies. For instance, the Galería showed photographs by Jay Ojeda and Robert Pérez-Diaz, and drawings by Gloria Osuna, documenting their experience as volunteers with the Venceremos (We Shall Overcome) Brigade, an organization for Americans to show solidarity with the Cuban Revolution by working in Cuba. The show also featured well-known Cuban artist René Mederos and his series of posters "that reflect an obvious love for the Vietnamese people."[119] The gallery's political disposition was not just sympathetic with the social consciousness of communism, but implicitly hopeful in spurring some form of revolution among the people of the Mission District. Similarly, a 1971 exhibit of Alejandro Stuart's photographs of "Murals of New Chile," and a June 1973 exhibit of silkscreens from Chilean president Salvador Allende's cultural campaign (Fig. 3.9) reflected the gallery's sympathies with the socialist revolution in Chile.[120] The ideals of Galería de la Raza, as a people's gallery, drew from leftist mass movements for social change around the globe.

In various ways, Galería de la Raza was never just an art gallery, but also a vehicle for expressing political beliefs, both abroad and at home. The gallery explicitly and implicitly critiqued racism in the United States. Sadly, Rubén Salazar inspired another memorial exhibition only a few months after he contributed so powerfully to the first exhibit. A Los Angeles policeman killed Salazar while he was seated, unarmed, inside a bar, during the Chicano moratorium against Vietnam, on August 29, 1970.[121] Whether it was through the Salazar memorial exhibition, or through the Chilean solidarity exhibits, or the art programs in the community, Galería de la Raza became a space to speak out against injustice and emphatically reject the Eurocentrism of the San Francisco establishment. Over time, shows included paintings, both representational and abstract, but also less-acknowledged mediums, such as posters, food, weavings, newspapers, murals, Gestetner mimeograph copies, photographs, and tortilla art.

Many of the Galería's exhibits were not overtly political, but they still conveyed the desire to cultivate a broad sensitivity to Latin American and Third World cultures. Early shows included the graphics of Argentina, Brazil, and

Figure 3.9. René Yañez codesigned this *Por Chile* poster for an exhibition at Galería de la Raza from June 29 through July 14, 1973. The show featured silkscreens supportive of the Salvador Allende presidency and its socialist reforms. Just two months later, General Augusto Pinochet led a coup overthrowing the Allende government and instituting a dictatorship, covertly supported by the United States.

Costa Rica; photographs of the Quechua people of Peru; a group show of local Filipino and Samoan artists; yarn paintings of the Huichol people of Guadalajara, Mexico, and a benefit for the 1972 earthquake victims of Nicaragua.[122]

Moreover, the Galería continued to show abstract art. Thomas Albright gave favorable reviews to the works of Gustavo Rivera and Peter Rodriguez, whose art fit Albright's taste more than some of the more didactic expressions (Fig. 3.10).[123] Rodriguez founded the Mexican Museum in 1975, another important component of the Latino arts movement in San Francisco, not covered here.[124] Albright, Camplís said, "at first was very supportive and he reviewed Chicano and other minority art exhibits—many were favorable. Then after a short period of time, he did an about-face and completely ignored minority exhibits, except for a select few, such as Rupert García, Manuel Neri. Apparently

Figure 3.10. Peter Rodriguez, untitled, c. 1970. Oil on canvas, 36 × 55 inches, collection of Irene Christopher. Rodriguez grew up in Stockton, California and loved art from a young age. His many travels to Mexico proved inspirational to his development as an artist. In 1969, he moved to San Francisco and participated in the creation of Galería de la Raza. His experiences catalyzed his quest to build a major museum dedicated to exhibiting Mexican art. He founded the Mexican Museum in the Mission District in 1975. In 1982, the museum moved to Fort Mason. In 2015, after years of planning, Rodriguez attended the groundbreaking ceremony for a four-floor, multimillion-dollar complex to house the Mexican Museum in the heart of downtown San Francisco. He continued painting until his death in 2016.

he was chastised by the elite establishment he represented."[125] Whether or not this perception is accurate, Camplís's statement highlights the constant tensions framing interactions between cultural organizations in the Mission District and San Francisco's more established forums.

For many of the artists, the ideal was not just making art, but educating the community. Such an approach automatically distinguished the gallery from the elite venues downtown. An *Artforum* reviewer noted, "On the afternoon when I stopped by, one youngster, possibly twelve years old, was drawing under the scrutiny of several instructors hovering nearby, and another, two or three years older, was having the diaphragm of a camera explained to him."[126] The gallery created an area just for children's art, developed arts workshops, and

offered weekly Sunday celebrations with food.[127] According to Rolando Castellón, "Our main interest was to better ourselves and to educate and to get more people into the arts. . . . Whether it is the Galería de la Raza or the Mexican Museum or Casa Hispana de Bellas Artes, the main thrust was the education really through the arts. And by association . . . we became also a political force."[128]

Reflections on an Arts Revolution

In a cosmopolitan city where artists regularly entertained new ideas and networked, the Mission District emerged as a significant nexus for discussing and defining Chicano and Latino art and politics. Idealistically, the Mission was the artists' muse—a site for creative inspiration, cultural identity, and contact with other like-minded people. The Mission was also their audience—an audience to uplift and radicalize. If anything created solidarity in the community, it was this tandem effort to pay homage to the Mission as a center of Latino and indigenous cultures and to educate the people about their shared cultural history.

Even if the art was not obviously political, its distribution was. The ideals of street theater, free galleries and art classes, mural making, and music in the streets celebrated multiple cultures, challenged the de facto barriers of class and race, inspired future artists, and politicized the community. Regardless of the medium and content, the desire to make art accessible to all infused the arts movement. Artists, writers, and performers developed new galleries, publishing collectives, and theatrical venues to enable their creativity and critique Eurocentric perceptions of art and culture.

Mission artists cultivated a Raza identity that could unite the Latino community but that was not always successful. Nationally and locally, Latinos who were not Chicanos found themselves included or excluded according to the shifting permeability of the Chicano movement. Carlos Loarca, a Guatemalan, felt such exclusion in the Mission District of the early 1970s: "And part of the misunderstanding of the politics is that we were Latinos not born here—Chicanos were born in here, so they were first. And they deserved more attention than the ones that were born on the outside."[129] A sense of difference between Chicanos and other Latinos divided Latino communities, but the construction of a Raza identity attempted to glue people together.

Even with these lines of exclusion, the 1960s saw local, regional, national, and transnational debates that contributed to the richness of the moment. For many, the opportunity to plan and participate in events involving diverse cross-sections of Chicanos and Latinos became a critical element of developing their art. The situation also created a difficult balance for artists—many felt their al-

legiances to art tested against their ethnic identity. As Chicanos or Latinos were they meant to generate a uniform image to please reviewers and/or themselves? Finding where lines were drawn, where exceptions and exclusions were made, underscored tensions in the community, but also served as points of inspiration.

Chapter 4

The Third World Strike and the Globalization
of Chicano Art

In November 1968, students at San Francisco State College initiated the longest student strike in U.S. history, known as the "Third World Strike." The students, predominantly people of color, called for the immediate creation of an ethnic studies department, the substantive hiring of nonwhite faculty, and the expansive recruitment of nonwhite students. From November 1968 through March 1969, the "mama strike" lasted for almost five months and contributed to "baby strikes" at other universities, including UC Berkeley, Columbia, and Cornell.[1]

The strike ended on March 20, 1969, when the college acceded to some of the student demands: the School of Ethnic Studies, the first such department of its kind in the country, opened in the fall of 1969. In addition, administrators guaranteed the enrollment of approximately five hundred qualified nonwhite students and four hundred nonwhite "special admittees."[2] The strike marked a formative moment in San Francisco history and encouraged many to align with a "Third World" outlook in their politics and art. Artist Juan Fuentes recalled, "I think the whole concept of Third World Studies . . . was just like an eye-opener. Because it just made me see, 'wait a minute, we're connected to this whole other sphere of people in the world.' And it also I think made me very confident. . . . As a person of color, it made me feel like, 'Hey, we belong here. We have a right to this.'"[3]

The Third World Strike contributed to the political awakening of three Chicano artists: Juan Fuentes (b. 1950), Rupert García (b. 1941), and Yolanda López (b. 1942). While none acted as a lead organizer, the strike had an indelible impact on their artistic and political consciousness. Their art came to reflect diverse interests in the Chicano movement, the Third World movement, and the Left. All three artists incorporated the ideas and iconography of the Black Panthers.[4] They envisioned a new iconography to challenge dominant visual

cultures and spur change, and their experiences spotlight the ways that Chicano artists adopted transnational perspectives in their art.[5]

Posters proved a critical medium to express their ideals. The demand for posters surged alongside the growth of 1960s social movements. The affordability of the technology, both in terms of production and distribution, along with a poster's capacity to synthesize a movement's objectives, spurred production globally.[6] Fuentes, García, and López gravitated to posters as an efficient, effective, and affordable medium to distribute their work. In doing so, they hoped to politically awaken others as they experienced for themselves. Their objectives aligned with scholar George Lipsitz's view that "people cannot enact new social relations unless they can envision them."[7] Notably, these artists found themselves drawn to the Mission, a place that supported and reflected their political and artistic concerns.

The recollections of Fuentes, García, and López show how the strike reframed people's perception of the world and underscored the complexity of political and cultural communities. While the Chicano movement figured prominently in their intellectual growth, so too did other movements and events. Frequent representations of the 1960s as a moment of ethnic nationalism often undercuts the complexity and multiplicity of people's identifications. Their experiences point to a more expansive community of "cultural workers" in the Bay Area who sought to affirm a global Left community and overturn racism.

Because the strike played such a fundamental role in their lives, this chapter provides an overview of the event, before turning to the ways the strike shaped the political and aesthetic vision of these three artists. Both López and García participated in the strike, while Fuentes arrived later as a beneficiary of more inclusive admissions policies. In their art, they hoped to shake people from the status quo and change their outlook on the local and the global.

A Brief History of the Third World Strike

Known as the year of international student strikes, 1968 inspired many youth to consider themselves as part of a global Left community. Protests in Paris, Tokyo, Mexico City, and San Francisco contributed to a sense of shared international struggle, largely revolving around the desire to overturn authoritarian control and bring "power to the people." George Katsiaficas wrote that "television, radio, and traveling spokespersons spread the movement around the world as never before, synchronizing its actions and making the political generation of 1968 a truly international one."[8] Simultaneously, repression and violence in connection with the protests intensified: The May student strikes in Paris erupted in "Bloody Monday," a night of violent clashes between police and

protesters; street battles between students and police in Germany ensued after a student leader was violently attacked; and the Mexican military opened fire and killed hundreds of students in the Plaza de la Tres Culturas, in the Tlatelolco neighborhood of Mexico City in October. In the United States, tensions heightened with the escalation of the Vietnam War; the assassinations of Martin Luther King and Robert Kennedy; and the police beating of protesters at the Democratic National Convention in Chicago in August. A sense of impending revolution and swift suppression characterized 1968.[9]

At San Francisco State College, tensions built between students and administrators, especially after the college began informing the Selective Service Office of student eligibility for the draft. As college archivist Helene Whitson noted, the 1967 reinstatement of this policy "reinforced the feeling that higher education was totally unsympathetic to student ideas and irrelevant to their needs."[10] Increasing and sometimes violent conflicts between white and nonwhite students on campus reflected the heightened tensions of the nation. A 1967 fight in the student newspaper office between black students and the white editor exemplified the palpable racial divide on campus.[11] Over the course of early 1968, concerns about the war abroad and civil rights at home sparked a series of direct actions, including the occupation of campus buildings, sit-ins, and multiple demonstrations. Campus tensions escalated, both as a result of specific local concerns and in the context of a larger global movement of striking students.

In March 1968, the Third World Liberation Front (TWLF) emerged as a loose coalition of ethnic student organizations. The alliance included the Black Student Union (BSU); the Philippine American Collegiate Endeavor (PACE); the Intercollegiate Chinese for Social Action (ICSA); the Latin American Student Organization (LASO); the Asian American Political Alliance (AAPA); the Mexican American Student Confederation (MASC); and later, to a limited extent, the predominantly white Students for a Democratic Society (SDS). The BSU emerged as one of the most vocal organizations, often coordinating efforts with the Black Panther Party.[12] Each group existed independently, but similar concerns and political interests propelled collaboration as part of the TWLF.[13]

"Third World" organizing counterbalanced the politics of ethnic separatism. Many ethnic students saw the potential of organizing collectively and perceived ways in which their unequal status with Anglo Americans paralleled the global divide between "Third World" countries and "First World" superpowers. The term *Third World* developed from the Cold War to describe populaces positioned economically and politically outside the Euro-American capitalist system and the Soviet communist bloc. Activists appropriated the term in the United States to cultivate cross-ethnic alliances and critique systems of empire, racism, and inequality.[14] As Angie Chung and Edward Chang described the

TWLF, "The objective interests of the organization converged at the cross-roads of racial and class liberation such that all forms of human oppression became the basis for resistance."[15]

More practically, the TWLF protested the ways cultural imperialism structured academic curriculums, admissions, and funding. Student concerns focused heavily on the absence of students of color in higher education. At San Francisco State, the student body hovered at 20 percent nonwhite, while the city of San Francisco was more than 50 percent nonwhite, a significant discrepancy for a public institution.[16] Students wanted more than a change in admissions policies. They demanded a massive overhaul of educational curriculums and hiring practices, or what William Barlow and Peter Shapiro called "an alternative philosophy of education."[17]

The final catalyst for the strike came with the college's November 1, 1968 suspension of English instructor and Black Panther Minister of Education George Mason Murray, ostensibly because of his public advocacy of black militancy.[18] His removal forced a showdown between students and authorities. The BSU and the TWLF released a series of parallel demands, including the immediate reinstatement of Murray, the recruitment of fifty faculty members to support a School of Third World Studies, and the adoption of open admissions for all Third World students. Anticipating a negative response from the college president, students organized a general meeting to discuss the merits of a strike. Stokely Carmichael, prime minister of the Black Panther Party, delivered the keynote address on November 5, emphasizing the importance of a long-term shutdown of the college to address widespread institutionalized racism. The next day, the strike began.[19]

Of course, not all students participated, but the number who did and the guerrilla tactics they employed—hallway chanting, setting fires in trash cans, invading classrooms, occupying buildings, raiding offices—turned the campus upside down. Combat-ready police turned the college into a militarized zone. College president Robert Smith closed the college, but in doing so, lost authority in the eyes of trustees, government officials, and faculty. Under pressure, Smith reopened the campus on November 20, attempting to appease faculty concerns by holding a three-day, campuswide convocation to ease tensions.[20] However, Smith's inability or refusal to comply with any of the TWLF demands, the failure to cancel classes during the convocation, and the simultaneous delivery of suspension notices for most of the TWLF leadership undercut any potential dialogue. On November 21, the second day of the convocation, TWLF led a morning walkout, Smith resigned, and the strike picked up full force.[21]

Over the five-month struggle, hostilities between strikers and authorities intensified. Violence erupted from both sides. The replacement of Smith with S. I.

Hayakawa as the new college president heightened tensions. Hayakawa refused to relinquish any control and maintained a strong police presence on campus. As a Japanese American who saw himself as living proof of the American dream, he rejected the militancy of the students and criticized their failure to acknowledge the opportunities already in place. His position accorded with the sentiments of then-governor Ronald Reagan, who had little tolerance for the student demands.[22]

The student strike expanded in unexpected ways. Hayakawa's arrogance toward faculty helped launch a simultaneous strike on campus by the American Federation of Teachers (AFT) union. The AFT strike, initiated on January 6, 1969, added to campus unrest. A parallel Third World Strike of students began at UC Berkeley on January 21, 1969. The concerns of the Third World Strike reflected a cultural shift in education that administrators finally had to engage, regardless of their personal antipathy. As anthropologist Johnnetta B. Cole wrote, "It was precisely because the traditional departments and curricula failed to deal adequately with issues of racism and sexism, and consistently demonstrated an unwillingness to hire Black or women staff, that a need for Black Studies and Women's Studies arose."[23]

Moreover, students could not continue the struggle indefinitely, facing constant demands on their time, arrests and fines, factional bickering, nothing concrete to show for their college "attendance," and the sense that "the authorities were determined not to lose this battle no matter what the cost."[24] On March 20, 1969, the college administration and the TWLF signed a compromise to end the strike. While the college did not consent to rehire George Murray or Nathan Hare, another vocal faculty member for the strike, authorities did agree to create a School of Ethnic Studies and implement new admissions policies to recruit students of color.[25]

Some expressed disappointment that the strike did not accomplish more.[26] Marjorie Heins described how the strike met with a backlash that "crushed and ushered in severe repression on California campuses."[27] Hayakawa continued to purge academic departments of his political opponents over the next few years.[28] Ostensibly, students won the battle, but many issues persisted well after the settlement.

Even so, the Third World Strike reframed the curriculum of American universities for a sizable body of students and faculty who turned to ethnic studies to counter Eurocentric, canonical approaches.[29] The creation of educational opportunity programs in colleges and art schools around the country opened up attendance to students previously "tracked" out of higher education.[30] New admissions policies, new curriculums, and new ethnic studies departments marked the event's impact. The Third World Strike had abstract ramifications,

too. For López, García, and Fuentes, the strike transformed their vision of who they wished to be as artists and as activists.

Yolanda López and the Counter-Image Revolution

Yolanda López was not a newcomer to political activism or feminism. She grew up in a household of strong women. In an interview, she recalled her mother's political beliefs as representative of her independence: "My mother was a staunch Democrat, so she voted for Adlai Stevenson instead of Eisenhower in a military town."[31] Her mother's willingness to defy the conservatives of San Diego made an impression on López, as did the memory of her mother taking López and her sisters to stuff envelopes for Jack Kennedy. When López moved to Northern California in the early 1960s to live with her uncle and attend college—first at San Francisco State, and then the College of Marin—she joined the Student Non-Violent Coordinating Committee (SNCC) and immersed herself in the ideas of the civil rights movement. Upon graduating from the College of Marin, she returned to San Francisco State to take art classes and found herself in the midst of a massive student movement.[32]

López quickly saw the value of the TWLF demands. López explained, "To me, the civil rights movement was black-and-white. And it was through the Third World Strike that I actually began to see that Latinos had a history that . . . I had not known anything about. And that we needed to really begin to fight our own fight within the civil rights movement."[33] López recalled the college's 1968 convocation as a consciousness-raising session: "I went to the convocation and it was at that point that I realized that it was important to have black people talk about black history, and Latinos talk about Latino history."[34] Ultimately, López joined the picket blockade at the main entrance to the campus: "I was out on the picket line . . . and just told people not to go to school. We just were out there every single day."[35] Her experience in the strike launched her involvement as an artist for Los Siete de la Raza (The Seven of the People), an organization that blended Chicano and Black Panther nationalism with Third World organizing.

López's involvement in the Third World Strike reframed her political outlook in at least three ways. First, López redefined her ethnic community, stating "In Southern California we were Chicanos and in Northern California and in San Francisco we were Latinos." Second, she reevaluated the importance of class, attributing to San Francisco a "much more Marxist orientation." As she described it, "We recognized class, the differences in class, and the allegiance of class in looking at working-class blacks, in looking at working-class whites, looking at working-class Chinese, so that there were ways of building coalition."

Last, López gravitated to the Black Power movement—she especially admired one of the Black Student Union leaders, Nesbit Crutchfield—and perceived herself as one of the "Latinos identifying with the black struggle."[36]

López came to the Bay Area in 1961 because her uncle, Michael Franco, offered to support her through college. She explained, "He didn't even graduate from high school either, and he worked as a hairdresser," but his hopes for a different life helped her imagine an alternate path. López linked her uncle's migration to the Bay Area with his identity as a gay man: "It was the tail end of the beatnik generation, so that was very exciting for him."[37] Both López and her uncle benefited from the spirit of tolerance and creativity in bohemian San Francisco.

López recalled wanting to be an artist since childhood, though her working-class background made such a career choice unlikely. According to López, "I've always made drawings. In first grade there was a chalkboard, and while the boys drew airplanes and bombs, I did little farm kids with straw hats."[38] The culture of the Bay Area launched her career as an artist, partly through her access to education in the arts and partly through the transformative environs. The strike galvanized her interest in the power of images in everyday life. She was under constant police surveillance: "We were being photographed, all the way up and down the line. . . . So we were told to bring our own cameras . . . film or not, just bring it out there and start shooting back because . . . if you're going to take a photograph of me, I'm going to take a photograph of you. . . . There was a real recognition that the power of the image was really important."[39] For López, surveillance and countersurveillance crystallized the question of representation: who had the power to define the other.

Much of López's work as an artist has relied on this dichotomy between the subject of the image and the image maker: Who is making the image? What power relationships does the image reveal in its configuration? What stereotypes or gender roles does the image solicit? Feeling both objectified and empowered by the camera, López grappled with a theme that reappeared in various ways over the course of her career: "I'm interested in how images function. And I'm interested in how we understand images because . . . the images affect our consciousness and they affect our consensus."[40]

Though the Third World Strike formally ended in March 1969, López's development as a cultural worker continued, most immediately with the 1969–1970 trial of Los Siete de la Raza for shooting a police officer. Reportedly, on May 1, 1969, police officers Joseph Brodnik and Paul McGoran stopped to interview a group of men sitting outside a house with a television set, which the officers presumed stolen. According to Officer McGoran, one of the men knocked him down, stole his gun, and shot and killed Officer Brodnik. Subsequently,

police arrested six men: José Mario Martinez, 16; his brother Rodolfo "Tony" Martinez, 20; Nelson Rodriguez, 19; Danilo "Bebe" Melendez, 18; José Rios, 19; and Gary Lescallet, 18. The seventh suspect, Gio López, remained missing. Not only did many question the number of arrests, but the story of an officer shot with another officer's gun spurred skepticism of the official story. Indeed, the defendants argued that Officer McGoran aimed his gun at one of the suspects and accidentally shot his partner.[41]

Many Raza activists involved with the Third World Strike turned to this case as an opportunity to apply their ideologies in the real world. López stated, "There was an issue for us to actually grab a hold of . . . and so out of that came the development of the organization."[42] Since none of the defendants identified as Chicano—all seven hailed either from El Salvador or Nicaragua—community organizers adopted the inclusive *Raza* appellation to amass support across the Latino community. Activists formally adopted the name El Comite para Defender Los Siete, but the colloquial Los Siete de la Raza prevailed in popularity. For activist Carlos Córdova and many others, the trial of Los Siete de la Raza, "created a cohesive movement and it became a catalyst for many individuals to become organized and become very vocal."[43]

The organization's principal objectives focused on helping the families of the accused with legal aid and countering systemic prejudices in the media and the courtrooms. The case also represented growing tensions between a predominantly Irish American police force and an increasingly visible Latino community. Writ large, activists used the case to protest a more pervasive abuse of police authority locally and nationally.[44] The activism around Los Siete de la Raza participated in a wave of public dissent against arbitrary legal authority. The trial of Black Panther leader Huey Newton in Oakland and the conspiracy trial of the Chicago Seven raised questions about government abuse of authority.[45] The unsubstantiated arrest of seven Latino men for killing a police officer also hearkened back to the Sleepy Lagoon murder trial of 1942, the archetypical case of unjust authority directed against the Chicano community.[46]

In aligning with the Black Panthers, Los Siete defined itself as a more militant wing of community organizing. In fact, alliance with the Black Panthers was the first conflict to split would-be Los Siete activists apart. López remembered attending a meeting in the Mission shortly after the arrests. While one side advocated working with the Black Panthers, others argued that such support would alienate conservative Latino families. For López, the choice was difficult, but ultimately inescapable: "I decided in the end that it was important to make a moral stance. . . . We needed to stand by our friends, the Panthers, because I knew the Panthers at that point, were being totally misrepresented. And I actually had a great admiration for the Panthers. So, I went with Roger

[Alvarado] and Donna [James] and became part of Los Siete de la Raza. And then Jimmie [Queen]'s faction became a part of RAP [Real Alternatives Program], which also became very important in working with the youth in the Mission."[47]

Close ties with the Black Panthers helped Los Siete emulate Panther community organizing tactics: Los Siete expanded its focus to include community issues unrelated to the trial. It established political education (PE) classes, built up the free breakfast program at St. Peter's Church, and established a small restaurant, El Basta Ya, across from the Levi-Strauss factory, in hopes of serving and potentially organizing the predominantly Latina garment workers.[48] The community service efforts of Los Siete focused on basic needs, so that people then might have the time and financial wherewithal to contribute to the organization's larger objectives for social equity and inclusivity.

The *Basta Ya!* (roughly "Enough Already") newspaper reflected Los Siete's organizing strategies to reach "the people." The paper initially emerged as a section of *The Black Panther* newspaper on June 17, 1969. Articles spoke to Los Siete's wide-ranging mission to educate the community about police brutality, Vietnam, and various other social movements across the nation and abroad. As Tomas Summers Sandoval wrote, "Whether at the local or global level, all of the newspaper's contents communicated a radical critique of power as it sought to inform and educate."[49] López recalled working on *Basta Ya!* as formative: "What happened is that I knew what I wanted to do as an artist. And I could work as an artist within the organization."[50] She could establish her political voice *and* use her artistic skills.

The Black Panther newspaper served as a model for *Basta Ya!* in aesthetic as well as political terms. López recalled, "We went over to Panther headquarters and saw how the Panthers laid out their newspaper, and I met Emory Douglas who is still one of my heroes." Trained in commercial design, Douglas reinvented *The Black Panther* newspaper with his dramatic layouts and powerful, often shocking images. Black Panther member Bobby Seale recalled how Emory turned their "Support Your Local Police" campaign into visual terms. According to Seale, "Emory took a drawing of a four-legged, snout-nosed hog and drew on it a police cap, a star-shaped badge, and a police utility belt complete with a revolver. When he showed us the layout, we were all flabbergasted with Emory's artistic abilities."[51] Mainstream media failed to acknowledge police brutality directed at the black community, but Douglas's art provided visual corroboration. He regularly included images in *The Black Panther* of pigs standing in police uniforms, with flies buzzing around their heads, either enacting violence or suffering violence at the hands of the most vulnerable (Fig. 4.1). Along with Black Panther songs and texts, Douglas's art popularly redefined

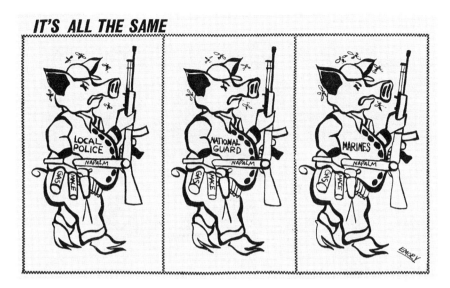

Figure 4.1. Emory Douglas, *It's All the Same*, newspaper graphic from the *Black Panther*, September 28, 1968. Emory Douglas / Artists Rights Society, New York.

police as pigs. His portrayals gradually evolved to show pigs as actors in all forms of state violence.[52]

López reveled in Douglas's "audacious" portrayals of the police as pigs. In particular, she recalled the shock of seeing Douglas turn even Santa Claus into a pig.[53] As Stew Albert remarked, "Emory's militant chutzpah peaked when he portrayed Santa Claus as a mean-looking pig."[54] The viciousness of Douglas's art inspired López to push herself to critically engage with sacred icons. She also understood Douglas's work in a larger context of social change. As the Black Panther minister of culture, Douglas sought to redress the lack of images of black Americans, especially poor black Americans, in the media.[55] His layouts prioritized people who were ordinarily invisible in the mainstream media. According to López, "One of my favorite pictures, too, is of him showing a black soldier from the head up in profile and his face is a collage of lynchings and killings of Vietnamese and sort of like the history of the black movement and slavery and all that in there, and then there's a tear coming out of one of his eyes."[56] López gravitated toward this overlapping of oppositional images and the ways that Douglas borrowed from constructivist aesthetics and other radical arts movements.

Liberated to transgress, López created one of her first posters for Los Siete. The *Free Los Siete* (1969) poster circulated widely as a result of its insertion in a fall 1969 edition of *Basta Ya!* and its subsequent use in various protests (Fig. 4.2).

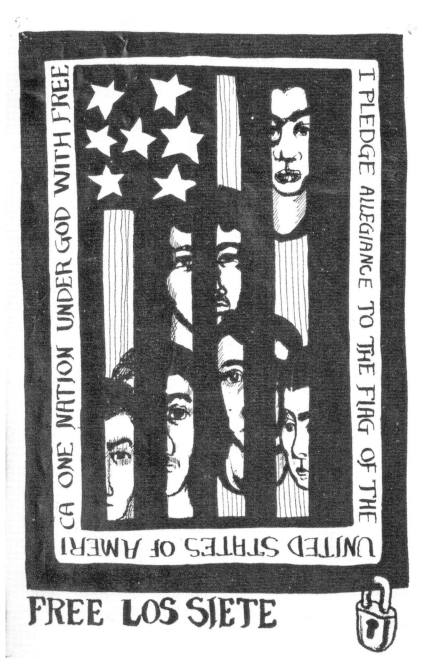

Figure 4.2. Yolanda M. López, *Free Los Siete*, fall 1969. Image courtesy of the artist.

The image also appeared on the front page of *Basta Ya!* just shortly after the poster's insertion.[57] The poster featured the faces of six men behind bars with the prison bars also serving as the stripes of the American flag. In place of the seventh face, who was literally missing from the courtroom, López recreated the banner's stars, but significantly numbered them as seven rather than fifty. The Pledge of Allegiance circled the flag, but the word "freedom" appeared cut in half. A padlock on the bottom right corner locked the men behind the bars and stars, blocking their access to rights and privileges. As Karen Mary Davalos observed, "Because the mass media portrayed the Latino defendants as 'hoodlums' and 'militants,' López was determined to examine the role and function of these images by offering new ones."[58] The work also expressed López's deep interest in representing cultural contradictions and playing with visual puns.[59]

For another issue of *Basta Ya!* López created a poster insert entitled *Libertad Para Los Siete* (1970) (Fig. 4.3). Various small homages to the Black Panthers, Diego Rivera, and the Cuban revolution illustrate the multiplicity of López's political interests. López adopted the collage technique to display a photograph of an empty lot backed by a line of Mission District houses. Her colleague, activist and layout artist Donna James, added "Viva Che" graffiti on the wall of the empty lot to amuse and provoke.[60] López incorporated a reclining figure in the bottom left as a homage to Diego Rivera's line-art images.[61] Though the image exposes the poverty of the neighborhood—lots do not sit empty in wealthy neighborhoods—the text reflects neighborhood pride—the poster's subtitle states, "Bring the Brothers Back Home to the Mission!" There is no need to translate the headline into English, or to translate the subhead into Spanish, since the two statements convey the same idea—freedom for "The Seven" meant a homecoming for the Mission. The Mission was where Los Siete belonged and a place people could call home.

On November 7, 1970, one year and six months after the shooting, the court acquitted the defendants of all charges. The announcement sparked cheers and a parade down Mission Street. The success of community organizing through the Third World Strike and Los Siete de la Raza proved that ordinary people could change the system. Though Los Siete only lasted a few years, its impact as an organization exemplified the ideological power of the Third World Strike.

Moreover, Los Siete played a significant role in the evolution of poster art in the Mission District. An informal poster workshop started in 1969 when the trial began. In 1970, La Raza Information Center opened next door to Los Siete and started producing silkscreen prints. As Sal Güereña notes, "Volunteers flowed between the La Raza Information Center and the 'Los Siete' Defense

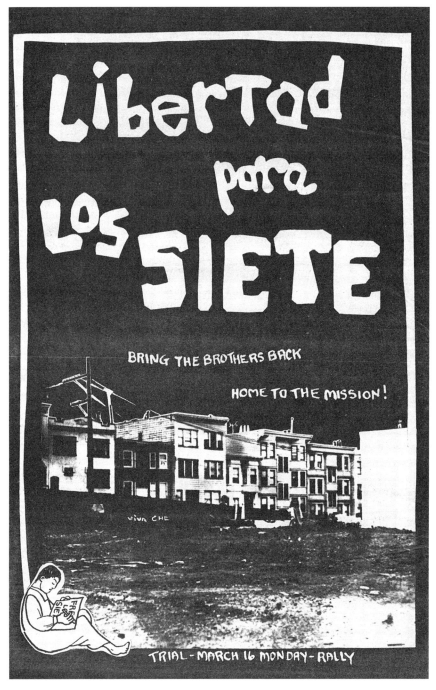

Figure 4.3. Yolanda M. López, *Libertad Para Los Siete: Bring the Brothers Back Home To the Mission!* 1970. Back page (page 12) of *Basta Ya!* Number 8, March 1970. Image courtesy of the artist and the Bloom Alternative Press Collection (Bloom 022), Archives and Special Collections, Amherst College Library.

Committee; the interior doors between the two storefronts were always open." Under the leadership of Al Borvice, Oscar Melara, Pete Gallegos, and Tomás Morales, the informal setup eventually evolved into La Raza Graphics Center, which produced hundreds of posters relating to local, national, and international concerns.[62]

López's work at *Basta Ya!* placed her at the forefront of Chicana printmaking. As Holly Barnet-Sanchez noted, "More Chicana printmakers were working in the 1980s and 1990s than during the earlier, more militant phase of the movement of the late 1960s through the mid-1970s."[63] López frequently encountered people expecting a male artist as the creator of her work. When Graciela Carrillo recruited López to participate in the first all-women's show at Galería de la Raza in 1970, she showed three of her newspaper pages. López recalled, "People were surprised to know that the *Basta Ya!* covers were done by a woman artist."[64] This experience contributed to López's consciousness raising as a feminist.[65]

López has characterized herself as a "provocateur," using the words and images of everyday life to illustrate power, gender, and race. For example, her well-known 1978 triptych of herself, her mother, and her grandmother as the Virgin of Guadalupe emerged out of her desire to question and redefine the boundaries of a powerful and restrictive cultural icon (Plate 5). In her self-portrait, she is an athlete, rebelliously baring her long legs and jumping off a pedestal. While traditional representations showed the Virgin as immobile, with her body fully cloaked and her feet invisible under layers of fabric, López's self-representation jumps off the paper, holding a cape in one hand and serpent in the other. Her tennis shoe squashes the wing of the angel that traditionally held the virgin in place. Although some considered the triptych, many responded enthusiastically to López's empowering redefinition of a sacred icon. López recollected this series as "one of the first systematic efforts on my part to explore the presentation of Raza women as we see ourselves."[66]

López created this influential work while attending graduate school in San Diego in the late 1970s, but then returned to the Mission District and partnered with fellow artist René Yañez. In the 1980s, fully ensconced in San Francisco's Latino arts community, López continued to play with self-representation. Her 1985 drawing *Taking It Off and Getting It On: Unity with the Women of Central America* captures some of the ambivalence of her international self at a time when the United States was supporting brutal political regimes in Central America (Fig. 4.4).[67] Depicting a woman holding a mask above her head, the image reflects a woman caught between her identity as an American and as a Third World woman, framed by bombs and guns on one side, and flowers and houses on the

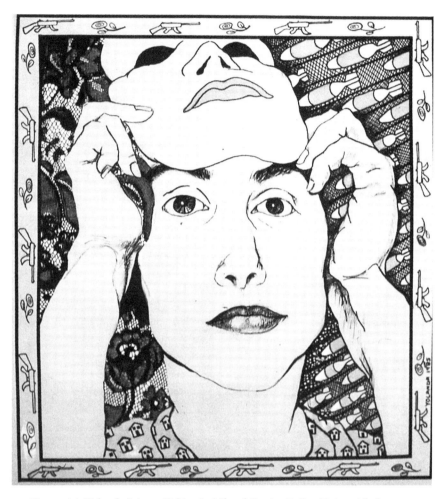

Figure 4.4. Yolanda López, *Taking It Off and Getting It On: Unity with the Women of Central America*, 1985, pen and ink on paper, 12 × 16 inches. This image appeared on the cover of the March 1985 issue of *El Tecolote* as part of a "Women's Day Supplement." Image courtesy of the artist.

other. López represents herself as the battleground of dueling forces. The image captures the irresolvable ambiguity and complexity of her identity as a Chicana, a Latina, an American, and a woman of color in the context of global events.

Though the Third World Strike was just one event in López's life, the experience contributed to an intellectual trajectory critical of labels and dedicated to deconstructing visual culture. Urging others to share in her critical gaze,

Figure 4.5. Yolanda M. López, installation photograph from the exhibition "Cactus Hearts/Barbed Wire Dreams" at Galería de la Raza from September 6 through October 1, 1988. Image courtesy of the artist.

López assembled a series of popular and troubling representations of Mexican culture for her 1988 exhibition, "Cactus Hearts Barbed Wire Dreams: Media Myths and Mexicans," at Galería de la Raza (Fig. 4.5). She culled together many of the materials while making her short film *When You Think of Mexico: Commercial Images of Mexicans* (1986). On one exhibit wall, she hung clothes and advertisements laden with images of sombreros and cacti above the text, "Things I never told my son about being a Mexican." In the foreground she presented a large taco sculpture decorated with commercialized foods, such as nacho cheese chips and Mexicola soda. Another wall featured romanticized depictions of men in sombreros and the next room included a cut-out human figure with his hands behind his head, as if under arrest. Together, these objects conveyed widely accepted, vastly negative constructions of Mexican culture. With all of this López advocated, "We need to become visually literate and by extension critical."[68] This sensibility evolved alongside her various experiences with the Black Panthers, the Chicano movement, Third World movements, Central American solidarity movements, and in San Francisco's Latino arts community. Over the course of her career, her art has played on expectations and

stereotypes that have shaped human interactions, deconstructing visual culture in order to show the dynamics of power.[69]

Rupert García and Human Rights, Abroad and at Home

While López swiftly gravitated to the energy of the strike, Rupert García initially kept his distance. García's experience as a soldier in Vietnam had stirred his political consciousness, but his veteran status kept him isolated from other students. Born in French Camp in 1941 and raised in nearby Stockton, García enlisted in the United States Air Force in 1962. As art historian Peter Selz noted, "While in the Air Force in Southeast Asia [García] had thought that he was helping to protect the world from communism. Now in San Francisco he witnessed peace demonstrations and the growing movement of protest."[70] Given the antiwar sentiments of most students, García kept his experience as a veteran "very, very inside."[71]

As García's recollections make clear, his radical environs made him doubly conscious of how culture was propagated: "When I come back from the military in '66 and go to San Francisco State, that moment of international protest brings clear to me that art and society and politics are not mutually exclusive, but we have been told that they are, and we were told that for political reasons. Political reasons. And that really gets me thinking systematically about looking at society, looking at culture, looking at history, and the various bodies of knowledge that try to explain human behavior and thought. I began to look at those with a more critical eye, whereas earlier I did not."[72] García's new outlook prompted him to respond more critically to his training as an artist. His teacher's pervasive emphasis on Western art history and the absence of any recognition of Third World art led him to rebel:

> I stand up and I criticize the instructor, I criticize the material, and I say, "Here we are talking about this art history and its culture and how important it is and how some of the artists were critical. Outside the door of this art building there are students doing the very same thing about which we are studying. So what do we do? Do we just sit on our asses here? Or do we go out and participate in this important 'decolonial situation'?" So I said, "Let's go!" [laughs] "Let's get out of here and go out there." And so some students come and some don't. I have no idea who came and I have no idea who didn't. But I know I went out.[73]

García did not belong to any organization associated with the strike but, like others, he incorporated and acted on the ideals of decolonization. His art

expanded on this new perspective. García began his silk-screening career during the strike, partly inspired by the success of poster-making for the May 1968 general strike in France. According to García "Some students and a few faculty became inspired and intensely involved in producing silkscreened posters in support of the student strike. We eventually began selling the many posters made. The money was used as bail."[74]

As Jean Franco noted of García, "Participation in the [Third World] movement was more than a mere episode in his life for it profoundly altered his view of the function of art."[75] The moment was a turning point for García, who felt that "in '68 there was this moment, not only in Paris in May, and in Mexico, but also at San Francisco State and other moments in our country, too, on the various campuses. So that '68 is the moment that I really began to . . . pinpoint what I think I want to do. And to make connections with things that I used to think were separate."[76] García's perception of his role as an artist was intimately connected with his sense of belonging to an expansive community well beyond the physical boundaries of the United States.

One of García's earliest posters is an image of Che Guevara—a lithograph rendering of Alberto Korda's famous 1960 photograph of the communist revolutionary—with the text "Right On!" printed underneath (Fig. 4.6).[77] The 1968 poster joins the efforts of student activists at San Francisco State with the ideals of the Cuban revolution and reflects the ways in which students of color sought other political models to challenge the status quo. García's depiction of a communist revolutionary as an idealized leader was an obvious political statement, but García's politics defied easy characterization. According to García, "I didn't necessarily subscribe to a structured ideology. You know, no particular line did I subscribe to. I wasn't CPUSA [Communist Party USA]. I wasn't Progressive Labor Party, not an official member of the TWLF. And they were all there. But I was just interested in what's going on."[78]

García avoided dogma, but over time, his work came to reflect his politics. As Ramón Favela noted, "By the time he created the brilliant and densely colored pastel portrait *Mao* (1977), his position was obvious."[79] Some critics automatically labeled García a Marxist, but he rejected such categorization. According to García, "I'm not a Marxist. There are Marxian perspectives that one can have without being a Marxist with a capital 'M'. So I am molding a point of view that is shared in different ways with other groups."[80] García sifted through the writings of Marx, Mao, Guevara, and other socialist and communist revolutionaries in order to build his own left perspective on the world. García recalled first reading Mao's essay "On Art and Literature" while teaching at San Francisco State in 1969: "I had never before read such an acute analysis of the socio-political responsibility of the artist to society."[81] The article synthesized García's interest

Figure 4.6. Rupert García, *Right On!* 1968, lithograph, 26 × 20 inches. Reproduction provided by Fine Arts Museums of San Francisco. Gift of Mr. and Mrs. Robert Marcus. Image courtesy of the artist and the Rena Bransten Gallery.

in producing art with a purpose. Though not declarative of a single political position, García's images reflect his general advocacy for human rights, his desire to identify and overturn racism, and his interest in redistributing wealth.

In 1970, García allowed himself to speak out against the war he had witnessed firsthand. He created the silkscreen *¡Fuera de Indochina!* (Fig. 4.7) for the Chicano moratorium against the Vietnam War in East Los Angeles on August 29, 1970.[82] The close-up of a Vietnamese woman's face screaming "*¡Fuera de Indochina!*" (Get out of Indochina!) clearly communicates opposition to U.S. intervention. The decision to have the woman speak in Spanish, not English, underscores García's intent to deliver a specifically Chicano antiwar perspective. Her use of the term *Indochina*, rather than *Vietnam*, emphasizes the long history of Western colonialism in the area. As the work of a Vietnam veteran, the image also documents García's dramatic shift from soldier to protestor.

Figure 4.7. Rupert García, *¡Fuera de Indochina!* 1970, silkscreen on white wove paper, 24 × 18 inches. Reproduction provided by Fine Arts Museums of San Francisco. Gift of Mr. and Mrs. Robert Marcus. Image courtesy of the artist and the Rena Bransten Gallery.

García's recollections suggest that he never felt happy in the military—in fact, he looked back on his enlistment as a mistake—but the dramatic change in his outlook indicates how place and culture can alter perception. When he first learned about the antiwar movement while stationed in Vietnam, García felt, "for my own well-being, how dare somebody question me being here. Having my life on the line twenty-four hours a day and some son-of-a-bitch back in the United States drinking coffee, just protesting. . . . I said, 'You go shoot 'em. That'll teach 'em.' "[83] Ultimately, however, as García pursued his education at San Francisco State, he felt betrayed: "I learned, 'Well, God damn, I had been duped into believing all this stuff about the Communist[s].' All that stuff comes out and I'm very disappointed, very upset, and very angry about how I, in particular, was led to believe that what I'm doing is the right thing to do—is in fact propaganda. And, man, you know, that's an eye-opener for a young man who had just come back a few months ago."[84]

In confronting his experience in Vietnam, García cast a critical eye upon the world as a whole. Contemplating the manipulations of Cold War politics, the racial segregation of his upbringing in Stockton, and the pervasive acceptance of social inequality and violence around the globe led García to question his assumptions. The world became both more complex and more accessible: "Some mysteries were demystified, and the world became such that I could reach out to it and grab it and do something with it."[85]

Since 1968, García's work maintained a steady vision of global solidarity for human rights. In 1977, he stated, "The Chicano expression and struggle is not

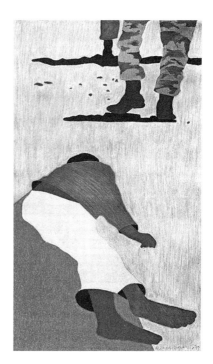

Figure 4.8. Rupert García, *Mexico, Chile, Soweto . . .* , 1977, pastel on paper, 51 × 36 inches. Image courtesy of the artist and the Rena Bransten Gallery.

divorced from other art, people or universal conflict. Our fight for freedom and human dignity is part of the struggles for freedom in Africa, Latin America, Indo-China and the Middle East."[86] An image from 1977, *Mexico, Chile, Soweto . . .* (Fig. 4.8) perfectly captures his understanding of parallel human struggles around the globe. The pastel on paper illustration, appropriated from a U.S. Spanish-language newspaper, depicts a beaten and bloody civilian corpse next to a standing soldier, represented only by combat boots and fatigues.[87] The title forces the viewer to contemplate the parallel forms of violence enacted in Mexico, Chile, Soweto, and elsewhere, and admonishes the viewer for acceptance of these images in mass media without action.

García culled most of his images from published sources. He stated, "As far as I can remember, I have always been interested in referring to images that already have built-in to them an audience, be it thousands who look at the photographic reproduction in the *San Francisco Examiner*, be it millions who see it in *Time* magazine."[88] His poster of Angela Davis (Fig. 4.9) came out of his desire to criticize her imprisonment on conspiracy charges for an alleged attempt to free the Soledad brothers. García stated, "Being a Chicano, and developing an understanding of the common struggle of Third World and other oppressed peoples, I supported her." He located a photograph of Davis in a news-

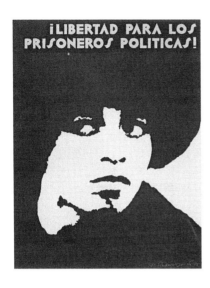

Figure 4.9. Rupert García, *¡Libertad para los Prisoneros Politicas!* 1971. Reproduction provided by Fine Arts Museums of San Francisco. Gift of Mr. and Mrs. Robert Marcus. Image courtesy of the artist and the Rena Bransten Gallery.

paper that "seemed to have the quality I wanted." He enlarged and simplified the image to produce his 1971 three-color silkscreen of Davis in brown and sienna, with the Spanish-language headline in peacock blue, *¡Libertad Para Los Prisoneros Politicas!* (Freedom for Political Prisoners!). García said, "I used Spanish to express international solidarity between Black and Raza peoples, and the solidarity with our struggling comrades in Latin America. At the time, I recall thinking especially of the Cubans and their struggles."[89]

Rupert García prioritized building a Third World identity through his art. He said, "I didn't feel the necessity to, in a sense, emphasize my Mexican heritage. It was always there and I always felt comfortable with it and so my concern was something other than that. It was more concerned with the situation of Third World people. . . . What it means to be a Chicano, in the '60s, was very important for me, philosophically. . . . But not necessarily the production of the images."[90] His 1969 silkscreen *DDT* is an example of a poster inspired by the concerns of the Chicano movement, most prominently espoused by the United Farm Workers (UFW), but reckoning with the impact of a chemical with global repercussions. Below the giant letters DDT is a comparatively small portrait of a little girl, who stands with mouth agape in a silent scream, her body deformed, without arms. The graphic visual displays the physical destructiveness and painfulness of the chemical. No other text is necessary and no reference to the UFW is included. The work condemns anyone who supports the use of DDT.[91] García did not turn away from his Chicano identity, but rather sought to illustrate the many global identities that disseminated from that experience.

García's work integrates iconic symbols of Chicano identity—images of Emiliano Zapata, Frida Kahlo, and the maguey plant—with a larger Raza or Third World iconography, including images of Davis, Guevara, and political prisoners at home and abroad. Many scholars have noted that the Chicano movement inspired a visual language of Chicano art, a language that Rupert García knew well. In 1977, García declared, "The images often used by Chicanos are unique to them because of their particular history. We use the *calavera* [skeleton], the *corazón* [heart], jalapeños, the *Pachuco*, the farmworker, lowriders, *pintos-pintas* [convicts], *Virgen de Gudadalupe,* nopales."[92] García made ready use of these images. At the same time, he sought new sources and felt a deep affinity with the Black Power movement.

Several of his early posters conveyed his support of the Black Panthers. FBI Director J. Edgar Hoover's 1968 declaration that the Black Panthers were "the greatest threat to the internal security of the country" tended to fall on deaf ears among artists and activists of color, particularly in the Bay Area where the Black Panthers originated.[93] García's *Down with the Whiteness* (1969) depicts a member of the Black Panther Party with both fists in the air (Plate 6). Few details of the figure can be distinguished beyond the dark glasses, the beret, and the symbolic power salute. Counter-balancing the image is the provocative text, "Down with the Whiteness." The call is not against "whites," but against "the Whiteness," a more ambiguous term. The poster does not invoke reverse racism, but demands an end to institutionalized social hierarchies cultivated through racist practices. García's construction of Black Panther politics does not affirm militant racial separatism, but points to a more complex ideological position targeting whiteness as a power structure to be identified and deconstructed.

Poster-making developed García's voice; his move from painting to poster-making was also a political necessity. As he later recalled, "I don't know if I was at the point where I was exposed to the notions of easel painting being bourgeois yet. . . . But painting seemed to be impractical. It seemed to be ineffective at the moment. And so I just stopped painting."[94] As someone trained in classical art history, García understood the lesser reputation of poster-making and ultimately discarded this elitism. He turned to posters for their immediacy, accessibility, and relevance. As García pointed out, "In some instances, the poster is the only document existing as a record that the event took place. When making a poster, I sometimes become conscious of this and am reminded of my responsibility to be accurate."[95] Every image, regardless of the depicted ethnic communities, carries an implicit call for justice. As an artist, his work is not defined by his Chicano identity, though that consciousness was part of his inspiration. For García, "What began as a moment of artistic expedience in the context of the strike in 1968 becomes a turning point for my sensibility as an

artist."[96] As Angela Davis noted, "Many who have been historically excluded from portraiture find their place in his work."[97]

His work found supporters in the Mission District, if not in other institutional frameworks. In June 1970, Artes 6, the initial incarnation of Galería de la Raza, gave García his first solo show. "I consciously decided to have my master's show at Artes Seis in 1970. Because I wanted to demonstrate that the art that I made can be shown anywhere . . . and I want to show it now in Artes Seis because I want to make a statement. And the statement is that, 'At this moment I'm working with these artists in the Mission District and what I'm doing is a political gesture.' "[98] The exhibit featured all the posters García had created for the Third World Strike and fulfilled the requirements of his master's degree from San Francisco State College, though, according to García, "not one faculty member from the art department came to the show."[99]

The Oakland Museum later reconstituted García's show alongside a group show of Raza art. The curators at the museum revealed their discomfort with the political content of García's work when they removed the *Down with the Whiteness* poster from the exhibition. A reporter from *El Tecolote* noted, "The directors made it a point to attach a statement with Rupert's show that said the 'works are solely the opinions of the artist and not of the museum."[100] Though museum administrators distanced themselves from García's politics, curators still were drawn to his aesthetics. Upon the 1977 showing of García's work at the San Francisco Museum of Modern Art, fellow artist and poet José Montoya wrote with anger, "that came about simply because it would prove too embarrassing to deny him access."[101]

Part of García's acclaim as an artist resulted from how his work gelled with the aesthetics of pop art. San Francisco art critic Alfred Frankenstein wrote in 1978, "Rupert García may well be the only designer of political posters in the Bay Region whose work deserves exhibition in an art museum."[102] The "bright, bold, and flat shapes of unmodulated color" that García created echoed the graphic design of Andy Warhol and Roy Lichtenstein.[103] García admitted, "When I did some reading and critiquing of Pop Art I did embrace and enfold into my work some of their issues, and that also determines how my art looks."[104] As Selz observed, García "was drawn to the pictorial dislocation in space in the work of R. B. Kitaj and was impressed by the painting of James Rosenquist in particular and pop art in general."[105] Moreover, García's willingness to refer to his use of media images as "readymades" effectively stated his alliance with Marcel Duchamp and delineated his debt to Dadaism.[106] García's appreciation for diverse art forms gave him the capacity to contextualize his work in accordance with the theories guarding the interiors of museums and galleries.

The overt political engagement of García's art broke with the chic stylistics of pop art. While Warhol proposed that a can of soup could be art and Lichtenstein deconstructed a printed comic as a collection of dots, García crafted images of the UFW and the Black Panthers, leading critic Thomas Albright to categorize García as a "radical political portraitist" as opposed to a "Pop Art poster artist."[107] Favela noted that García "appropriated the pictorial devices and premises of pop art and subverted them from a Chicano and Third World perspective to serve his aesthetic and ideological ends, which were very different from the cool detachment and politically disengaged 'neutrality' of Anglo-American pop artists and their legacy, the contemporary post-pop 'image scavengers.'"[108] In essence, García reapplied contemporary graphic design and aesthetics to his political sensibility, which also has meant that his art is still more likely to appear in a Chicano art exhibition than in a pop art exhibition.

García and his art landed firmly in the Mission District. García began teaching silk-screening at the Artes 6 gallery, where he served as a mentor to his friend Ralph Maradiaga and established friendships with other Mission District artists, including Francisco Camplís and René Yañez. Consequently, he became one of the many founding members of Galería de la Raza. For García, Artes 6 was "the cultural instrument that connects me with not only Camplís, but also many other artists in the Mission District (as well as others), and how we become a part of a cultural force along with Carlos Santana and other musicians and cultural producers. We were all part of this large group. I mean, we were not buddies; we were all part of this contextual moment—which must be seen, by the way, in the light of the Chicano-Latino civil rights and cultural . . . what we called a renaissance."[109]

Parallel to Yolanda López, Rupert García's aesthetic trajectory showed how the Third World Strike helped shape the art and politics of Mission District cultural workers. These artists used their art to politicize and mobilize the community. Whether the community mobilized or not, these artists laid the groundwork for a cultural renaissance grounded in Third World politics. García made change as one of the first Chicanos hired to teach in San Francisco State's art department, as an academic who sought to document the history and significance of Chicano art, and as a mentor for many in the community, including his student and later roommate Juan Fuentes. As a prominently recognized artist, García hoped to spark in others the critical outlook that first came to him in 1968.

Juan Fuentes and the New Left

Juan Fuentes was born in Artesia, New Mexico, in 1950. However, he grew up in California's Salinas Valley, where he and his ten siblings worked alongside

their parents in the fields.[110] Gradually, they acquired a sharecropper's house in Watsonville, but their financial situation always felt precarious. When his father died in 1958, Juan was only eight years old. As he recalled, "Everybody said it was just asthma. But now, looking back . . . it had to have been from all that exposure to all those pesticides and stuff that they were spraying."[111] His family managed to scrape by with the earnings of his older brothers and sisters.

On completing high school in 1969, Fuentes presumed he was bound to work in the canneries, the military, or a trade. As he recalled, "The high school that I went to—they had this system where they classified students into X, Y, and Z. And unless you were in the Y division, or the X division . . . you were not going to be college bound."[112] Attending college, much less becoming an artist, seemed unlikely. Nor did Fuentes imagine he might benefit from any pending social change: "I wasn't really that aware of the importance of the civil rights movement or the Chicano movement or the black power struggle."[113]

Fuentes's acceptance at San Francisco State in 1969 as part of the mass recruitment of students of color catalyzed a shift in his consciousness. As he put it, "I had seen injustices and I had already experienced poverty, and I had lived under it, so it wasn't really that big of a step for me to figure out, well, wait a minute, who's the oppressed and who's the oppressor."[114] Fuentes's experience was critical to developing his "oppositional consciousness"—what Jane Mansbridge described as "an empowering mental state that prepares members of an oppressed group to act to undermine, reform, or overthrow a system of human domination."[115] Not only did the Third World Strike indirectly propel Fuentes onto a new career path as a student and an artist, it solidified his determination to speak for others.

While his high school training left him woefully unprepared for college academics, Fuentes worked hard to catch up and gravitated to people who could help him advance, many in the new School of Ethnic Studies. Up until that point, Fuentes had never identified himself as a Chicano. "I was just Mexicano—I was always Mexican—that's how I was raised." Fuentes recalled, "But there were people that I met there, Chicanos that I met there for the first time . . . from Stockton, Sacramento, Salinas, Pittsburg, Visalia—I mean just different places. And it was some of those students that came from those areas that really introduced me to even the farm workers struggle, which I wasn't aware of. Even coming from an agricultural place. . . . We just didn't have any exposure to any of that.[116]

For Fuentes, his time at San Francisco State awakened him to the institutional structures that defined his childhood. Encounters with people like himself from all over the state expanded the scope of his personal experience and solidified his decision to identify as a Chicano. He said, "I still basically refer

to myself as Chicano because it has political implications in that it also places me in a certain context of Americanism that is connected to a social movement that happened at a particular time in history to Mexican Americans."[117]

However, in San Francisco, he not only came to understand himself as Chicano, but as Latino: "When I came to San Francisco State, even though I was around a lot of my friends at school—the community itself, the San Francisco community was very isolating for me. . . . And the Mission was the one place where I actually felt like I had a community and I had a family. And I felt comfortable. And also, it was an education for me because I didn't know what a Nicaraguan was, or a Salvadoran was, or a Costa Rican, and those flavors and those kind of people." The experience of living in San Francisco and attending San Francisco State catalyzed a new consciousness of parallel communities and concerns. As Fuentes said, "It was interesting to me . . . to even consider myself a Latino because I didn't know what a Latino was either. Until I got to the Mission and started to understand what Latino was and what Latin America meant."[118]

Spending time in San Francisco and attending San Francisco State launched Fuentes on an educational journey that intimately linked his development as an artist with his understanding of himself as a Chicano, a Latino, a Third World person of color, and a member of the Left. As Fuentes said, "I did posters around the Vietnam War, I did stuff for all the farm workers, I did posters for the Nicaraguan struggle, the Salvadoran struggle, the Native American struggle, [and] South Africa." For Fuentes, all of these concerns belonged together as part of a globally oriented, Left-identified political movement. Fuentes stated, "It was actually a social movement, a Left social movement, and I was real active in it."[119] His poster for the July 4, 1976 rally partly captures his multiple alliances (Fig. 4.10). The dominant image incorporates a visual of nine defiant multiethnic faces, all blending into a single group, to march "in struggle" through the Mission on the day of the U.S. bicentennial. Rather than celebrate the nation's independence, Fuentes depicts a multiethnic call to action. Inspired by his education in and outside the classroom, Fuentes channeled his art into his political vision for a just universe, largely in parallel with struggles of an international Left social movement.

As an artist, Fuentes challenges the culture that had depoliticized his youth. "I really make a conscious effort to depict people of color in a really positive and empowering or strong manner. Only because it's not what we see in everyday American society or life."[120] Michael Denning wrote, "For a generation of New Left thinkers around the globe, the issue of culture was not simply the fact of the existence of the new technologies of mass information and communication, but the reshaping of the everyday lives and struggles of subaltern classes and peoples by those new forms."[121] While Denning's observation posits a view of

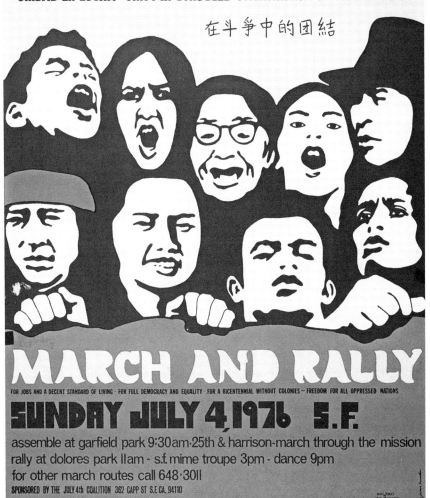

Figure 4.10. Juan Fuentes, *July 4, 1976*. Lithograph, 21 × 16 inches. Reproduction courtesy of Lincoln Cushing / Docs Populi. Image courtesy of the artist.

technology happening to marginalized communities, Fuentes's experience indicates ways that "the subaltern" appropriated the printing press and countered mass culture.

However, the act of becoming an artist was elusive. Neither his family nor his educators offered encouragement. The high school tracking system ignored his interest: "The only classes that they would allow me to take were metal shop, auto mechanics, or wood shop. . . . I'm really good with woodworking tools."[122] Moreover, family, friends, and Fuentes himself had difficulty imagining the relevance of art beyond the practical aspects of everyday handicrafts. Yet he found himself drawn to study art at San Francisco State. He described his entrée this way: "I walked into the art department one day. . . . People were printmaking, people were painting, people were drawing, people were doing ceramics. . . . They were making rugs or weavings. . . . 'Wow, they're making all this stuff by hand.' My mom does this stuff, and my grandmother makes this stuff. So, I took an introductory art class by this professor named Ralph Putzker, and he just totally opened up my mind and eyes to seeing the world in a different way through art."[123]

Though the experience recalled his childhood, it also placed creative activities in a new context. Putzker, well known for his teaching, helped catapult Fuentes (and López) into life as an artist.[124] Soon thereafter, Fuentes enrolled in more art classes, though not without obstacles. Not immediately declaring himself an art major and with no seniority, he discovered he was either barred or unable to obtain his desired classes:

> I knew there were certain classes that I was not going to be able to get. Because the priority was for juniors and seniors. . . . And it was a result of the liberation struggles that were going on—Chicano Studies, the Chicano movement, the Black Power Struggle—that I could walk to the front of that line, and none of those white kids were going to tell me anything. And I dared them to tell me anything. And they didn't. And I took my classes. And that's how I was able to do it. Because they were afraid of me, to tell you the truth.[125]

Fuentes also found two significant role models: García, one of his first art professors, and Malaquías Montoya, who produced posters for the Chicano movement and TWLF at UC Berkeley, provided intellectual and aesthetic inspiration. "They were sort of my mentors in terms of learning how to do the art work and *why* we were doing the art work. It was really connected to trying to advance community issues."[126]

In addition, a 1973 trip to Cuba with the Venceremos Brigade played a formative role in his appreciation for the relationship between social equity and art "because at that point . . . I really couldn't quite figure out where my art was going to—how it was going to be used, or how I was going to be able to survive with it. . . . But going to Cuba . . . I actually saw the work integrated into society in a lot of different ways."[127] The experience led Fuentes to cocurate a Cuban poster exhibition at the California Palace of the Legion of Honor and coproduce a television program the following year with Susan Adelman.[128]

Fuentes graduated from San Francisco State in 1974 with a new sense of purpose: "I started doing posters as a way to basically try to give something back to the community."[129] His community interests encouraged his orientation toward the Mission District. Over the course of the 1970s and 1980s, Fuentes held multiple jobs in the Mission, including working as a volunteer for *El Tecolote*, working for the Mission campus of City College, and working for the community-oriented silkscreen centers La Raza Graphics and Mission Gráfica.[130]

When Fuentes became director of Mission Gráfica, he hoped to model the organization along the lines of a Latin American *taller*, or arts workshop, where future artists could train and produce work for the community.[131] Mission Gráfica images reflect the international perspective of its artists in content, exhibitions, and cultural exchange. As Chilean artist René Castro pointed out, "Artists from all over the world have been . . . especially welcomed by Mission Gráfica, and have left their graphic imprint that adorns the multicolored tapestry of one of the most fascinating portfolios generated in our artistic community."[132] Jos Sances added, "But always our primary allegiance was to the community and political organizations we served. Gráfica had deep connections to liberation struggles throughout the world."[133] As a place that trained hundreds of artists in the arts of silk-screening, screen-printing, etching, mono-printing, and woodblock-printing, Mission Gráfica maps a complex transnational exchange of visual culture and politics.

Fuentes explained his trajectory as follows: "A concept that came out of San Francisco State and Third World ethnic studies . . . was 'go into your community and help empower your community by creating resources for it. So be a teacher in your community, be a doctor in your community, be an artist in your community.' That concept really stuck with me. And that was coming out of San Francisco State."[134] Of course, this concept was not only coming out of San Francisco State. Certainly, President John F. Kennedy's famous statement "Ask not what your country can do for you—ask what you can do for your country" carried some weight in this cultural milieu.[135] However, for Fuentes and many

others, Third World organizing reframed the mission away from the nation and toward global communities.

Fuentes's work appropriated many of the dialogues shaping U.S.–Third World politics, most obviously redistributing wealth, eliminating racism, and empowering people of color. In the 1970s, Fuentes began perfecting his black-and-white pencil drawings, several of which were reproduced in *El Tecolote,* which often criticized life in the United States by highlighting alternative political regimes abroad. In *Viva Vietnam* (1975) Fuentes celebrates the military victory of communism in Vietnam through his cheerful depiction of communist leader Ho Chi Minh and a smiling Vietnamese soldier (Fig. 4.11). Applauding the government in Vietnam invited controversy in the United States. For Fuentes, Vietnam's victory challenged American cultural and economic imperialism.[136]

Similarly, his graphic *El 26 de Julio* (1976) supports the Cuban revolution through its depiction of Fidel Castro's first failed attempt to overthrow the Cuban government in 1953 (Fig. 4.12). He divides the image in two, with the body of a male rebel dead and bleeding on the left, while a female rebel stares out from behind prison bars on the right. The image is meant to secure the sympathies of the viewer for the rebels by documenting the brutality of Fulgencio Batista's regime. Marifeli Pérez-Stable wrote of the July 26 uprising: "The nation was horrified by the governmental repression and moved by the daring, if reckless, action of the young Cubans."[137] During his trial, Fidel Castro famously declared, "Condemn me, it does not matter. History will absolve me!" Fuentes's

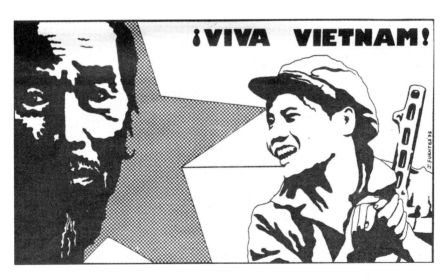

Figure 4.11. Juan Fuentes, *Viva Vietnam*, newspaper graphic, *El Tecolote,* May 28, 1975. Image courtesy of the artist and Acción Latina / *El Tecolote.*

Figure 4.12. Juan Fuentes, *El 26 de Julio*, newspaper graphic, *El Tecolote*, July 1976. Image courtesy of the artist and Acción Latina / *El Tecolote*.

image captured a turning point in Cuban history, which culminated in the 1959 communist revolution. To emphasize the point, a short article accompanied Fuentes's image, notably not translated into English: *"El 26 de Julio es la fecha histórica que señala a America Latina el camino hacia su completa liberación e independencia del imperialismo Yanqui y el principio de un nuevo mundo fundado en el Socialismo, en una sociedad basada en la dignidad human y el respeto a la vida."* (July 26 is the historical moment that teaches Latin America the path toward complete liberation and independence from Yankee imperialism and the beginning of a new world founded in socialism, a society based on human dignity and respect for human life.)[138]

Fuentes's controversial homage to the Cuban revolution appeared in *El Tecolote* just as the United States celebrated its July 1976 bicentennial. *El Tecolote* editor Juan Gonzales, another Third World Strike alum, took the opportunity to reflect on the nation's celebration. "200 years of 'Progress,'" a set of short, critical articles, raised questions about social inequalities in the Mission. Asking, "What do we have to celebrate about?" Gonzales cited the Mission District's 16 percent unemployment rate (11 percent for the city), with 22 percent of the population living well below federal poverty levels, and less than 12 percent of Latinos over age twenty-five having a college education.[139] Growing upheaval and violence in Nicaragua, El Salvador, and Guatemala spurred new migrants to the Mission and signaled more change for the community.[140]

In 1982, Fuentes and Regina Mouton participated in the Galería de la Raza's "Progress in Process" exhibition, a high-profile program designed to show the Mission District community how artists work. According to curator Tim Drescher, "Everyone was free to come in and look and talk with the artists as they worked."[141] Fuentes and Mouton created a painting entitled *The Last Supper* (Plate 7). The image showed the smiling, well-dressed, military elite of Latin America sitting in front of a banquet of food and drink, while three scantily clad bodies sprawled before them, having bled to death. Of the painting, Fuentes stated, this is "the last supper for this class of people in Latin American and throughout the world. They represent death. The kids are in color because they represent a future culture, even though they are dead."[142] The painting is at once both dark and hopeful. While the artists attempted to give agency to the victims by presenting them in color, they are nonetheless disempowered by greed. The painting demands an empathetic response from viewers—it is a call to action to prevent this perpetual violence. The fact that Fuentes and Mouton created the work inside the Galería de la Raza, while working alongside other artists, and in conversation with nearby residents and visitors, reflects the participatory culture of the artists' community. The exhibition demonstrated how the artists drew from their environs, but also projected a political vision for the Mission. The image is especially striking considering how Fuentes grew up working in the fields of rural California. His formal and informal education at San Francisco State launched a radical redefinition of himself in the world, aided by global travels, and life in the Mission.

A Lasting Influence

The development of Fuentes's art showed a remarkable transformation from his experience growing up politically isolated in rural California to living as an artist committed to world affairs from a Left perspective. López and García experienced similarly complex transformations in their outlooks on the world. Part of their development stemmed from their varied connections to the Third World Strike. The event reframed how they defined their political and cultural communities. The strike magnified their consciousness of international struggles, and their art continues to bear the mark of this critical event.

The Third World Strike launched the field of ethnic studies across the nation and encouraged the incorporation of more people of color in U.S. education, both in terms of admissions and curriculum. As the longest student strike in U.S. history, the event is filmic and deserving of more scholarship and study. Those that do study this history understandably focus on the many facts leading up to

and through the strike. The stories of these three artists illustrate how the ram-
ifications of the strike persisted in even more profound and abstract ways.

Activists in San Francisco saw correlations between local and global events
that fundamentally shaped their activities and their art. The Third World Strike
was hardly the only event changing their perspectives. The event was emblem-
atic of a cultural shift, as youth of the 1960s and 1970s aspired to understand
themselves in a global context. While Latino artists turned their attention to
the Mission, their activism and art maintained an internationalist Third World
politics. This vision of the world contributed to the politics of the community
mural movement, to the community organizing for Nicaragua and El Salvador,
and to the spirit of a Latino arts movement in the Mission. For Latino artists
after the strike, part of their mission became the Mission. They turned to that
neighborhood determined to make art and make change.

Chapter 5

Hombres y Mujeres Muralistas on a Mission: Painting Latino Identities in 1970s San Francisco

Reflecting on the mid-1970s, writer Alejandro Murguía described how San Francisco's Mission District "teemed with painters, muralists, poets, and musicians, even the occasional politico or community organizer who acted beyond the rhetoric and actually accomplished something. . . . We had no problem being understood because La Mission was a microcosm of Latin America, and the whole barrio seemed in perfect sync."[1] Murguía's words expressed the neighborhood's romance, though not everything was in sync.

Like many poor urban neighborhoods in the 1970s, the Mission District struggled with development and inner-city neglect. By 1976, nearly half of 260 American cities with more than 50,000 people were experiencing some form of gentrification.[2] In the Mission and elsewhere, the pervasive threat of displacement through development spurred activist responses. Artists turned to murals to invoke community identity and save the landscape from outsider interests, local speculators, crime, and neglect.

Murals as tools to counter displacement gained credibility when William Walker and a group of twenty other artists painted the "Wall of Respect" in Chicago in 1967. The tribute to African American culture in the middle of the blighted South Side barely survived five years; however, community rallies that prevented at least two demolition attempts demonstrated how murals could visually express resistance and territorialize space.[3] As Chicago muralist John Pitman Weber described, community murals "assert moral claims to public space, claims concerning the history, identity, and possible future of the surrounding area."[4]

In the early 1970s, murals physically and psychically transformed the Mission District's landscape and became part of what defined the neighborhood.[5] Interior

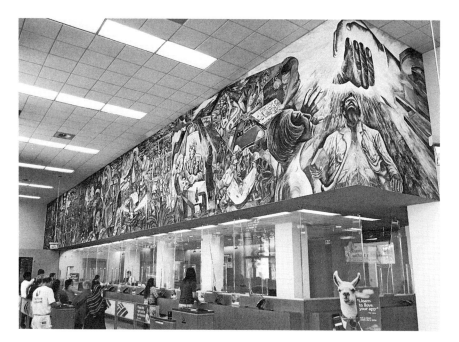

Figure 5.1. Jesús "Chuy" Campusano, Michael Rios, and Luis Cortázar, *Homage to Siqueiros*, 1974. This mural exists inside the Bank of America building at Mission and 23rd Streets. A bank plaque for the mural lists five additional assistants: Jaime Carrillo, Candice Ho, Julio Lopez, Anthony Machado, and Jack Navarez. Photograph by Cary Cordova, July 28, 2016. Image courtesy of Andres and Sandra Campusano.

murals already existed in the Mission, at least by 1963, but the community mural movement moved the painting into the streets.[6] By 1975, local poet Roberto Vargas described the Mission as "an implosion / explosion of human colors, of walls being painted by *hombres y mujeres muralistas* [men and women muralists]."[7]

While a number of artists contributed to this explosion of images, the artists responsible for *Latino America* (1974) (Plate 8) and *Homage to Siqueiros* (1974) (Fig. 5.1) stood out for their close ties to the community, their continuing influence on the local aesthetic, and the substantial media coverage their work inspired. *Latino America* continues to provoke discussion as one of the key works by the influential Mujeres Muralistas, a cooperative of women muralists. *Homage to Siqueiros* is just as noteworthy for the publicly confrontational, flagrantly anticapitalist voice of its three male artists.

Local newspapers announced the completion of these two murals, thereby allowing these works to attain an uncustomary level of recognition.[8] The

increasing visibility of murals, the escalating skills of the artists, and the
introduction of public receptions to celebrate a project's completion contrib-
uted to this media coverage. Moreover, the artists of *Homage to Siqueiros* cre-
ated a media spectacle designed to undermine their corporate sponsor, while the
artists of *Latino America* caught attention as one of the first all-female commu-
nity mural groups in the nation. Though *Homage to Siqueiros* still exists in the
home of its sponsor, the Bank of America, *Latino America* suffered a fate common
to many exterior murals: the building owners whitewashed the painting in the
1980s. The afterlife of these two works underscores the way murals attain value
in interior spaces—*Homage to Siqueiros* is now insured for over a million
dollars—and deteriorate in exterior spaces.[9]

In comparing the origins of *Latino America* and *Homage to Siqueiros*—two
murals painted in the same year—I trace the artists' efforts to galvanize the
neighborhood as well as how their use of different symbols represented differ-
ing visions for social change in 1974. Their contrasting histories reveal dissen-
sions, most visibly in the gendered division of the artists, but also shaped by the
context and reception of the work. This close analysis illustrates the value of
examining community murals—from inception to erasure—as historical doc-
uments, activist interventions, and artistic creations.

Urban Redevelopment and the Community Mural Movement

In 1966, the San Francisco Redevelopment Agency (SFRA) released a pro-
posal to construct two Bay Area Rapid Transit (BART) subway stations within
ten blocks of each other on Mission Street (the Mission District's central thor-
oughfare). The proposal sparked immediate concerns about gentrification. As
Manuel Castells wrote, "The concern of the Mission residents was more than
understandable given the SFRA's record as a major instrument of demolition
and displacement."[10] BART, a transportation system designed to help outlying
suburban commuters move swiftly in and out of the city, had little obvious value
for inner-city residents. Moreover, city plans to turn the stations into South-
American–style tourist attractions led residents to view the new system with con-
siderable distrust.[11] Local residents foresaw more disruption and destruction of
local businesses than opportunity. Concerned activists argued that "the land
around the BART stations will become too valuable for poor people to occupy."[12]

While residents battled potentially harmful redevelopment interests, they
also faced the opposite problem: criminal negligence and illegal displacement
tactics. Within three years of BART's 1974 opening, 133 fires erupted in a three-
block radius of the new 16th Street station. If averaged, this would work out to

about one fire every eight days. Authorities declared at least forty-one of the fires to be arson. Presumably, landlords sought to collect insurance rather than invest in a struggling community. Moreover, since the fires eliminated dilapidated properties, they facilitated redevelopment projects with greater economic potential.[13]

The history of BART illustrates the widespread plight of low-income neighborhoods, caught between gentrification and abandonment. In 1966, Congress passed the Model Cities Act to eliminate inner-city decay. San Francisco adopted the program in 1968, with a focus on the Inner Mission and Hunter's Point. Many residents viewed the Model Cities Act with distrust, concerned that redevelopment was a ploy to displace low-income people. Efforts to fight displacement coalesced with the formation of the Mission Coalition Organization (MCO), a powerful grassroots effort to bring residents together and speak out against the harmful effects of redevelopment. Castells described the MCO as "one of the most successful examples of Alinsky-style community movement, showing a remarkable capacity to combine grassroots organization with institutional social reform."[14] Though internal divisions gradually emerged, for many, the MCO exemplified how a community could counter city hall and the San Francisco Redevelopment Agency.

In spite of the potentially negative implications of the Model Cities Act, the legislation, combined with the 1964 Economic Opportunity Act, provided important funding opportunities for neighborhood improvement. Many programs benefited, including Arriba Juntos, Horizons Unlimited, Mission Rebels, and the Mission Health Neighborhood Center.[15] These new nonprofits drew volunteers from all areas of the city to the Mission. For instance, Mission Rebels recruited many paid and volunteer counselors to teach art, drama, music, and fashion design to youth, while Horizons Unlimited cultivated support for its Teatro de la Calle, a street theater program.[16] Many community-based programs turned to the arts as a means of reaching Mission youth.

The community mural movement crested on this wave of energy. New funding through the Model Cities Act, the Supplemental Training and Employment Program (STEP), and the Comprehensive Employment and Training Act (CETA) of 1973 provided critical financial support. Thanks to the efforts of John Kreidler and the San Francisco Art Commission, San Francisco became the first city to propose that CETA employ artists in a vein similar to the Works Progress Administration (WPA) of the 1930s. The city hired the first twenty-four CETA artists in December 1974 "after a winnowing down from 400 people who applied. When money was freed for more jobs, the Art Commission offices . . . were swamped with 1400 applications. Seventy-seven people were picked."[17] In San Francisco, there was no shortage of artists seeking employment.

In addition, many of the emerging nonprofits proved to be mural patrons. Alan Barnett cites the Horizons Unlimited mural—painted by Spain Rodriguez, Jesús "Chuy" Campusano, and Bob Cuff—as the first community mural in the Mission.[18] In a 1983 interview, local artists Jerry Concha and Rolando Castellón both recalled producing the Mission Rebels mural with Robert Crumb, Rubén Guzman, and Bob Cuff before the Horizons Unlimited mural.[19] Whichever came first, the Mission's community mural movement began to flourish by 1971.

City and federal funding alone does not explain the community mural movement. As Patricia Rodriguez declared, "I'm doing exactly what I was doing before, except I'm getting paid for it."[20] Community murals were happening apart from financial incentives, reflecting the desire of artists to work in their communities and bring art to the people.

A Tribute to the Mexican Masters: Painting
Homage to Siqueiros

Homage to Siqueiros captured local attention for its powerful appearance and its subversiveness. In 1974, the Bank of America commissioned Jesús "Chuy" Campusano, Luis Cortázar, and Michael Rios to create a mural above the bank teller counter of its 23rd and Mission Street branch. Murals promised a low-cost way of appealing to local consumers: the bank paid the muralists an estimated $15,000 to $18,000, including supplies.[21] According to a bank official statement from 1974, the bank felt "For us, the mural is a symbol of our desire to offer the best financial services in the Mission District."[22] The bank hoped the mural would illustrate its compatibility with local residents.

The private commission did not stop the young muralists from speaking out against their sponsor, a company at the time facing widespread protests over the ethics of its investments. In 1970, student protestors famously firebombed the Isla Vista Bank of America branch near UC Santa Barbara because they linked the institution with heightened U.S. involvement in Vietnam. The May 1970 cover of *Ramparts* magazine declared that "the students who burned the Bank of America may have done more toward saving the environment than all the teach-ins put together."[23] The high-profile action radicalized many students, including future members of the Symbionese Liberation Army.[24] In addition, César Chávez often criticized the bank for its antiunion activity. In his view, the Bank of America worked in cahoots with the grape growers; Robert Di Giorgio of the Di Giorgio Corporation, the largest grower in the Delano area, also sat on the bank's board of directors.[25] Moreover, the bank's landmark high-rise altered San Francisco's city skyline and displaced many residents. All of these events added fodder to the public ire.[26]

The muralists sought every opportunity to distance the creation and content of their work from the interests of the bank. To justify painting in such an institution, the three artists likened their situation to the experience of Diego Rivera painting a mural in support of labor in San Francisco's Pacific Stock Exchange. Artist Michael Rios stated, "As Diego Rivera said, if the mural serves the purpose of nourishment and enlightenment, it's OK even if it's hung in the Bank of America."[27] In drawing parallels to Rivera and the tradition of "Los Tres Grandes," or "The Big Three" Mexican muralists of an earlier generation (Rivera, David Alfaro Siqueiros, and José Clemente Orozco), the young men sought to invoke their artistic lineage and ethnic pride and to enable their political voice.

The artists incorporated various homages to Los Tres Grandes into the mural. As Carlos Francisco Jackson pointed out, many Chicano artists at this time "would look to Los Tres Grandes for a blueprint of how to create culturally and politically empowering public art."[28] The trio included a portrait of Siqueiros, notably on the far left of the mural, in the prison garb he wore when arrested for participation in a May Day demonstration—thus capturing him speaking out for his beliefs, regardless of the consequences (Fig. 5.2). By dedicating their work to Siqueiros, the men honored the Mexican master painter in the year of his death and cultivated his political and artistic persona. Through these references, the American artists asserted their ability to communicate directly with the people, regardless of the commercial interests of their sponsor.

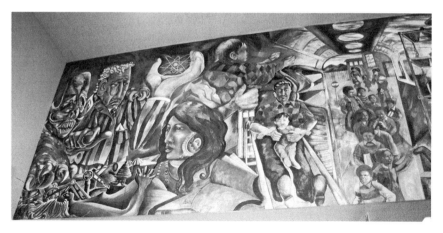

Figure 5.2. *Homage to Siqueiros* far left panel detail. Siqueiros is depicted in pinstripe/prison garb holding the symbol of atomic energy. The children along the right are in line to board school buses. Photograph by author. Image courtesy of Andres and Sandra Campusano.

The trio's public alignment with Los Tres Grandes helped them skirt the bank's attempts at censorship. In this regard, local artist Emmy Lou Packard stepped in to convince the bank of the muralists' right to freedom of expression based on her experience as an assistant to Diego Rivera. Packard had moved her studio to the Mission from Mendocino, California the year before, seeking a return to city life. The move led one reporter to remark, "Miss Packard is one of dozens of artists and photographers who are moving to the Mission."[29] Mission artists welcomed Packard as a local conduit to Rivera and Frida Kahlo and sought to include her in the community. In turn, she gave the group technical and aesthetic advice. She recalled, "A group of young Latin American painters came to me because they heard I had worked with Rivera, and they are back into socially conscious painting again . . . it's kind of funny that now the young kids in their 20's are doing exactly what I was doing in my 30's!"[30] Campusano expressed his gratitude to Packard publicly, stating, "She argued strongly with the Bank about our civil rights as artists to express what we wanted."[31] The bank expressed its appreciation more privately, in a letter from the bank's public information officer, who thanked Packard for her "calming influence when unnecessary and illogical strife seemed to be brewing."[32]

Packard also represented an ideological link to the progressive activism of an earlier generation, as a long-time peace and First Amendment activist. In 1957, Packard was one of fifty Bay Area artists subpoenaed by the House Un-American Activities Committee as a result of her reputation for supporting "radical" causes and producing politically oriented artwork.[33] When Packard assisted Campusano, Rios, and Cortázar with *Homage to Siqueiros*, she parlayed her knowledge of the Mexican muralist tradition and her experience as an organizer of the Left. Packard introduced Campusano to Mexican muralists Juan O'Gorman and Pablo O'Higgins as well as to César Chávez, whom she knew from her work for the United Farm Workers.[34] In turn, Campusano invited Packard to participate in the contemporary Mission District scene, leading to her work with local venues like Galería de la Raza and the Mexican Museum.[35] Their relationship revealed the many political and cultural connections between the Old Left and the New Left.[36] The appropriation of the Mexican muralist tradition invoked ethnic identity and leftist politics.

For the mural opening, the bank released marketing materials offering people a chance to win Giants tickets or a trip to Latin America. The muralists responded with their own media campaign, printing *Tres Muralistas,* a pamphlet hostile to the bank, refuting any representation of their work as supportive of the institution, and organizing an opening ceremony that would be sure to undermine the wishes of local bank officials. The artists invited their friend Roberto Vargas to read a poem for the opening reception on June 4, 1974. More

diatribe than verse, Vargas entitled his work, "La BoA," which conflated the bank's acronym with the name of a snake and featured bank founder A. P. Giannini as the character "A.P.G.O. Money." Bank officials managed to prevent a public reading of "La BoA." Instead, Vargas read "They Blamed It on Reds"—an indictment of the San Francisco police for their alleged murder of Vicente Gutierrez—which at least minimized disparagement of the bank. Nevertheless, residents had access to the text of "La BoA" in the local paper, which published the poem alongside an article describing the radical antics of the muralists.[37]

About the bank, Campusano stated, "We all know they support the grape and lettuce growers in California and that they're involved in Latin America. I didn't do the mural for them. I did it for all those people in the Mission who stand on the long lines in the bank on Friday afternoon."[38] Indeed, the central figure of the mural depicted an agricultural worker extending his fist at the viewer as another man opened a text to César Chávez's statement, "Our sweat and our blood have fallen on this land to make other men rich" (Fig. 5.3). The bank whitewashed Chávez's words from its promotional materials. Minor acts of censorship notwithstanding, the bank used the mural to demonstrate its exceptional tolerance and support of freedom of expression. One reporter declared that the presence of the mural "is proof in itself that the $41.8 billion-deposit bank did not attempt to limit the artists' vision or censor the subject matter."[39] The bank's posturing is part of the reason the statement has survived intact on

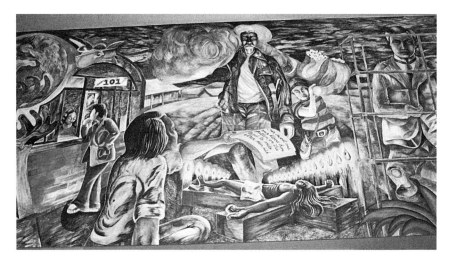

Figure 5.3. *Homage to Siqueiros* center detail. Text in the open book quotes César Chávez's statement, "Our sweat and our blood have fallen on this land to make other men rich." Photograph by author. Image courtesy of Andres and Sandra Campusano.

the mural to this day. Eva Cockcroft speculated that the mural served "as a sort of fire insurance for the branch," redirecting those that otherwise might have been inclined to harm the building.[40] Ultimately, the muralists and Packard successfully protected the work from its patron by placing it in the grand tradition of political art.

Inventing "Latino America"

Just a few blocks down Mission Street, another mural project also was underway. The mural *Latino America* drew attention because of the gender of its artists and the large scale of the work (Plate 8). Eight women—four lead artists (Patricia Rodriguez, Graciela Carrillo, Consuelo Mendez, and Irene Pérez) and four assistants (Tuti Rodriguez, Miriam Olivas, Xochitl Nevel-Guerrero, and Ester Hernandez)—worked together on the seventy-foot-long by twenty-five-foot-high wall. Although many women, including the lead artists, had contributed to neighborhood mural projects, the group was unusual in using *only* women artists, calling themselves Las Mujeres Muralistas (The Women Muralists). According to Ester Hernandez, "People were really shocked that a group of women were going to do the whole thing, from setting up scaffolds to doing the drawings to doing cartoons."[41] Their work evolved into a stunning mural that disproved the long-standing stereotype that mural painting, especially Chicano mural painting, was a practice best performed by men. Indeed, their success opened doors and inspired many other women to pursue the art form. Susan Cervantes, founder of Precita Eyes Mural Arts organization, watched the Mujeres Muralistas paint *Latino America* and recalled the moment as "an inspiration to me because I saw how they worked—collaborated, together. And I thought that it was a really, really good way to work with a group."[42]

The artists held an inauguration party for the mural on May 31, 1974, four days prior to the opening of *Homage to Siqueiros*. A poster invited locals to enjoy music and food in honor of the work's completion.[43] Like the men, the women passed out a statement to contextualize their work. Signed by Carrillo, Mendez, Pérez, and Rodriguez, the brief declaration makes it clear that the mural was a feminist vision not only in content but in creation: "Throughout history there have been very few women who have figured in art. What you see before your eyes is proof that woman, too, can work at this level. That we can put together scaffolding and climb it." Though this statement is in many ways as militant as the men's, articles reporting on the new mural ignored the radical gestures and emphasized collective creation. Many used or paraphrased their statement: "We are four women who are working. All the work that you see before your eyes was done collectively. We feel this work is really impor-

tant because it takes art beyond the level of individualism."[44] The Mujeres Muralistas' public posture emphasized women's superior collaborative skills.

That emphasis on collaboration served partly to challenge their experience working with men. As Patricia Rodriguez recalled, "For the record, it wasn't negative in the sense that the men blocked us or they didn't let us do anything. It's just that they didn't accept us to work with them." She described the contrasting relationship among the four lead artists: "There was no leader; there was no director."[45] Not only was this work dramatically different, the collaborative technique also kindled different content and ideologies in their work.

Ironically, rejecting patriarchal structures did not register as militancy. While critics recognized the efforts of the Mujeres Muralistas as groundbreaking for women, they also suggested that their work was not as political as that of their male counterparts.[46] Undoubtedly, the strident voices of the men, both within the mural and at the opening, produced a remarkable spectacle. In addition, the Mujeres Muralistas emphasized their less violent voice. They stated that they "had decided that the men's murals of the time had too much 'blood and guts' and that they wanted a more positive image of their culture."[47] As a result, their work is frequently described as evoking "a pan-American aesthetic where highly visible images of women and emphasis on ceremony, celebration, caretaking, harvest and a continental terrain worked toward the creation of a new mythology."[48] Such comments track the work of women muralists into traditionally feminine and supposedly apolitical terrain—leaving the political realm to men. In fact, the artists grounded the art in the current political discourses shaping the community's identity.

While the men sought to pay homage to the male Mexican muralists of the past, the women argued for an entirely new vision. Patricia Rodriguez stated, "We didn't want to give any more credit to the Mexican painters. We were the new cadres of painters, right after Rivera. We were those people. . . . And so, this mural historically is one of the most important in that sense because we break that trend for the first time in history. We say, 'We live here, we're two cultures. We're an American culture and a Latino culture.' "[49]

The original title of the work, *Latino America*, embodied this bicultural sentiment. The mural's inaugural poster and statement referred to the work as *Latino America*, but with the passage of time, other titles overtook the original. Scholars have relied more on the names *Latinoamérica* or *Panamerica*.[50] The most pervasive title, *Latinoamérica*, is the official Spanish term for Latin America and, as a result, suggests the painting's focus is most directed toward depicting the countries comprising Latin America. Alternatively, *Panamerica* suggests more of a hemispheric unity, encompassing North and South America. *Latino America* without the accent maximizes the double meaning of the work,

suggesting that Latinos in the United States are reinventing America as a na-
tion as well as articulating a larger kinship to the Américas. The artists of
Latino America centered this bicultural vision in their work in order to explore
the complexities of multiethnic identities and to elicit some sense of commu-
nity unity in the face of larger, crippling socioeconomic forces.

A Closer Look: *Latino America*

Pinpointing the exact date *Latino America* vanished under a coat of cream paint
is difficult. Perhaps the mural disappeared not too long after its patron, the Mis-
sion Model Cities, vacated the premises and the building owners converted the
property into a laundromat. That the mural no longer exists testifies to the tran-
sitory nature of murals as well as the public's failure to recognize a culturally
significant work of art. In contrast, the bank now values *Homage to Siqueiros* at
well over a million dollars. While the different valuations may stem from the
failure to take women's work seriously, physical location also matters.

Like any outdoor mural, *Latino America* suffered environmental decay and
the vagaries of changing property owners. A similar erasure befell Chuy Cam-
pusano's *Lilli Ann* mural (1982), an abstract montage on the Seventeenth and
Harrison building; the title alluded to the building's history as the Lilli Ann
garment factory. In 1998, new owners whitewashed the mural, likely unaware
of the million-dollar value attributed to Campusano's Bank of America mural.[51]
Their action illustrated the widespread presumption that outdoor murals are
expendable. The destruction of *Lilli Ann* provoked anger in the community
and sparked a landmark case for California's exterior murals: the Campusano
family sued the property owners and won $200,000 in damages under the 1979
California Art Preservation Act.[52] That suit showed how legislation could
protect exterior murals, but successful cases require extensive community and
financial support. The loss of *Latino America* roused no such attention. Patricia
Rodriguez later remarked, "It must have been in the late '80s. It was just gone.
And we couldn't get anybody in the city to support it."[53]

In *Latino America*, the artists sought to make the wall visually appeal to
various segments of the Mission's Latin American community. Muralists often
include signifiers in their work that evoke special meaning for locals but that
might go unnoticed among the general public. In the mural, from left to right,
were llamas native to the Andes, Peruvian pipe players, a group of Venezuelan
Yare devils, the central holy image of a family in an Indian sun design, a Jabiru
bird native to the Pantanal of Brazil (Fig. 5.4), a group of American youth
(Fig. 5.5), a Bolivian *diablada* figure (Fig. 5.6), and an Aztec fifth sun casting its

Figure 5.4. *Latino America* detail showing Venezuelan devils and family unit framed in a *zia* sun symbol. The Jabiru bird is along the bottom edge. Image courtesy of Patricia Rodriguez.

Figure 5.5. *Latino America* detail showing youth of the Mission. Image courtesy of Patricia Rodriguez.

Figure 5.6. *Latino America* detail showing Bolivian *supay* figure. Image courtesy of Patricia Rodriguez.

light on a princess and warrior figure. A row of maguey plants and cornstalks framed the bottom of the mural. Patricia Rodriguez explained, "Irene Pérez painted the magueys and the maize. Graciela Carrillo painted Guatemala. Consuelo Mendez painted the center of the mural, which is a family unit, and Venezuela. I painted Bolivia and Peru."[54]

The mural emphasized the indigenous and mestizo heritage of Latin America. The mural not only reminded local residents of their homelands, it also celebrated the survival of various cultures under Spanish colonialism. This emphasis created a parallel between the peasant and Indian classes in Latin America and the inner city poor in America. The artists drew the parallel more distinctly in the area framing local Mission District youth (Fig. 5.5): the youth appeared in color, but the surrounding area was black-and-white, entirely and purposefully drained of color, a nod to the stylistics of newsreel footage and an allusion to the popular-comics style of many murals in the Mission at that time.[55] The empty whiteness also suggested the American urban dehumanization Latinos must prevent through the cultivation of their indigenous past. Maintaining

cultural traditions against assimilation was an overriding dynamic in Mission murals—an attempt to form a community identity apart from, and even opposed to, black-and-white "American" life. The image suggested an attempt to break from the traditional black-and-white binary that has dominated dialogues on race in America. Instead, the multiethnic youth depicted in the forefront indicated America's complexity and more accurately reflected the Mission's demographic diversity.

The artists' representation of a plurality of identities resembled the actions of community activists who sought to build solidarity in the Mission by linking diverse groups under the rubric of Third World coalitions. The artists of *Latino America* depicted close ties between Latin American and African cultures, abroad and at home. For instance, images of devil figures linked indigenous and African cultures of Latin America. In particular, one towering red figure wore a snake-adorned devil's mask and intricate costume in the tradition of *supay*, carnival figures in Oruro, Bolivia (Fig. 5.6). His appearance invoked the *diablada*, or devil's dance, which scholars most commonly locate emerging out of the culture of enslaved indigenous and African miners following the Spanish conquest. The devils on the left, with colorfully painted masks and bright red costumes, embodied the image of Venezuelan Yare devils, which are part of the yearly Feast of Corpus Christi. Though Venezuela's "dancing devils" celebration has similarly vague origins, most acknowledge its indebtedness to African culture, in addition to indigenous and Spanish cultures.[56]

Both the Bolivian and Venezuelan devil figures flanked the mural's central family-sun image and served as representations of a rich, if oppressed, cultural heritage, not just for people of African descent in Latin America, but for all of Latin America and its diaspora. Similarly, the Aztec figures on the far right and the Peruvian musicians on the far left referenced Latin America's indigenous roots and highlighted the need for community organizing between Latinos and Native Americans in the United States. In the 1970s, the Mission became an important site for American Indian community organizing, offering important meeting places, such as the American Indian Center and Warren's Bar.[57] The muralists invoked their diverse indigenous heritages to align themselves with the concerns of American Indians and the larger Third World community. The use of the *zia*, or Navajo sun/star image, in the center of the mural, indicated this linkage.[58] In representing the African and Indian roots of Latino America, the mural visually articulated the need for recognizing the shared concerns of African American, Native American, and Latino residents in the United States.

As these elements expressed, the iconography of the painting represented far more than feminist domesticity, although this aspect also played a role. The center of the painting showed a glorified image of a family with a woman holding her children, who was soon to give birth to the fetus image superimposed on her belly. The superior placement of the family in a saint-like frame underscored the mural's celebration of familial and maternal love. As a whole, the mural replicated the cycle of life: the sun nurturing the plants, which in turn fed the people, who then gave birth to the next generation.[59]

However, the work might not be as strictly female-oriented as surface readings suggest. While the mother figure had the central position of power, she was flanked by the male devil figures.[60] The red clothing and animal masks distinguished the Venezuelan devils on the left from the ornately costumed Bolivian *supay* on the right. Along with the prominent placement of male figures, there was a certain heralding of male sexuality, most evocatively suggested by the Bolivian *diablada*'s position next to an exterior red pump that is strikingly phallic (Fig. 5.6). Patricia Rodriguez pointed out that she painted the *supay* figure at the height of the 1970s gas crisis; in fact, the devil's trompe l'oeil emergence out of the gas pump conveyed her criticism of the nation's increasing reliance on oil.[61] Thus, the mural was just as much an indictment of U.S. consumption as it was a representation of family and harvest.

The Mujeres Muralistas did not choose to heighten this political aspect of their painting, perhaps in part because street murals often steered away from explicit controversy to avoid provoking vandals.[62] Painting in the streets forced the women to produce a less obviously political work than the men painting in a private corporate institution. However, viewers tended to present this political difference more as a product of gender than physical context.[63]

The women also sought to represent solidarity with their viewers. According to the Mujeres Muralistas, "A lot of people have told us that our work is pretty and colorful, but that it is not political enough. They ask us why we don't represent the starvation and death going on in Latin America or even the oppression of women. . . . Our interest as artists is to put art close to where it needs to be. Close to the children, close to the old people who often wander the streets alone, close to everyone who has to walk or ride the buses to get to places."[64] Such representations laid claim to positive images as a means of reaching out to the community, but also obscured the mural's implicit political images.

Patronage also played an important role in the subject matter of the Mujeres Muralistas. In a 1982 interview, Patricia Rodriguez recalled that it was the director of Mission Model Cities who said, "You can do anything on the wall except we don't want blood or guts or revolutionary guns."[65] The women welcomed the

director's request, since his wishes aligned with their own. However, the decision not to "represent the starvation and death going on in Latin America" was not just based on gendered interests, but on the command of their patron.[66] The women complied, since doing so fit with their interests and ethics. This was not the case for the men painting a mural for Bank of America.

A Closer Look: *Homage to Siqueiros*

The artists of *Homage to Siqueiros* needed to create a mural agreeable to the bank and acceptable for themselves. On the surface, the mural appears celebratory of community, technology, and achievement, but various details subvert this initial understanding. Throughout the mural, the artists balanced images of terror, greed, and technological destruction with markers of indigeneity, family, and heroic masculinity. A closer reading unveils the political stances the muralists wished to articulate for the sake of Mission District residents and Third World people everywhere.

From left to right, the muralists showed a devilish being, easily suggestive of a capitalist pig, stretching imperialist talons toward a prone, pregnant mother—a likely Mother Earth. The devil's left arm wraps around the shoulders of another man—Siqueiros, in a suit jacket of black-and-white convict stripes, who holds Bohr's symbol of atomic energy aloft in his left hand (Fig. 5.2). For emphasis, the artists duplicated this scene on the far right corner of the mural, depicting themselves sketching the devil and Siqueiros, again with the atom in hand. The repetition of the atomic symbol referenced Siqueiros' mural *The Resurrection of Cuauhtémoc,* painted in 1950 in the Palace of Fine Arts in Mexico City. Siqueiros's work evolved from a series of murals on Cuauhtémoc, the Aztec prince who led the resistance against the Spanish conquistador Hernan Cortez. Of the painting, Siqueiros explained, "I presented Cuauhtémoc in armour to signify that Mexico, and in general weak peoples, should take up arms in order to bring down their enslavers and executioners. I employed the centaur . . . to symbolize the conquistador as the conqueror and destroyer of cultures. The centaur raises in his hand the symbol of the atomic bomb to represent the form of massacre employed today."[67]

For Campusano, Rios, and Cortázar, the parallel between Cuauhtémoc fighting the conquistadors and themselves fighting American cultural and political imperialism proved an easy comparison. The artists inserted Siqueiros as their contemporary hero and spokesperson, dressing him in a business suit, much like Cuauhtémoc appeared in Spanish armor. A touch of humor is implicit in the conflation of the suit's pinstripes and prison stripes, bespeaking

the difficulty of differentiating good from evil, respectability from criminal-
ity. Siqueiros holds the atom in his hand as the ultimate power: the power to
kill, but also the power of restraint. Correspondingly, the devil figure, perhaps
an American banker or politico, becomes the contemporary conquistador, sac-
rificing culture for financial and technological gain. The mural's depictions of
technology can be read as celebratory, but close readers will recognize the art-
ists' grim view of technology.

Moving into the center of the mural, the artists included an image of school-
children boarding a bus, counterbalanced by a BART train on the right (Fig. 5.2
and Plate 9). Seemingly innocuous, both images of public transportation repre-
sent controversy. Barnett noted that the bus symbolized the practice of busing
students into other neighborhoods to propel integration.[68] According to one
poll, most residents at the time opposed busing and many resisted various ef-
forts toward school desegregation.[69] Similarly, the image of BART, the area's
new subway system, could appear to denote technological achievement, but its
representation as a serpent about to run over the people of the Mission is more
likely.[70] Another Rios mural showed people forced to carry the burden of the
BART train on their shoulders. For the Mission District, technology generally
meant either an increase in the division between rich and poor, or displacement.
The artists appeared to cater to the tastes of the bank, but residents could easily
read the contentious attitudes in the iconography.

The artists sought to be critical and instructive. Two larger-than-life
portraits—of Mexican revolutionary Emiliano Zapata and Nicaraguan poet
Rubén Darío (Plate 9)—articulate the need for political action and cultural expres-
sion to work together in the struggle for human rights. Both men are impris-
oned in scaffolding, akin to a 1930s San Francisco Art Institute mural by Diego
Rivera, *The Making of a Fresco Showing the Building of a City*. In the Rivera
mural, also known as *Workers in Control of Production,* the central figure is an
immense male laborer with a red star pinned to his chest. The red star, as the
symbol of revolution and socialism, makes Rivera's political attitudes obvious.
The trio's homage to Rivera's mural indicated their political stance without hav-
ing to fight the bank to include a red star. The panel of microscopic images to
the right of Darío suggest some censorship. The cells pay homage to Rivera's
Detroit and Rockefeller Center murals, which contained microscopic images
with discrete political symbols, including a hammer and sickle.[71] In *Homage to
Siqueiros*, local legend says the top cell originally contained the seven-headed
serpent symbol of the Symbionese Liberation Army, a radical militant organ-
ization dedicated to redistributing wealth. Today, the top cell is painted white.[72]

The center of the mural features the most powerful image of a man holding
a book open to César Chávez's statement, "Our sweat and our blood have fallen

on this land to make other men rich"[73] (Fig. 5.3). The phrase hovers over a Christ figure crucified on the ground, a symbol of the martyrdom of the common people to the wealthy. A farmworker in the background affirms the muralists' indictment of the bank. The crucifixion invokes the most visible homage to Siqueiros, as a blatant allusion to his famously censored mural, *Tropical America*. In 1932, Siqueiros painted a work above Los Angeles's Olvera Street. His sponsors hoped the mural would echo the paradisial tropicalization of the landscape they were attempting to create, envisioning a vibrant shopping mecca full of piñatas and maracas. Instead, Siqueiros painted symbols of oppression and colonialism, culminating in his image of a crucified Indian suspended by the talons of an American eagle. While the sponsors whitewashed the work, over the years, the image began to show through, seemingly voicing its resistance to censorship and emerging as a symbol of continuing struggle. By alluding to the famous image, the men made their homage to Siqueiros complete.[74]

While *Latino America* clearly emerged from a collaborative feminist consciousness, *Homage to Siqueiros* is the work of three men, one of whom later stated, "I'm sorry we didn't put more women characters in the mural. We've received some criticism from our sisters for that. But we are learning."[75] While the work features more men than women, from the devil banker to the heroic agricultural worker, women also have visible, if circumscribed, roles. The painters counterbalanced an image of a naked, pregnant woman, prone to various dangers, on one side of the painting with an image of a nurse snipping a child's umbilical cord (Plate 9). Not far from the operating table stand three figures waiting to see the newborn. A woman with her back turned wears a shawl that suggests her elder status, and in this context, invokes the role of the *partera* (midwife) or *abuelita* unable to participate in the most basic cultural rite of passage. While one can imagine the muralists representing this scene to their corporate sponsor as symbolic of the technological achievements of medical science, it also represents how medicine displaced the intimacy of birth from the family and usurped a role of power for women.[76] The traditional critical distinctions of *Homage to Siqueiros* and *Latino America* as emerging out of a specifically male or female sensibility does not account for the more complex iconography.

Shared Visions

An obvious parallel exists in the ways that both sets of artists use Latin American indigenous images to assert strategies for survival in the United States. Most of the images reflect a preconquest "purity" or mestizo heritage that rejects Spanish colonialism as much as U.S. imperialism. The two works even share certain touchstone images that would register with local residents. For instance, the

maguey or agave plants, native to Mexico, sprout like weeds from the bottom of both murals. The plant not only serves as the source of tequila and *pulque*, a traditional beverage, but also represents a tenacious survivor against powerful American marketing campaigns for beer in Mexico. The propensity of the plant to appear like a weed doggedly rising to the surface speaks to the ability of inner-city residents to maintain traditions and survive American cultural and capitalist imperialism. Rupert García's 1972 silkscreen, *Maguey de la Vida*, which features an abstract silhouette of the plant, signals some of the popular appreciation attributed to this symbol of strength. Patricia Rodriguez recalled, "We did research on the maguey plant and on maize, and learned the historical significance of these crops." Many artists continued to replicate the image, recognizing its cultural and aesthetic history within the Chicano movement.[77]

In a statement about their work, Las Mujeres Muralistas described their intent as "reaching back to what we came from and understanding that what we come from is better than this country, and this country is making our countries like what they are like today."[78] Their comment parallels Rios's description of *Homage to Siqueiros* as an effort "to make connections with our past. The primitive consciousness, the way people used to be in harmony with nature." Indeed, Rios pointed out the parallel himself, remarking, "All the murals that are being done now in the Mission seem to reflect this feeling: our mural, the one we're doing in the 24th Street Mini-Park and the one the women are doing at Model Cities [*Latino America*]—all going back to this primitive vision."[79] This primitivist iconography continues to appear in many later works, including the 1976 Mission Neighborhood Health Center murals by Rios and Graciela Carrillo. In the words and images of the Mujeres Muralistas and Rios, a "primitive" vision appears to mean a return to the purity of the Latin American and indigenous past.

In a similar vein, the story of Balmy Alley conveys this idealistic spirit. Emilia "Mia" Galaviz de Gonzalez orchestrated the first major painting of Balmy Alley as a children's mural project in 1972. According to Galaviz de Gonzalez, "My dream was to make a safe environment, a cleaner environment, a healthier environment, a place where children and old people could be safe, or feel safe. And I really think the Mexican experience was very supportive to that thinking. . . . The lifestyle in Mexico is different, it's so much more balanced than it was here."[80] Galaviz de Gonzalez sought to recreate the Mexican *jardín* (garden) in Balmy Alley, a place "where everybody comes to congregate." She explained, "My fantasy was to do mosaic on the street, to have a bench where you could sit down, because it's nice, there's not a lot of wind there, and the older people could sit down . . . and also to help that drug trafficking be lessened, because Garfield Park was at the other end."[81] Through children's art, mosaics, and benches, Galaviz de Gonzalez hoped to recreate Mexico and uplift

Figure 5.7. Las Mujeres Muralistas, untitled mural, Balmy Alley, c. 1972. Photograph by Tim Drescher. Image courtesy of Patricia Rodriguez and the archive of Tim Drescher.

the Mission District. She found support among her neighbors. Graciela Carrillo and Patricia Rodriguez of Las Mujeres Muralistas lived on the alley and painted a mural at the same time, aided by a supply of paint from Galaviz de Gonzalez. Their tropical painting of flowers, plants, birds, and fish fit with the joyful landscape that Galaviz de Gonzalez hoped to create (Fig. 5.7).

Change Is Coming

In the late 1970s and 1980s, world events transformed the content and iconography of Mission District murals. Political upheavals and a dramatic influx of refugees and immigrants from Central America forced new community signifiers. Artists depicted the struggle of Nicaraguans, Guatemalans, and Salvadorans to survive in the face of violence, while they still paid tribute to the beauty of the land. The 1984 collective painting of Balmy Alley symbolized this change, when a group of more than thirty artists came together to create twenty-seven

murals to challenge U.S. intervention in Central America. The concentration of murals in a single block proved an astonishing display of diverse aesthetics and shared politics.

Calling themselves PLACA, meaning "to leave a mark," the artists declared, "PLACA members aim to call attention to the situation that exists today in Central America, as a result of the current Administration's policies. The situation in El Salvador, the situation in Nicaragua, the situation in Guatemala, the situation in Honduras. PLACA members do not ally themselves with this Administration's policy that has created death and war and despair, and that threatens more lives daily. We aim to demonstrate in visual/environmental terms, our solidarity, our respect, for the people of Central America."[82]

Artist Ray Patlán spearheaded organizing and funding for the PLACA project, beginning in October 1983. He also had institutional support from Galería de la Raza, which offered to serve as a "fiscal agent" for the community project.[83] Part of PLACA's success was predicated on its decision to seek private funding and to circumvent "approval battles over political content of the imagery."[84] PLACA drew inspiration from Artists Call Against U.S. Intervention in Central America, an international organizing effort, but this artistic protest stood out as an unusual and formidable visual demonstration of the strength of San Francisco's community mural movement and its politics.[85]

Almost all of the Balmy Alley murals from 1984 convey some aspect of human tragedy in Central America. Artists Miranda Bergman and O'Brien Thiele created *Culture Contains the Seeds of Resistance*, a mural divided in two. On the right, the work presents the potential bounty and joy of Central America, but on the left, women hold photographs of the *desaparecidos* in the tradition of Las Madres de la Plaza de Mayo, or the Mothers of the Plaza de Mayo in Argentina (Fig. 5.8). A hungry child sits holding an empty plate on top of boxes of foodstuffs only for export. In Juana Alicia's *Te Oímos Guatemala* (*We Hear You, Guatemala*), a woman prostrates herself over a dead body covered by a white sheet. According to Juana Alicia, she drew inspiration from the film *When the Mountains Tremble*, which documents a massacre in a small Mayan town. All the bodies are laid out in white sheets "and it seems like every woman is screaming."[86] Ray Patlán and Francisco Camplís created a more subtle critique of violent conditions with *Camino al Mercado* (*On the Way to the Market*) (Fig. 5.9). Mural viewers look from above at two women dressed in long white dresses and *rebozos*, each holding shopping bags, ostensibly moving to and from the market. The shadow of a helmeted soldier suggests they are under surveillance, but only the viewer can decipher the rifles hidden in the fabric of the women's clothes, presumably to aid revolutionary forces. The dramatic transformation of iconography indicates a profound change in the community's concerns.

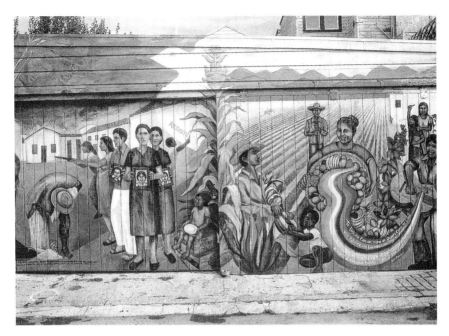

Figure 5.8. Miranda Bergman and O'Brien Thiele, *Culture Contains the Seeds of Resistance which Blossoms into Liberation*, 1984. Balmy Alley. Photograph by Vincent Leddy. Image courtesy of Miranda Bergman.

For many of the muralists, the conditions in Central America became a key theme, or part of a larger mandate for peace and against violence. For instance, in 1988, shortly after returning from a mural project in Nicaragua, Juana Alicia painted the powerful *Alto al Fuego* (*Ceasefire*) on the wall of Café Nidal on Mission Street. The mural shows a young boy in the fields with his book bag, volcanoes and mountains in the background, and sun radiating across the green and grassy landscape (Fig. 5.10). Along the bottom, four rifles point at the child, but they are blocked by two anonymous hands raised in a plea not to fire. When she redid the piece in 2002, Alicia made the work "a little darker, in more *chiaroscuro* tones, given the ongoing nature of its theme." Reflecting on this repainting, she wrote, "The wars in Central America had ended, but the U.S. government continued and continues to wage war in Palestine, Afghanistan and Iraq. Unfortunately, it is a piece whose time has come and gone and come again."[87] Juana Alicia produced dozens of murals in the Mission and elsewhere that urged viewers to see the vulnerability and value of human life and emphasized a call for peace.

Murals in Balmy Alley have changed over time, but often with heed to this 1984 call for peace. For instance, when the garage doors on which Nicole Emanuel

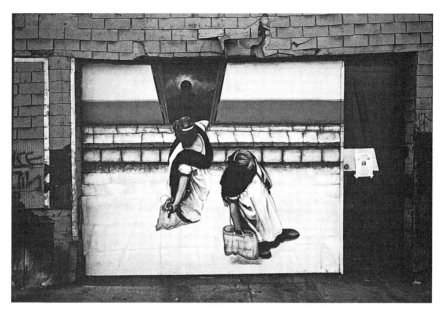

Figure 5.9. Ray Patlán and Francisco Camplís, *Camino al Mercado* (*On the Way to the Market*), Balmy Alley, San Francisco, c. 1984. Photograph by Tim Drescher. Image courtesy of Ray Patlán and the archive of Tim Drescher.

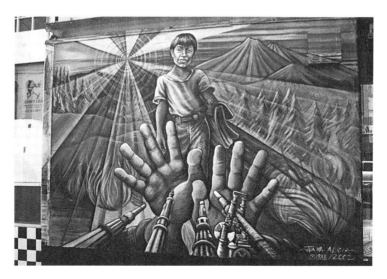

Figure 5.10. Juana Alicia, *Alto al Fuego* (*Ceasefire*), Politec and Novacolor acrylic mural on cement wall, 9 × 13 feet, Mission Street at 21st Street. Initially painted in 1988 and restored in 2002. A tagger sprayed the work in 2013, prompting the city to whitewash the wall in 2014, without consulting the artist. Image courtesy of Juana Alicia.

Figure 5.11. Susan Cervantes, *Indigenous Eyes: War or Peace*, 1991. This work exemplifies the change and continuity of Balmy Alley murals. Nicole Emanuel painted *Indigenous Beauty* as part of the PLACA painting of Balmy Alley in 1984. When residents replaced the garage doors, Susan Cervantes retained Emanuel's bountiful landscape as the frame, but changed the visual drama with her large-scale representation of a child's watchful gaze. Photograph by the author. Image courtesy of Susan Cervantes.

painted her 1984 mural *Indigenous Beauty* needed replacement in 1991, Susan Cervantes stepped in to paint a mural that could honor earlier intentions (Fig. 5.11). Emanuel's mural focused on the beauty of the Nicaraguan landscape and its people, but a soldier's shadow in the bottom left hinted at violence. Cervantes left Emanuel's frame in place, but also reimagined the work in her own style, renaming the work *Indigenous Eyes: War or Peace*. Inspired by a friend's photographs of Nicaraguan children, she painted a close-up of the eyes of a child. On the left, Cervantes mirrored the soldier as a *calavera* (skull), while on the right she offered hope with the symbol of a dove. This form of creative homage is still characteristic of Cervantes, who stated, "My thing is to preserve what was done before, to respect the effort that had gone into it."[88] In 1977, Susan and Luis Cervantes cofounded the Precita Eyes Muralists Association, a nonprofit that flourished under her leadership and gradually became the base of operations for many San Francisco muralists. Susan Cervantes's impulse toward preservation has proven an important force in the culture of Bay Area mural arts.

And while the mural movement may have seemed spontaneously local, the art reflected an extensive international network of communications and an expansive political consciousness. National and international publications

announced new murals and exchanged information on technological innova-
tions. San Francisco benefited when established artists, such as Ray Patlán of
Chicago and Susan Greene of New York, relocated to the city. Other locations
benefited from visits by San Francisco artists: Patricia Rodriguez worked in
Corpus Christi, Texas; Juana Alicia worked in Nicaragua; and Susan Cervantes
worked in Russia. The movement had global implications, with muralists trav-
eling around the world to exchange art and ideas.

A number of books and articles on the community mural movement have
developed helpful chronological essays, pinpointed artistic attribution, or
cheered overall accomplishments, but the lack of close readings of murals as
cultural texts is astonishing. Too often, the lowbrow origins of murals as "the
people's art" renders them significant only as transparent propaganda or eth-
nic pride. Laurance Hurlburt, in his homage to the superiority of the Mexican
muralists, declared, "However valid the murals of Third World countries (such
as Cuba, the Chile of Allende, Nicaragua) and North American urban ghettoes
may be as political commentary, they often entirely lack any esthetic concern,
and many are painted by 'artists' who have no formal artistic training."[89] Hurl-
burt's elitist attitude conveys how scholars devalue cultural texts such as *Latino
America* and *Homage to Siqueiros*.

Looking back, many of the works that emerged out of the Mission District
during the early 1970s used representations of Latin America to visualize an
idealized past. Over time, the idealization dissipated or grew more complicated,
since the ability to represent Latin America as a haven from the United States
lost its meaning as political strife intensified in those countries during the
late 1970s and 1980s. The paintings invoked an iconographic primitivism,
which was unable to survive the increasingly brutal human rights violations
in Latin America that escalated during the Reagan administration.[90] The aes-
thetic transformation underscored the ways the iconography of the community
mural movement shifted as artists struggled to deliver art meaningful to their
communities.

Examining these early murals provides a lens for understanding how com-
munity muralists looked to an idealized vision of Latin America as a means of
constructing, protecting, and unifying their neighborhood. Upon examination,
at least four common themes emerge. First, by generating a visually united
image of Latin America, community activists and artists sought to build cul-
tural ties in the United States that otherwise were complicated by diverse geo-
graphic, political, historical, and cultural borders. Second, the iconography of
Latin America provided a means to visually appropriate the local landscape
and subvert urban redevelopment plans likely to displace residents. Third, the
use of Latin American imagery countered traditional lines of U.S. education

and articulated alternatives to mainstream perceptions about history, identity, and culture. And fourth, uniting the local landscape with Latin America provided a means to criticize American foreign policy and simultaneously protest the manifestations of colonialism at home.

Jorge Mariscal passionately argued against the continuous replication of stereotypes that portrayed the early Chicano movement as narrowly nationalist, separatist, and riddled with sexism. These murals serve as useful lenses for developing a more concrete understanding of the "competing political agendas" and shared ideologies that characterized the movement and its cultural production.[91] Though the artists of *Homage to Siqueiros* and *Latino America* were predominantly Chicanos, their iconography suggested far more expansive pan-Latino references, in keeping with the diversity of Mission District residents and their work is deserving of more considered analysis.

By visually representing the history, significance, and cultural influence of Latin America in public spaces, artists and community leaders wrestled for pride, social control, political power, and community identity. Over time, the landscape and cultural production of the Mission District grew to represent, both physically and symbolically, a vast expanse of Latino cultural traditions rooted in the multiple histories of Latin America and the United States. Even though the images of Latin America changed over time, the intent stayed the same: muralists hoped to educate, politicize, and build solidarity. Neighborhood murals conveyed ideologies that the artists consciously and subconsciously presumed central to a pan-Latino identity.

In the Mission, the murals offered a powerful backdrop to the political and artistic activities taking hold of the neighborhood. In so many ways, the community mural movement built a space for the political actions to come.

The Mission in Nicaragua:
San Francisco Poets Go to War

This shared cement ground
Surrounded by a sweet shop
A fast food store and four bus stops
Was renamed by
WE THE PEOPLE
From a radius of twenty miles or so
"Plaza Sandino"
—Nina Serrano

In the late 1970s, a community of poet-activists rechristened their usual gathering spot, the plaza above the BART station at 24th and Mission Streets, as Plaza Sandino. Their literary seizure of the land in the name of Nicaraguan peasant hero Augusto Sandino (1893–1934) signaled the ways this public space in San Francisco had become a meaningful place to express solidarity with the leftist struggles in Nicaragua and elsewhere.

Landmarks like Plaza Sandino and the broader Latinizing of urban space whittled away any sense of difference across the Americas. In *The Medicine of Memory* poet-activist Alejandro Murguía described how the neighborhood zeitgeist transformed his identity. In 1971, after reading Gabriel García Márquez's *One Hundred Years of Solitude*, he stated, "Suddenly we reinterpreted our existence, we were no longer exiled in the cold north, in the pale United States. We transposed our Latino roots from Central America, land of volcanoes and revolutions; from the Caribbean, land of palm trees and salsa music, and from Aztlán, land of lowriders and *vatos locos,* and fused these tropicalized visions to our barrio and made the concrete sidewalks, the asphalt streets, and the sterile buildings sway to a Latin beat."[1]

Poet Roberto Vargas described the mood of the barrio as follows: "The Mission is now aware of itself as a body of many people, all tribes aware of themselves. . . . There is a collective feeling of compassion for each other Nicas Blacks Chicanos Chilenos oppressed Indios. The sense of collective survival, histories full of Somozas Wounded Knees written on the walls: Muera Somoza Free Angela."[2] Vargas poetically united diverse groups and struggles. His words brought together the war to overthrow the Somoza family dictatorship in Nicaragua with the battles at Wounded Knee and the fight to free U.S. activist Angela Davis. His words echoed the internationalist spirit of community organizing in the 1970s Mission District.[3]

Drawing on revolutionary struggles around the globe became a key means for cultural workers to advocate for revolutionary change at home. Nina Serrano's poem "I Saw It Myself on the Corner of Mission and Twenty-Fourth Streets" illustrates the ways that protests at Plaza Sandino collapsed transnational struggles into a single vision for change. Marking the ceremonial nature of the protests, she wrote:

We chanted/incanted
circling circling
circling circling
"Pinochet Romero
Y Somoza
Son La Misma Cosa"
And it was raining

We chanted/incanted
circling circling
circling circling
"se siente
se siente
Sandino esta presente"
And it was raining
Ending a three year drought.

I saw it myself on the corner
Of Mission and Twenty-Fourth streets[4]

According to the poem, "Pinochet, Romero, y Somoza Son La Misma Cosa" (are the same thing). For Serrano and many others, the dictatorial heads of Chile, El Salvador, and Nicaragua (Augusto Pinochet, Carlos Humberto

Romero, and Anastasio Somoza Debayle) presented a single oppressive entity. The brutality of these U.S.-sponsored, right-wing regimes generated a global solidarity movement critical of U.S. politics and supportive of left-leaning guerrilla mobilizations.[5] Simultaneously, Serrano's poem celebrated the presence of Augusto Sandino ("*Sandino esta presente*"/ [Sandino Is Present]), the heroic antithesis of these regimes, the soldier for the underdog, whose magical presence in the rain suggests an almost saintly ability to end drought and dictatorship. In the poem, Sandino symbolized hope for another way of life not just in Nicaragua, but everywhere, and perhaps especially in the Mission.

In the 1970s, the evolving politics of Chile, El Salvador, and Nicaragua played a pivotal role in the construction of Latino art and activism in San Francisco. While political struggles in these countries diverged in important ways, key concerns about sovereignty, the distribution of wealth, and respect for human rights led cultural workers like Nina Serrano to see the situations as "*la misma cosa*." For example, the devastating impact of the 1973 U.S.-sponsored right-wing military coup in Chile dramatically illustrated what was at stake in Nicaragua and El Salvador.[6] The repressive regime in Chile mobilized Bay Area activists into more passionate support for the guerrilla struggles in Nicaragua. Similarly, San Francisco political actions in support of the Sandinistas in Nicaragua propelled a wave of parallel actions in support of the FMLN in El Salvador. This understanding of each of these situations as part of the same struggle profoundly shaped local Latino cultural production, from filmmaking, to poetry, to the visual arts. Artists and activists found themselves supporting political causes that changed how they saw the world and how they defined themselves. To say cultural workers viewed these struggles as exactly the same is too simplistic. However, recognizing their interrelationship is relevant to understanding the development of a Latino arts movement in San Francisco, and how that movement reverberated nationally and transnationally. The shared sense of struggle and the transnational cross-pollination of ideas contributed to a Latino and leftist cultural front rooted in San Francisco's Mission District.

In many ways Nicaragua came to represent a place where the problems of the Mission could be solved. Especially from 1972 to 1979, San Francisco cultural workers mobilized to support Nicaragua's Frente Sandinista de Liberación Nacional (FSLN) as part and parcel of local community organizing. Pro-Sandinista sentiment flourished in San Francisco, not simply out of sympathy for Nicaraguans, but because cultural workers saw the situation abroad as part of the struggles defining life in the Mission. If the Sandinistas succeeded, Nicaragua promised to become a new and better Cuba, an amends for the loss of Chile in the 1973 coup, and a model for freedom and equality around the world, including within the United States. The activism of the Sandinistas articulated

the Marxist ideals of San Francisco cultural workers and expressed their dissatisfaction with U.S. capitalism from a front of their own, the Latino barrio of San Francisco. The parallels were ready-made, and the struggle was the same.

Presenting these strong ties between San Francisco and Nicaragua provides ample evidence of the cosmopolitanism of at least one barrio community. As Gina Pérez, Frank Guridy, and Adrian Burgos Jr. argue, "While racism, segregation, uneven development, and urban policy help to create barrios, the residents within them often develop and sustain important place-based networks that also transcend local and national boundaries."[7] The socially accepted disenfranchisement of barrio communities can naturalize representations of these spaces as insular and disconnected, but the transnational demographics of residents suggests otherwise.

Many San Francisco residents drew inspiration from the communist and socialist politics of Cuba and Chile. Transnational travel and communication networks emerged to disseminate these ideals, inspiring local residents to go abroad and encouraging influential cultural workers from abroad to come to the Mission. Residents traveled to Mexico to study mural-making and theater, visited Cuba as part of the Venceremos Brigade, campaigned in Chile for Salvador Allende, and attempted to rebuild Nicaragua after the 1972 earthquake. Simultaneously, cultural workers invited visits from prestigious international leaders, including Roque Dalton, Enrique Buenaventura, Ernesto Cardenal, and a host of others. At a time when, as Murguía complained, "the typical Anglo American couldn't find Nicaragua or Colombia on a map, even if it bit them in the ass," cultural workers in the Mission established an intimate and often romanticized relationship with Nicaragua.[8] The imagined Nicaragua circulated in San Francisco poetry, murals, and literature and sparked a leftist idealism. While many have heard of the Nuyorican poetry movement of the 1970s, few know that there was a similarly rich, transnational poetry movement evolving in San Francisco's Mission District.[9]

In order to document this largely unwritten history, I turn to three poets: Nina Serrano, Roberto Vargas, and Alejandro Murguía. None of the three was ever "just" a poet. Their expansive activities drew inspiration from a long line of Latin American revolutionary poets, including Cardenal, Dalton, Ruben Darío, and Pablo Neruda. All three participated in the Neighborhood Arts Program and became leading activists in the community. Together, they organized a long list of intersecting events—poetry readings, rallies, and demonstrations—all calling for revolution in Nicaragua. Murguía and Vargas even went to Nicaragua to join as soldiers in the struggle.

Notably, only one of the three—Vargas—is Nicaraguan. Murguía identifies as Chicano, originally from Los Angeles, and Serrano is a Colombian

American originally from New York. In various ways, the cultural workers of San Francisco drew attention to a struggle that encompassed both Nicaragua and the Mission in a much larger quest for revolutionary change.

The Nicaraguan City

Demographics helped forge the city's strong solidarity movement with the Sandinistas. The city's large Nicaraguan-American population grew in tandem with Pacific Coast trade routes established in the late 1800s, particularly owing to the coffee industry. In addition, a large influx of Nicaraguans came to the city just prior to, or in the wake of, the 1934 assassination of revolutionary leader Augusto Sandino. Most were sympathetic or active supporters of Sandino. The ensuing rise to power of right-wing dictator Somoza prohibited a return to their home country for the next forty years. This was the case for poet Roberto Vargas, whose family "came in the human wave fleeing the brutality of the Somoza regime."[10] These earlier communities helped establish strong neighborhood migration networks, such that revolutionary priest Ernesto Cardenal later nicknamed San Francisco "la ciudad de los nicaragüenses" (the Nicaraguan city).[11]

The passage of the 1965 Immigration Act and growing political turbulence increased migrations over the course of the 1970s. As Brian Godfrey pointed out, by 1988, "San Francisco [had] come to be a major center of Central Americans in the United States."[12] Gradually, increasing migrations from Central America over the last half of the twentieth century challenged Mexican and Mexican American majorities in the West and Southwest and Puerto Rican, Cuban, and Dominican majorities in the Southeast and New England, forging an often unrecognized redefinition of Latinos in the United States. As Arturo Arias discussed, "Central American-Americans are a group doubly marginalized in 'our' overall understanding, if not imagined space, of what Latinos and Latinoness constitute in the United States."[13] The narrative of Nicaraguan solidarity in San Francisco provides a valuable lens for viewing this shift in Latinoness across the nation.

Ties between San Francisco and Nicaragua solidified when a devastating earthquake tore Managua apart on December 23, 1972. The disaster took the lives of up to 20,000 people and destroyed more than three-quarters of the city's housing and businesses.[14] San Francisco cultural workers sought to make a difference through fundraising—for instance, Vargas and a handful of activist Nicaraguan exiles started the Comité Cívico Latinoamericano Pro-Liberación de Nicaragua to send aid. Murguía described the membership of El Comité Cívico as the convergence of older anti-Somoza exiles with younger Nicaraguans born in the United States.[15] Once established, El Comité Cívico organized rallies, po-

etry readings, lectures, and even produced radio and television shows.[16] Rapidly, the group became a powerful organizing force in the Mission and in Nicaragua.

Significantly, the earthquake also revealed the scale of Somoza corruption to the world, since most of the international aid never left government coffers. Stuart Kallen reported that "although Nicaragua received more than $100 million in international aid for earthquake relief, very little went to the suffering of the poor."[17] The 1972 earthquake proved a turning point, or as Thomas Walker noted, "the beginning of the end" for the Somoza regime. By the mid-1970s, Walker added, "Somoza stood out as one of the worst human rights violators in the Western hemisphere."[18] Matilde Zimmerman argued that the earthquake is overestimated as a turning point, but did acknowledge that "the aftermath of the earthquake did exacerbate real economic and political conflicts between the Somoza family and other sections of the Nicaraguan bourgeoisie."[19] For Zimmerman, focusing only on the disaster obscured the earlier history of Sandinista organizing.

The guerrilla Sandinista Front promised a radical social revolution. While the FSLN struggled with internal divisions, its ideology promised social justice for the masses. According to Carlos Fonseca, who later earned the title "Supreme Commander" of the Nicaraguan revolution, "The question is not only to bring about a change of the man in power, but to transform the system, to overthrow the exploiting classes and achieve the victory of the exploited."[20] In 1978, the FSLN published a list of twenty-five objectives that clearly established its revolutionary ambitions: to redistribute land, create an agrarian revolution, enhance labor conditions, control prices, enhance public transportation, provide utilities to rural areas, develop decent housing, provide free medical assistance and education to all in need, politically incorporate indigenous communities, protect natural resources, eliminate torture and political assassinations, encourage free speech, and end discrimination against women.[21] Such social reform perfectly intersected with the ideals of community organizers in San Francisco.

In the late 1960s, San Francisco's activism encompassed intersecting issues, from the Native American takeover at Alcatraz and the controversial trial of Los Siete de la Raza to the Third World Strike at San Francisco State University and the Black Panther breakfast programs. Significantly, protests against the war in Vietnam had produced a community suspicious of U.S. Cold War interventions and anticommunist propaganda. Of course, many of the student protest movements of the late 1960s grew out of a longer history of radical and leftist politics in the Bay Area.[22] Wilma Mankiller, a former resident of the Mission and subsequent chief of the Cherokee nation, writes that, "by the time the 1960s were underway, any self-respecting radical, nonconformist, or renegade knew the place to be was San Francisco."[23] Not surprisingly, art and politics went hand in

hand; the city produced a multitude of posters, murals, and artistic interventions in support of these issues. As such, support for the Sandinistas in Nicaragua indicated a more expansive cultural milieu.

San Francisco support for the Sandinistas swelled as migration from Nicaragua increased. Poet Cardenal, who later became the revolution's minister of culture, described how the cultures of San Francisco and Nicaragua merged in the Mission:

> Como los puertorriqueños en Nueva York, los cubanos en Miami, y los mexicanos en Los Ángeles, eran los nicaragüenses en San Francisco. La calle Mission era la calle de los nicas; allí estaban los restaurantes y bares nicaragüenses, se vendía La Prensa de Managua, se bebía cerveza nicaragüense. Y allí había una oficina del Frente Sandinista: con la bandera rojinegra, retrato de Sandino, pósters revolucionarios; bajo la vigilancia y amenaza del FBI y de la CIA.

> Like the Puerto Ricans in New York, the Cubans in Miami, and the Mexicans in Los Angeles, it was the Nicaraguans in San Francisco. Mission Street was the street of the Nicaraguans; there were Nicaraguan restaurants and bars, they sold Managua's newspaper La Prensa, they drank Nicaraguan beer. And there was even an office of the Sandinista Front: with the red and black flag, portrait of Sandino, revolutionary posters; under the threat and surveillance of the FBI and CIA.[24]

Nicaraguan restaurants, merchants, and community spaces, including a base for the FSLN, altered the Mission landscape and culture. As Serrano recalled, at the urging of her friend Vargas, "I went down to the Sandinista headquarters . . . right off Valencia Street . . . and met all the *compañeros*, who barely, almost all exiles, barely spoke English. . . . They wanted me to help them with organizing a group to speak to the American people about Nicaragua, and to stop U.S. intervention in Nicaragua. And as a result, I helped to form NIN—Non-Intervention in Nicaragua." Serrano added that her recruitment efforts largely consisted of organizing "the only people I knew, which were all the poets."[25] As Serrano's story illustrates, the physical presence of Sandinista organizations had a radicalizing effect on the neighborhood.

One reporter later stated, "There is a quasi-joke among certain sectors here that half the Nicaraguan revolution was planned in back rooms around Mission Street."[26] It was hardly a joke. According to Cardenal, "*La célula sandinista de San Francisco era la más importante de los Estados Unidos*" (The Sandinista cell in San Francisco was the most important in the United States).[27] Obviously,

organizing for the Sandinistas was safer in San Francisco than it was in Nicaragua. Former soldier Walter Ferreti stated that "the FSLN could operate in the U.S., could make demonstrations, and could publicly expose the cruelties of the Somoza dictatorship. We had an office and made propaganda against the regime."[28] Protections of free speech and free assembly facilitated San Francisco support for the Nicaraguan revolution. The Mission subsequently served as a second home to various high-profile revolutionaries, including Ferreti, Casimiro Sotelo, Raúl Venerio, Lygia Venerio, and Bérman Zúniga.[29] The cultivation of this relationship between San Francisco and the Sandinistas resulted in a sometimes covert and reciprocal intimacy.

FBI infiltration and surveillance intruded on this relationship. Ferreti reported, "Of course, the office was vandalized, the printing press was broken, and the files stolen. To this day we don't know if this was done by Somoza's agents or by the FBI. And of course, those of us who worked there were stopped in the streets or in our cars by the police. They would ask us where we were going and what we were doing. They would call us 'communists' and tell us to go back to Nicaragua."[30] Regardless of official U.S. or Nicaraguan interventions, San Francisco proved a key location from which to support a revolution.

"Stoned on Liberation and Love at the Risk of Seeming Ridiculous"

The sense of being part of the same struggle, "*la misma cosa*," profoundly shaped local Latino cultural production. Cultural workers like Roberto Vargas, Nina Serrano, and Alejandro Murgía supported the revolution in Nicaragua as part of a larger internationalist vision of liberation. In 1975, Vargas called on his fellow residents to support the Sandinistas in *El Tecolote*: "Being in the belly of the U.S. monster, we can help bring about a real change in Nicaragua. . . . From San Francisco, we can provide moral and material support to Nicaraguans struggling against U.S. imperialism." His phrase "being in the belly of the U.S. monster" was a subtle way for Vargas to connect his efforts to the work of Cuban revolutionary José Martí (1853–1895), who described his life of exile in New York as existing "*en las entrañas del monstruo*" (inside the monster).[31] The reference enabled Vargas to unite the revolutionary struggles in Nicaragua and Cuba. He also invoked Martí's call for a unified Latin America in response to U.S. empire building. In a widely circulated 1891 article "Our America," Martí urged Latin Americans to "form ranks lest the seven-league giant stride on! It is the hour of retribution, of the united march, and we must go forward in close formation, like silver in the roots of the Andes."[32] Vargas echoed Martí, declaring that "every Latino has the responsibility to work toward the liberation of

our people. There is no neutral or middle ground, and we must join the struggle."[33] There was perhaps a small but important difference between the two, since instead of calling for the joining of Latin American nations, Vargas called for the joining of all Latinos, especially those living in the United States and most particularly those in San Francisco.

That this pan-Latino perspective pervaded the neighborhood is evident in the newspapers, the poetry, and the culture. For instance, *El Tecolote* amplified Vargas's call for action with an accompanying three-page "special report" on "Nicaragua: Its People, History, Politics, and Economy." The article provided a brief summary of U.S.-Nicaraguan relations, describing past and current U.S. interventions, U.S. investments ("$34.2 million in AID loans"), and Nicaraguan poverty. The article highlighted the lack of education ("only 5% reach the sixth grade") and poor life expectancy ("50% of the deaths occur in children under the age of 14"). In a sidebar editorial, *El Tecolote* staff declared firm agreement with Vargas, stating, "In doing research for this article, two themes have come up consistently: U.S. intervention, whether direct or indirect, which clearly has been used to the detriment of the Nicaraguan people, and their courageous and continuous struggle for control over their own lives and country. As Latinos we are part of this same struggle. It is important to show our solidarity with the progressive struggles of all people and to support them in any way we can."[34] Alongside these articles appeared a photograph of anti-Somoza graffiti in the Mission, labeled "Wall-writing in the Mission," along with a graphic of protestors carrying a banner declaring, "*basta ya de Somosas!*" In depicting the "*Muera Somoza*" (Die Somoza) graffiti, *El Tecolote* showed the outrage and solidarity of the neighborhood and affirmed its political convictions as part of the neighborhood's struggle.

The ideology of transnational liberation shaped the neighborhood's cultural production, defined what it meant to be Latino, and contributed to the ways that action abroad and at home merged. Vargas, born in Nicaragua but raised in San Francisco, dedicated himself to bringing revolution to both places. Vargas writes in a "prefatory poem" to his book *Nicaragua: Yo Te Canto Besos Balas y Sueños de Libertad*:

I am mounted on a procestoro
called revolución on 2 planes (Mission)
(Managua) expressions multiplied/complicated . . .[35]

I sing you
BESOS BALAS Y SUEÑOS (Kisses Bullets and
 Dreams)

DESDE ACA!	(From here)
GLORIA ETERNA A	(Eternal glory to)
TODOS NUESTROS HEROES Y MARTIRES	(All our heroes and martyrs)
VIVA NICARAGUA LIBRE!	(Long live free Nicaragua)
VIVA EL FRENTE SANDINISTA	(Long live the Sandinista Front)
DE LIBERACION NACIONAL	
PATRIA LIBRE O MORIR[36]	(Free Nicaragua or death)

As this poem suggests, Vargas saw his fight for the Mission and for Nicaragua as two fronts of the same war. For Vargas, "Nicamerica" poetically expressed the ideological linkage of these two places so far apart, so different, and yet not.

Vargas turned to poetry as a meaningful tool of self-expression, as an aid to combat colonizing histories and pedagogies, and as a voice to organize and redefine communities. His 1971 book of poems, *Primeros Cantos*, assembled a series of socially conscious poems critical of capitalism. Poems such as "Elegy Pa Esso," "They Blamed It on Reds," and "Elegy *Pa Gringolandia*" ridiculed American love for the dollar. In "Elegy *Pa Gringolandia*," Vargas fantasizes about the death of capitalism:

It seems . . . just the other day
The *Wall Street Journal* (His Masters voice)
Chanted extreme Unction rites
To the tinkle of a no-sale cash register
In the belly of the Stock-Exchange
Amerikka Hemmoraged internally
And died . . . Of an overdose of Hate
(Did they blame it on reds?) (O say
 can you
 see . . .)

It seems . . . just the other day
A new world . . . began . . . again
Chepito in Nicaraguan natural
Sticking life to drumskin
Splashing Tim-Timbale voodoo

On Santana's Mayan/pocho/Afro
Sinfonia (Jingo-Jingova)
And today the new children
Are STONED on Liberation
> And love. . . . (At the risk of
>> of seeming
> Ridiculous . . .)

For Vargas, the death of "Amerikka" birthed true liberation, a world return-
ing to a mestizo culture of pounding drums and natural incantations of love.
His dramatic reading of the poem, very much akin to the spoken-word style of
Beat and Nuyorican poets, sounded emphatically musical, playing with tempo
and singing certain phrases ("o say can you see" and "jingo jingova").[37] The
poem captured Vargas's idyllic hopes. "Amerikka" might practice egregious fi-
nancial activities ("in the belly of the Stock-Exchange"), but people have an-
other choice: fight for liberation and love.

Readers versed in revolutionary literature will recognize Vargas's ideologi-
cal inspirations. For instance, he used the line "stoned on liberation and love
at the risk of seeming ridiculous" as a call to risk being passionate about the
world. Like love, liberation induces a drug-like high, a sense of purpose, and a
willingness to sacrifice one's self for the sake of something more profound. But
the line also referred to the writings of Cuban revolutionary Ernesto "Che"
Guevara, who famously stated, "Let me say, with the risk of appearing ridicu-
lous, that the true revolutionary is guided by strong feelings of love. It is im-
possible to think of an authentic revolutionary without this quality."[38] As his
poetry evinced, Vargas sought to be an authentic revolutionary, especially by
drawing inspiration from the writings of Guevara and Martí. Vargas was not
alone in this regard. As George Mariscal pointed out, "By the time of the first
Chicano Youth Liberation Conference in March of 1969, the image of Che had
become a staple at most Movimiento gatherings."[39] Guevara's writings also
proved inspirational for the Black Panthers.[40] In embracing this phrase from
Guevara, Vargas aligned himself with a larger sphere of resistance.

More practically, Vargas sought to turn his writing into action. Thus, as
Murguía noted, "Roberto took the concept of organizer and expanded it to mean
everything: organizer of poetry readings, writing workshops, film and theater
projects, community dances, and eventually even political marches and rallies
for Nicaragua."[41] Vargas's many activities can be read as "*la misma cosa*," all
endeavoring to radicalize the neighborhood and beyond, in hopes of creating a
world of liberation and love. In 1974, Vargas cofounded the *Gaceta Sandinista*,
a San Francisco Spanish-language newspaper dedicated to covering the strug-

gle in Nicaragua. The fact that San Francisco became the home of the only newspaper in the United States devoted to the Sandinista cause is illustrative of the Bay Area culture.[42]

The newspaper's editorial staff reads like a list of Sandinista soldiers, including Vargas, Ferreti, Sotelo, and Venerio Jr., all in San Francisco, while another set of "reporters" served in Los Angeles.[43] Nina Serrano reported that Ferreti, an exiled member of the Nicaraguan student movement whose uncle had fought with Sandino, found work as a cook and waiter in local high-end hotels, but otherwise spent his energies directing and distributing *Gaceta Sandinista*. In fact, all the reporters contributed a portion of their salaries toward maintaining an office on Bartlett Street between 22nd and Mission streets, which served as an all-around base of operations for the community.[44]

The newspaper provided information in a way that would have been impossible within Nicaragua without serious repercussions from the government. Much of the reportage focused on the conditions of political prisoners, the government's repressive violence and corruption, and successful FSLN actions. The newspaper was one facet of increasingly powerful community organizing in the Mission.

In fact, *Gaceta Sandinista* signaled a dramatic expansion of independent publishing in the city. Alejandro Murguía's experience conveys the close ties that existed between *Gaceta Sandinista* and the various Third World publishing collectives that had mobilized throughout the city. After moving to San Francisco from Los Angeles in 1971, Murguía joined Editorial Pocho-Che, an organization first started in 1968 to serve the publishing needs of Latino writers and artists.[45] He also cofounded Third World Communications in 1972 and the Third World Poetry Series at San Francisco State in 1974.[46] As a writer, editor, and organizer, Murguía had a hand in bringing various projects to publication, including *Time to Greez!: Incantations from the Third World* (1975) and a series of chapbooks that included the work of José Montoya, Roberto Vargas, Raúl Salinas, and Nina Serrano.[47] As Murguía's repertoire expanded, he also became an editor for *Gaceta Sandinista* and the official Bay Area FSLN representative. Not coincidentally, Editorial Pocho-Che became part of the publishing arm for *Gaceta Sandinista*.[48] The rise of these Third World publishing ventures reveals the internationalist spirit driving local support for the FSLN.

Relatively quickly, the revolution in Nicaragua stimulated Murguía's political and literary activism in the Mission. He first learned about Nicaragua through Vargas, who introduced him to the writings of Ernesto Cardenal in 1972.[49] He also remembered the rapid popularization of a mock "wanted" poster in the Mission featuring Anastasio Somoza Debayle with the line *"se busca"* (wanted) for murder, extortion, and robberies committed against the Nicaraguan people. Murguía later discovered that Casimiro Sotelo, a Nicaraguan

exile living in Burlingame as an architect and a member of el Comité Cívico, was responsible for circulating the poster.[50] Sotelo and other like-minded Nicaraguan exiles gave urgency and relevance to the political situation in faraway Nicaragua. As Murguía recalled in a 1981 article, "My own involvement started around 1974 when I had the privilege of meeting several patriotic Nicaraguans who told me of this tyrant Somoza who had ruled their country for 45 years and of their national hero who had fought the U.S. Marines back in the 1920s, Augusto Sandino."[51] It did not take much for Murguía to see Nicaragua as part of a larger struggle. As he wrote in the same article, "Nicaragua was a classic confrontation: a puppet regime installed and supported by the United States, challenged by a National Liberation Front. Vietnam in the western hemisphere."[52] Angered by the disaster of U.S. policy in Vietnam, Murguía saw it as imperative to engage with the struggle in Nicaragua.

In December 1974 a spectacular hostage event gave worldwide visibility to the Sandinista cause. Nine Sandinista soldiers raided an elite party in the home of the former minister of agriculture in honor of departing U.S. ambassador Turner Shelton (who had left by the time of the raid). The Sandinistas killed four and threatened to kill the remaining thirteen hostages if their demands were not met. Somoza consented to several demands, including a million-dollar ransom, an eighty-minute radio broadcast, the printing of a political manifesto in *La Prensa*, and the release of fourteen Sandinista prisoners, including Daniel Ortega Saavedra (later president of Nicaragua). Stephen Kinzer wrote that "the assault stunned and humiliated the Somoza dictatorship and gave the Sandinistas a reputation for audacity that attracted many new militants."[53]

The seizure of hostages also spurred a dramatic counterresponse. Zimmerman noted that "the government immediately declared a state of siege and launched a wave of repression that resulted in an estimated three thousand deaths . . . dropping bombs and napalm on settlements, burning peasant homes and fields, and disappearances, rapes, and incarceration in concentration camps."[54] Government repression escalated dramatically. News of the widespread human rights abuses and violence not only kindled more worldwide support for a new regime in Nicaragua but also spurred an exodus of Nicaraguans. Many exiles found a new home in the Mission, thereby adding to a diasporic community committed to eliminating Somoza from power.

In his memoir, Murguía recalled his first demonstration for the FSLN, likely in early January of 1975: "We carried these beautiful black-and-red posters of Sandino silk-screened by La Raza Silk Screen Center, and we waved them at passing traffic and stood outside El Tico-Nica bar exchanging insults with Somoza sympathizers"[55] (Fig. 6.1). The moment was captured in an *El Tecolote* photograph printed in June 1975, which showed a cheerful Murguía and Vargas

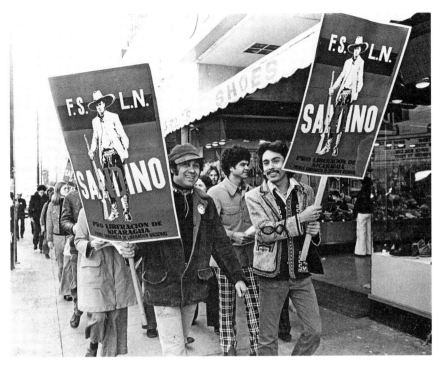

Figure 6.1. Roberto Vargas and Alejandro Murguía marching down Mission Street in support of the Sandinistas in 1975. Photograph by Alejandro Stuart. Image courtesy of Alejandro Murguía.

leading a crowd of protesters down Mission Street with their signs of support for the Sandinistas. The image also conveys how the posters from La Raza Silkscreen Center contributed to the visible solidarity of the movement. And while Murguía's recollection indicates that Somoza sympathizers did exist in the Mission, the thrust of community organizing was decidedly in favor of the Sandinistas.

Similarly, an *El Tecolote* photograph (Fig. 6.2) of a 1975 press conference in support of the FSLN is striking in its diverse representation: The image featured Black Panther member Angela Davis, FSLN soldier Casimiro Sotelo, poet-activist Roberto Vargas, and the charismatic Glide Church's Reverend Cecil Williams, a tireless advocate for one of San Francisco's most disenfranchised neighborhoods, the Tenderloin. By featuring Davis and Williams as key members of El Comité Cívico, the press conference visibly and emphatically showed that the fight for Nicaragua held relevance not just for Latinos, but also for African Americans and other struggling communities. By 1975, El Comité

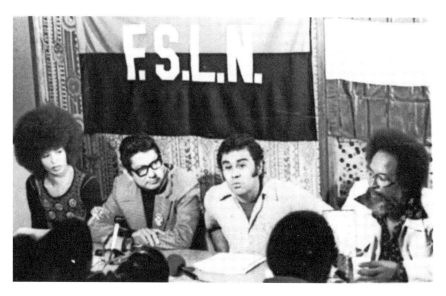

Figure 6.2. A press conference of members of El Comité Civico Pro-
Liberación de Nicaragua on September 10, 1975. From left to right are Angela
Davis, Casimiro Sotelo, Roberto Vargas, and Reverend Cecil Williams, 1975.
The image appeared in the October, 1975 issues of *El Tecolote* and *Gaceta
Sandinista*. Both Sotelo and Vargas became Nicaraguan ambassadors to the
United States after the Nicaraguan Revolution of 1979. Image courtesy of
Acción Latina / *El Tecolote* archive.

Cívico already had positioned itself as one piece of a much larger set of strug-
gles in the Bay Area, the nation, and abroad.

Local support for the Sandinista movement came to a head with the open-
ing of the Mission Cultural Center in 1977. The building was the result of a
decade-long battle between cultural workers and City Hall for neighborhood
arts centers. As Nina Serrano stated, *"Esto, que parecía ser un regalo era una
concesión para silenciar la creciente protesta de la comunidad por el costoso 'Da-
vies Hall' que se construiría pronto para beneficio de los gustos artísticos de los
sectores ricos y suburbanos"* (Though this building may have appeared like a gift,
it was really a concession to silence the growing community protest over the
cost of Davies Hall [Louise M. Davies Symphony Hall], which would be under
construction shortly to benefit the artistic tastes of wealthy suburbanites).[56]
San Francisco's investments in high-art institutions like the symphony, opera
house, and performing arts center spurred public calls for equivalent invest-
ment in low-income communities. After considerable protest, the city finally
agreed to fund neighborhood arts programs and cultural centers.[57]

Murguía, as the first director of the Mission Cultural Center, and Vargas and Serrano in their roles as community organizers, contributed to its political and artistic orientation.[58] That all three were calling for revolution in Nicaragua while calling for a cultural center in the Mission demonstrated the kind of ideological overlap between these seemingly disparate needs. Together, they were determined to create a place where residents could congregate, where art could be taught and shared, and where ideas could revolutionize the future of the barrio. Finding a good physical home for the center was critical to their agenda. With the help of the community, they transformed a long-neglected former furniture store on Mission Street into a cultural center. Their insistence on purchasing the building, as opposed to renting, contributed to the center's survival in an area where property values later increased astronomically.

To mark the opening of the Mission Cultural Center, Vargas, Murguía, and Serrano created an event that would reflect the institution's ideological future. They invited Sandinista poet Ernesto Cardenal to speak at the opening. Such an invitation clearly placed the Mission Cultural Center in solidarity with the Sandinistas and other like-minded struggles around the world. However, according to Serrano, not everyone was pleased: Another group threatened to block Cardenal's visit by interfering with a community election to support his visit, revealing a pivotal disagreement between cultural workers who sought to implement an internationalist perspective and others who demanded that the Mission Cultural Center reflect a strictly community-based focus.[59] These differences played out in the center's first election.

Those who disapproved of a Sandinista presence had city hall support. As Serrano recalled, "They had, with all of their funding, poverty pimps; they had youth on their payroll who they could give stipends to come to the meeting. And so they were going to pack the meeting with all these kids . . . who would vote."[60] News of the potential conflict spread, including to the office of *Gaceta Sandinista*. According to Serrano, "Just before it was time to vote, in walked the Sandinistas . . . seven of them. . . . Seven small men in military formation. And they marched in and they formed a military line and stood in silence. And the whole place went silent. And then we made our proposal, and we voted and no one knew if they were armed or not, and we voted and we won the election."[61] What is most remarkable about this story is imagining that the Sandinista soldiers served as electoral observers for their comrades/fellow residents in the United States.

Cardenal not only gave the inaugural address but, according to the Mission District's literary journal *Tin Tan*, also "baptized a group of children, in a very moving ceremony in which he called on the spirits of greed, capitalism, egoism and Somoza, to keep out of these children."[62] The event drew approximately

two thousand attendees.[63] His presence symbolized the hope for social change that cultural workers sought for the community.

Within a very short amount of time, the Mission Cultural Center became a hub of publishing, home to *Tin Tan*, *El Tecolote*, *El Pulgarcito*, and *La Gaceta Sandinista*. As poet Juan Felipe Herrera argues, the Mission District experienced a literary renaissance under the unobservant noses of San Francisco's major literary circles, who saw the neighborhood "as dangerous, noisy, and devoid of literary power and writing culture."[64] Indeed, the turmoil in Central America stirred a wave of creative energy in San Francisco's barrio, with poetry and politics spilling into the streets.

Taking Up Arms: Poets in the Revolution

By 1978, the Sandinista movement had widespread support in the Bay Area and throughout the United States, particularly as the Somoza regime seemed likely to topple. One publication pointed out the strength of this support in the presence of over twenty pro-Sandinista committees in just Washington, New York, Los Angeles, and San Francisco.[65] Emily K. Hobson has pointed out how gay and lesbian activists in San Francisco turned to this struggle as part of an anti-imperialist mobilization for social justice. According to Hobson, "Lesbian and gay leftists looked to Nicaragua as the site of a revolution they must defend, as an inspirational model for their own struggles, and as a vehicle for sexual liberation whose meaning could be glimpsed in women seizing arms."[66] In San Francisco, solidarity with the Sandinista struggle filtered into many aspects of life in the city, appearing regularly in the culture and the landscape. The Mission Cultural Center sponsored a "Week of Solidarity with the People of Nicaragua," consisting of films, music, and poetry. Events featured an impressive list of poets, including Victor Hernández Cruz, Diane di Prima, Jack Hirschman, Michael McClure, David Meltzer, Ricardo Mendoza, Janice Mirikitani, Ishmael Reed, and Alma Villanueva.[67] San Francisco's 24th Street BART station, or Plaza Sandino, saw nightly vigils and weekend rallies to call for the removal of Somoza.[68] As popular support for the Sandinistas increased, disapproval of U.S. policies in Central America grew.

Murguía's and Vargas's activism reflected increasing personal risk, from publishing and protesting to taking over the Nicaraguan consulate. Murguía recalled, "[We] took over the office, and expelled the consul and his staff. We held the office for a whole day before finally agreeing to withdraw."[69] Fellow cultural worker Roxanne Dunbar-Ortiz remembered the day: "I happened to be working that day in the Treaty Council office in the Flood Building at Powell and Market, which was on the floor below the Nicaraguan consulate. When I

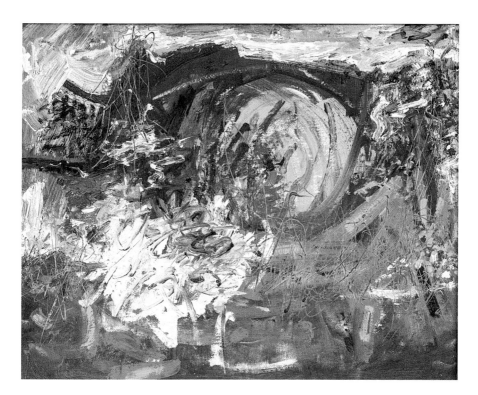

Plate 1. José Ramón Lerma, untitled landscape, 1956, oil on canvas, 17 × 21 inches. Photograph by Jed A. Jennings. Image courtesy of the artist, his family, and the private collection of Si Rosenthal and Emily Brewton Schilling.

Plate 2. José Ramón Lerma, untitled (Punchbowl), 1959, ink and pastel drawing, 22 × 17 inches. Collection of the author. Image courtesy of the artist and his family.

Plate 3. Luis Cervantes, *A Gift for the Darkness*, 1967, Politec acrylic paint on canvas, 66 × 66 inches. Cervantes sometimes opted to hang this series of mandala-style paintings tipped as diamonds rather than perpendicularly. Image courtesy of Susan Kelk Cervantes.

Plate 4. Carlos Loarca, *El Hombre Multiple* (*The Man of Multiples*), 1965, oil on canvas. Loarca showed the painting as a Casa Hispana de Bellas Artes contribution in the San Francisco Art Festival of 1967.

Plate 5. Yolanda M. López,
*Portrait of the Artist as the
Virgin of Guadalupe*, 1978, oil
pastel on paper, 22 × 30 inches.
Image courtesy of the artist.

Plate 6. Rupert García, *Down with the Whiteness*, 1969, silkscreen on white wove paper, 33 × 26 inches. Image courtesy of the artist and the Rena Bransten Gallery.

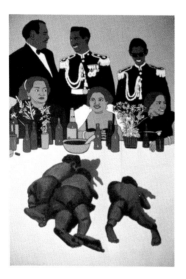

Plate 7. Juan Fuentes and Regina Mouton, *The Last Supper*, 1982. Painting created as part of the "Progress in Process," exhibition at the Galería de la Raza, May 4–June 12, 1982. Photograph by Yolanda López. Galería de la Raza Archives, CEMA 4. Image courtesy of the artist and the California Ethnic and Multicultural Archives, Department of Special Research Collections, UC Santa Barbara Library, University of California, Santa Barbara.

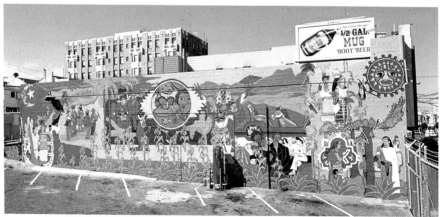

Plate 8. Las Mujeres Muralistas, *Latino America*, 1974, mural on Mission Street between 25th and 26th Streets, approximately 25 × 70 feet, destroyed. In this instance, Las Mujeres Muralistas consisted of Graciela Carrillo, Consuelo Mendez, Irene Pérez, and Patricia Rodriguez, with assistants Xochitl Nevel-Guerrero, Ester Hernandez, Miriam Olivas, and Tuti Rodriguez. Photograph by Eva Cockcroft. Image courtesy of Consuelo Mendez, Patricia Rodriguez, and the archive of Tim Drescher.

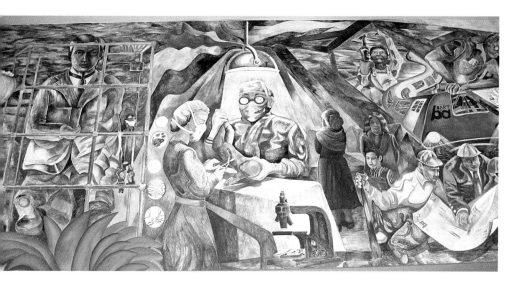

Plate 9. *Homage to Siqueiros*, right panel detail. Ruben Darío sits in a cage in a separate sphere from the birth of an infant. A BART (Bay Area Rapid Transit) train swoops down from above next to two artists sketching a black and white cartoon with another image of Siqueiros holding the atomic symbol. Photograph by author. Image courtesy of Andres and Sandra Campusano.

Plate 10. Romeo G. Osorio, untitled, 1983. Pencil and ink on rag paper. While in hiding in El Salvador, Osorio created this delicate drawing of minuscule hatch marks crossing a series of rectangular borders. A jarring red line cuts down the middle. Photograph by Robin MacLean. Image courtesy of the artist.

Plate 11. Enrique Chagoya, *Monument to the Missing Gods*, 1987, diptych, ceramic, raw clay, gold leaf, egg tempera, enamel, acrylic, and found objects. Each box is 9 × 14 × 3.5 inches. © Enrique Chagoya. When it was first exhibited, Chagoya incorporated painted black and red backgrounds that coordinated with the color of each box "to represent the opposite sides of knowledge in ancient Maya and Nahua mythology." Chagoya placed the boxes side by side with skulls on the left. Photograph by Wolfgang Dietze. Images courtesy of the artist.

Plate 12. Juan Pablo Gutiérrez, *AIDS / SIDA*, 1984, mixed media altar at Galería de la Raza. Photographer unknown. Galería de la Raza Archives, CEMA 4. Image courtesy of the artist and the California Ethnic and Multicultural Archives, Department of Special Research Collections, UC Santa Barbara Library, University of California, Santa Barbara.

Plate 13. Rio Yañez, *Ghetto Frida Returns*, 2006, digital art posted on Flickr.com. For his "Ghetto Frida" series, Yañez reimagined Frida Kahlo as a tough and confrontational "Original Gangsta" living in the Mission. In a mock interview accompanying this image, Kahlo declared, "I'm not a painter, I'm a gangster with paintbrushes." Image courtesy of the artist.

heard the racket, I walked upstairs and saw the small band wearing black-and-red scarves over their faces. Even so, I recognized Roberto and Alejandro." Amazingly, the authorities did not arrest anyone because they could not determine who had jurisdiction.[70] More than likely, Vargas and Murguía drew partial inspiration for their takeover from other media-savvy Sandinista political actions, such as the 1974 kidnappings.

In the Mission, as in Latin America, poets became not just figurative, but actual revolutionaries. As a Sandinista victory appeared increasingly imminent, Vargas and Murguía made the decision to join the fighting in the southern front. In fact, a team of sympathizers began training in the Bay Area hills. Murguía stated, "During the period between October 1978 and June 1979, I devoted full time to organizing solidarity committees across the United States in support of the Nicaraguan people, as well as editing the journal, *Gaceta Sandinista*. In June of 1979, along with the *compañeros* 'Armando' and 'Danilo,' I left for Costa Rica to join in the Final Offensive."[71] Murguía subsequently documented the fighting in two books: the fictional *The Southern Front* (1990) and the autobiographical *The Medicine of Memory* (2002).

In *The Southern Front*, Murguía drew together an amalgamation of his and others' experiences fighting for the Sandinistas through the trajectory of his central character, Ulises. Murguía's outlook on the war surfaces in the expressions of Ulises's thoughts, such as when he wrote, "He'd always believed that once in your life, without being drafted or impressed, you had to be willing to risk everything for what you believed was righteous, even beautiful, and you had to go to this battle with a pure heart and singing—and this was it for him, a clear-cut, well-defined little war."[72] The line purposefully evoked Che Guevara's call to be a true revolutionary, further emphasized by the fact that Ulises kept *El Diario del Che en Bolivia* in his pocket.[73] Ulises, and really, Murguía, followed in Guevara's footsteps in a battle that resembled the fight for Cuba. In an earlier version of *The Southern Front*, in a 1981 article published as "A Chicano Sandinista in Nicaragua," Murguía not only linked Ulises's commitment to the Sandinistas to a longer historical trajectory, placing it in parallel with the fight against Franco in 1930s Spain, he also critiqued the Chicano movement for insularity and apathy and urged a more transnational vision of activism. Murguía wrote:

You know, if I had done the 1930s thing, I would have joined the International Brigade that fought against the fascist in Spain. But as it was, I grew up during the Chicano Movement, the Crusade in Denver, the Youth Conferences, Reies Lopes [sic] Tijerina, Chicano Moratorium, Brown Berets and so on. I've been through all that Aztlan stuff, La Raza,

self determination, anti-imperialist, down with the gringos bullshit. So what better place to put up or shut up? I mean it's like really easy to be in your campus office with a Zapata poster on your wall and mouth rhetoric, but it's something else to take it to the trenches.[74]

Murguía showed little patience for empty rhetoric and suggested the true revolutionary "takes it to the trenches." The decision to go to war proved Murguía's and Vargas's commitment to their ideals in the tradition of Che Guevara. Others wrestled with this masculinist turn to military action.[75] The presence of widespread support for the Sandinistas in San Francisco did not mean there was agreement about the mode of revolution. Poet Nina Serrano's experience illustrates some of the complex gender dynamics and disharmonies that shaped the Nicaraguan solidarity movement in San Francisco.

The Pacifist Poet

As a pacifist, Serrano struggled with the militant rhetoric shaping activism for Nicaragua. A Colombian American originally from New York, she moved to San Francisco in 1961 with hopes of joining the Beat counterculture. Her love of theater and politics led her to become a writer for the San Francisco Mime Troupe. She also established her filmmaking career when she and her then husband, Saul Landau, produced *Que Hacer?* (*What Is to Be Done?*), a film supportive of the Allende government in Chile, which they released during the 1973 coup. Of the moment, Serrano recalled, "I made a pledge to devote myself to the cause of Chilean freedom and to try and use our film to help with that."[76] Still, she wrestled with turning to violence as a means to an end.

Serrano originally learned about the Nicaraguan struggle in 1969 while working on a play with Salvadoran poet Roque Dalton in Cuba, and it was his dangerous life that caused Serrano to meditate on the role of violence in pursuit of liberation. While she supported the struggle intellectually, her preference for nonviolence caused her enormous internal conflict. Serrano's poem, "To Roque Dalton Before Leaving to Fight in El Salvador (Havana, 1969)," indicated her ambivalence—loving this revolutionary figure who was already larger than life in the minds of many while sensing that his life would end tragically:

"Don't die," I whispered, in person.
Only the air and revolutionary slogans hung between us.
"When I die I'll wear a big smile."
And with his finger painted a clown's smile
on his Indian face

"Don't die!" the whisper beneath the call to battle.
My love of man in conflict
with my love for this man.[77]

Serrano found herself trapped in a catch-22, as she simultaneously sup-
ported "the call to battle," but also could not help but whisper, "don't die." Her
poem spun on the contradictory romance of revolution, as she found herself
caught between her values as an activist and as a humanist: "My love of man in
conflict/with my love for this man." In the poem, Dalton joked about his im-
pending death, making light of something that is pinned on "revolutionary slo-
gans." The ambivalence of the poem reflected how Serrano's pacifism tempered
her appreciation for revolution.

As a woman, Serrano struggled with her responsibilities in this male-
dominated culture of revolution. Her poem elicited the gendered lines of war:

Women die too.
They let go their tight grip on breath and sigh,
And sigh to die.
They say that Tania died before Che.
I saw her die in a Hollywood movie.
Her blood floated in the river.[78]

For Serrano, the implications were unclear. Women "die too," but they cer-
tainly did not attain the fame of their male counterparts. In the end of the poem,
she weighed her fate:

I stand by a puddle in Havana
A woman full of blood
Not yet spilled.
Can I spill blood by my own volition?
Now it flows from me by a call of the moon.
The moon . . .
 A woman mopping her balcony
 Spills water from her bucket
 On my hair, my breast
 And into the puddle.
The question is answered.[79]

Contemplating her role as a revolutionary, she posed the question, "Can I
spill blood by my own volition?" She used this question to change the direction

of the poem, moving suddenly from the blood of war, to the blood of life, using the metaphor of her menstrual cycle to affirm the giving of life over the taking of life. Her identification as a woman became a way of separating herself from the brutality of warfare. Significantly, her interest in the roles that men and women played in revolutionary struggles continued to shape her art.

In 1979, Serrano and Lourdes Portillo grappled with the gendered roles of revolution in *Después del Terremoto* (*After the Earthquake*), a short film depicting the experiences of a woman who migrated from Nicaragua to the Mission after the earthquake.[80] Portillo, who later directed multiple films, stated, "I was also involved in the Sandinista movement in the United States in the late seventies, in solidarity with them, Nina Serrano and I . . . we decided to make a film that would inform the people about the struggle."[81] The film drew inspiration from its Mission District setting, using familiar places and local residents to act the parts (including a cameo by Serrano). In their request for funding, they described the neighborhood as a place where "people walk, talk and 'visit' on the sidewalk," where "music can be heard emanating from car radios and transistors," and where "young people have painted street murals of history, culture and community problems."[82]

The film illustrates the ways that cultural workers pushed to radicalize the community and the ways that everyday life in the barrio often subsumed interest in such issues. Early in the film, Irene learns her former fiancé Julio is in San Francisco after suffering three years of torture by the Somoza regime. They meet again in the Mission, but they have become different people "after the earthquake" and are unable to reconnect romantically.

Irene works hard as a maid and dreams more about buying a television than about improving conditions in Nicaragua. However, her character is complex, since her experience as a working woman in the United States propels a feminist consciousness. She finds more sexual freedom and independence in San Francisco than she ever knew in Nicaragua, displayed by the first scene of Irene handling a book entitled *Vida Sexual: Prematrimonial* (*Premarital Sexual Life*). For Irene, the purchase of a television signifies her freedom as a woman. Irene tells Julio, "I think that a woman must be independent, as I am becoming. To show you, I've just bought a TV."[83] Portillo and Serrano represent Irene sympathetically, but also suggest the ways new migrants are co-opted by the glamour of American capitalism.

Julio, a passionate revolutionary, appears more in tune with the politics of the filmmakers, but his rabid approach alienates the people he tries to reach. At a birthday party, Julio initiates a slide show to recruit assistance for the revolution, not unlike slide shows organized by the Mission's Comité Cívico. Julio talks over the images of poverty: "This shack is a school in our beautiful country—a

country with thirty percent illiteracy. . . . This is a child dying of malnutrition. Yet, millions of dollars in U.S. aid are used by this corrupt dictator to buy arms and continue to keep our people under submission. This is an abuse of power. This is oppression." His audience is resistant. One woman responds, "For this stupidity the Immigration Department can deport us!" while another states, "We know all this, but we are not there, we are here." The responses echoed popular sentiments in the neighborhood. The filmmakers, like Julio, were invested in transnational action, but they also empathized with the fears and concerns of new migrants and low-income residents.[84]

According to Portillo, the decision to fictionalize the representation of Nicaraguan exiles in the Mission provoked a mixed response. Portillo recalled, "I didn't want to make a film that was a documentary—a straight, hard-hitting factual documentary. And I saw the richness of their life and I wanted to capture it. At the same time, when I did that, it was a struggle against them [the Sandinista movement in the United States] and they disowned us in the process. . . . They wanted us to do a documentary . . . very factual, very political, very one-sided."[85]

El Tecolote offered evidence of this preference for nonfiction in its 1979 review of the film *Patria Libre o Morir*, a documentary to support the FSLN, which played to "a standing room only crowd at the Mission Cultural Center."[86] Notably, the realism of the documentary style tended to favor a masculine orientation of the struggle, largely focusing on the fighting, which rendered women's lives and responses relatively invisible. Serrano's and Portillo's film presented an unusual focus on a female Nicaraguan exile, when so many of the expressions of solidarity embraced a Che Guevara vision of revolution.

Portillo added that some did not find the film radical enough. Criticized by those who might be most sympathetic, the film encountered even stronger disapproval in the industry, as it was unable to secure distribution in the United States, more than likely for the picture it painted of U.S. foreign policy.[87] The censorship underscores the ways that political sympathies in San Francisco did not reflect the U.S. mainstream.

In 1979, the year that *Después del Terremoto* was released, the dreams of the FSLN and of San Francisco cultural workers came to fruition. After weeks of military advances, the FSLN took over the capital city of Managua on July 17, 1979. President Somoza fled to the United States, then Paraguay, while the Sandinista government declared the revolution a success. The dramatic change in leadership catalyzed a pervasive hopefulness for the left. Alejandro Murguía described the months leading up to that moment:

Durante los meses de mayo, junio y julio de 1979, miles y miles de nicaragüenses, latinoamericanos, chicanos, indígenas y norteamericanos

progresistas se lanzaron a las calles de importantes ciudades de EUA tales como San Francisco, Los Angeles, Seattle, Tucson, Nueva York y Washington DC, en apoyo a la ofensiva final que traería a Nicaragua su largamente esperada liberación.

During May, June, and July of 1979, thousands and thousands of Nicaraguans, Latin Americans, Chicanos, indigenous peoples, and North American progressives stormed out into the streets of cities in the United States, such as San Francisco, Los Angeles, Seattle, Tucson, New York, and Washington, D.C., in support of the final offensive that brought Nicaragua its long awaited liberation.[88]

The promise of Nicaragua spoke to the dreams of thousands of people in the United States. Artists marked the victory of the Sandinistas into the Mission District landscape with a mural on Casa Nicaragua (Fig. 6.3). Located at 24th Street and Balmy Alley, near a growing collection of neighborhood murals, the building served as a gathering place, gallery, and information source for the

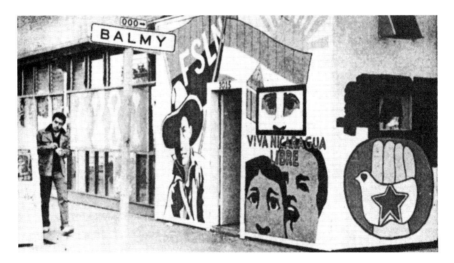

Figure 6.3. Artists Francisco Letelier, Jose Letelier, René Castro, and Bethan Cagri worked together as the Brigada Orlando Letelier to paint this mural on Casa Nicaragua, at the corner of Balmy Alley and 24th Street. Juan Pablo Letelier, Cristian Letelier, and Jose Labarca also assisted in the project, making this the only mural worked on by all four children of Chilean diplomat Orlando Letelier, who was famously assassinated in Washington, D.C. This photograph appeared in the March, 1981 issue of *El Tecolote*. Image courtesy of Francisco Letelier and Acción Latina / *El Tecolote* archive.

The Mission in Nicaragua 175

Nicaraguan leftist community in San Francisco. The mural illustrated how Bay Area cultural workers viewed the struggles in Chile and Nicaragua as "*la misma cosa*." The art covered the building and featured "Chilean and Nicaraguan symbols beneath a handshake of support between the two countries."[89] The linkage reflected the political concerns of the four mostly Chilean artists, known collectively as the Brigada Orlando Letelier, in honor of the Chilean diplomat assassinated in Washington, D.C., in 1976. Letelier's two sons, Francisco and José, painted the mural with René Castro, another exiled Chilean artist, and Beyhan Cagri. The mural resembled the "flat style" of murals that decorated Chile during the Salvador Allende government, which the Pinochet government sought to eradicate. The artists were completing the mural in the summer of 1979, just as the Sandinistas overthrew the Somoza government, so its creation also served as a visual celebration of the victory.[90]

After the Revolution

After the revolution, the cultural exchange between San Francisco cultural workers and the Sandinistas continued to flourish. Murals proved a popular import into the new Nicaragua, particularly with Ernesto Cardenal as minister of culture. As art historian David Kunzle noted, "In the decade of Sandinista rule following the Triumph of the Nicaraguan revolution in 1979, close to three hundred murals were created in a tiny, poor country of three million or so inhabitants."[91] Among the Bay Area muralists to travel to Nicaragua were the Brigada Orlando Letelier, Miranda Bergman, Juana Alicia, and Susan Greene. The exchanges had a profound impact on the artists. Greene wrote of her experience, "I saw what underdevelopment in Central America looks and feels like; and I witnessed how hard the Nicaraguan people are working to change their country. For example, 400,000 adults have been taught to read since 1979. . . . Through the experience of living and working in Nicaragua, solidarity now has the faces and words of friends. . . . ¡*Sandino Vive!*"[92]

The 1979 triumph of the Sandinistas prompted a shift in the direction of migration, as the new Nicaraguan government invited its U.S. supporters to participate in the revolution. Roberto Vargas and Casimiro Sotelo, both from the Mission, became Nicaraguan ambassadors. Nina Serrano's intimate connections with the country led her to translate Nicaraguan poetry and cofound Friends of Nicaraguan Culture. Both of Serrano's children left the Bay Area to live in Nicaragua for extended periods of time. As she stated, "For the next many years, many, many years, we produced international cultural exchanges, including music, art, theater, and interchanges of travel—interchange between American artists and Nicaraguan artists."[93] Roxanne Dunbar-Ortiz described

the Nicaragua of 1981 this way: "Poetry was in the air and everywhere—workshops and literacy training just for the purpose of being able to write poetry. It was a national obsession, writing poetry. But the contents of the poems were brave, not confessional, meant to bolster weakened spirits. Bravado poems, I called them."[94] An expansive energy of cultural production reigned in Nicaragua immediately after the revolution. It was a brief but profoundly exciting cultural renaissance that celebrated a major victory in the war against "*la misma cosa.*"

Of course, this story did not end in the way that cultural workers hoped. The Sandinistas could not deliver the utopian vision that had attracted supporters. This, combined with U.S. intervention, precipitated the fall of the Sandinista regime in the 1990 election. As Gary Prevost and Harry Vanden stated, Reagan's Contra war "took 30,000 Nicaraguan lives, cost more than $12 billion in damages and bankrupted the Nicaraguan treasury."[95] The magnitude of U.S. military and diplomatic forces ensured the election of a presidential candidate who would protect U.S. interests. Serrano "was totally disheartened when they lost the election. It just was very, very painful."[96] Murguía felt angry: "After ten-plus years of a democratic-capitalist government . . . Nicaragua is now the poorest country of Latin America, and in the Western Hemisphere is second only to Haiti in lowest per capita income. This is the great benefit of the Contra War sponsored by the United States."[97] For many, the hope of the 1970s was destroyed by the violence of U.S. intervention in Central America over the course of the 1980s.

Traditional assessments of the 1970s suggest the period was empty of hope. Historian David Farber characterized the 1970s as a period when "Americans too often felt that they faced nothing but bad choices." According to Farber, "Events lent themselves to a litany of despair: inflation up, employment down; oil prices out of control, American-made automobiles breaking down; factories closed, marriages over, homicide rates soaring; President Gerald Ford."[98] Indeed, economic stagflation, deindustrialization, and decreased public funding hit neighborhoods like the Mission District especially hard. Nevertheless, out of this barrio, a transnational social movement flourished with hope. The issues were not unrelated. The promise of Nicaragua in the 1970s embodied what cultural workers hoped to build in the Mission and around the world. In the context of 1960s civil rights social movements, anti-Vietnam protests, and San Francisco liberalism, the Mission District became center stage for Latino arts organizing with a decidedly leftist bent.

U.S. support of the Contra War is well documented, but the story of popular American support for the Sandinista revolution is hardly recognized or taught. Acknowledging the history of this political activism and cultural pro-

duction is not only imperative to understanding the political and aesthetic development of Latino arts in the Bay Area and beyond, it is central to thinking about diaspora, transnational solidarity, and conflicted patriotism. Upon reflection, perhaps one of the most salient points to consider here is how the actions of these poet warriors might be interpreted today. The act of fighting for enemy forces, or serving as an accessory for a community at odds with U.S. diplomatic policy is not tolerated. But deciding to take part in these actions emerged from an internationalist vision of the world, a vision built on hope and driven by the desire to eradicate oppressive social and economic policies in and beyond the barrio.

Chapter 7

The Activist Art of a Salvadoran Diaspora: Abstraction, War, and Memory in San Francisco

Martivón Galindo fled El Salvador in 1982 because she knew she would die if she stayed.[1] As she put it, "The police made that decision. They said you are out of the country or else. I didn't make that decision."[2] The threat of violence during the Salvadoran civil war led Galindo and thousands of other Salvadorans to seek refuge.[3] In the United States, the Salvadoran population skyrocketed from a little under one hundred thousand people in 1980 to well over half a million people—in fact, some estimate closer to a million—by 1990.[4]

When Salvadorans fled El Salvador in the 1970s and 1980s, San Francisco served as a logical destination for many because of kinship networks, and for others because the city welcomed the kind of leftist politics that had forced their exile from El Salvador.[5] The majority of Latino migrants to San Francisco made their home in the Mission District, which served as a space of de facto segregation and a place of community formation.

The scale of 1980s migration obscures a much longer interconnectivity between El Salvador and the United States, and especially between El Salvador and San Francisco. As Ana Patricia Rodríguez noted, "The history of Salvadoran transnational migration to the United States . . . dates to the nineteenth century, when Salvadoran émigrés began to travel to U.S. industrial centers tied to agricultural production in Central America."[6] Cecilia Menjívar argued that San Francisco has had "the longest, yet least studied history of [Salvadoran] migration in the United States."[7] Indeed, while the majority of people caught in El Salvador's 1980s Great Migration to the United States landed in Los Angeles, in some ways the smaller size of San Francisco meant that migrants not only had a more immediate impact on the local culture but also encountered a

city already grounded in Salvadoran culture.[8] As Carlos B. Córdova pointed out, earlier professionals "paved the way for others that would follow during the Civil War and thereafter."[9]

The number of Salvadorans present in San Francisco during these years is difficult to determine, since the 1980 census did not count Salvadorans separately and since the 1990 census is contested for undercounting Salvadorans, many of whom were undocumented. The 1990 census indicates a minimum of 17,979 Salvadorans out of 100,717 Hispanics within the city of San Francisco, or at least 34,000 Salvadorans out of 233,000 Hispanics in the metropolitan area. At that time, the city of San Francisco counted around 11,000 Nicaraguan residents and close to 4,000 Guatemalan residents, so Salvadorans emerged as the largest demographic from Central America by 1990. Using these numbers as a rough guide, estimates suggest Salvadorans represented close to 20 percent of San Francisco's Latino population by 1990, and that altogether, Central Americans made up around 35 percent of San Francisco's Latino population by 1990.[10] Although a preponderance of San Francisco's Hispanic demographic identified as Mexican or Mexican American (around 38,000 residents or 38 percent of San Francisco's Hispanic population), Central Americans maintained a relatively equal and visible presence within the city.

San Francisco's sizable Salvadoran population catalyzed the city's strong sanctuary movement, which included providing transport and safe houses for refugees of the Salvadoran civil war.[11] In fact, various cities in the Bay Area and across the nation took a stand against the U.S. federal policies of deportation at that time.[12] In addition, the Bay Area's extensive involvement in the Nicaraguan revolution seemed, at least initially, a model for community organizing for El Salvador's insurgency. Consequently, art and culture in San Francisco reflected a growing preoccupation with the struggle in El Salvador, largely in opposition to official U.S. policy.

The trauma of the 1980s cultivated an image of Salvadoran refugees and exiles as victims. Images of disempowered Central Americans pervaded popular culture, from films like *El Norte* (1984), *Salvador* (1985), *Romero* (1989), and *Mi Familia* (*My Family*) (1994), to the many media accounts documenting narrow escapes and pitiable futures. While the hand of U.S. intervention did not necessarily disappear in these accounts, these materials did little to locate the violence in a larger, longer history and overwhelmingly presented Salvadorans as voiceless, powerless, and historyless. As Rodríguez noted, "Although they leave their homelands as political martyrs, in the United States they are forced into a labor migrant narrative, in which they become depoliticized, dehistoricized, and deterritorialized economic seekers, searchers for

the 'American' way."[13] The physical, metaphorical, and historical dislocation of Salvadorans fomented a master narrative of passivity, mostly situated within the 1980s, and largely crafted around their economic productivity, or lack thereof.

Using oral histories with three artists—Galindo, Romeo Gilberto Osorio, and Victor Cartagena—this chapter complicates some of the master narratives of Salvadoran migration and culture. These oral histories illustrate the ways that Salvadoran experiences can call into question some of the popular culture representations of Salvadorans as well as challenge classic assumptions about Central Americans in the United States. These artists drew on a transnational Salvadoran diaspora, on the leftist politics of a sizable Latino arts community in San Francisco, on the infrastructure and interests of an American avant-garde, and on the momentum of Central American solidarity movements. Though some cities in the United States cultivated more conservative voices in Salvadoran politics—Miami and Washington, D.C., for instance—this was not the case in San Francisco.[14]

Understandably, the majority of Salvadoran migrants did not come to the United States to be artists, nor did most seek a career in the arts after their arrival, especially given the more pragmatic pressures of seeking personal welfare and gainful employment in the United States. However, it is through art that Galindo, Osorio, and Cartagena found a realm of empowerment that was not available via other forms of employment in the United States. In fact, as each attests, the culture of San Francisco facilitated their ability to be artists in a way that El Salvador did not. Osorio came to the United States seeking a college degree in the sciences; Galindo was a trained architect; and Cartagena had dreams of becoming a musician. Their experiences in San Francisco, desired or not, transformed their identities, their careers, and their goals.

Central Americans have figured only marginally in U.S. histories and American Studies and are not often the focus of Latino Studies and Ethnic Studies. In response, scholars such as Arturo Arias, Claudia Milian, and Ana Patricia Rodríguez have shown the ways that the study of the Central American diaspora can cultivate new perspectives in diverse academic fields.[15] These authors are not simply calling for equitable inclusion but are more specifically pointing to how the oversimplification of Central American narratives in the United States is part of a process of selective memory, institutional priorities, and legitimizing histories that needs to be called into question. While there is an extensive literature on the history of U.S. intervention in Central America, there is still much room to develop the ways that the Central American diaspora has challenged notions of Latinidad, has physically and culturally changed the

urban landscape, and has illustrated the transnational contradictions and complexities of citizenship and belonging in U.S. culture.

From the U.S. Air Force to El Salvador's FMLN:
The Migrations of Romeo G. Osorio

For Osorio, growing up in the village of Ilobasco, El Salvador, a place known for delicate ceramics and painted miniatures, art was a craft, not a career. He stated, "I used to have a little bit of talent for art, and I liked it very much, but I never thought I would become an artist. . . . We had personal contact with artists, but they weren't prominent in the sense that there was not a market or an infrastructure that would promote them."[16] Osorio sought a more pragmatic career, though what that meant was understandably vague. His move to San Francisco and his subsequent involvement in San Francisco's Latino arts movement of the late 1960s and 1970s caused him to reevaluate this pragmatism. His experiences training with local artists like Rupert García and Ralph Maradiaga, his experience as the first gallery director of the Mission Cultural Center, and his social networks with a variety of Bay Area activists and artists helped redirect him to become a fine artist, curator, writer, craftsman, and soldier.

When Osorio came to the United States in 1965, he was not arriving for the first time. He was born in San Francisco in 1947 but raised in El Salvador from the time he was six months old until he turned eighteen. Growing up, he stayed connected to the United States through his American grandfather and Salvadoran-American mother. However, his return was not greeted with any enthusiasm by his native land. After touring Mexico, Osorio planned to cross into the United States with his American passport. He recalled, "When I came to the border, they took me apart, thinking that I had stolen the [passport]— and they said, how can you be American if you don't speak English? Well, you would be amazed how many Americans don't speak English."[17] Osorio's U.S. citizenship and family ties to the Bay Area dating back to at least the 1940s exemplify the longstanding social networks linking San Francisco and El Salvador, just as the border blockade he experienced on his return represents the ways Latinos are constantly presumed to be recent foreign arrivals.

In his return to the states, Osorio hoped for a better education. "It wasn't a continuous education. It got broken up by the unrest that plagued the country."[18] Like many Salvadoran migrants, Osorio came to the United States because of the push of unrest and the pull of opportunities in the United States. Paul Almeida argued that after years of political repression, symbolically enforced by *la matanza* (the famous massacre of 1932), El Salvador in the mid-1960s was

showing increasing signs of openness to social change. Almeida wrote that "the newly established domain of civic organizations permitted by expanded regime liberalization culminated in the outbreak of a protest wave between 1967 and 1972—the longest period of sustained contention since the late 1920s and early 1930s." This earlier political instability is often overshadowed by representations of El Salvador's civil war as only emergent in the 1980s. If anything, El Salvador's civil war had been ongoing, as waves of protest and repression, since the 1920s.[19]

The time Osorio spent in the United States was intellectually formative, but not quite as he anticipated. Osorio quickly found his plans to attend college in the United States thrown asunder by the ongoing war in Vietnam. Prodded by his uncle, Osorio dutifully registered for the draft, and, within three months of his return to the United States, he had enlisted in the U.S. Air Force in order to circumvent a draft notice into the army. Initially, he had escaped the draft. According to Osorio:

> They gave me a 1-Y, which is mentally retarded because I didn't speak English. And then my uncle was really mad when he got it, and said, "no, we're going to rectify this," and we went over there. I wish he would not have, because I would have been exempted, but then also, it would have been hard to get into universities and things if I was a "moron." The legal trappings are incredible. So they redo it, and after three months, well, welcome, you're going to the army. So I enlisted in the air force.[20]

Osorio spent four years in the Air Force, though most of that time he was a mechanic at Travis Air Force Base outside of Sacramento.

It was during this time that Osorio not only learned military culture but began to struggle with conflicting political ideologies. Whether sitting through military training films or seeing the hippies "dancing naked" in the Haight Ashbury, Osorio began to meditate on the meaning of the war and his personal involvement. On his release in 1970, Osorio used the GI Bill to pursue his college degree, first taking classes at City College and then at San Francisco State—notably, only two years after the Third World Strike had transformed its curriculum. Gradually, Osorio shifted from studying math and physics to majoring in art and ethnic studies. As he noted, "It attracted me in the sense that I had perceived a lot of racism in the air force, but I couldn't quite understand what was going on."[21]

Through his studies with Chicano artists like Garcia and Maradiaga, Osorio developed an appreciation for the practicality of poster art and silk-screening (Fig. 7.1). As he recalled, "We sort of plastered the Mission District with images

Figure 7.1. Romeo G. Osorio, *Homenaje a los Heroes Caidos en 1932* (*Homage to the Fallen Heroes of 1932*), c. 1975, silkscreen. A portrait of revolutionary hero Agustín Farabundo Martí adjoins details about an event to pay respect to the fallen heroes of El Salvador's 1932 massacre. Attendees are invited to meet at "Plaza Farabundo Martí," which is more often known in the city as 24th and Mission Streets. Photograph by Robin MacLean. Image courtesy of the artist.

of Sandino, Farabundo Martí, Roque Dalton. We used to constantly produce those things. . . . And I did a couple of posters in solidarity with El Salvador. But that's what I liked, the practicality of the utilization of mediums."[22] His artistic training encouraged a new consciousness of his identity and his politics.

Activists expressed solidarity with the leftist struggles in Central America by applying revolutionary names to popular public gathering spaces. In this vein, one of Osorio's posters, *Homenaje a los Heroes Caidos en 1932* (*Homage to the Fallen Heroes of 1932*), c. 1975, invited participants to pay tribute to the legacies of Salvadoran revolutionaries by meeting at the Plaza Farabundo Martí at 24th and Mission streets (Fig. 7.1). In fact, this space, largely defined by two kitty-corner BART station exits, became San Francisco's customary gathering point for protesting intervention in Central America, with the Salvadoran

Plaza Farabundo Martí on the southwest side of the street and the Nicaraguan Plaza Sandino on the northeast side of the street.[23] There is a certain visual poetry in these two plazas just across the street from each other, reconstituting Nicaragua and El Salvador as neighbors, while also laying claim to the San Francisco landscape. The insurgent landmarks have not yet attained official recognition but do reflect the ways that the movements in support of Nicaragua and El Salvador carved out space in the city.

Two local poet-activists influenced Osorio: Roberto Vargas, a Nicaraguan, and Alejandro Murguía, a Chicano. Osorio stated, "I just happened to take all the classes from these guys, and they were all fairly radical. They were preparing to go to Nicaragua. . . . So we grabbed an example from the Nicaraguans, and the Mexicans in that sense, from the Chicanos basically. And started our own movement, Salvadorans."[24] Osorio's experience is a good reminder of the kind of intellectual crossover shaping his radicalization. Trained by Chicano artists and Nicaraguan poets in the Mission, Osorio was primed to engage with the problems facing El Salvador.

In 1975, Osorio and another U.S.-born Salvadoran activist by the name of Felix Kury helped found an organization called El Comité de Salvadoreños Progresistas (Progressive Salvadorans). It bore many similarities to the neighborhood's Nicaraguan community organizing, which was spearheaded by members of El Comité Cívico Latinoamericano Pro-Liberación de Nicaragua.[25] For instance, the Salvadoran committee immediately began to publish a predominantly Spanish-language newspaper called *El Pulgarcito*, which paralleled the *Gaceta Sandinista,* the local Nicaraguan newspaper that Vargas and Murguía had helped establish. An editorial on the second-year anniversary of *El Pulgarcito* provided some of the publication's history: "Our formation was sparked by the masacre [*sic*] of July 30, 1975 of workers and students who were peacefully protesting the spending of several million dollars for the Miss Universe Pageant as well as the takeover by the government of Colonel Arturo Armando Molina of the University of Santa Ana. The man responsible for the massacre is the current president of El Salvador, Carlos Humberto Romero, who took power by way of the electoral fraud this past February 20th."[26] *El Pulgarcito* reported on escalating human rights violations in El Salvador in order to provoke a counterresponse. The paper also covered various other leftist struggles, including the civil war in Guatemala, the independence movement in Puerto Rico, and the struggle over affirmative action in the United States.

Through publications like *El Pulgarcito,* the Salvadoran diaspora found one of the safer approaches to critiquing corruption and violence in El Salvador. The newspaper drew energy from the tremendous activism in El Salvador. As Paul Almeida indicated about social protest in El Salvador, "The massacres of the

mid-1970s, such as the July 30, 1975, student massacre, the killing of Fathers
Rutilio Grande and Alfonso Navarro, and the February 28, 1977, Plaza Liber-
tad massacre became annual homage events in which to condemn the regime."[27]
El Pulgarcito not only covered these events but regularly announced and docu-
mented similar events occurring outside of El Salvador, all of which would give
roots to the more visible Central American solidarity movements of the 1980s.
Through its news coverage and editorials, *El Pulgarcito* served as a critical tool
to establish like-minded social networks for the Salvadoran diaspora.

It is largely only through the reportage of small local papers like *El Pulgar-
cito, La Gaceta Sandinista,* or *El Tecolote*, and not through any of the main-
stream press, that one can see the rise of a sizable Salvadoran protest movement
in the United States in the late 1970s. As Osorio remarked, "The newspapers
weren't covering anything. To them, everything was fine. Nicaragua wasn't even
a problem at the time. I mean, we were telling them, there's going to be a war, a
much crueler war than Nicaragua, in El Salvador, because of the nature of the
army, [which] was much more professional. And they wouldn't believe us."[28]
Thus, each week, the tally of those killed, missing, or kidnapped increased,
largely outside the purview of U.S. popular concern.[29] The public demonstrations
in front of the Salvadoran consulates, the Immigration and Naturalization
Service offices (INS) in Washington, D.C., and official public sites abroad—all
reported in *El Pulgarcito*—warranted no substantive responses from the U.S.
media or Salvadoran officials. In 1977, *El Pulgarcito* quoted Julio Bermudez of
the Salvadoran consulate repudiating any problems in El Salvador. "Everything
is quiet and peaceful there. It's not true the government is persecuting priests!"[30]

As a result, dramatic events in El Salvador led activists like Osorio to take
greater and greater risks. On April 5, 1978, to draw attention to a massacre that
had occurred in El Salvador the previous week, Osorio, along with fellow activ-
ists Felix Kury and Magaly Fernandez, seized the offices of the Salvadoran
consulate in San Francisco's Flood Building. In a perfect blending of issues,
Sandinista supporters aided the activists by staging a demonstration outside
and serving as protective eyewitnesses to the event. The FBI arrested the three
activists, prompting coverage in the *San Francisco Chronicle*. While the story
featured a close-up of a masked Osorio, the reporter failed to grapple with the
catalyzing event in El Salvador. Fortunately for the three activists, they escaped
prosecution because of some debate about the authority of the FBI versus the lo-
cal police in the arrest and subsequent questions about appropriate protocols.[31]

While Osorio struggled as an activist to put a spotlight on the violence in El
Salvador, he simultaneously contributed as an artist to a growing Latino arts
movement in San Francisco's Mission District. Gradually, however, his art took
an abstract turn that he felt excluded him from places like Galería de la Raza,

which at that time was mostly co-curated by his former teacher Ralph Maradiaga and René Yañez. Initially invited to show his work, Osorio felt their rejection of his conceptual wooden sculptures hinged not just on a preference for representational, political work but also on an ethnic focus on Chicano art that facilitated showing the conceptual work of Manuel Neri but not Osorio.

This painful rejection by his peers led to Osorio's determination to set his own parameters for showing his artwork. With help from a number of other Latino artists who struggled with these aesthetic and political borders, Osorio launched the Palmetto Museum in 1975. The first show featured the work of Armando Caseres, Luis "Choco" Castellano, Carlos Córdova, the Gallardo brothers (Mario, Carlos, and Hermes), Cecilia Guidos, the Maciel brothers (Alfonso and Oscar), Ricardo Montalvo, and Mauricio "El Nene" Santos.[32] Notably, Carlos Córdova went on to become a prominent scholar of Salvadoran American history, Cecilia Guidos became an important voice in the Cultural Documentation and Investigation Center of El Salvador (CODICES), and Oscar Maciel and Osorio became important figures in the Mission Cultural Center. Though not long-lived, the Palmetto Museum gave Osorio a platform to critique some of the political and aesthetic exclusions in San Francisco's Latino arts scene. The space also served as an important launching pad to argue for his next leadership position—as the gallery director of the new Mission Cultural Center.

Partly as a result of his close ties with Vargas and Murguía, Osorio joined the editorial staff of Pocho Che, a literary collective, and became involved with the lengthy battle to build a cultural center in the Mission. While strong community support existed for creating an art gallery within the Mission Cultural Center, what that gallery might look like and whose art might be featured was up for debate. According to Osorio, several people submitted proposals, including Yañez and Maradiaga, but he argues that his proposal prevailed because it "was more wide open, for anybody in the community."[33]

In 1977, Osorio became the first gallery director of the new Mission Cultural Center. His first show at Galería Museo, "Numero Uno," invited a wide array of Latino artists to participate, setting a precedent for inclusivity in terms of nationality and chosen medium. The poster for "Numero Uno," done by Oscar Maciel and reminiscent of Victor Vasarely's optical art represented the modernist orientation that Osorio brought to the gallery (Fig. 7.2). Maciel recalled making the poster for the event: "I created a small and simple pattern, then I proceeded to cut it up and paste to create a larger field of increasingly complicated matrix like field of vision. . . . This exercise had nothing to do with being Latin and therefore had no acceptance at the traditional community showplaces. Other artists like Gilberto Osorio were producing abstract art and ex-

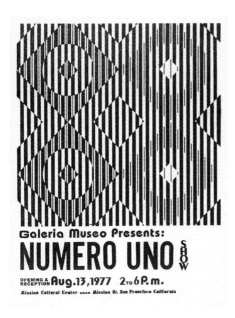

Figure 7.2. Oscar Maciel, *Numero Uno*, 1977, silkscreen advertising the first gallery show at the Mission Cultural Center. Photograph by Robin MacLean. Image courtesy of the artist and the archive of Romeo G. Osorio.

perienced the same obstacles in the community."[34] Maciel's memory highlights the ways that Osorio's curatorship forged a space for artists who felt excluded from other local venues. For Osorio, "It became the place to be in Latin arts at that time." He added, "We used to give the [Mission Cultural] Center to any organization, as long as it was Latin, to express themselves. And that created a boom, an artistic boom, where anything that was somebody in Central America or Latin America went through there."[35]

Despite Osorio's experiences as an activist, he purposefully avoided didacticism in his art. From his first encounters with the work of Clyfford Still and Jackson Pollock at the San Francisco Museum of Modern Art, he became enamored with abstract expressionism. Then gradually, Osorio found his taste shifting toward minimalism and conceptual art. Looking back, he stated, "The artistic endeavor is bourgeois, you know what I mean. It's not proletarian. And definitely, my inclination toward abstract expressionism left things open to interpretation, but I did have a little trajectory in silkscreen poster-making and things like that, and in the creation of the center. That radicalizes anybody."[36] In many ways, his art took a quieter, more oblique stance than his activism.

In the late 1970s, inspired by the spirit of artists like Richard Serra and Eva Hesse, he began to play with different media, in order to analyze "the peculiar behavior of the material" and "to look for solutions to different things." He experimented with the malleability of textiles and plastic, pushing and pulling

Figure 7.3. Romeo G. Osorio, untitled, c. 1979, textiles/mixed media. This work appeared in Osorio's "One Man Show: Recent Plastic Works" at the Mission Cultural Center, December 7, 1979 through January 12, 1980. Image courtesy of the artist.

them to generate new surfaces. He subsequently produced a series of works in plastic and cloth materials draped, cut, or stretched into abstract, semi-geometrical figures. This "tapestry art" could easily fill a large wall, such as one untitled work (Fig. 7.3) whose sizable, stiff rectangularity is dramatically ruptured by voluminous drapery tearing across the center. The visible suturing of these two contrasting textiles, one with a skin-like leathery toughness and the other a buttery fragility, were suggestive of a kind of violence, or a gaping wound. The intentional unevenness of the construction is emphasized by a row of fringe cascading down one side, like multiple incisions. Though this work offered no direct political statement, Osorio's political concerns certainly justify considering this piece in relation to the ongoing violence in El Salvador, and in doing so, the rupturing takes on momentous emotional power.

At times, Osorio felt his abstract aesthetics excluded him from opportunities to show his work. "At that moment," he recalled, "the Chicano movement and the Latino movement . . . was very strong, and if you didn't do a Virgencita de Guadalupe, you went nowhere. And to me, I was totally against that. To me, that was the path to oppression for the indigenous people. And so I wouldn't relate to that. To me, abstraction was much more representative of what my feelings were."[37] For Osorio, it was not that abstraction had nothing to say, but that it had everything to say.

In some ways, the feelings hidden in Osorio's art also reflected a very prag-matic need to disguise his politics. His decision in 1980 to join the guerrilla army in El Salvador, popularly known as the FMLN (Frente Farabundo Martí para la Liberación Nacional, or Farabundo Marti National Liberation Front), forced him to cut all links to his family and to live a clandestine life. His underground life allowed little time for art, but what he was able to produce in-tentionally veered away from legibility. As he recalled, "You couldn't express yourself out of the line in El Salvador because they would kill you. And so I did these mandalas, which were . . . not constructivist, but geometrical work. . . . And to me, the ability of keeping up this exercise, because I did it with little lines, with pencils, and inks, and things, the means of being able to produce these different sort of things became a demonstration that inside, I was calm."[38] Obviously labor-intensive, the drawings served as silent witnesses to his expe-riences as a soldier in El Salvador. Osorio spent hours drawing rows upon rows of minuscule hatch marks with his pencil. In one untitled work from 1983, a red line cuts down the page and violently begins to bleed as it descends, steadily extinguishing most of the hatch marks from continuing to the other side (Plate 10). Given his situation, the hatch marks resonate with the classic act of mark-ing time, or taking count, yet they also communicate the fragility of human lives caught in a gash of violence.

For most of the 1980s, Osorio lived in El Salvador as a soldier for the FMLN, inspired by the decision of Vargas and Murguía to fight in Nicaragua for the Sandinistas. As he described it, "When everybody is Sandinista, 'I'm going to fight over there,' and you're here, living the good life. . . . Well, I'm going to go over there and see what I can do." His training in the U.S. Air Force gave him an important skill set; he rose in the ranks to the position of comandante. As he put it, "I fit perfectly with my little training that I had from here."[39] Radical-ized by his experience in the U.S. military and San Francisco's Latino arts and activism, he repositioned himself in El Salvador as firmly counter to U.S. policy.

Osorio's story is an excellent reminder of why it is imperative to break away from frequent references to the Salvadoran civil war as a 1980s phenomenon. Focusing on Salvadoran artists only in the 1980s not only blankets over Osorio's considerable contributions to the Latino arts community of the 1970s, but also obscures U.S.-Salvadoran activism of the 1970s. Nonetheless, the early 1980s propelled the Salvadoran civil war onto a global stage. When Osorio returned to El Salvador, many of his compatriots were trying to flee the country.

With the 1980 election of Ronald Reagan, El Salvador became a critical, tactical space to establish U.S. leadership in the Cold War. President Reagan

saw the fall of El Salvador as part of a row of dominos leading to what he called "the last domino," otherwise known as the United States. In 1984, President Reagan delivered an address to the nation justifying his policies. Reagan declared, "Central America is a region of great importance to the United States. And it is so close: San Salvador is closer to Houston, Texas, than Houston is to Washington, D.C. Central America is America. It's at our doorstep, and it's become the stage for a bold attempt by the Soviet Union, Cuba, and Nicaragua to install communism by force throughout the hemisphere."[40] Such logic helped justify the funneling of billions of dollars in U.S. military and economic aid to maintain an oppressive regime in El Salvador.[41]

This newfound, global attention had profound implications for El Salvador and its residents. Most obviously, "civil war," was a misnomer, given the enormous imbalance of the violence, which was overwhelmingly orchestrated by government and military authorities with deep pockets and directed at presumed leftist activists and civilians to cultivate a culture of fear and control.[42] For artist Victor Cartagena, "It was a repression, it was a dictatorship. It wasn't a war. They were killing. That's what was happening."[43]

While there was a revolutionary insurgency, it in no way matched the economic and military force of El Salvador's leadership.[44] Moreover, and not surprisingly, the state-sanctioned violence launched a massive exodus of Salvadorans, many thousands of whom sought political asylum. U.S. authorities rarely granted asylum, since they defined the massive Salvadoran migration as the product of economic forces, and not as the required product of "well-founded fear of persecution."[45] The majority of Salvadoran refugees were caught between living illegally in the United States or the likelihood of dying in the violence of their homeland.[46]

A Salvadoran Renaissance in the Mission: Martivón Galindo and the 1980s

Martivón Galindo was one of the lucky few whose familial ties enabled her to migrate legally to the United States. Although she came as a political exile, her class status, her education, and her relative ease of entry already circumvented the stereotypes of Salvadoran migration. While Galindo had no intention of coming to the United States, political unrest in El Salvador had prompted her to obtain a green card in an earlier visit, via the American citizenship of her father. As she recalled:

> It was the farthest thing in my mind that I would be coming to the United States. It was impossible for me. So my mother asked me, begged

me, and said, Martivón, do it for me, I just want to sleep in peace at night that we have this government, and you will be able to leave very easy. So I said, "okay," so we came, I think it was February, or March, of 1982, to the United States, to Houston, and signed all the documents. And I got my green card, all of us—I mean, my mother, my brother, my nephew, my niece, and my son, everybody. And I said, "forget it." Three months later, I was out of the country. If I hadn't followed my wise mom's advice, like I never did before, I couldn't have done it because they never would have given me a visa. . . . But I came legally, I didn't have that problem.[47]

Even so, her move to San Francisco was filled with challenges as she tried to find work, a good place to raise her child, and a way to process the loss of her country, as well as her sense of exile and alienation. One of her earliest published poems, "El Shopping Center," was a lament over her entry into U.S. culture, which seemed defined by these shopping centers in *"el culo del mundo"* (literally, "the ass of the world," but figuratively, "off the face of the earth"). In the poem she wrote, *"el Norte es frío, es muerto helado/Aquí ya no hay catedrales blancas/y solo se ora en los 'Shopping Centers'/catacumbas con luces que encienden y apagan."* (The North is cold, it is the frozen dead/here there are no white cathedrals/and only prayer in the shopping centers, which are catacombs with lights that they ignite and they extinguish.)[48] The poem expressed Galindo's dissatisfaction with the superficial nature of her new surroundings, which she saw as revolving more around the sale signs at the mall than the lively discourse of the Latin American plaza. Such writing would lead one to believe that Galindo's life was devoid of an intellectual community, but the fact is, Galindo was simultaneously tapping into an enormously lively, activist community, largely dedicated to promoting social change for El Salvador and Central America.

In fact, Galindo pointed to the ways that the migration of Salvadorans encouraged the importation of Salvadoran community organizing into San Francisco and other cities across the country. She stated, "We have to consider that we have a lot of mass organization in El Salvador in the '70s. So that learning of how to organize was done in every place that Salvadorans went They founded CARECEL, the Central American Refugee Center, then CARE-CEN, the legal center for Central Americans, CODICES, and all the political houses, Casa El Salvador. In L.A., in New York, in Washington, even in France, there were Salvadorans founding different things."[49] Plenty of evidence supports Galindo's claims that San Francisco and other cities across the United States became home to an expanding array of Salvadoran led activist organizations over the course of the 1980s. According to Héctor Perla, the two largest

transnational Salvadoran solidarity committees were the Committee in Solidarity with the People of El Salvador (CISPES) and the faith-based SHARE Foundation.[50] While certain local organizations, such as the Mission Cultural Center and Casa Nicaragua, offered critical support, these grassroots Salvadoran organizations are also evidence of the enormous, though typically unrecognized, activism that Salvadorans generated in the United States at this time. As Perla discussed, most histories of the Central American Peace and Solidarity Movement "focus exclusively on the movement's U.S. activists as its sole protagonists while neglecting crucial elements of the vital role played by Central American revolutionaries—both in their home countries and in the diaspora—as purposive actors in the movement's rise and growth."[51] Though these many organizations can be seen as important components of a much larger Central American solidarity movement, typically Salvadoran voices have not been portrayed as leaders of this global social movement, or of the sanctuary movement.

Unlike many, Galindo had the privilege of a green card, a result of her father's U.S. citizenship, and a professional education as an architect. Her father's ties to San Francisco led her to resettle in nearby Daly City. However, she quickly discovered that her advanced education meant little in the United States. As she recalled, "I went looking for jobs as an architect, under the illusion that I would find very soon a job that suited me, and that was impossible. I ended up working as a decorator." Still occupying a privileged position in the labor force as compared to many of her fellow Salvadorans, Galindo's sense of displacement and exile led her to turn to writing and drawing as a means of grappling with her situation. She quickly discovered she was not alone in her desire to process, engage, and respond to both the ongoing transformation in her former home and the challenges of building a life in the United States.

Within a short time, Galindo became involved in a very active Salvadoran exile community. She cofounded CODICES in the mid-1980s with Cecilia Guidos and Joaquín Domínguez Parada. The group adopted three specific objectives: to "rescue and preserve our national identity," to "promote and disseminate in the United States, the art and popular culture of El Salvador," and to "establish a network of support for Salvadoran cultural workers."[52] Their plans were ambitious—creating a cultural center with offices, a café, a gallery, and a theater, and regularly publishing a journal. Although CODICES only lasted about six years, falling apart just after El Salvador's 1992 peace accords, its founding indicates the ways that trauma in El Salvador contributed to a creative, activist Salvadoran diaspora in San Francisco.

Poetry readings, art shows, and political meetings in San Francisco provided an outlet for Galindo to process the political upheaval in El Salvador. The energy she had dedicated to her professional success in El Salvador as an archi-

tect, interior designer, and gallery director, she redirected to cultural work in San Francisco, painting, writing, and fighting for El Salvador.[53] "I still remember my first art exhibit with two other women at the Centro Cultural Macondo in 1985 in San Francisco. These were the years of rage and pain when the walls of my small world were shattered by winds of war and greed."[54] As Shifra Goldman noted about Galindo's work, "Overt political messages and love of her land suffuse Galindo's drawings, pastels, and paintings. Titles such as *It Shouldn't Hurt To Be a Child*, *Chaos*, *Endless Suffering*, and *The Past Is Always Flourishing* are not at all rhetorical, but reflect a real and desperate situation."[55] At a time when Galindo felt deeply disempowered by massive social changes, her artwork provided a critical space to invoke protest, raise awareness, and decry institutional policies that facilitated "war and greed."

Much of her poetry and artwork represented women as targets of the ongoing violence. For instance, the cover of her 1996 book of poetry features *Impotencia (Impotence)*, a portrait of a woman whose figure and features are barely discernible (Fig. 7.4). The woman appears powerless, her eyes closed with illegible text pasted over her face and neck. The fragmentary words suggest a poem or a prayer. Martivón Galindo's name is printed on the woman's forehead and the line "Does God have his own God" is printed on her chest. The texturing of the paint serves as a shroud, enclosing the woman in coffin-like repose. It was perhaps a recollection of Galindo's personal experience in police custody. Combined with the title of her book—*Retazos (Fragments)*—and the dark orientation of her poems, one can catch a glimpse of the ways that writing and the visual arts became a tool for Galindo to remember, to document, to protest, and to mourn.

In fact, in some ways, the dark evocations of this work obscure the life Galindo was building for herself in San Francisco. As Galindo stated, "It was amazing. The contradiction, the irony, that we were giving birth to an art, to a center, for a culture here, while our people were being killed in El Salvador, and a whole country was condemned to death."[56] Galindo's experience showed the divergent impacts of the civil war for people in El Salvador versus the diaspora. While the 1980s was a culturally devastating decade for El Salvador and many of its migrants, Galindo observed the ways that this trauma built her art and her community in San Francisco.

For Galindo, her work with CODICES reflected the growth of a monumental social movement that few outside of the Salvadoran diaspora recognized. As she put it, "I really compare these years to the '60s in the United States. The '80s for Central Americans living afar, and for Salvadorans, we sacrificed everything, family, money, time, in order to create this movement that would reflect in art, the suffering of our country then." The desire for social change was supplemented by the desire to create art. "So it was not all in the vacuum. It was

Figure 7.4. The cover of Martivón Galindo's book of poems, prose, and drawings, entitled *Retazos* (*Fragments*) (1996), featuring her painting *Impotencia* (*Impotence*). Image courtesy of the artist.

not something in the work. It was a reflection through art of what was our lives far away from our country and our need to connect . . . with our identity."[57] For Galindo and others, art became a fundamental method of resistance, a way of speaking out in the United States about the beauty of El Salvador and the determination of the people, when most of the media only represented El Salvador through a decontextualized violence.

The transnational aspirations of CODICES formed part of a cultural transformation for Salvadorans in San Francisco and abroad. Artists of El Salvador began to build networks that transformed traditional Salvadoran skills into artistic enterprises. Galindo described how Salvadorans in the United States "used a skill in doing very fine carpentry, cabinet making things, carving, and things like that, and painting like in oil, and it became a piece of art, not of furniture, but really as art." As Galindo noted, "CODICES was not making only these connections through the artists living here, but doing connections with the artists living in other places in the United States."[58] To recognize the art and activism of the Salvadoran diaspora should not undermine the overwhelming tragedy of the civil war, but rather, question the application of passive stereotypes and emphasize how many Salvadorans actively continued to participate in the struggles of their nation.

Prior to obtaining its own space in Balmy Alley, CODICES held its first show of Salvadoran artists at Casa Nicaragua in September 1986. The event included the works of many of its artist-members: Galindo, Tony Avalos, Joaquín Domínguez Parada, Milton Lazo, Ricardo Portillo, Carlos Texca, and Herbert Siguenza. Siguenza, of course, became famous as one of the three members of the comedy troupe Culture Clash, but he started as a graphic artist and served as the art director for La Raza Graphics Center for ten years prior. According to Siguenza, "I was doing community, political posters, which I thought was a way of educating and organizing people, and so when I got into theatre, it was just kind of by accident. It was just another tool, another way of expressing or communicating to the people."[59] Perhaps indicating a divide between Salvadorans born in the United States and the growing exile community, Galindo characterized Siguenza as "a Salvadoran that was raised here in the Mission and is mostly Chicano."[60] Galindo's interpretation of Siguenza's Chicano-ness was another way of referring to his acculturation to the United States, which also made him slightly foreign to the nationalism defining this new Salvadoran activism. Siguenza, in turn, explained how Culture Clash fit him because of its biculturalism and "because we were able to be ourselves."[61] Siguenza's experience offers an excellent reminder of the divisions within the Salvadoran diaspora, even when invested in similar politics.

The politics of CODICES's first show provoked an unexpected response. As Galindo reported, "It was a really amazing experience because some Cubans

came and shot in our window because they said that they are a communist ex-hibit."[62] The shooting demonstrated the ways in which not only the artists but other members of the community saw CODICES's work as part of a cultural front. Undeterred, the members of CODICES continued to create shows and invite speakers, including writer Manlio Argueta, musician Carlos Mejía Godoy, writer Claribel Alegría, and artist Guillermo Huezo.

Even though much of Galindo's visual art, poetry, and prose during the 1980s struggled with the destructiveness of this violence, she also threaded her work with a willful determination to survive. Her short story "Armas," pub-lished in 1986, is a fictionalized account that draws from her personal experi-ence with torture.[63] The story describes a doomed young woman who is barely holding on to life, trapped in a prison cell and struggling to survive her torture. The opening presents a terrifying and hopeless start: "*Y sigo viva, cuando ya mi cuerpo ha aceptado ser torturado, despedazado, descuartizado*" (I continue alive, after my body has accepted being tortured, beheaded, sliced and torn to shreds).[64] Accompanying "Armas" is Galindo's illustration of a woman trapped in darkness who seeks to raise her blindfold but who would only find herself framed in a spider's web, subject to a dangerous, skeletal form. Though the woman never escapes, Galindo used the story to declare the character's will to fight for what she believes. If anything her torturers made her more deter-mined:

> *Yo voy a volver, ¿cuándo? No lo sé. . . . Por querer verte nuevamente como un país nuevo, diferente, salvado de esta miseria, de esta indignidad, de estos monstruos innombrables. Volveré a verte y como dice la canción, es-taré en la plaza, gritando, enarbolando estandartes, amándote más . . . porque el dolor te mata o te hace más fuerte. . . . Y yo seguir adelante. No van a acabar mi voluntad, ni mis convicciones, los insultos, amenazas y terror de éstos llamados defensores del orden, incapaces de pensar, de sen-tir como seres humanos, seres informes, degradados.*

> I will return. When? I do not know. . . . Because I need to see you this time around like a new, different land, freed from that misery, that in-dignity, from those unnamable monsters. I will return to you and, like the song, I will be in the plaza, screaming, waving the banners, loving you more. Because the suffering will kill you or will make you stronger. I will stay in the struggle. They will not vanquish my will, my convictions; their insults, threats, and terror of these self-proclaimed guardians of our public safety, unable to think, to feel like human beings, degraded, dishonored, shameless beings.[65]

The text ends with the declaration that her country can never take away her true armaments, her mind, her heart, and her spirit, and that whatever becomes of her, she will continue to live—"*Y sigo viva!*"

While Galindo sought to give visibility to the violence targeted at women, as well as represent their strength, she also found a strong feminist support network in CODICES, largely because it had a number of strong women, such as Cecilia Guidos and herself, in leadership positions. Galindo stated, "I was director and I think I found more trouble outside . . . than within our small group."[66] Indeed, Galindo has written extensively about the marginalization of women, both in El Salvador and in the diaspora. For Galindo, Salvadoran women of the diaspora underwent a double exile, as their lives paled against the pervasive representations of male revolutionary figures, such as Che Guevara and Roque Dalton, and as their struggles outside of El Salvador appeared substantially less visible.[67]

Around late 1986, CODICES secured its own place to gather, a garage in Balmy Alley. Local muralist Juana Alicia later painted a mural of Archbishop Romero on the garage door, to mark the politics of the space. This physical space, maintained from 1986 to 1992, did not just serve as a site to protest the violence, but also as a place to reimagine El Salvador and its possibilities. It capped its final years with a celebration of Oscar Romero in 1991 and a celebration of the indigenous people of the Americas in 1992. Knowing that the war lasted for a dozen years and killed thousands upon thousands of people, it is easy to lose sight of the fact that continuous waves of hope for an earlier peace, and for a victory by the people, also gave this struggle momentum in San Francisco's Mission District. The public mourning for the dead and the missing that followed the 1992 peace accords often obscured the profound hopefulness and determination that defined Salvadoran activism in the 1980s.

Moreover, the 1992 peace accords prompted many activists to return to El Salvador, including Galindo, just briefly, as well as Dominguez Parada, one of the most active members of CODICES and CARECEN. Some of these return migrations may have contributed to the invisibility of Salvadoran activism during the 1980s, since a sizable contingent of dedicated activists packed their bags and took their stories and their art back to El Salvador. While the peace accords diminished El Salvador's presence in the media, the Salvadoran diaspora of the 1990s struggled to make sense of, and not be defined by, the violence.

Forgetting El Salvador: Victor Cartagena and the 1990s

The 1990s produced a strange silencing of El Salvador's story, while simultaneously serving as a time for mourning. The civil war disappeared from the

international news, as El Salvador finally reached a peace accord in 1992, but the deaths of approximately 80,000 citizens and the dispersal of about a million citizens to distant places around the globe created a gaping wound in the country.[68] The expatriate Salvadorans, now stretched around the world, colloquially became known as "Los Hermanos Lejanos," or "Departamento 15," describing the diaspora as distant brothers, or a fifteenth province, existing entirely outside the physical boundaries of the nation.[69] As Andrés Torres noted, "Salvadorans who arrived in the 1990s, however, received far less public attention. The Solidarity Movement waned after the wars in Central America ended, and many of the non-Central American activists diverted their energies to other causes."[70] The work of Victor Cartagena is inextricably tied to his experiences as a member of this Salvadoran civil war diaspora, though his work as a visual artist was maturing just as the visibility of Salvadorans in the United States subsided.

Cartagena, born in 1965, grew up watching the violence. His political education began when he witnessed soldiers shooting demonstrators in the streets: "We saw the soldiers shooting the people running. . . . They killed our neighbors . . . And we couldn't say anything . . . That's when I have a sense of repression, and probably when I started feeling something against those who have. And I started feeling something against my family, because they have, and I tried to understand why those who have are different."[71] Cartagena's school only underscored the repressive atmosphere: "The school was really the place that my generation suffered, because we couldn't finish, we couldn't go, come back, go, come back. They closed. They killed my teachers. . . . They disappeared."[72] When his brother was taken to prison, Cartagena feared he was next on the list. But the worst was losing his friends. "All my friends started appearing dead everywhere. It's like, oh, that guy was killed. Oh, they found the body of that person there. All my friends. And I was feeling depression. When is it going to be me? When is it going to be me? They're coming."[73] It seemed only a matter of time.

Fearing death and facing recruitment into the military, Cartagena left El Salvador in 1984 and headed north. He finally reached San Francisco, where he had family who could help him get situated, in 1986.[74] However, instead of following his uncle's advice and finding work at a restaurant, Cartagena applied to work at a frame shop. That decision proved critical in determining his future as a visual artist. As Cartagena described, "It's like the domino, you hit one piece and then you know that it's going to go all the way to the end, and that's it." Working at a frame shop introduced Cartagena to a multitude of images and possibilities. It served as the ideal education, tapping into his childhood love of drawing and painting. He found possibility in the repopularization of Diego Rivera and Frida Kahlo. He said, "In those years, the eighties, the Chicanos were really framing Diegos, Fridas. . . . And I wanted to be like Diego."[75] Using his

art lessons in the frame shop, Cartagena started painting and drawing at home. A customer saw his work and offered him his first solo show. Cartagena gradually came into contact with the artists of CODICES, and shortly thereafter joined in the formation of Tamoanchán, a printmakers' collective composed entirely of Salvadoran artists, including his brother Carlos Cartagena, Ricardo Portillo, Carmen Alegria, and Galindo.[76] This energy, this community, played an important part in launching his career as an artist, though it was all a bit accidental.

Through Tamoanchán, Cartagena experimented with popular notions of magical realism as practiced by authors like Gabriel García Márquez and Isabel Allende. Cartagena joined the fantastic and the ordinary in his art, netting images of humans conjoined with animals and other hard-to-decipher but rarely tranquil images. For instance, his untitled print of a man and a burro fastened together at the man's thigh is an intentionally awkward construction, nothing like the streamlined centaur of classic Greek mythology. The figure is undressed but for a small bit of cloth across his midsection that does not cover his penis, which rests on the donkey's back. A mask covers the man's face and something like a boxing glove covers his right hand, but little else remains to make sense of the scene. It is a troubling image that foreshadows Cartagena's fascination with the human figure, with deformity, with blindness, and with other sensory deprivations.

While Cartagena aspired to be an artist, he had mixed feelings about the art he was expected to make as a Salvadoran. It was important to create some distance between himself and his home country. He borrowed widely from Matisse, Rivera, and others, but he could not entirely shake the memory of the war. Claudia Bernardi, a Bay Area artist originally raised in Argentina, helped Cartagena come to terms with his concerns. Bernardi, a forensic anthropologist, had become an artist as a result of her work. Exhuming 143 skeletal remains, 131 of which were of children, from a mass grave at El Mozote was a turning point in her life. For her, "Nothing was the same, ever."[77] She sought a way to process the loss. She started crafting sculptures that partly replicated the remains but also served as determined reclamations of lost lives. For Bernardi, her work "reconstructs the journey from the actual findings at the site of El Mozote to the alchemical process of transforming painful memories of anonymous human remains into the poetry of resistance and the persistence of hope."[78] To help others process the trauma of the civil war, she started offering art classes in the Bay Area. She became an influential teacher and guide for Victor Cartagena, his brother Carlos, and Galindo, and subsequently organized shows and events that featured all of their works.[79]

Cartagena's art gravitated toward trauma, loss, and violence, but his work was not always about El Salvador. He stated, "The moment that you say, 'I'm

Salvadoran,' everybody wants to talk about the civil war and the death and the killing there, and that was really killing me. I just want to be Salvadoran. El Salvador is more than the civil war. El Salvador has history."[80] In fact, Cartagena's desire to push himself as an artist facilitated his ability to demonstrate the trauma of El Salvador as part of a larger culture of violence and complicity. A key moment of transformation emerged when Cartagena planned an homage to Leonardo da Vinci. He decided, "I can basically follow his idea of studying the human anatomy, and that is going to be my car, my wheels, to go to where ever I want."[81] His new aesthetic mobility landed him mentally back in El Salvador, the place where images of human bodies stirred memories of the disappeared. "Then I said I'm going to talk with these memories."[82] He subsequently titled this 1999 series of works, "Anatomical Memories." He used print paper that he stained with coffee, emblematic of El Salvador, and purposefully, unevenly joined two pieces of paper to fill his kitchen-door easel. He drew "door-size," or life-size, vulnerable nude figures with jarring details that suggested unrestful states of being. For some, he added blindfolds and wings that spilled off the page, such as one untitled work of a nude woman with her back to the viewer and wings inexplicably attached to her body (Fig. 7.5). The wings may have paid homage to da Vinci's fascination with flight and technology, but Cartagena offered no concept for his engineering. Instead, the wings became poetic expressions of bodies striving for flight, but also bodies in perpetual violence.

Figure 7.5. Victor Cartagena, untitled, c. 1999, mixed media drawing on paper from the "Anatomical Memories" series. Image courtesy of the artist.

He also began to craft images from physical memories. He started sculpting the drawings with letters from his family, old shirts, and mementos to conjure "people who I remember, and not directly, but there is a little bit of everything in each of them."[83] He later gave the drawings voices, literally, by attaching voice-box recordings. The series served as a pivotal ceremony for Cartagena. He said, "I feel like after that series, I was really carrying something really inside me for so many years, and they're there."[84] Looking at the series is a window into grief and the processes of mourning for Cartagena.

In 2002, curator Tere Romo commissioned Cartagena to create an altar for Day of the Dead at the Oakland Museum of California. His work evolved into a spectacular installation entitled *Homenaje a Roque Dalton* (*Homage to Roque Dalton*) (Figs. 7.6 and 7.7). The altar drew its visual power from his use of 10,500 black-and-white identification photographs, which he hung in carefully

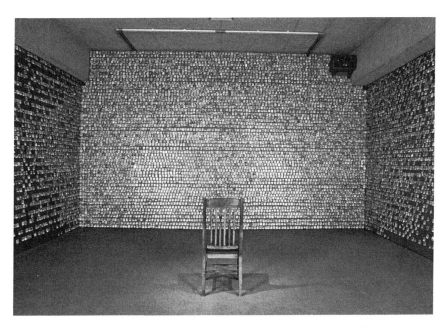

Figure 7.6. Victor Cartagena, *Homage to Roque Dalton*, 2002, mixed media. Installation featured approximately 10,500 passport photographs, wood chair, and audio from ceiling speaker. The title announced an homage to Salvadoran hero Roque Dalton, but the room full of individual portraits expressed a more expansive *ofrenda* for the Salvadoran people. Presented at the "Espíritu sin fronteras: Ofrendas for the Days of the Dead" exhibition curated by Tere Romo at the Oakland Museum of California. Image courtesy of the artist.

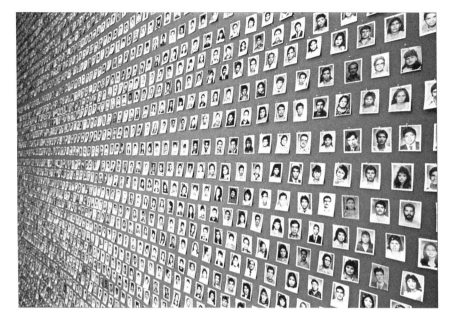

Figure 7.7. Victor Cartagena, *Homage to Roque Dalton*, detail. Image courtesy of the artist.

measured rows on all four black walls of the room. A speaker system in the ceiling provided a reading of Roque Dalton's "Poema de Amor" (Poem of Love), a paean to the uncelebrated life and labor of Salvadoran people. He recruited family and friends to help him individually space and hang each photograph with a single nail. He recalled, "It was a beautiful thing because you see one by one and you take time to see that face. And it was like, you remind me of somebody. It looks like one day I saw you. It was such a beautiful process."[85]

Cartagena conceptualized the altar while visiting El Salvador. Inspiration came when he visited a photo studio he had used for his own identification photos. In an increasingly digital world, the studio stood as a former shadow of its busy past. In conversing with the shopkeeper, Cartagena learned the studio maintained years of negatives, and after some convincing of his good intentions as an artist, he struck a deal with the shopkeeper that gradually tallied up to an order of 10,500 identification photos from the 1980s.[86] Independently, identification photos rarely register as art, but gathered in one place and contextualized with the words of Roque Dalton, the photos gathered in the room served as a profound expression of love and tragedy. The scene resonated with the history of using similar images on posters to search for the missing and the dis-

appeared, but also with the possibility of using such photos on passports to flee the country. In title, the altar honored a Salvadoran hero, but visually, the altar expressed love and grief for generations of Salvadorans who experienced the violence, trauma, and exile of the 1980s.

Working through such "Anatomical Memories" helped free Cartagena from some of his most haunting memories and released him in new directions. The work that he did remembering the Salvadoran civil war propelled him to think about trauma, loss, and violence apart from El Salvador. Criticizing himself for too much self-indulgence in his Salvadoran past, Cartagena considered how to confront his present circumstances. Living in San Francisco, he transformed "Anatomical Memories" into a series on homelessness. "Somehow, I connected them," he said.[87] The portraits depict men in shirts made of lottery tickets and street maps, with conical speakers as literal mouthpieces, piping out an amalgamation of recorded voices of San Francisco's homeless (Fig. 7.8). He hung signs begging for money around their necks, signs he requested or found on the streets of San Francisco. The authenticity of the signs and the voices gave the portraits a painful urgency, reminding his viewers that his aestheticization of the homeless is based on reality. In his depictions, whether of the Salvadoran civil war, of homelessness, or of prisons, Cartagena invoked a larger critique of systemic violence and subtly pointed a finger at the United States and capitalism for fundamentally shaping these situations.

The completion of the "Anatomical Memories" series was a turning point for Cartagena, a moment when he applied the visual lens of El Salvador to the rest of the world. Cartagena's later work targeted a culture of violence in the broadest possible sense, from the death penalty, to toy guns, to the exploitation of immigrants. The experience of El Salvador informed Cartagena's art, but the vantage point of his San Francisco community globalized his concerns.

Finding a New Life

Remarkably, what most draws these three artists together is not a single nation or aesthetic, but the way that San Francisco inspired their careers as artists. The artistic careers of Osorio, Galindo, and Cartagena emerged in the context of their migrations and displacement, through the lens of their identities as Salvadorans and Americans, and through their desire to come to terms with the past and to paint a desired vision for the future. In other words, their education as American artists was fundamental to interpreting their identities as Salvadorans. Admittedly, their intellectual trajectory and privileges might set these artists apart from other Salvadoran migrants, but their stories are also an opportunity

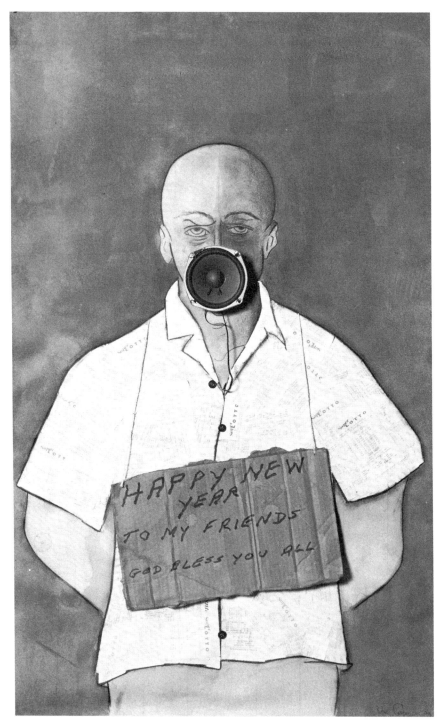

Figure 7.8. Victor Cartagena, untitled, c. 2001, mixed media on paper from the "Anatomical Memories" series on homelessness. Cartagena developed this series with signs that San Francisco's homeless used to request help. He also played recordings of their voices through the startling mouthpiece. This portrayal includes a shirt composed of lottery tickets. Image courtesy of the artist.

to recognize the real, if often hidden, presence of Salvadoran intellectual communities in the United States.

It is impossible to say whether any of the three would have become artists without the context of their migrations. In the case of Osorio, his move to the United States in 1965 with "bourgeois" thoughts of becoming an engineer transformed him into an abstract artist and Marxist soldier. He continued to move between San Salvador and San Francisco, developing galleries here and there, and managing a publication, *Voces*, dedicated to Latin arts. Osorio later opened the Piñata Art Gallery, which sold his piñatas in front and incorporated a modernist studio and gallery in the back. Much of his art continues to be purposefully illegible and not obviously political, but his life is the story of an activist. It is a balance that gives Osorio purpose, where his art can be something beautiful, emotionally evocative, simple and haunting, while his life has reflected a resolute sense of justice and fairness, most obviously displayed in his decision to return to El Salvador and fight with the FMLN.

Osorio has maintained close ties with many people in El Salvador, which has facilitated the activism of the local Salvadoran community. As Galindo pointed out, "He has been helping people that have been maimed by war. And we have been helping him also. Because he has this spirit, and we support him. Every year he does this auction with the Salvadoran artists living here, and we donate, I donate three, two, or four pieces every year. And Salvadorans buy them. Salvadorans living here, they buy them. . . . Because they want to support a cause. They have this need to be linked to El Salvador."[88]

Galindo went from architect to poet and from draftsperson to artist. Publishing her poems and drawings in her 1996 book *Retazos* demarcated a kind of spiritual and cultural journey. As she remarked, "I lost my profession. I didn't lose only material things, I lost my family, my country, my profession, everything. But . . . I was never able to devote myself to art in my country because I was an architect. So here I devote myself to being a writer and an artist. . . . It's like a person was dead over there, and there's a new person here that begins. And it starts all over again."[89] She became a college professor at Oakland's Holy Names College and has continued to illustrate, write, and teach the Central American experience.

Like Galindo, Cartagena experienced the start of a new life in the United States, though perhaps even more literally. In El Salvador, he was known as David, but the process of migration forced him to change his first name. For Cartagena, this was a turning point in his identity. He stated, "Victor is a different person, and Victor was born here."[90] While Cartagena rejected war as the sole criteria of Salvadoran culture, it is also clear that his art work has been fundamentally shaped by this trauma.

In fact, Cartagena's feelings illustrate the difficulty of grappling with Salvadoran American identity apart from the trauma of civil war. His images often depict people in vulnerable, dangerous, or tenuous situations—often naked, with muted mouths, or partly disfigured, in ways that conjure the war in his homeland. He is drawn to the most vulnerable in society, and his images encompass representations of the tortured, disappeared, homeless, imprisoned, or exiled. However, his subjects are frequently not Salvadorans. While he admitted that his art has helped him process the trauma of war, it also emerged from his ability to see the everyday violence engendered by life in the United States and around the world. He explained, "I want to scream what I feel that needs attention. And the way I scream is through my art."[91] To see his work through the prism of the Salvadoran war becomes oppressive but is simultaneously always relevant.

Notably, while each of these artists has produced art that is inherently Salvadoran, there is nothing inherently similar in their work. Their art is just as inherently "American" or just as inherently of the Mission. Tracing their steps is a political and aesthetic journey through the 1970s, 1980s, and 1990s. The experiences of Osorio, Galindo, and Cartagena show their paths intersected with multiple other institutions and artists in the Bay Area. While their art grappled with various forms of violence, their lives represent the vibrant energy and politics of the Latino arts community in the Mission District. And while the "American Dream" of immigrants has a million overblown connotations, in this case, the passage to the United States proved a strange, tortured, spiritual crossing into the arts.

Chapter 8

The Politics of Día de los Muertos: Mourning, Art, and Activism

In the 1980s, mourning permeated life in San Francisco. As writer Richard Rodriguez declared, "In San Francisco death has become as routine an explanation for disappearance as Mayflower Van Lines."[1] Most obviously, AIDS had devastated the city. Between 1981 and 1986, San Francisco recorded more than 1,500 AIDS-related deaths. By 1995, the city cited 22,185 cases of the disease and 14,892 deaths.[2] As the epidemic grew, residents sought ways of coping with the trauma, including candlelight vigils, public memorials, and cultural production. In addition, many in the city also mourned the devastating impact of thousands of *desaparecidos* in El Salvador and Guatemala.[3] The city's close ties to Central America, as already outlined here, meant that many residents experienced these losses all too intimately. Others simply sought to articulate their sense of shock, fear, and outrage at the violence abroad.

Those grieving for Central America and those grieving for AIDS felt frustrated and helpless, particularly in the context of the Reagan administration, whose policies only seemed to aggravate both situations.[4] Cold War tensions heightened a sense of powerlessness. One survey conducted by NBC and the Associated Press declared that by the end of Reagan's first year in office, "76 percent of the American people believed that nuclear war was 'likely' within a few years, an increase from 57 percent the preceding August."[5]

Mourners from all walks of life sought ways of articulating their concerns and venting their grief. Many embraced new forms of expression. The Latino celebration of Día de los Muertos (Day of the Dead) provided a cultural nexus for mourning in 1980s San Francisco. The Latino arts community in San Francisco already had popularized this event in the 1970s as a way of acknowledging ethnic traditions and inspiring artistic expression. By the 1980s, artists in San Francisco and elsewhere in the United States started applying more innovation and generating "Americanized" visions of altars, artwork, and performance.

As Tomás Ybarra-Frausto noted, "The individual aesthetics and skills of trained artists re-interpret the traditional *ofrenda* [altar] into fanciful, political, and personal visions."[6] The result was the formation of a Día de los Muertos art and culture that integrated the spiritual and predominantly leftist political concerns of Bay Area residents.

Though a religious celebration, Día de los Muertos also has a history of enabling pundit-free speech to critique causes of death and the vanity of the living. The work of nineteenth-century engraver José Guadalupe Posada embodies this politicizing of the event with his *calavera* (skeleton) images that annually poke fun at Mexico's elite, reminding everyone that no matter how wealthy or privileged, no one escapes death.[7] Inspired by Posada, San Francisco artists used their wit and talent to produce work that expressed loss and critiqued contemporary politics.[8] For instance, René Castro's 1989 "Burn, Baby Burn" altar featured a skeleton with an American flag draped over his shoulders and flames licking at his legs. The text written behind him declared, "When you reach my age, you don't need to be walking around burning flags." The caustic *calavera* humorously conveyed the role the living needed to play in critiquing American politics, since it was too late for the dead. In this way, San Francisco cultural workers increasingly used Día de los Muertos to dramatize the necessity of local and global activism.

As the celebration transitioned from intimate, familial events to large-scale public altars and performances, participants increasingly relied on its rituals to speak out against social systems that allowed, facilitated, or produced death locally and around the world. Each year the political messages grew stronger in content and form. Popular interest in the celebration contributed to its growth and its commodification, raising issues of cultural appropriation and gentrification. The popularization of Día de los Muertos radically changed the trajectory of the celebration, but also signaled the way Latino artists in San Francisco made this event a highly visible illustration of their politics. This chapter focuses on the ways this religious celebration became a complex space for artists to mourn and protest in the midst of multiple social crises. The popularization of the celebration also demonstrated some of the pressures facing Latino residents in San Francisco, as forces of displacement intensified and threatened to undo the Latino-ness of the neighborhood.[9]

Cultural Roots and Regional Influences

Día de los Muertos varies by region and over time, but one idea remains central: as Concha Saucedo stated, "Día de los Muertos is the day in which our ancestors visit us and is the day that connects us to our cultural past."[10] Tomás Ybarra-

Frausto called the event a "time of *recuerdo* (remembrance) where the living relate to their dead in direct and familiar ways."[11] These ways include the creation of personal and communal altars, overnight trips to the cemetery to visit the spirits and clean the graves, pageants poking fun at death, and the cooking and serving of special foods for the dead. While preconquest indigenous cultures performed rituals to recognize the dead throughout the calendar year, colonialism bound these practices to the celebration of All Souls Day and All Saints Day on November 1 and 2. These two days became the pivotal moment when the spirits of the dead would visit the living and when the living commemorated, celebrated, and meditated on the lives of those who had passed into the spirit world.[12]

The altar, or *ofrenda,* provides a centerpiece of the event.[13] Though varying by region, an altar is loosely composed of mementos of the dead, religious images, sugar skulls, incense, favorite foods, water, beer, *pulque* (an alcoholic beverage made from the maguey plant), *atole* (corn-mash drink), and *cempazuchitl* (marigold flowers).[14] People of various cultures and faiths gravitate to the rituals of Día de los Muertos—from altar-making, to candle-light processions, to street theater—as a means of dealing with death. The event addresses a critical hole in U.S. culture: mourners deal with death publicly, openly, and humorously. To mourn is not to accept loss passively but to celebrate the dead and thereby to find spiritual fulfillment and political empowerment.

Chicanos in California began developing public celebrations to reconnect with their indigenous heritage in the late 1960s and 1970s.[15] In the context of the national civil rights movement and the growing emphasis on multiculturalism, Día de los Muertos proved attractive for its roots in indigenous, Catholic, and pagan practices. The annual November event enabled a spiritual and performative invocation of mestizo ethnic heritage. Through the creation of *ofrendas*, processions to the cemetery, and public performances, the event celebrated the presence of the dead among the living and visually heightened the resistance of Chicanos to colonial conquest.

Most references to San Francisco's Día de los Muertos celebration have given credit to artists René Yañez and Ralph Maradiaga at Galería de la Raza for initiating public celebrations in 1972. Theirs was not the first public celebration—Casa Hispana de Bellas Artes held a Día de los Muertos event the year prior—but Galería de la Raza became the most visible leader of public celebrations in San Francisco.[16] By "public" celebration, I differentiate large-scale exhibitions and processions from the intimate tradition of family altars and practices that long existed in the community on a smaller scale. For instance, San Francisco native Yolanda Garfias Woo started celebrating Día de los Muertos as a young adult in the late 1950s, after the death of her father. Garfias Woo said her father was

"a true Mexican in the heart. And everybody else . . . was trying very hard not to be."[17] She turned to Día de los Muertos rituals to mourn her loss as well as to symbolically convey her affinity for her father's culture.

Many Bay Area residents grew up with intimate memories of their parents and grandparents practicing Muertos-related rituals. Texas artist Carmen Lomas Garza used her memories of practicing Día de los Muertos with her family to produce an academic study of altars in 1971. Upon moving to the Bay Area in the mid-1970s, she came to the Galería because of their celebrations for Día de los Muertos—she perceived the organization was "trying to, sort of create a renaissance of celebrating the Day of the Dead."[18] Similarly, Bay Area folklorist Rafaela Castro recalled stories from her mother's youth in Texas of trips to the cemetery. "She thought it was great fun, like a picnic of sorts, even though the entire day was spent reciting the rosary."[19] Texans such as Lomas Garza, Castro, Juan Pablo Gutiérrez, Tomás Ybarra-Frausto, and others connected the private celebrations of their youth with the emerging public celebrations in San Francisco. The public event nourished nostalgia for familial intimacy in an urban setting.

Of course, representations of Día de los Muertos existed in popular culture prior to the project of Chicano reclamation, albeit often from a perspective that presumed its disintegration. In the 1950s and 1960s, a wave of anthropological or documentary projects sought to commemorate the passing of Día de los Muertos. Many of the projects presumed that technology and progress would soon eliminate such a "primitive" celebration or, at the very least, permanently erode its authenticity. Celebrants often were characterized as a people close to nature and therefore in opposition to progress. Such themes and images of Days of the Dead penetrated the works of Russian filmmaker Sergei Eisenstein, British author Malcolm Lowry, and American designer Alexander Girard. Eisenstein, for example, with the patronage of American author Upton Sinclair, shot extensive footage of the celebration in Mexico in the early 1930s.[20] In 1947, Lowry published his classic novel *Under the Volcano*, set during Día de los Muertos in Mexico. Girard used indigenous imagery as inspiration in his designs and helped produce a documentary film by Charles and Ray Eames on *Día de los Muertos* (1957). Later, Girard's formidable collection of Día de los Muertos objects helped grow the Museum of International Folk Art in Santa Fe, New Mexico. The work of Girard and others propelled the American anthropological gaze toward Día de los Muertos.[21] The ritual spectacle easily lent itself to the invocation of many similarly romanticizing and primitivist visions of Mexico.

At the same time that Girard was collecting Día de los Muertos items to document the past, Octavio Paz was declaring the Mexican perspective on death to be one of the most significant characteristics of Mexican identity. Paz

published *The Labyrinth of Solitude* in 1950. Though eleven years passed before an English translation of the book became available, it had an immediate impact, both in Mexico and abroad. In his writing, Paz asserted a Mexican identity on the global stage that appealed to Mexicans but that also affirmed its "othered" position among nations. He wrote:

> The word death is not pronounced in New York, in Paris, in London, because it burns the lips. The Mexican, in contrast, is familiar with death, jokes about it, caresses it, sleeps with it, celebrates it; it is one of his favorite toys and his most steadfast love. True, there is perhaps as much fear in his attitude as in that of others, but at least death is not hidden away: he looks at it face to face, with impatience, disdain or irony. "If they are going to kill me tomorrow, let them kill me right away."[22]

Paz's meditations on Mexican identity served as a guide for understanding the Mexican attitude toward death. As Chicanos sought to strengthen their Mexican heritage in the 1960s and 1970s, they also showed greater interest in understanding and cultivating Mexican attitudes toward death in the United States, as outlined by Paz and other Mexican philosophers.[23]

In many ways, Día de los Muertos appealed as a malleable form of spiritual and cultural fulfillment in a time of increasing disillusionment with organized religion.[24] Garfias Woo began lecturing about Día de los Muertos in the early 1960s, soon after she started teaching at the John McLaren School in San Francisco's neglected, predominantly African American Visitation Valley community. Garfias Woo recalled, "The death in that school was very high. These kids were living with death constantly. And no one was talking about it. One boy had seen his mother shot to death by his father, that morning, on his way to school, and they sent him to school! . . . And so I started doing Muertos."[25] Garfias Woo turned to the celebration as a source of healing for school children in crisis.

The introduction of Día de los Muertos to the Bay Area was greeted with some distrust: In fact, the reactions were so uninformed as to be humorous. Garfias Woo recalled a moment around Halloween time when she began to teach children about the event at the John McLaren School: "The teacher next door to me, who was Irish . . . she stood at her door, I'll never forget, she had this big witch's hat . . . and this long black gown and she said, 'You know, Yolanda . . . that's witchcraft. You can't teach that in the schools.'"[26] Rather than be deterred, Garfias Woo began a teacher training program that sought to dispel such reactions.

Reportedly, the curators of Galería de la Raza experienced similar misunderstandings. René Yañez recalled how difficult it was to plan for the candlelight procession that would become a defining element of the celebration: "It was

years before I could get a permit for the procession from the Mission [police] station. . . . This captain thought I was part of a Charles Manson cult or something. He said, 'Day of the what? No way, Man.'"[27] The perception that Día de los Muertos was a form of witchcraft alarmed some but also substantiated the celebration's counterculture authenticity for Chicanos seeking an indigenous form of expression. In fact, the rituals blended with notions of the counterculture. René Yañez attributed the creation of his first altar at his home in Oakland in 1967 to a visit to Mexico. He recalled, "I invited some of my friends over, and they thought it was a happening."[28] Thus, Día de los Muertos not only served as a framework to assert ethnic heritage, but also as a means of defining oneself apart from the U.S. mainstream.

"We Can Invent What It Means to Us": Tradition and Innovation in the 1970s Celebration

Interest in Día de los Muertos in the United States immediately sparked debate about how traditional customs of Latin America should be upheld or transformed. The flexibility of Día de los Muertos was part of its appeal. As many have noted, "Celebrations vary from region to region, as does the timing of events."[29] Los Angeles artist Gronk (Glugio Nicandro) recalled attending a meeting in the early 1970s at Self-Help Graphics, the organization largely responsible for initiating the public Día de los Muertos procession in East Los Angeles.[30] Gronk recalled, "They'd showed a movie about the Day of the Dead, and we sat through it . . . but we sort of rolled our eyes like, 'Are we gonna repeat that?' Just like, 'That's fine for somewhere else, but that's not for us. Day of the Dead can mean a lot of different of things, and it doesn't necessarily mean paper cutouts, skull heads. We can invent it, what it means to us.'"[31] The idea was to borrow various facets of the Latin American celebration, but also to bring one's personal and creative energies to bear.

San Francisco artist Emilia "Mia" Galaviz de Gonzalez shared in the experimental approach to the event largely because she had no firsthand knowledge of the celebration. Her only guide was her friend and fellow altar-maker Yolanda Garfias Woo, who described what an altar should look like based on her studies of Oaxacan customs. However, Galaviz de Gonzalez, having no photographs to guide her, recalled the novelty of building an altar for one of Galería de la Raza's initial shows:

> I had a space, and then I asked them to put a pole down for me so I could suspend some curtains. It was actually purple curtains, which is wrong, purple! You don't do it now, you didn't do it then, you do it like in Easter

time, but who knew! So I had these beautiful deep purple curtains . . . so I sewed chiles on the curtains, on the edge of the curtains, so that when they opened up, you had these *cadenas de chiles* [chains of chiles] . . . and tons of flowers . . . [and] religious things and little food things. Because I did not know what it was. . . . And that was my first installation. It was organic materials and . . . the virgin and a cross and everything religious that I just threw like a potpourri of kitchen sink things.[32]

In hindsight, the altar initiated the artist's career in installation, though such terminology did not apply at the time. Galaviz de Gonzalez's memory reflects how easily the worlds of Día de los Muertos and contemporary art blended.

As the event took root, it also became regionally specific. While Southern and Northern California public celebrations both started in the early 1970s and reflected a substantial cross-pollination of ideas from Sacramento to San Diego, they also reflected local characteristics. In San Francisco, the celebration showed a predominantly Mexican influence, although the event was celebrated throughout Latin America. Local authority Yolanda Garfias Woo helped promote this orientation as a result of her bicultural upbringing in the United States and Mexico and deep interest in Mexican cultural practices.[33] In addition, Chicano artists such as José Montoya, Ricardo Favela, and Francisco Camplís started making playful allusions to the *calavera* artwork of Posada even before the public celebrations of Dia de los Muertos.[34] Such invocations of Mexican art and culture contributed to a more Mexican-oriented event.

However, the San Francisco celebration did not start as a Mexican-centered event, nor did that later emphasis go uncontested. In fact, the first public celebration of Día de los Muertos was emphatically pan-Latino. Casa Hispana de Bellas Artes planned the celebration of Día de los Muertos as part of its October "Mission Arts Festival" in 1971 (Fig. 8.1). Members of Casa Hispana—many of whom were associated with Galería de la Raza—recognized the enormous potential of festivals for expanding community outreach and showcasing their work as writers, artists, and performers. By 1971, Casa members had expanded their six-year-old October celebration of Día de la Raza to become a month-long Mission Arts Festival, ending with a celebration of Día de los Muertos.[35]

The Casa Hispana event is important in representing an alternative and forgotten approach to the celebration of Día de los Muertos in the city. Casa Hispana stated its intent on the 1971 program: "We want not only to honor 'Día de las Animas' [Day of the Spirits] but also to present a literary concert through poetry and prose to honor the creative writers from the Mission District and those from the larger Raza/Hispanidad communities who have written in different times and places on the theme of the day."[36] A diverse group of local

Figure 8.1. Casa Hispana, *Día de las Animas* (*Day of the Spirits*), 1971, poster, approximately 8.5 × 13.5 inches, printed by the San Francisco Art Commission. This poster marks one of the earliest public celebrations of Day of the Dead in San Francisco. The annual Galería de la Raza celebrations began in 1972. Image courtesy of the archive of Don Santina.

poets participated, including Nina Serrano, Carol Lee Sanchez, Jessica Hagedorn, Elias Hruska-Cortes, and Roberto Vargas, reflecting Casa Hispana's attempt to encompass wide-ranging cultural perspectives. The poets read from or referred to the works of Octavio Paz (Mexican), Pablo Neruda (Chilean), and Roque Dalton (Salvadoran). The program oriented audiences to the many regional forms of Día de los Muertos existing in Mexico, Peru, and Guatemala. The event also featured readings of noted Spanish poets Jorge Manrique and Gustavo Adolfo Bécquer. As a whole, the program reflected the desire to assemble a pan-Latino or Raza identity. Though the work of Casa Hispana was gradually erased from traditional histories of the event in the city, the pan-Latino approach to the celebration never entirely disappeared and, in fact, gradually resurfaced.[37]

The 1970s exhibits provided definitions in their programs and in their displays. Early exhibitions displayed a variety of traditional *calavera* sculptures, masks, and *papel picado* (delicately crafted paper cutouts). The visual culture of Día de los Muertos largely revolved around a wide range of pre-Colombian imagery and material culture. For instance, Ralph Maradiaga's posters for Día de los Muertos in 1972, 1974, 1975, and 1976 all used traditional Mexican *calavera* (skeleton) or Aztecan imagery.

The Mission Cultural Center opened in the summer of 1977 and held its first exhibit for Día de los Muertos that same year. Salvadoran gallery coordinator Gilberto Osorio, interviewed for an article in *Arts Biweekly,* recalled, "The idea for the show was presented by a white person, and the whole committee decided to do the show together. People asked, 'What is the traditional color—black?' And we told them, 'No, orange.' They asked if there was any artist particularly associated with the holiday, and we told them José Guadalupe Posada, a Mexican graphic artist who influenced Siqueiros and Orozco. We all read books and studied together, in order to do the show."[38] According to the article, the 1977 show "included an Homenaje a los Revolucionarios Inconocidos [Homage to Unknown Revolutionaries]; a 4,000-year-old mummified foot from a tomb in Peru; and an amazing display, by Carlos Córdova, of the herbs and saints traditionally associated with the day of the dead."[39] Such Salvadoran and Peruvian cultural representations underscored the event's capacity to transform in different settings and in relation to the interests and backgrounds of the artists.

Educating children was an important principle of the celebrations. In 1976, Maria Pinedo of Galería de la Raza reported that more than seven hundred children toured the gallery and viewed the Día de los Muertos show. Many, she added, "returned later with their families for a second look."[40] The gallery produced mask workshops, showed films, educated school children, led processions, and created eye-popping exhibits. Their success encouraged other locales to do the same.

Also in the late 1970s, the Galería started a public procession for the event, likely inspired by the success of the Self-Help Graphics procession in Los Angeles. Though the first San Francisco procession only counted a hundred people, the event grew into the thousands over the course of the 1980s. According to Pinedo, "Back in the '70s the procession started as an art expression. It began with the idea that in Mexico, in the evening, people used to go to the cemeteries and have all night vigils combined with a celebratory event.... We only had 100 people back then. We made hot chocolate on a hot plate and served cake afterwards." The group even attempted to create little bonfires, "but the fire department stopped us and gave us fines."[41] Her recollection gives insight into the intimate appeal of the celebration—of modest size, familial, and close-knit.

The 1978 celebration at Galería de la Raza signaled a change in how local artists imagined Día de los Muertos. Rupert García, Carmen Lomas Garza, Maradiaga, Amalia Mesa-Bains, Pinedo, and Yañez organized a show at Galería de la Raza dedicated to the memory of Frida Kahlo (Fig. 8.2).[42] Tim Drescher wrote, "The opening reception was an evening of rare respect and intensity, where people who had known and worked with Frida wore necklaces she had given them, and those who had studied her paintings and recognized an affinity with her wore earrings of hands holding paintbrushes, as Frida had worn."[43] The event marked a turning point in Kahlo's reputation, as the feminist movement encouraged a reevaluation of Kahlo's work apart from her husband Diego Rivera's shadow.[44] As Shifra Goldman pointed out, "Kahlo did not have a major exhibition of her work in Mexico until 1953 (Galería de Arte Contemporáneo), or a major retrospective until the Exposición Nacional de Homenaje at the Palacio de Bellas Artes in 1977."[45] The Bellas Artes exhibit traveled to the United States in early 1978 and propelled U.S. interest in Kahlo's work. The Galería artists significantly contributed to the Kahlo revival and, more covertly, critiqued the race and gender politics of the art world that had perpetuated Kahlo's absence.[46] Mesa-Bains recalled making the "first *ofrenda* for Frida Kahlo in 1978" with Lomas Garza and Yañez. She stated, "We took what was traditionally a familial and personal practice and we turned it into a community, public practice. We mixed our families in with historical figures who had died. We used that as a way to historicize our past."[47] By dedicating Día de los Muertos to Kahlo, local artists transitioned a traditionally private offering to friends and loved ones into a homage to a public figure.

Limited Entrée: Día de los Muertos in the Museum

By the end of the 1970s, the learning curve for Día de los Muertos had plateaued in the Bay Area. Familiarity dispelled the initial discomfort. In fact, the cele-

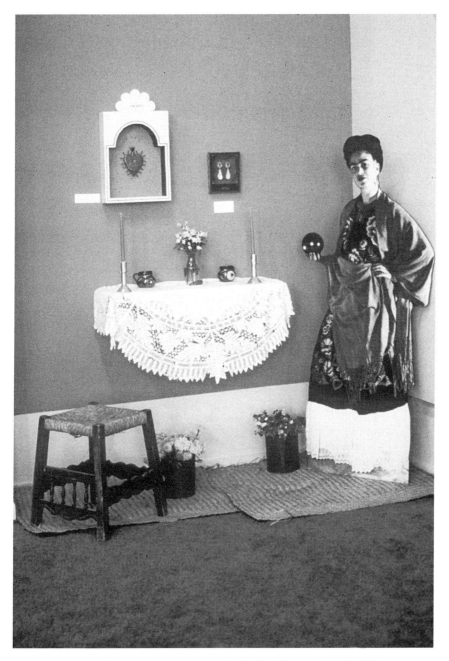

Figure 8.2. René Yañez, *Homenaje a Frida Kahlo* (*Altar to Frida Kahlo*), Galería de la Raza, 1978, mixed media altar. Photograph by Maria Pinedo. Galería de la Raza Archives, CEMA 4. Image courtesy of the artist and the California Ethnic and Multicultural Archives. Department of Special Research Collections, UC Santa Barbara Library, University of California, Santa Barbara.

bration emerged as a multicultural favorite, with shows at San Francisco State University, the De Young Museum, the Mexican Museum, the Triton Museum, and the Mission Cultural Center. By 1981, Galería de la Raza curator Carmen Lomas Garza could say "This last year we saw that our annual Day of the Dead/Día de los Muertos exhibition has had an influence on other arts institutions."[48] In fact, a sense of the celebration's spiraling growth may have motivated the pronounced declarations of Galería authorship. In various ways, San Francisco's Galería de la Raza sought to lay claim, not entirely unjustly, to this cultural shift that was no longer local but national.[49]

However, neither museums nor altar-makers were entirely comfortable with Día de los Muertos entering the more austere art world. In 1975, the De Young Museum invited Garfias Woo to display her Día de los Muertos collection and to create a traditional Oaxacan altar. Though Garfias Woo was glad to participate in this educational project, she experienced resistance among the staff: "I heard many people say . . . this is very cute and everything, but it doesn't belong in a Fine Arts Museum."[50]

Museum staff had to reconsider their dismissive response. Though Garfias Woo had instructed them to leave the altar to her care, staff members took it upon themselves to create her altar. That the staff even considered creating Garfias Woo's altar for her betrayed a disregard for the artist's skill. Garfias Woo recalled, "It was very symmetrical, very western, very European, so when I came down after work, I said, 'you know you did a great job guys but, let me fix this a little bit.' And they all stood and they were watching me and they said, 'oh, oh!' because it was so totally different from anything that they had ever done" (Fig. 8.3).[51]

The museum staff quickly learned that this folk art drew major media attention. The day the show opened, a museum representative called Garfias Woo in a panic, stating, "We have channels four, five, and seven here, with full camera crews, and they're asking all kinds of questions and there's nobody here who can answer anything." Not only did Garfias Woo come to their aid, the experience launched her involvement with a one-hour ABC special on Día de los Muertos. NBC's *Alma de Bronce* show also covered the event, as did CBS's *Somos Vida*. Garfias Woo thought the experience helped awaken the museum to the meaning and popular appeal of her work. She added, "I found out afterward that this had always been a sore spot for the museum. They could never get news people to the Museum for the opening of any exhibit. . . . And here they had all three channels."[52]

Garfias Woo's experience conveys how contemporary art institutions did not perceive altar-makers as artists, though they were steadily gaining entrée. It was "folk art," or "outsider art," but not "contemporary art." Laura Pérez pointed out the discriminatory practice of only inviting Chicanas into the

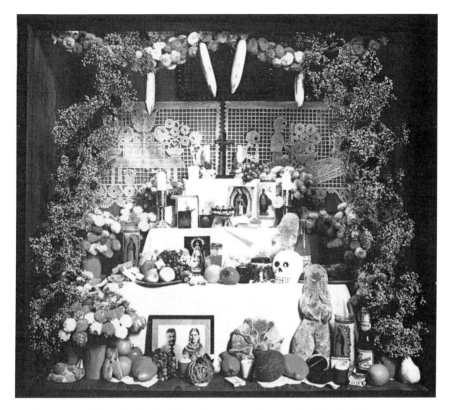

Figure 8.3. Yolanda Garfias Woo, *Homenaje a Papa y los Abuelos* (*Homage to My Father and My Grandparents*), 1975–1976, mixed media altar at the de Young Museum in San Francisco. Image courtesy of the artist.

museum for Día de los Muertos installations. She wrote, "Inviting them to install altars solely on 'Hispanic' occasions runs the risk of folklorizing their contemporary art forms and reinscribing them in the margins of an ostensibly multicultural museum in ethnically prescriptive ways."[53]

Nor did some traditional altar-makers necessarily see themselves as artists. Their work was a ritual of daily life and a deeply personal and communal invocation of spiritual desires, not something that many expected ever to appear in art institutions. In a 1993 interview, Mexican altarist Herminia Romero said of altars, "*Es un deber y una costumbre. En él se ve la inspiración de la persona, sus cualidades. Pero allá nunca pensamos que es un arte. Es como escribir a máquina.*" (It's a duty and a custom. In it one sees the inspiration of the individual, their qualities. But there, we never thought of it as an art. It is like writing on a typewriter.)[54]

Both altar-makers and taste-makers responded ambivalently to the repre-
sentation of altar-making as an art form, yet increasingly, the altars reflected
avant-garde influences and contemporary political visions that eschewed the
"folk art" label. In particular, the rise of installation art as an accepted medium
in the art world significantly changed how artists and art-based institutions
reconceptualized altar-making.[55] Galaviz de Gonzalez's reference to her first
altar as her first installation indicated the affinity between these two worlds.
Similarly, Amalia Mesa-Bains once noted the two threads influencing her cre-
ative process: "The making of altars grew out of my early experiences in my
family and in the church. My formal training as an artist has affected the form
of expression despite it[s] basically spiritual and ceremonial nature. Construed
by many to be a folk art form, the altar maintains some traditional elements,
yet it is a contemporary medium."[56] For both of these artists, their work was not
just a product of their ethnic identity, but of their understanding of themselves
as artists. This dual identity was important in stimulating creativity and chal-
lenging traditional iconography for a generation of artists wishing to experi-
ment with this new medium. As Kay Turner and Pat Jasper observed of the new
altar-making, "Some of the treatments are personal, some are political, some
are fanciful, but all of them remove the *ofrenda* tradition from its original Mex-
ican folk context by making use of the altar not as a religious and familial site
primarily, but as a sculptural form that generates the potential for a multilay-
ered assemblage of images, objects, and meanings."[57] The professionalization
of American *ofrendas* mirrored the growth of installation art and assemblage.
Their similar trajectories blurred different political and spiritual intentions.

Día de los Muertos and Political Insurgency

By the early 1980s, the visual culture of Día de los Muertos had branched in all
directions. Local artists connected the event to encounters with death in the
present, in the past, and in the future. Artists even began showing work that
they did not necessarily create for the event, but that perfectly intersected with
the spirit of the exhibitions. In fact, the early 1980s marked a clear transition in
the celebration, as the altars and the processions reflected a forceful adaptation
of political messages. The works of Ester Hernandez illustrate the multidirec-
tionality of the images. For the 1983 show, Hernandez submitted at least three
works. One was her now-famous serigraph *Sun Mad* (1981), which clearly
pointed the finger at California's grape growers as agents of death by replacing
the image of the smiling Sun Maid Raisins girl with a more ominous *calavera*
(Fig. 8.4). Hernandez later stated, "I made the print 'Sun Mad' as a very personal
reaction to my shock when I discovered that the water in my hometown, Di-

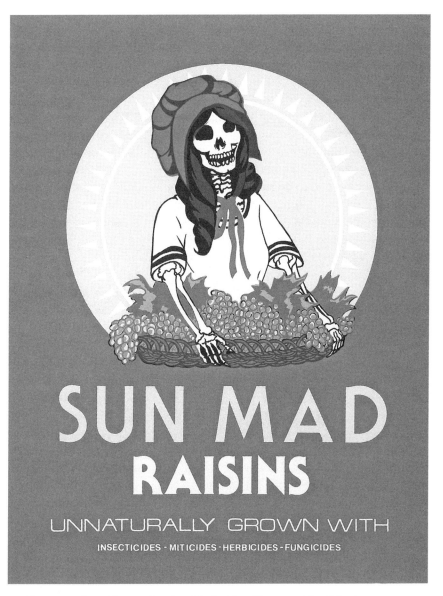

Figure 8.4. Ester Hernandez, *Sun Mad*, 1981, silkscreen, 22 × 17 inches.
© Ester Hernandez, www.esterhernandez.com. Image courtesy of the artist.

nuba, California, which is the center of the raisin-producing territory, had been contaminated by pesticides for 25 to 30 years. I realized I had drunk and bathed in this water."[58] Hernandez's depiction undercut the pleasant corporate marketing with an image that was both humorous and painful. As Amalia Mesa-Bains observed, "In the fashion of the Mexican popular arts printer, Posada, Hernandez applies the *muertitos* tradition of satire to America's sweetheart."[59] Though this work has become an icon of Chicano art, it also was a very personal mediation on Hernandez's own mortality.

Hernandez's visual critiques of systemic violence dovetailed with the event's focus on death. In another work, *Self-Portrait with Tecate, Watermelon and Nuclear Explosion* (c. 1983), Hernandez portrayed herself with an *ofrenda* of beer and watermelon in front of a mushroom cloud.[60] The image's absurdity expressed the event's classic laughter at death, but also critiqued a society that crafted such weaponry. Others joined in her protest. For instance, Chilean artist René Castro submitted his sardonic *Nuclear War Is a Dangerous Sport*. In 1985, Irene Pérez exhibited *Día de los Muertos, C/S*, a gouache illustration of missiles launching from the Lotería card of death (La Muerte). Alongside this grinning skull with a missing tooth, Pérez depicted the card for the world (El Mundo), but rather than resembling the Earth, the globe appeared completely black, foretelling complete annihilation. Pérez offered some levity, with her inclusion of three perfectly manicured female hands with bright pink fingernails balancing over the cards, suggestive of a fortune teller and her subject. While these two women saw the future of the world in their Lotería cards, others failed to take this foresight seriously. In these various ways, the artists drew on the event's festive attitude toward death to cope with the greatest imaginable tragedies.

Though humor continued to resonate in the celebration, the force of human trauma abroad and at home escalated the expressions into more dramatic and graphic responses. At Galería de la Raza, multiple artists used the event to take issue with growing violence in Central America. René Castro and Jos Sances produced a work entitled *We the Disappeared Have a Right to a Shroud*, which featured a full-body skeleton laid out beneath a transparent white veil.[61] The work heightened visibility for the rising numbers of *desaparecidos*, and demanded dignity for the dead. The horrors of death were not simply in the senseless violence, but in the strewn remains of human bodies. Other works reflected growing concerns over violence in Central America. Labor activist Jack Heyman showed two of his documentary photographs from 1983: one called *Mothers of Slain Nicaraguan Soldiers Are Honored Guests at Military Rally in Jalapa, Nicaragua*, and the other titled *Managua Cemetery*, which featured the sister of a slain Sandinista soldier. Both images offered a critique of the CIA's covert funding of the Contras in Honduras.[62]

Día de los Muertos partly became a key event to express protest because of its proximity to November elections. In 1984, the impending reelection of President Reagan heightened the seriousness of the event and propelled a variety of passionate, overtly political protests within the celebration. That year, as processioners walked through Balmy Alley, they passed a sea of murals protesting U.S. intervention. Filled with depictions against the violence in Central America, the Balmy Alley murals contributed to the gravity of the celebration.[63] The procession ended in Garfield Park with the creation of a communal altar and multiple performances. Inside the Galería de la Raza, Hernandez showed her *Tejido de los Desaparecidos* (*Weaving for the Disappeared*) (1984), a clever work that played off the aesthetics of traditional textiles (Fig. 8.5). In place of indigenous designs, Hernandez stitched symbols of the violence in Central America, including bodies, skulls, and helicopters. Hernandez dispensed with the colorful stylings of traditional weavings and delivered her work in black and white, except for the representation of blood spatter across the top. The violence in Central America propelled artists to create graphic responses to the violence, which then significantly shifted the tone of Day of the Dead celebrations.

Figure 8.5. Ester Hernandez, *Tejido de los Desaparecidos* (*Weaving of the Disappeared*), 1984, silkscreen, 17 × 22 inches. © Ester Hernandez, www .esterhernandez.com. Image courtesy of the artist.

Gradually, exhibitions curated a wide variety of altars and artwork critical of human violence. In 1987, Enrique Chagoya showed *Monument to the Missing Gods,* a diptych construction that evolved from a series of works Chagoya developed while completing graduate school (Plate 11). The work consisted of two cigar box constructions hung next to each other, counterbalanced on black and red backgrounds "to represent the opposite sides of knowledge in ancient Maya and Nahua mythology."[64] In the black box on the left, Chagoya placed a set of miniature skulls inside and around the edges, similar to the *tzompantlis,* or skull racks, of pre-Columbian ruins. He decorated the blackness above and around the skulls with gold leaf *citlalli,* resembling half-opened eyes, "because that's the way the stars were depicted in a pyramid in the Kingdom of Texcoco where the Aztec library was burned to ashes during the conquest."[65] Chagoya paralleled the skulls with Coca Cola bottles in the red box, loosely equating the violence of the conquest with "a commercial product symbolic of colonialism."[66] The black and red colors alluded to pre-Columbian knowledge but also represented the colors of European anarchists, Mexican strikers, and the Nicaraguan Sandinistas.[67] In choosing to exhibit the work in a Día de los Muertos exhibition, Chagoya intended the piece to be an *ofrenda.* Just as native peoples of the past offered up the skulls of their enemies to the gods, so Chagoya offered up the bottles of Coca Cola. Even so, Chagoya invoked a sense of hopelessness in his title, *Monument to the Missing Gods.* The piece is emblematic of how the work of San Francisco artists and the celebration of Día de los Muertos convened in a discourse critical of violence and expressive of grief.

Día de los Muertos and AIDS

Curiously, for all the politically conscious art that appeared in the Galería de la Raza's 1983 exhibition, little evidence remains to suggest that year's show addressed an increasingly urgent concern: AIDS. In August 1981, local health reports counted eighteen cases of Bay Area gay men battling an unusual immune deficiency.[68] By that December, New York's gay newspapers were crowded with stories on a series of new diseases befalling gay men, but the San Francisco press was slower to follow suit. By the fall of 1982, just a little over a year after those first eighteen cases, the gravity of San Francisco's situation was sinking in and mobilizing local political forces. Later reports estimated at least 20 percent of San Francisco's gay men were infected with the AIDS virus by the end of 1982. In September 1982, the city allotted $450,000 for the Shanti Project to create the world's first AIDS clinic, grief counseling, and personal support center. Though the sum was not even half a million dollars, journalist Randy Shilts pointed out that the amount was "nearly 20 percent of the money com-

mitted to fighting the AIDS epidemic for the entire United States, including all the science and epidemiology expenditures by the U.S. government."[69] The fall-out of such short-sightedness on the part of the federal government became obvious as mortality rates soared in 1986 and 1987.

In an effort to draw attention to this major public health threat, San Francisco activist Gary Walsh planned a candlelight march. Multiple cities joined in on the May 2, 1983, event. Walsh drew inspiration from the memory of a similar march following the murders of Supervisor Harvey Milk and Mayor George Moscone. The funereal crowd carried photographs and signs commemorating the dead. Many showed evidence of their own physical deterioration.[70] The candlelight march of 1983 marked one of the earliest attempts to grapple with the grief of AIDS in a public way.

By 1983, the topic of AIDS appeared more often in mainstream media, but it still carried multiple social taboos as a perceived "gay disease." Many Latinos in the Mission were reluctant to respond publicly to a sexually transmitted disease, particularly a disease so closely tied to homosexuality.[71] A reporter writing about the 1,500+ deaths between 1981 and 1986 noted that, "although the AIDS virus is nondiscriminatory—and in fact attacks children, men and women of all sexual orientations—all but three percent of its victims in San Francisco have been gay or bisexual men."[72] Whether or not this assessment was accurate, the statement tended to give false credibility to the popular perception of AIDS as a "gay disease."

Signs of the disease's impact began to filter into Día de los Muertos celebrations by 1984. Juan Pablo Gutiérrez's altar from that year's show at Galería de la Raza delivered a powerful visual plea (Plate 12). The free-standing hinged wall display festooned with purple ribbons not only illustrated grief for the dead, but critiqued the living for the failure to take action. One side showed Saint Sebastian, known as a protector against plague and as an unofficial patron of gay men. On the other side in large letters appeared the text, *"Mientras la sociedad nos da la espalda, morimos miles, y miles, y miles"* (while society turns its back, we die by thousands and thousands and thousands). Gutiérrez incorporated a poem written on a scrap of paper into his indictment: *"Tras las montañas negras / de la homofobia / marchamos forzados mártires / en esta guerra de microbios / financiada por la Democracia / de mi país."* (Across the black mountains / of homophobia / we march forced into martyrdom / in this microbial war / financed by the Democracy / of my country.)[73] Works such as this show how *ofrendas* became a powerful medium to mourn, as well as to demand activism.

The work generated positive and negative responses from the neighborhood. Gutiérrez recalled that "the Latino community was not ready but René Yañez who curated the exhibition that year took the chance in allowing us to do the

'installation.' He got a lot of 'flack' from various sources who wanted it removed from the exhibit, but he decided to keep it in the exhibition after a Latino couple (Husband and Wife) knelt crying in front of the installation since their young teenage son had just died of AIDS. It was after this particular incident that René also decided to include as part of the 'Bill Board' outside . . . Latinos Who Have Died from AIDS-SIDA."[74] Gutiérrez's memory illustrates the ways an altar provided a space of solace in the midst of crisis. Though some represented the Mission District as homophobic owing to a form of Latino conservatism, the fact is that many residents in the Mission were experiencing the brutality of this disease firsthand.[75] Horacio Roque Ramirez pointed out that the first obituary for a Latino gay man in the *Bay Area Reporter* appeared in February 1984.[76] Roque Ramirez's important archival work shows the ways that Latinos struggled with this disease, but their deaths often remained invisible in larger dialogues about AIDS.

In addition, at least one of the Día de los Muertos performances of 1984 dramatized the impact of AIDS. Photographs depicted a man in a pink triangle shirt speaking to the crowd next to "bodies of evidence"—people tagged as dead with their backs facing the audience. The 1984 celebration became a turning point for Día de los Muertos in San Francisco, affirming the celebration as a means to express the political voice of those disenfranchised by President Reagan's policy of silence on AIDS. The lack of media coverage, the failure of the federal government to act quickly, and the slowness of health education and blood-bank testing all contributed to the high rate of infection. Randy Shilts wrote, "In no place in the Western world was this despondent future more palpable than on Castro Street in late 1984," and notably, "many turned to mysticism."[77]

Reagan's reelection on November 6, 1984 contributed to the despondency, but also forced a new insurgency. Shilts described the Gay Pride Parade of 1985 as a sign of a cultural shift: "The depression that had marked the penultimate phase of a community coming to grips with widespread death was beginning to lift." The parade symbolized a gradual acceptance of AIDS as a life-changing, culture-changing force, but the moment was also a turning point for AIDS activism—a new determination to reverse the odds.[78]

Mourning for AIDS became a prominent public activity over the course of the late 1980s, evidenced by the creation of the AIDS candlelight vigil in 1983, the AIDS quilt in 1985, Art Against AIDS in 1987, and A Day without Art in 1989. The culture of mourning as activism proliferated throughout public life. The 1980s marked a cultural shift toward acceptance of large-scale public mourning in America, relying on grief to mobilize communal concern and generate healing. Additional influences, such as the visual power of the Vietnam Veterans Memorial (1984) in Washington, D.C., and the high-profile mourning of the

Mothers of the Plaza de Mayo in Argentina, showed the political and emotional relevance of grieving publicly.[79]

In San Francisco, the intersections between Día de los Muertos and AIDS grew more prominent. Grace Cathedral, an Episcopal church, created a Day of the Dead service as part of an "AIDS Day of Remembrance." Similarly, Yolanda Garfias Woo, an instrumental force in the cultural reclamation of Día de los Muertos, recalled how a Presbyterian church invited her to set up an altar in Oakland. Garfias Woo stated, "I was kind of surprised because there were almost no Hispanics. . . . But when I went there to do the presentation, they had a huge AIDS quilt out, and they said that so many of their parishioners had died that they really wanted to do an altar in their church for these AIDS victims."[80] Her experience shows how Día de los Muertos altar-making filtered throughout the city and beyond, largely in response to AIDS.

Mourning for the World: Día de los Muertos and Expressions of Transnational Grief

Gradually, Día de los Muertos transitioned to respond to a vast range of spiritual and political desires for mourning. Perhaps one of the most profound changes to San Francisco's celebration came as a result of René Yañez leaving Galería de la Raza to work as an independent curator. One of his first solo events was a "Rooms for the Dead" exhibit at the Mission Cultural Center in 1990. Galería de la Raza was a small space, but the Mission Cultural Center was a former department store offering vast possibilities. Yañez split up the top floor into a maze of twenty-nine private eight-by-eight rooms, "each containing a universe of creations, memories, and reflections on life and death."[81] The labyrinthine setting created many intimate environments for mourning, which taken as a whole became a powerfully moving reflection of grief in the city.

Yañez not only physically expanded the concept of Día de los Muertos exhibitions but expanded their cultural scope. He wanted a multicultural celebration that encompassed not just Latino artists, but everyone in the city. More than fifty artists participated in the "Rooms for the Dead" exhibit, with each bringing their personal and political visions to bear. Traveling through the rooms, visitors encountered altars dedicated to heroes of the Left such as Chilean president Salvador Allende and Nicaraguan revolutionary Augusto Sandino. Other altars were more abstract: Chicana artist Galaviz de Gonzalez created an altar to Cuban-American artist Ana Mendieta, invoking Mendieta's abstract style within the altar (Fig. 8.6); Pilar Olabarria, in "For Whom the Bell Tolls," represented bloodshed in the Middle East by hanging tiny bells from thin red ribbons, like lives hanging by a thread; Mauricio Rivera played with the idea of

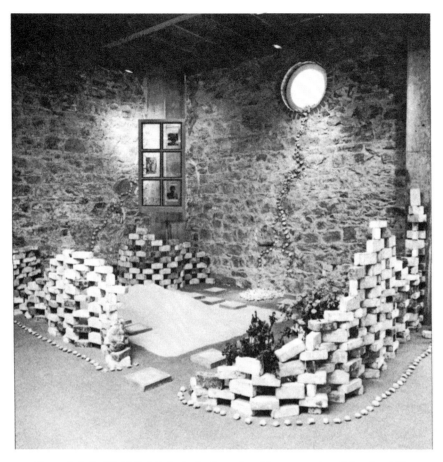

Figure 8.6. Emilia "Mia" Galaviz de Gonzalez, *Homage to Ana [Mendieta] II*, 1995. Image courtesy of the artist.

"Lost Souls" in his montage of shoe soles and other amorphous forms; and Flora Campoy's room of "Reflextions, Reflections" grieved for Latinos with AIDS, taking issue with the Catholic Church for failing to offer support.[82] The 1990 show solidified the expression of leftist political sentiments within the ritual framework of San Francisco's Día de los Muertos.

The show provided a sumptuous visual feast that opened the eyes of many. Reports suggest close to 1,000 attended the opening night reception and about 5,000 the procession. Cultural critic José Antonio Burciaga wrote a short essay on the "chingonometric" event, noting the steady stream of schoolchildren who visited the event "abuzz with the bewildering discovery of a Disneyland of death." In part, he wrote to scold Bay Area art critics for failing to write a single

article on Day of the Dead.[83] While shows of the late 1980s received human-interest press, no art reviews appeared. René Yañez felt that the spirit of the event was too different from the art world's expectations. In fact, though Día de los Muertos found inspiration in installation art, he was searching for work that was less in line with current trends: "I went through a lot of proposals by professional artists who wanted to put in neon and stainless steel, but I was looking for ones with heartfelt expression, with a lot of passion."[84] Perhaps Burciaga's scolding did not fall on deaf ears: *Artweek* shortly thereafter gave the show an admiring review. Reviewer Gary Gach wrote, "Quite simply, *Rooms* is an intercultural landmark, monumental, universal, diverse."[85] The elaborate creative works, the high attendance, the new public recognition all suggested that in 1990, San Francisco's Día de los Muertos had entered a new phase. Yañez remarked, "This is an American custom now. I don't know where it's going; it's taken on a life of its own."[86]

Consuming Día de los Muertos: The Struggle
for Authenticity

By the late 1980s, Día de los Muertos celebrations appeared everywhere in San Francisco as well as around the country. As Kay Turner and Pat Jasper noted, "The trend continued to grow—in fact, it exploded—and by the late 1980s, Day of the Dead exhibits were being held in such diverse places as New York City, Chicago, Houston, and Miami."[87] Events included museum and gallery exhibits, musical performances, theatrical productions, dances, and art demonstrations. The primary Latino organizational forces in San Francisco were Galería de la Raza, the Mission Cultural Center, La Raza Grafica, and the Mexican Museum. In 1989, *Sunset Magazine* devoted four glossy pages to Day of the Dead in the Mission. The author encouraged readers to visit the Mission and enjoy the exotic other: "Watch a Mexican artist spin a sugar skull or whittle a fantasy afterworld for the Day of the Dead—then shop for colorfully macabre holiday artifacts." The author also recommended sampling the pastries of *calaveras, conchas,* and *churros,* and provided a long list of restaurants to investigate. The mainstream press easily incorporated Día de los Muertos as another Mexican-style fiesta to enjoy eating unusual foods and wearing dramatic costumes. The surface coverage of the event submerged but did not subdue its political and social meaning. *Sunset Magazine*'s only reference to the event's social issues appeared in a fleeting reference to processioners "bearing crosses for people killed in Central America, or people who have died from AIDS."[88] Few of the articles gave much thought to the meaning of death, who was dying, and who were the people being remembered.

After 1990, San Francisco's Día de los Muertos events experienced considerable tensions as a result of its popularity, particularly in terms of the procession, which grew from a hundred people in the 1970s, to several thousand in the early 1990s. While the altars inside became more experimental, more multicultural, more installation-like, and more dramatic, the procession also changed. Reporter Lon Daniels described the scene of thousands of people in 1990 as follows: "Costumed participants resembled extras in horror movies. Makeup made some look like emaciated zombies. Giant sculptures of bird and dog skeletons flanked parts of the parade. Human skeletons seemed to dance while visions of death walked on stilts and percussion instruments punctuated the evening with rhythms reminiscent of Carnival celebrations."[89] The physical distinctions between Halloween and Día de los Muertos were blurring, and cultural guardians of Día de los Muertos began to register their concern.

Event organizers struggled with the popularized simplifications of Día de los Muertos and its proximity to Halloween. In 1981, San Francisco journalist Warren Hinckle declared, "With the gay explosion in San Francisco in the early '70s [Halloween] became the gay national holiday."[90] The high profile of New York's carnivalesque Greenwich Village parade likely contributed to the national "queering" of the event.[91] In 1982, San Francisco Halloween photographer Bennett Hall declared that "in a few years, Halloween will become to San Francisco what the Mardi Gras is to New Orleans—a kind of city holiday."[92] Just as Día de los Muertos had come to evoke a specific Chicano or Latino identity, Halloween also had grown to celebrate a carnivalesque gay identity. Gradually, the cultural practices of Halloween—the ghoulish costumes, parties, and general boisterousness—were intersecting with the more meditative practices of Día de los Muertos. Fear that Halloween would turn Día de los Muertos into just another Americanized fiesta spurred concern in the Latino community.

Simultaneously, a movement to cultivate a more authentic Halloween challenged the semi-established meaning of Día de los Muertos. In 1979, Starhawk published her influential book *The Spiral Dance*, which advocated reclamation of Halloween as a spiritual event—"The overarching purpose was to initiate a large public ritual that melded art, music, ritual and politics, and to bring the Craft out of the broom closet."[93] Participants described themselves as part of the "Reclaiming Community" and advocated black magic as a positive healing agent for society's ills. In their quest for a more traditional Halloween, or Samhain, practitioners began to implement the rites of Día de los Muertos. Strangely enough, cross-pollination between Samhain and Día de los Muertos

began with advocacy for public needle exchanges to prevent the spread of AIDS. Rose May Dance, a member of the Reclaiming Community, recalled that "at the time, the City was officially saying no to needle exchange. Feinstein was mayor. It was pretty bad. . . . We did a lot of magical work, and we realized that Día de los Muertos (The Day of the Dead) was an extremely important day to begin. The help of the dead was very necessary for what we were doing, both the recently dead from AIDS, and the Mighty Dead of the Craft."[94]

The cross-cultural impact was unavoidable. Just as Día de los Muertos could serve as a vehicle for mourning AIDS, it also could serve as a vehicle for the wild celebrations of Halloween, or the black magic of Samhain. In fact, subsequent coleaders of the procession, Francisco Alarcon, a gay Latino poet, and Starhawk, a spiritual guide for Samhain, embodied the celebration's diverse appeal. The cultural appropriation caused consternation for some, but others continued to appreciate its flexibility.

In 1993, the Galería de la Raza withdrew from organizing the Día de los Muertos procession in an effort to return to a more authentic celebration. Galería director Liz Lerma explained, "We felt that we have to address the issue of people coming here but not knowing exactly why. It is not a Halloween parade, it is a Día de los Muertos procession, and that is different. It had meaning. Rather than put all our energy in producing this parade we want something that will attract more families, seniors and children. It will be a day-time event with more stress on the tradition . . . to educate people, to understand what Día de los Muertos is all about."[95] In rebuilding its focus, the Galería sought to institute a new tradition, the "24th Street Community Altars Window Walk." Artist Sal Garcia led an effort to create altars in storefront windows along 24th Street. The displays reflected the diversity of the neighborhood: the Fong Lam Restaurant featured an altar of "dancing skeletons with bowls of rice and tea"; the Mission Economic and Cultural Center showed an *ofrenda* to Miles Davis and Bob Marley; the Bank of America branch incorporated an altar to a recently passed away vice president; and China Books included an altar incorporating stones "arranged in the Korean symbol for rebirth."[96] Even in its efforts to kindle a more authentic celebration, Galería de la Raza still represented the event's inclusivity as a cross-cultural opportunity for everyone to mourn.

René Yañez continued curating "Rooms for the Dead" shows, first at the Mission Cultural Center, then at Yerba Buena Gardens, and later at SOMArts. His shows became increasingly more spectacular and experimental, with labyrinth-like environments that made use of every imaginable medium. Many of the altars spoke to political issues, but the diversity of political opinions

expressed and the number of Bay Area Día de los Muertos events represented the spectacular popularization of the event.

Mourning Día de los Muertos

When artists and activists began developing public celebrations of Día de los Muertos, they hoped to represent cultural traditions, to create a space for grief, and to subtly critique a Eurocentric vision of the world. An unexpected consequence was the creation of more exotic altars and the event's entry into unexpected political and cultural spheres. In many ways, these public representations of the event superseded the personal, familial, and communal nature of its origins. As Garfias Woo commented, "What bothers me about some of the modern installations is that I'm afraid that so many people who don't really understand what Muertos is are misinterpreting it and the tradition of Muertos can be changed and lost in that process."[97] Her fears paralleled other concerns about the popularization of the procession, the cultural appropriation of the event, and the seeds of commodification that threatened to undo the spiritual and political orientation of the event. Shifts in the celebration signaled changes in demographics, participants, and politics. A sense of threat to this tradition emerged more profoundly in the 1990s as gentrification began to displace more people from the Mission District.

Tracing shifts in the celebration offers a window onto a community that changed dramatically from the 1970s into the 1990s. In San Francisco, the celebration became an annual public expression of grief, solidarity, art, and politics. In his short story, "Ofrenda," published in 2000, Alejandro Murguía poetically captured the spirit of the event in the Mission:

> The Day of the Dead in La Mission is not exactly a Christian ritual, no reverent high mass, either. Aztec dancers led the procession, swooping and swaying, shuffling and twirling down the middle of 24th Street, pounding leather drums and rattling ankle bells, feathered headdresses bobbing over their braids. A raucous mob of candle-bearing Calaveras followed them, lifting their voices in song and laughter, snaking their way through the heart of the barrio like a luminous serpent. Giant matachines, their stilts hidden by baggy pants, danced to a calavera batería playing fast samba riffs on their tambores. Barking dogs trailed the procession, wrought into a frenzy by so many bones. Beautiful brown angel Calaveras with wire wings bore candles for the disappeared in Central America, for those snuffed by gang violence in the barrios, for those ravaged by AIDS, for those murdered by racism, for those strangled by

evictions, for the dying planet even, and for all those who don't know how to love, the living dead—the truly forever dead.[98]

Murguía's description conveys how the event jumbled together multiple visions, hopes, and fears. Above all, the celebration was a spiritual event, but in the context of the 1980s and 1990s, its rituals also provided a means to grapple with senseless tragedy and speak to power.

By the early 1990s, the public celebration of Día de los Muertos showed a dramatic shift from its initial homages to Mexican culture. Indeed, the event had grown so much it was just as likely to be celebrated in Brattleboro, Vermont as it was in San Francisco or Oaxaca. Public celebrations grew grander in scope with ever more dramatic expressions of protest. For instance, activists staged a shared celebration in Mexico City, Los Angeles, and Tijuana in 2000 in order to protest the deadly impact of militarizing the U.S.-Mexico border.[99] Awareness of trauma on various fronts heightened the importance of Día de los Muertos in San Francisco and elsewhere.

The event provided an important outlet for people to vent their fears of death and to speak for the dead or the soon-to-be-dead. The fears of nuclear war, violence in Central America, AIDS, environmental poisoning, and many other concerns became crucial factors in reformulating the event in San Francisco and in the nation as a whole. For many people who felt their culture had been disregarded and their political beliefs discarded, Día de los Muertos served an important role for spiritual healing and political protest. By openly mourning the dead, the event urged greater care for the living, and in this way, it also articulated a political vision for peace.

Epilogue: This Place Is Love

> This place is love that has spirit, inner action, practice, life, history, our blood, what we eat, what we sleep, how we die, how we rise up again, relationship, an everyday practice. That's what gives this place its meaning. And no matter how much you still seize it—those greedy people that feel that they can occupy and reoccupy—what they miss and what they lose is the spirit. The spirit of the actions, the dedications, the engagements, the struggles.
>
> —Celia Rodriguez, speaking at the "Mission No Eviction" event at Brava Theater, October 26, 2013

In the summer of 2014, I made my way across the bay to see my friend Rio Yañez and check out his new apartment near the Fruitvale BART station in Oakland. It was early on a Sunday evening and all the shops in the BART plaza were just beginning to close their doors. As we walked toward International Boulevard, Rio talked about how the location reminded him of Mission Street in the 1980s, and I knew what he meant. There was something about the mix of low-rent businesses, the speeding traffic headed for other destinations, the easy mix of Spanish and English signage, and the quick clip of pedestrians vanishing into the dusk that spurred our childhood memories of the Mission.

We talked a lot about the social and economic transformations that had landed Rio in Oakland. It felt odd to talk about San Francisco with Rio from outside the city limits. While I've lived outside the city for many years—a voluntary exile shaped by my academic career—Rio has been one of my mainstays: someone I turned to for thoughts about life and art in the Mission.

Rio grew up in the heart of the Mission and in the thick of Latino art, as the child of two influential artists—Yolanda López and René Yañez. His parents separated when he was young, but they stayed physically close, renting apartments on the same floor of a small apartment building just a few blocks from Valencia Street. Rio grew up moving back and forth between their apartments

and his third home, the Galería de la Raza, where his father worked and where his mother served as a contributing artist and archivist.

A sense of Rio's unusual upbringing emerges when one considers that his mother dedicated one of her exhibits at Galería de la Raza to her son when he was just a child. For her 1988 exhibit, "Cactus Hearts/Barbed Wire Dreams," López created an installation of everyday objects—plates, clothes, souvenirs— all laden with negative representations of Mexicans, especially the pervasive image of the sleeping Mexican leaning up against a cactus (Fig. 4.5). She titled one wall "Things I Never Told My Son About Being a Mexican," which empha- sized her predicament as a mother, but also her unwillingness to let her son accept these objects at face value.

Rio's parents urged a more practical career path than their own. As Rio re- called in 2007, "They've always supported my creativity, but not necessarily a career in the arts. . . . From the time I could walk, they told me there was no money in the arts and that it was a choice of poverty."[1] He understood the eco- nomic realities of an artist's life, but could not walk away. He added, "I don't consider it a form of rebellion, but I think it was inevitable."[2] He began his pro- fessional career as an artist and curator alongside his father at SOMArts, a cultural center in the South of Market neighborhood. Father and son constantly collaborated, producing shows and art in ways that testify to the richness of their intellectual and aesthetic engagement.

Emblematic of their shared humor is their membership in The Great Torti- lla Conspiracy along with artists Jos Sances and Art Hazelwood. On appointed evenings, the artists gathered in their white lab coats behind a sizable tortilla machine and produced stacks of tortillas to adorn with the most preposter- ous of images: the Virgin of Guadalupe, Subcomandante Marcos, Hello Kitty. Though treated with preservatives, the art is ephemeral, doomed to gradually perish as all tortillas do. But to focus solely on the end product misses the artful- ness of their performances as "the world's most dangerous tortilla art collective."[3] In creating an absurd tortilla lab, the artists blended avant-garde performance art with the traditional art of tortilla rolling, potentially expanding and exploding the boundaries of both these worlds.

Rio's work plays with cultural icons, generating what for some might be un- usual juxtapositions, but for him are reflective of his complex experience. The clash of high and low is visible in one of Rio's creations—a flour tortilla glazed and painted with an image of Hello Kitty reading a book titled *Chicano Art*, the tortilla packaged in clear plastic. The juxtaposition of Hello Kitty with the intellectual history of Chicano art blurs the borders of both worlds and pokes fun at their respective insularities. Rio's love of popular culture emerges in the

images he appropriates from his youth, drawing on brands from Sanrio to Lego, on comics from superheroes to animé, and on films from *Star Wars* to *Godzilla*. But these images are often counterbalanced, or at odds with fraught icons of Chicano art, such as the Virgin of Guadalupe, Frida Kahlo, César Chávez, Che Guevara, Zapatistas, and Mexican wrestlers.

The joining of pop culture and Chicano art icons illustrates Rio's life growing up in the art world of San Francisco's Mission District. His "Ghetto Frida" series pushed back against the sanctification and commodification of Frida Kahlo by outfitting her in Eazy E t-shirts, black-and-white track suits, and tattoos (a teardrop below her left eye and "Diego" tattooed across her neck). Rio accompanied the images with clever storylines that amplified Frida's toughness: He showed "Ghetto Frida" spray-painting an "X" across Diego Rivera's photo and hanging out in the Mission with a forty-ounce bottle of beer (Plate 13). The images pack a punch when one considers how his father participated in the reclamation of Kahlo in the 1970s, at a time when Kahlo's famous husband overshadowed her accomplishments. Rio's "Ghetto Frida" makes mischief with this history, but also raises questions about Latina visibility in the Mission landscape. Do viewers see Frida, or a gangster? Can viewers see the artists in the Mission, or do they just vanish into the iconography of "ghetto" life?

San Francisco Speculations

Meeting Rio in Oakland drove home our mutual displacement, as well as that of our parents and friends. The year before, when my father became very ill, I helped him move to an assisted living facility in the East Bay, since nothing was affordable in San Francisco. At about the same time, Rio's parents faced an Ellis-Act eviction, commanding them to leave their rent-controlled apartments. It was not the first time that Yolanda López and René Yañez had faced potential eviction, but this time the outcome looked grimmer.[4] Not only were all the building tenants facing the loss of their home and the lack of affordable alternatives, René and his partner, artist Cynthia Wallis, were battling different forms of cancer. This family's planned displacement spoke to the broader violence unleashed on so many longtime residents of San Francisco, especially over the last two decades.

Stories of eviction in San Francisco became commonplace in the late 1990s, in tandem with what was labeled the dot-com boom. The beauty of the city, the finite housing stock, and the appeal of its bohemian lifestyle to high-wage tech workers from Silicon Valley raised the stakes of San Francisco property. Evictions resulted less often from a failure of residents to pay rent than from a push by landlords to increase rent or sell property at prices once unimaginable. Many

residents breathed a sigh of relief in the aftermath of the 2000 dot-com bust, but the demand for San Francisco property persisted. By 2013, San Francisco real estate had boomed again. Speculation unleashed a wave of displacements, both voluntary and forced, with little government oversight or intervention.

Residents especially protested abuse of the Ellis Act, a provision intended for landlords to resume residency of their buildings but more often used to evict lower-paying tenants. Legislators passed the Ellis Act in 1985 to support land-lords transitioning their buildings out of the rental market. To minimize abuse, the act prevented immediate rerental: only twenty-eight petitions were filed from 1990 to 1997. However, as the dot-com boom of the late 1990s drove up property values, landlords discovered a way to circumvent the act's intentions: after using it to evict all tenants, they changed the use of their buildings from rentals to condos or joint tenancies. The change in use also made rental stock scarcer. At the height of the dot-com boom, the city oversaw 384 Ellis Act evic-tions in a single year (March 1999 to February 2000).[5] The numbers dropped significantly as the economy shifted but again began to climb in 2013. Accord-ing to the San Francisco Rent Stabilization and Arbitration Board, Ellis Act evictions went from 64 in 2012, to 116 in 2013, to 216 in 2014—practically dou-bling each year.

Of course, the Ellis Act is not the only problem; in some ways, this one factor overshadowed the realities of a more insidious process of gentrification. The 216 Ellis Act evictions recorded by the San Francisco Rent Board from March 2013 to February 2014 only account for 11 percent of all evictions that year. Indeed, evictions rose by 56 percent overall from 2010 to 2014 (1,269 in 2010 to 1,977 in 2014), such that Ellis Act evictions represented only a small proportion of people experiencing displacement from their homes.[6] Also noteworthy was the num-ber of landlords who gravitated to using "owner or relative move-in" evictions as a subterfuge to evict tenants. The landlords re-inhabited their building just long enough to justify the evictions prior to placing the unit(s) back on the mar-ket. Activist Erin McElroy initiated a campaign to spotlight landlords that re-peatedly abused eviction loopholes, creating pictorial lists of the top "Dirty Dozen" and "Dirty Thirty." Such efforts to identify and shame unscrupulous landlords evolved from her "Anti-Eviction Mapping Project," a digital map that went viral with its powerful visual illustration of the eviction crisis.[7]

In 2013, San Francisco's median home price hit one million dollars, a nice round statistic that perfectly illustrated how unaffordable buying a home is for anyone earning less than six figures.[8] Housing prices rose 22 percent in the prior eight years and 30 percent in the Mission.[9] Many pointed to the shortage of housing stock as part of the problem. Certainly, some long-term residents who purchased their home years before benefited from the increase, selling for a

profit or becoming landlords. Others survived thanks to rent control and be-
nevolent or disinterested landlords. Most low-wage workers coped by doubling
up in cramped spaces and subleasing upon subleasing to pay exorbitant rents.
In 2014, the median monthly rental rate was $3,057 in San Francisco, $2,187 in
Oakland, and $2,066 in San Jose, all with about 10 percent increases from the
previous year.[10] The same economic forces that propelled evictions made other
affordable housing options unavailable. Most telling is the city's general failure
to implement any substantive structural legislation to slow or reverse this pro-
cess during twenty years of aggressive displacement and gentrification.

The single greatest influence on change in San Francisco is its proximity to
Silicon Valley. Over the last decade, Google, Facebook, Yahoo, Apple, and vari-
ous other tech companies established private shuttle services between Silicon
Valley and all parts of the Bay Area. This made residing in San Francisco more
accessible and contributed to demand for property near shuttle stops. In 2007,
Google's 32 unmarked white shuttles made 132 trips each day and served 1,200
employees as far north as Concord (54 miles from Google's headquarters) and
as far south as Santa Cruz (38 miles away). Stops in San Francisco's Pacific
Heights neighborhood likely contributed to the increase of resident Google em-
ployees from twelve to sixty in two years.[11] Likewise, the emergence of five shut-
tle stops in the Mission spurred demand for nearby housing (Valencia and 24th;
Valencia and 20th; Dolores and 18th; Dolores and 16th; and Mission and
15th).[12] McElroy reports that 69 percent of no-fault evictions between 2011 and
2013 occurred within four blocks of known shuttle stops.[13] By 2014, the San
Francisco Municipal Transportation Agency estimated tech shuttles conducted
35,000 daily trips to and from San Francisco.[14]

While commuter shuttles contributed positively to worker quality of life, the
system also circumvented investment in public transportation. As the rows of
"Google buses" increased and appropriated public bus stops, even displacing
public buses, they came to symbolize the role of tech workers in the process of
gentrification. As one reporter commented, "You couldn't invent a more com-
pelling visual symbol for the privileged and disconnected lives that the tech
workers seem to live, cosseted behind smoke-tinted windows."[15] Obviously, not
all tech workers earned high wages. Stephen Pitti points out, "The history of
Latinos in Silicon Valley explodes local myths about the area's universal pros-
perity and social peace."[16] The tech industry often employed security guards,
landscapers, and other less visible working-class labor—including "Google
bus" drivers—as contract labor for minimal wages.[17] Still, "Google buses" became
the target of multiple shut-it-down protests in 2013 and 2014 because they were
the most visible symbol of gentrification. In 2014, protestors celebrated a small
victory, as Google and Facebook finally consented to pay the city $3.55 for each

passenger picked up and dropped off at a public bus stop. The city anticipated raising $3.7 million through the eighteen-month pilot program.[18] Of course, this battle was easier to win because it promised financial gain for the city.

San Francisco officials have turned to tech companies as vehicles for urban redevelopment. In 2012, the city promised Twitter a six-year exemption from city payroll taxes in order to encourage its headquartering in one of the most downtrodden neighborhoods of the city. The estimated $22 million in savings contributed to Twitter's decision to lease 295,000 square feet in the Mid-Market neighborhood and inspired at least a dozen more tech companies to set up shop in the area. As one article reported, "Twitter's New Home Is Helping Revive a Seedy San Francisco Neighborhood." What this relocation meant for San Francisco's poorest and most troubled residents went unspoken.[19] And while the city counted on the future economic promise of these tech companies, it also sacrificed millions in tax revenue.[20]

A large number of redevelopment projects targeted the Mission District for multiple reasons: the historic density of apartment dwellings, the ease of displacing low-wage workers, the appeal of a diverse but nonthreatening neighborhood, and the geographic convenience all played a role. As one New York Times reporter noted in 1999, "The Mission District, with two highways leading to Silicon Valley, 11 city bus lines and stops for the Bay Area Rapid Transit trains was just waiting to be discovered."[21] Redevelopment continues to transform the Mission from a working-class neighborhood, a refuge for immigrants and nonprofits, into a land of condos, upscale restaurants, and swanky bars. The neighborhood's history of housing working-class and low-income populations magnifies the stress of this change. For most of these residents, any form of eviction meant leaving San Francisco. Oakland became a popular destination, but that city consequently struggled to maintain its communities against this rapid change.

In 2014, the city's Human Services Agency illustrated the city's income inequalities with a report using mostly census data. San Francisco's middle class dropped by 11 percent from 1990 to 2012; both poor and wealthy populations increased. While tech companies offered astonishing recruitment packages, low-income workers experienced wage stagnation.[22] The high cost of living contributed to the exodus of middle-class families, especially those with children. In 1970 the city recorded 22 percent of San Francisco adults caring for children, but that number declined to 13 percent in 2010.[23] The absence of these middle-class families makes a starker divide between rich and poor.

Economics also spurred "black flight" out of the city; African Americans went from 13.4 percent of the city's population in 1970 to 6.5 percent in 2005.[24] The loss contrasted strongly with an influx of mostly white workers that

underscored the racial disparities shaping the city. In the Mission, Latinos dropped from 50 percent of the population in 2000 to 39 percent in 2010. Unlike the exodus of African Americans, the city's Latino population increased by 11 percent. Certain neighborhoods, such as the Excelsior and Bayview-Hunters Point, became key destinations for the incoming and the displaced.[25] As these numbers make clear, San Francisco's Latino population is still a significant force in the city. The push to the Excelsior and Bayview-Hunters Point resonates with the ways the city displaced Latinos from the Latin Quarter and South of Market neighborhoods to the Mission in the 1940s and 1950s.

Protesters of the new economy highlighted the way gentrification serves as a form of neoliberal ethnic cleansing. Los Uber Locos, the name of a team of four artists—John Leaños, Jaime Cortez, Gerardo Pérez, and Praba Pilar—used humor to critique the racial inequalities of gentrification. Their billboard for Galería de la Raza, "Ese, the Last Mexican," (2000) (Fig. 9.1) featured a blown-up local newspaper with the headline, "One Last Mexican Discovered in the Mission District." A photo of Ese hiding in a cactus accompanies the story, but he is partially obscured by a large leather boot stepping off the newspaper, visually communicating the little notice Ese earns from a well-heeled passerby. Highlighting the power of the tech industry, the article explains that Ese and two friends were "all unhoused when their space was reclassified from an apartment to an e-partment, with a corresponding rent increase." The artists played on the true history of Ishi, an indigenous man forced to live out his life under anthropological study, as they described how Ese must go live under observation at the "UC Department of Cultural Anthropology" so anthropologists

Figure 9.1. Los Uber Locos (John Leaños, Jaime Cortez, Gerardo Pérez, and Praba Pilar), *Ese, The Last Mexican*, billboard for Galería de la Raza, 2000. Image courtesy of John Leaños.

could record the traits of this last Mexican. Their exaggeration draws on a disturbing trend: while researchers predicted that people of color would continue to be the demographic majority in the Bay Area, they also predicted that San Francisco will have a non-Hispanic white majority by 2040.[26]

The struggles of residents living in poverty (up by 4 percent from 2007 to 2012) are hard to reconcile with San Francisco's expanding wealth. The influx of highly educated tech-company employees has skewed the city's economy, perhaps most evident in the fact that households earning over $200,000 a year more than tripled between 1990 and 2010. When compared to Los Angeles, Chicago, or New York, San Francisco's smaller population showed a higher density of very wealthy people—7.3 of every 1,000 people over age 25 have a net worth of at least $30 million (by comparison, Los Angeles, Chicago, and New York all had fewer than 2 of every 1,000 people over age 25 with this kind of net worth). In a nutshell, the city that once modeled civil rights organizing is now the model of income inequality.[27]

Keep the Murals, Evict the Muralists

Artists, teachers, nonprofit workers, seniors, families with children, and the poor are some of the people least able to survive in the San Francisco tech economy. The planned eviction of René Yañez and Yolanda López stirred public outrage because their ousting modeled the city's transformation. Various articles pointed out their historic contributions to the city, with one even referring to them as "Mission royalty."[28] Colleague and friend Guillermo Gómez-Peña lambasted the brutality of evicting these two influential artists in an open letter. "It's an outrage, it's tragic, and sadly it's all too common in this merciless city that seems to care nothing for those who've helped to make it what it once wanted to be." As Gómez-Peña makes clear, their eviction was part of a larger phenomenon of destruction and erasure. He adds, "Thousands of artists have moved to Oakland or farther away, sometimes back to their hometowns. I myself have lost at least 30 performance art colleagues in the last 5 years. I cannot stand the thought of losing you as well. It's like you once told me, 'This city loves to preserve its murals and to evict its muralists.'"[29] The threatened eviction of Yañez and López exemplified the widespread destabilizing of community, whether it was the Latino arts community or the unmooring of so many poor people, people of color, artists, senior citizens, nonprofits, activists, teachers, and youth.

René Yañez moved into the building on San Jose Avenue in 1978 when the neighborhood was far less desirable.[30] According to René, "When I moved to this place I had a separate studio, and then studio rents went up and up, and I

lost the work space. I no longer have the luxury of going to a space and working on a large project. So the scale and scope of my work is a lot smaller."[31] Artists made do with smaller spaces, but economics no longer allowed any space. As Rio points out, "Rent control is what afforded my parents with the opportunity to live in this city and make art." He adds, "Being an artist means they have no savings, no retirement, no health care. They live check to check. For their dedication to art, that's where they are. With elderly people like them, with limited income, this essentially makes them homeless."[32]

San Francisco adopted a rent-control policy in the 1970s to protect tenants from unscrupulous landlords. The policy required landlords to establish just cause for evictions and only raise rent in accordance with the Consumer Price Index for the Bay Area. However, unlike vacancy control policies adopted by some other cities, San Francisco set no limits on rent increases if the tenant moved out of the apartment. As one reporter described the policy, it "was designed to do only one thing: to protect tenants from getting priced out of the places they already lived in. It had nothing to do with keeping overall rents down."[33] Thus, low-income tenants who landed apartments subject to rent control found it necessary to hold on to their apartment for as long as possible, or find themselves priced out of the market.

While many rallied to protest the eviction of René Yañez and Yolanda López, others dismissed their evictions as a fact of life in a capitalist society. Their failure to save money, or own their own home, became a way to point to their lack of responsibility and foresight. One Internet critic declared, "I just have no sympathy for people who don't plan ahead or at all."[34] Another vented, "Sorry, but having a rally so the Yanez family can keep TWO $450 flats seems outrageous to me. . . . This whole protest smacks of anti-white racism."[35] Many sympathized with the plight of the landlord for earning so little rent— around $500–$600 a month for two of the five units.[36] For instance, "Think about how cheap that is, and how their landlord has been subsidizing this family for decades. Now they want everyone to rally around them to fight to keep their insanely good deal??"[37] Others argued that the protestors should stop griping and open their own homes, thereby dismissing the larger structural issues. A few pointed especially at Rio's responsibility as a dutiful son, never grappling with the ways that a young artist employed by a nonprofit and living with two roommates is unlikely to wield this kind of economic power. The irony, as many supporters pointed out, was that much of the value of Mission District property emerged through the work of residents like Yañez, López, and so many other community activists and small business owners. As one retorted, "Those who appreciate the Mission today and profit from it owe it to people like René Yañez."[38]

The Mission, for many of those experiencing displacement, has been more than a place to live. The neighborhood became a critical site for Latino community formation, a place where community organizing made a difference, and where Latino arts flourished. Artists fought for social justice with glorious murals that informed and protected the neighborhood. Activists fought to desegregate the schools, make housing safe and affordable, and supported the rights of immigrants, just as they fought for revolution in Nicaragua and to stop U.S. intervention in Central America. They formed critical spaces for advocacy of Latino arts and culture, including Galería de la Raza, the Mission Cultural Center, Precita Eyes, and the Brava Theater. Making this community often meant opting for less financial stability. As René Yañez recalled, "I . . . have not made a lot of money. And at times have rejected it, like when I started doing Day of the Dead processions, I was approached by beer companies and cigarette companies, and people that wanted a food booth, and they wanted to turn it into a street fair. . . . But I didn't want to do that and I turned down money. . . . And sometimes the things that I did for the community wasn't to make money, but to bring spirituality and ceremonial things to it."[39] The displacement of so many city residents has more consequences than simply a change in population.

Agreeing that gentrification is inevitable and that those who protest are simply out of step means that San Francisco and the nation do not have to reckon with the profiteering and the social inequalities that define this power struggle. As Nancy Mirabal states, "By casting gentrification as primarily an economic byproduct of a growing economy, dot-com or otherwise, it is possible to avoid, even ignore questions of difference and the role they play in the disposability of certain populations and the privileging of others."[40] The perception that residents have simply failed to properly acquire property in the city, or work hard enough to stay in the city, is a view that perpetuates a cycle of social violence.

All cities undergo change, but the speed and scale of economic transformation in San Francisco raised the cost of living and quickly changed the social fabric of the city. Since its founding, the city has cultivated a reputation for the bohemian life always at odds with its less visible, but parallel history of developers, financiers, and social elites. Authors like Gray Brechin showed how aggressive development interests shaped the city in the nineteenth century and that eclectic San Francisco is also "Imperial San Francisco."[41] Understanding how the city balanced these two worlds, attracting beats, beatniks, hippies, artists, and nonconformists with just a few dollars in their pockets while also building one of the world's most influential financial centers is a fascinating endeavor. It is too easy to say these spheres were in constant opposition, as plenty of hippies became landlords and plenty of financiers gave generously to progressive causes and the arts. However, within the last two decades, San Francisco

passed a tipping point, firmly establishing itself as a city of the wealthy. Few would argue that the San Francisco of today is a welcoming place for artists, students, low-wage workers, and the elderly on fixed incomes. That is a profound difference.

The most vulnerable populations—the poor, people of color, children, and seniors—are losing the battle to live in the city. The displacement of so many artists and nonprofit activists is also removing many people who fought for social justice. For those who found themselves unable to stay in the place where they were raised, or where they have lived for most of their lives, there is tremendous loss. As René Yañez stated, "I'm going to miss that house where Rio grew up and where I grew up, too. It has a lot of memories, it has a lot of roots there. I've been there for thirty-five years, and it's not easy to walk out of a place where you've been for so long."[42]

In October 2013, I attended a benefit for René Yañez and Yolanda López at the Brava Theater, largely organized by Rio's partner Sarah Guerra. The event overflowed with talented artists and performers. The audience enjoyed readings by writers like Cherríe Moraga, Alejandro Murguía, and Maya Chinchilla; artists like Guillermo Gómez-Peña and Celia Rodriguez; comedians like Marga Gomez and Culture Clash; and music by Loco Bloco, Dr. Loco, and Las Bomberas de la Bahia. The lobby featured a spectacular gallery of fine art, the product of many artists, including López, John Leaños, and Joe Ramos, who donated work for a silent auction. Rio respectfully announced at the start, "Speaking as someone who grew up in the Mission, tonight is kind of like a 1992 Olympic basketball dream team of performers."[43] The crowd of people waiting outside for a seat likely agreed. The show was a dazzling display of talent and love, but shaped out of crisis and loss.

The director of Brava Theater, Stacie Cuellar, observed, "Our neighborhood is under siege. We are losing lots of neighbors. We are losing lots of artists. We are losing our working-class families."[44] Many of the people present at the event were struggling to cope with the new San Francisco. I watched the benefit next to one of my closest friends, Mia Galaviz de Gonzalez, and grappled with the fact that she also was undergoing an eviction. The landlord had given her thirty days to close her Encantada Gallery, a space that for me had been a place of aesthetic delight and inspiration. She trained at Galería de la Raza before launching her own store in 1997. René Yañez acknowledged her from the stage and urged the crowd to reach out to her, too: "I want everybody to go support Mia Galaviz. Because Mia Galaviz started Balmy Alley, she had Encantada Gallery, and it was a place where I got my Milagros and my things for my altars, so it's very important to support Mia."[45] The gesture was poignant, as both people being evicted were present for each other that night.

The weight of a war on so many fronts cast a shadow on this awesome collaboration. Poet Maya Chinchilla gave voice to the bitterness in an electric reading of her poem "A Eulogy to Our Failures: A Love Letter." Crafted with the aid of friends Rio Yañez and Sarah Guerra, the poem mocks the false progressivism of the new San Francisco. Chinchilla addresses the greed as a deceitful lover: "Your love letters were like a mailbox full of pre-printed credit card offers, with only 29 percent interest a year./With poetic verses of eviction notices, school closings, and unemployment rejection notices./Your commitment to family values, while deporting and tearing working families apart in record numbers, inspiring." Ostensibly written to an individual, the poem personifies the brutality of the economic climate. Chinchilla encouraged the crowd to consider the poem applicable to anyone they would like to imagine dead, which elicited cheers from the audience. The poem reckons with what remains. As she stated, "Your walls, gates, and security measures will stand as a semi-permanent memorial to your clear dislike of the poor and unseemly, who used to live, work, breathe here."[46]

Chinchilla has named herself a "solidarity baby," to explain her childhood in the Central American solidarity movement of Los Angeles. As an adult, she found a home in Oakland. At the benefit, she likened herself to Rio Yañez as of the same generation, "*más o menos*," and declared with some humor, "both of us have sort of been trained in this way of understanding the end of the world."[47] Indeed, she and Rio are representative of generations of Latino artists raised in the politics of earlier social movements.

As one grapples with the physical changes that have transpired in San Francisco and the voluntary and involuntary exodus of people from the city limits, remembering that the people experiencing displacement do not simply disappear, and that their influences can be more lasting than acknowledged, can be helpful. Artists like Rio Yañez, Maya Chinchilla, and so many of the Bay Area artists who show their work at Galería de la Raza, the Mission Cultural Center, and SOMArts do exist and continue to work against the currents. There is something imprinted in the spirit of those trained by earlier generations that does not exist in the concrete architecture of San Francisco real estate. Perhaps this legacy, more than anything, is "The Place of Love" and "The Heart of the Mission." Whether or not the Mission will continue to physically serve as the center of Latino life and culture, the impact of the Mission lives on. And for the children who grew up knowing this neighborhood, they learned a social politics that will not be undone, no matter where they live.

Notes

Introduction

1. Glen Helfand, "San Francisco's Street Artists Deliver Their Neighborhood to the Art World" and sidebar "16th Street and Beyond, Where to Find the 'Mission School,'" *San Francisco Bay Guardian*, April 10–16, 2002, 1, 31; Glen Helfand, "Wheelin' and Dealin'," *San Francisco Bay Guardian*, February 2–8, 2005, 1.

2. Helfand, "San Francisco's Street Artists Deliver"; Helfand, "Wheelin' and Dealin'"; Jamie Berger, "Beyond Books: Adobe Is a Scrappy Bookshop—and a Locus of the Mission's Art Scene" and sidebar, "Adobe Proved Fertile Ground for 'Mission School' Artist: Chris Johanson's Work Featured in Whitney Biennial," *The San Francisco Chronicle,* April 10, 2003, E11; Blake Gopnik, "The Allure of 'Loser' Culture: How Skateboards Crashed the Gates of the Art World," *Washington Post*, July 10, 2005, N1. Also see Alan Baker, Aaron Rose, and Christian Strike, *Beautiful Losers: Contemporary Art and Street Culture* (New York: Iconoclast, 2004), an exhibit catalogue that featured several of the Mission School artists; Barbara Pollack, "The New Visionaries," *ArtNews* 102 (December 2003), 92–97; and "Fame," a season 1 episode of *Spark* (KQED Television, 2003), featured Janet Bishop, curator of the San Francisco Museum of Modern Art (SFMOMA), and Jonathon Keats, art critic, on Chris Johanson. The Mission School narrative was central to "Fertile Ground: Art and Community in California," a collaborative exhibit produced by the Oakland Museum of California and SFMOMA, held from September 20, 2014 through April 12, 2015. The exhibit inspired a short film, *A Neighborhood Thing: The Mission Art Scene in the '90s,* produced by KQED and SFMOMA (2015).

3. Timothy W. Drescher wrote about Balmy Alley and CAMP, prior to the Mission School nomenclature, in "Street Subversion: The Political Geography of Murals and Graffiti," in *Reclaiming San Francisco: History, Politics, Culture*, ed. James Brook, Chris Carlsson, and Nancy J. Peters (San Francisco: City Lights Books, 1998), 231–245. Also see Timothy W. Drescher, *San Francisco Murals: Community Creates Its Muse, 1914–1990* (St. Paul, MN: Pogo Press, 1991).

4. Jamie Berger wrote, "[Chris] Johanson is the latest in a string of artists to rise to art stardom out of what is now referred to as the 'Mission School' of San Francisco artists, a group that shares a rough-hewn style and interest in urban themes created with found or recycled materials or often painted directly on walls, graffiti-style." Berger, "Adobe Proved." The narrator for *Spark* (2003) said, "Like many of the other artists who have gravitated towards the Mission District, Chris [Johanson] was raised in the suburbs on a steady diet of television and pop culture. And much of his art is a direct response to what he considers the excesses of our commercial culture."

5. Rebecca Solnit and Susan Schwartzenberg, *Hollow City: The Siege of San Francisco and the Crisis of American Urbanism* (London: Verso, 2000), 157. At most, the articles and institutional representatives made fleeting references to the Balmy Alley mural project, but more in the context of recent Mission School mural contributions than in terms of Balmy Alley's long history as an early 1970s community mural project for local children, or as a 1984 political action to indict U.S. involvement in Central America. See Drescher, *San Francisco Murals*; Alan W. Barnett, *Community Murals: The People's Art* (Philadelphia: Art Alliance Press, 1984); Robin J. Dunitz and James Prigoff, *Painting the Towns: Murals of California* (Los Angeles: RJD Enterprises, 1997). The relevance of the Mission District location was obvious: Chris Johanson stated, "I'm really into the ethnic culture blender of

San Francisco." More specifically, Aaron Noble cited the Mission's Creativity Explored as an influence. That organization, founded in 1983, trains artists with developmental disabilities and gave some context for the "outsider" art influence that critics have noticed in the Mission School. Helfand, "San Francisco's Street Artists Deliver."

6. John M. Glionna, "Dot-Com Boom Makes S.F. a War Zone," *Los Angeles Times*, October 3, 2000, A1. Texts that discuss the counterculture proclivities of Internet companies include Mike Daisey, *21 Dog Years: Doing Time @ Amazon.com* (New York: Free Press, 2002). Daisey described his recruitment, recalling the placement agent stating, "Amazon is always telling us to find them the freaks . . . you know, people who might not fit in elsewhere" (17). Rodney Rothman delivered a humorous discussion of the corporate ethos in "My Fake Job," *The New Yorker*, November 27, 2000, 121–131; for a sharply critical discussion of the high-tech corporate mindset and the underlying politics, see Paulina Borsook, *Cyberselfish: A Critical Romp Through the Terribly Libertarian Culture of High Tech* (New York: Public Affairs, 2000); and David Brooks, who wrote that "the key is to be youthful, daring, and avant-garde, to personify change. The center of gravity of the American business culture has moved westward and youthward," *Bobos in Paradise: The New Upper Class and How They Got There* (New York: Touchstone, 2001), 113.

7. Bill Hayes, "Artists vs. Dot-Coms: Fighting San Francisco's Gold Rush," *New York Times*, December 14, 2000, F7.

8. Matthew Desmond, in his work on evictions, calls for attention to housing in the same way that society has tempered other forms of capitalism. See Desmond, *Evicted: Poverty and Profit in the American City* (New York: Crown, 2016), 305. On inequality and regulation more generally, see Thomas Piketty, *Capital in the Twenty-First Century* (Cambridge, MA: Harvard University Press, 2014), especially 422–424, 471.

9. Paulina Borsook, "How the Internet Ruined San Francisco," Salon.com, October 28, 1999, http://www.salon.com/1999/10/28/internet_2/.

10. Alejandro Murguía, *The Medicine of Memory: A Mexica Clan in California* (Austin: University of Texas Press, 2002), 120.

11. As art historian Shifra Goldman declared, Chicano art "was not born in the 1960s; there's been a long history of Mexican, Mexican American, whatever name you want to use, artists that have worked in the nineteenth century forward, but it has to be unearthed." Shifra Goldman, interview, Pasadena, CA, August 9, 1983, uncorrected transcript from Califas videotapes 102–105, transcribed by Philip Brookman and Amy Brookman, Califas Book 3, 25, in *Califas Conference Final Report*, Archives of American Art, Smithsonian Institution.

12. José Antonio Burciaga, *Drink Cultura: Chicanismo* (Santa Barbara, CA: Capra Press, 1993), 26–27.

13. George J. Sanchez, "Race, Nation, and Culture in Recent Immigration Studies," *Journal of American Ethnic History* 18, no. 4 (1999): 73.

14. Mary Romero and Michelle Habell-Pallán wrote, "The term 'Latino' is politically charged and has been defined by various communities in diverse geographical locations and at different moments in U.S. history in order to achieve a variety of objectives." See *Latino/a Popular Culture* (New York: New York University Press, 2002), 3–4; Suzanne Oboler, *Ethnic Labels, Latino Lives: Identity and the Politics of (Re)Presentation in the United States* (Minneapolis: University of Minnesota Press, 1995); and Clara E. Rodriguez, *Changing Race: Latinos, the Census, and the History of Ethnicity in the United States* (New York: New York University Press, 2000). For regional variation, see Arlene Davila and Agustin Laó-Montes, *Mambo Montage: The Latinization of New York* (New York: Columbia University Press, 2001); Jorge Duany, *The Puerto Rican Nation on the Move: Identities on the Island & in the United States* (Chapel Hill: University of North Carolina Press, 2002); Alejandro Portes and Alex Stepick, *City on the Edge: The Transformation of Miami* (Berkeley: University of California Press, 1993); Olivia Cadaval, *Creating a Latino Identity in the Nation's Capital: The Latino Festival* (New York: Garland, 1998); George J. Sánchez, *Becoming Mexican American: Ethnicity, Culture and Identity in Chicano Los Angeles, 1900–1945* (New York: Oxford University Press, 1993).

15. Davila and Laó-Montes, *Mambo Montage*, 7–8.

16. For more on San Francisco's Central American population, see Carlos B. Córdova, *The Salvadoran Americans* (Westport, CT: Greenwood Press, 2005), 64–66; Wallace Turner, "Mission District Seeks New Identity," *New York Times,* August 3, 1981; Carlos B. Córdova, "The Mission District: The Ethnic Diversity of the Latin American Enclave in San Francisco, Calif.," *Journal of La Raza Studies* 2, no. 1 (1989): 21–32.

17. Guillermo Gómez-Peña, author notes, Mexican Bus Tour performance, San Francisco, June 13, 2007.

18. Laurie Kay Sommers, "Alegría in the Street: Latino Cultural Performance in San Francisco" (PhD diss., Department of Folklore, Indiana University, 1986), 55. Sommers noted that "differences in politics, religion, class, race, urban/rural background, and language proficiency interface with ethnic origin and generational differences to create a staggering array of intra-group boundaries." Also see Ed Morales, *Living in Spanglish: The Search for Latino Identity in America* (New York: St. Martin's, 2002), 24–25; Ilan Stavans, *The Hispanic Condition: The Power of a People* (1995; repr., New York: HarperCollins, 2001).

19. Elizabeth Sutherland Martínez, *De Colores Means All of Us: Latina Views for a Multi-Colored Century* (Cambridge, MA: South End Press, 1998), 2.

20. Romero and Habell-Pallán, *Latino/a Popular Culture*, 7.

21. Guillermo Gómez-Peña, *The New World Border: Prophecies, Poems & Loqueras for the End of the Century* (San Francisco: City Lights, 1996), 5.

22. See Michael Denning's discussion of a "liberation movement" in *Culture in the Age of Three Worlds* (New York: Verso, 2004), 42. Also see George Katsiaficas, *The Imagination of the New Left: A Global Analysis of 1968* (Boston: South End Press, 1987), 19. I avoid the term *New Left* because it tends to frame the conversation in nationalist, as opposed to global, terms.

23. Quoted in "The Soaring Spirit of Chicano Arts," a sidebar to Jonathan Kirsch, "Chicano Power: There Is One Inevitable Fact—by 1990 California Will Become America's First Third World State," *New West*, September 11, 1978, 35–40.

24. June Gutfleisch, interview by Regina Mouton, "Let a Thousand Flowers Grow: An Interview with June Gutfleisch," Community Arts and Education Program, accessed September 28, 2004, http://temp.sfgov.org/sfac/CAE/about_us/.

25. Coco Fusco, *English Is Broken Here: Notes on Cultural Fusion in the Americas* (New York: The New Press, 1995), 46.

26. C. Ondine Chavoya, "Orphans of Modernism: The Performance Art of Asco," in *Corpus Delecti: Performance Art of the Americas,* ed. Coco Fusco (New York: Routledge, 2000), 240. Also see Chon A. Noriega, "The Orphans of Modernism," in *Phantom Sightings: Art After the Chicano Movement,* ed. Rita Gonzalez, Howard N. Fox, and Chon A. Noriega (Los Angeles: University of California Press, 2008), 16–45.

27. Glen Helfand added, "Buzz terms have been cropping up. 'The Mission school' has been uttered with some regularity. 'Urban Rustics and Digital Bohemians' were the terms given in an article by Center for the Arts curator Renny Pritikin." Helfand, "San Francisco's Street Artists," and "Wheelin' and Dealin'."

28. Sharon Zukin showed how the popularization of artists' lofts in New York contributed to gentrification in *Loft Living: Culture and Capital in Urban Change* (New Brunswick, NJ: Rutgers University Press, 1989), 2. Also see David Ley, "Artists, Aestheticisation and the Field of Gentrification," *Urban Studies* 4, no. 12 (2003): 2527–2544; Richard Kostelanetz, *Soho: The Rise and Fall of an Artist's Colony* (New York: Routledge, 2003); Brooks, *Bobos in Paradise;* Albert Parry, *Garretts and Pretenders: A History of Bohemianism in America* (1933; repr., New York: Dover Publications, 1960).

29. The term *gentrification* was coined by Ruth Glass in 1964, according to Neil Smith, *The New Urban Frontier: Gentrification and the Revanchist City* (London: Routledge, 1996), 33, citing Ruth Glass, *London: Aspects of Change* (London: MacGibbon and Kee, 1964), xviii.

30. Solnit and Schwartzenberg, *Hollow City*, 100.

31. Marjorie Heins, *Strictly Ghetto Property: The Story of Los Siete de la Raza* (Berkeley, CA: Ramparts, 1972), 25–27.

32. Miranda Bergman, "Mural, Mural on the Wall," in *Art on the Line: Essays by Artists About the Point Where Their Art and Activism Intersect*, ed. Jack Hirschman (Willimantic, CT: Curbstone, 2002), 359.

33. For more on this renewed appreciation, see Shifra M. Goldman, *Dimensions of the Americas: Art and Social Change in Latin America and the United States* (Chicago: University of Chicago Press, 1994), 8–9. For more about Cold War politics, see Ellen G. Landau, *Reading Abstract Expressionism: Context and Critique* (New Haven, CT: Yale University, 2005), 339–340; Frances Stonor Saunders, *Who Paid the Piper? The CIA and the Cultural Cold War* (London: Granta Books, 1999).

34. For a discussion of the San Francisco Redevelopment Agency's harmful approaches to progress, see Chester W. Hartman, *City for Sale: The Transformation of San Francisco* rev. ed. (Berkeley: University of California Press, 2002).

35. Mike Davis, *Magical Urbanism: Latinos Reinvent the U.S. City* (New York: Verso, 2000); Carey McWilliams, *North from Mexico: The Spanish-Speaking People of the United States* (1948; rev. ed., New York: Greenwood Press, 1990); William Deverell, *Whitewashed Adobe: The Rise of Los Angeles and the Remaking of Its Mexican Past* (Berkeley: University of California Press, 2004); James Oles, *South of the Border: Mexico in the American Imagination: 1914–1947* (Washington: Smithsonian Institution Press, 1993); Chris Wilson, *The Myth of Santa Fe: Creating a Modern Regional Tradition* (Albuquerque: University of New Mexico Press, 1997).

36. Gregory Dicum, "San Francisco's Mission District: Eclectic, Eccentric, Electric," *New York Times*, November 20, 2005.

37. Frances R. Aparicio and Susana Chávez-Silverman, *Tropicalizations: Transcultural Representations of Latinidad* (Hanover, NH: University Press of New England, 1997), 1.

38. Ibid.; Davis, *Magical Urbanism*.

39. Ann Powers, *Weird Like Us: My Bohemian America* (New York: Simon and Schuster, 2000), 40.

40. Keating spearheaded the "Yuppie Eradication Project," a fringe grassroots effort to expel the influx of affluent, Anglo residents, though he also recognizes his complicit participation. Quoted in Solnit and Schwartzenberg, *Hollow City,* 128.

41. Responses to gentrification are most visible in newspaper coverage. Examples include Lynda Gorov, "Classes Clashing: San Francisco Quarter Feels Squeeze," *Boston Globe*, July 13, 1999, A1; A. Clay Thompson, "Evicting Art: From Arts Mecca to Silicon Valley Suburb," *San Francisco Bay Guardian*, September 29, 1999; Joel P. Engardio, "Mission Implacable," *SF Weekly*, July 5, 2000; David R. Baker, "15 Arrested as Protesters Occupy Offices of Internet Firm in Mission," *San Francisco Chronicle*, September 22, 2000, A22; Glionna, "Dot-Com Boom"; Neva Chonin and Dan Levy, "No Room for the Arts: The Economic Boom Threatens to Kill Off S.F.'s Cutting-Edge Culture," *San Francisco Chronicle*, October 17, 2000, A1; Rose George, "Mission Undesirable," *The Independent* (London), November 5, 2000, 37; Bill Hayes, "Artists vs. Dot-Coms," F7. Also see Solnit and Schwartzenberg, *Hollow City*; Simon Velasquez Alejandrino, "Gentrification in San Francisco's Mission District: Indicators and Policy Recommendations" (master's thesis, City Planning, University of California, Berkeley, 2000).

42. Lynn Rapoport, "Wall Space: The Clarion Alley Mural Project Uses Public Art to Paint a Home," *San Francisco Bay Guardian*, October 23, 2002.

43. Alberto Sandoval-Sánchez, *José, Can You See? Latinos On and Off Broadway* (Madison: University of Wisconsin Press, 1999), 31.

44. Chon Noriega, "Why Chicanos Could Not Be Beat," *Aztlán* 24, no. 2 (1999): 3.

45. For another example, see Eric Lott, *Love and Theft: Blackface and the American Working Class* (New York: Oxford University Press, 1995).

46. Richard Montoya, quoted in Camille T. Taiara, "Surviving the Conquest: Culture Clash Confronts Gentrification in its Hometown," *San Francisco Bay Guardian*, January 17, 2001.

Chapter 1. Real Life and the Nightlife in San Francisco's Latin Quarter

1. *The Chapter in Your Life Entitled San Francisco 1940* (San Francisco: Californians, 1940).

2. Leonard Austin, *Around the World in San Francisco* (Palo Alto, CA: James Ladd Delkin, Stanford University, 1940) 104–107.

3. Teatro Verdi advertisement, *El Imparcial*, November 20, 1931, 7.

4. Ibid.

5. Brian J. Godfrey documented multiple demographic shifts and displacements in *Neighborhoods in Transition: The Making of San Francisco's Ethnic and Nonconformist Communities* (Berkeley: University of California Press, 1988); also see Manuel Castells, *The City and the Grassroots: A Cross-Cultural Theory of Urban Social Movements* (London: Edward Arnold, 1983).

6. Clarence E. Edwords, *Bohemian San Francisco: Its Restaurants and Their Most Famous Recipes/The Elegant Art of Dining* (Paul Elder and Company, 1914; San Francisco: Silhouette Press, 1973), 67–68. Citations refer to the Silhouette edition.

7. On Mexican populations in the Latin Quarter, see "Little Mexico," *San Francisco Chronicle*, July 20, 1890; Elizabeth Haight Strong, "Little Mexico in the Ruins of a Church," *San Francisco Sunday Call Magazine,* January 13, 1907; Herbert C. Thompson, "Our Own Broadway," *San Francisco Call*, August 11, 1912, 8.

8. Edwords, *Bohemian San Francisco*, 30, 31.

9. Austin, *Around the World*, 99.

10. George Sánchez and Gabriela Arredondo observed the dispersal of Mexican homes and colonias throughout working-class Los Angeles and Chicago. See George J. Sánchez, *Becoming Mexican American: Ethnicity, Culture, and Identity in Chicano Los Angeles, 1900–1945* (New York: Oxford University Press, 1993), 73–76; Gabriela F. Arredondo, *Mexican Chicago: Race, Identity, and Nation, 1916–39* (Urbana: University of Illinois Press, 2008), 39.

11. William Deverell, *Whitewashed Adobe: The Rise of Los Angeles and the Remaking of Its Mexican Past* (Berkeley: University of California Press, 2004); James Oles, *South of the Border: Mexico in the American Imagination: 1914–1947*, trans. Marta Ferragut (Washington, DC: Smithsonian Institution, 1993); Chris Wilson, *The Myth of Santa Fe: Creating a Modern Regional Tradition* (Albuquerque: University of New Mexico Press, 1997); Carey McWilliams, *North from Mexico: The Spanish-Speaking People of the United States*, updated by Matt S. Meier (1948; rev. ed., New York: Greenwood, 1990). Citations refer to the 1990 edition.

12. See Rodolfo Acuña, *Occupied America: The Chicano's Struggle Toward Liberation* (San Francisco: Canfield, 1972); Martha Menchaca, *The Mexican Outsiders: A Community History of Marginalization and Discrimination in California* (Austin: University of Texas Press, 1995); Juan Gonzales, *Harvest of Empire: A History of Latinos in America* (New York: Penguin, 2000).

13. Frank Soulé, John H. Gihon, and James Nisbet, *The Annals of San Francisco* (1855; repr., Berkeley: Berkeley Hills Books, 1999), 472.

14. Ken Gonzales-Day, *Lynching in the West: 1850–1935* (Durham, NC: Duke University Press, 2006); William Carrigan and Clive Webb, "The Lynching of Persons of Mexican Origin or Descent in the United States, 1848 to 1928," *Journal of Social History* 37, no. 2 (2003): 411–438.

15. Tom Stoddard, *Jazz on the Barbary Coast* (1982; repr., Berkeley: Heyday Books, 1998), 165.

16. David Gutiérrez, *Walls and Mirrors: Mexican Americans, Mexican Immigrants, and the Politics of Ethnicity* (Berkeley: University of California Press, 1995), 46.

17. David C. Bailey, *¡Viva Cristo Rey! The Cristero Rebellion and the Church-State Conflict in Mexico* (Austin: University of Texas Press, 1974).

18. Austin, *Around the World*, 104–107.

19. Tomas F. Summers Sandoval Jr. offered an overview of the church's history in *Latinos at the Golden Gate: Creating Community & Identity in San Francisco* (Chapel Hill: University of North Carolina Press, 2013), 69–82. Also see Gina Marie Pitti, "To 'Hear about God in Spanish': Ethnicity, Church, and Community Activism in the San Francisco Archdiocese's Mexican American Colonias, 1942–1965" (PhD diss., Stanford University, 2003).

20. Father Antonio M. Santandreu was born in Barcelona, Spain, in 1853 and trained for the priesthood in Dublin, Ireland, at All Hallows College, where he was ordained in 1876. Shortly thereafter, he traveled to San Francisco and served briefly as assistant pastor at Our Lady of Guadalupe Church in 1877, before obtaining other commissions. In 1889, he returned to Our Lady of Guadalupe as pastor, where he stayed until his death in 1944. See "Oldest Priest in California Dies," *Oakland Tribune*, September 6, 1944, 13; "Priest Tells of Marie's Manner," *San Francisco Chronicle*, August 2, 1910, 2; *San Francisco Directory* (San Francisco: Henry G. Langley, 1877), 759; Austin, *Around the World*, 93; Sandoval, *Latinos at the Golden Gate*, 69, 78.

21. U.S. Bureau of the Census, *Fifteenth Census of the United States: 1930, Population Bulletin, Second Series, Alabama to Kentucky* (Washington, DC: Government Printing Office, 1932); Clara E. Rodriguez, *Changing Race: Latinos, the Census, and the History of Ethnicity in the United States* (New York: New York University Press, 2000), 42, 177–181.

22. Godfrey, *Neighborhoods in Transition*, 139.

23. Ibid., 140.

24. David Gutiérrez pointed out that "a majority of the resident ethnic Mexican population in 1940 were U.S. citizens, but at least 60 percent of this population were either unnaturalized Mexican nationals or were the first U.S.-born generation of Mexican immigrant parents." This assessment illustrates the difficulty of using only "foreign-born" numbers to understand the scope of a population. Gutiérrez, *Walls and Mirrors*, 118.

25. Mike Davis documented these social networks of migration in *Magical Urbanism: Latinos Reinvent the U.S. Cities* (New York: Verso, 2000), 93.

26. Ibid.

27. Born in Nashville, Tennessee, William Walker came to San Francisco in the 1850s and famously led armed invasions of Baja California and Nicaragua, even declaring himself president of Nicaragua in 1856. He was executed in 1860 in Honduras. See Albert H. Z. Carr, *The World and William Walker* (Westport, CT: Greenwood, 1975). In the 1930s, many Nicaraguan Sandinista supporters relocated to San Francisco, a subject discussed more in depth in Chapter 6. More recently, the Mission District, and San Francisco generally, served as a base for Zapatista organizing. See Elaine Katzenberger, ed., *First World, Ha Ha Ha! The Zapatista Challenge* (San Francisco: City Lights, 1995).

28. Gladys Hansen, ed., *San Francisco: The Bay and Its Cities* (1947; repr., New York: Hastings House, 1973), 227.

29. Austin, *Around the World*, 93. Phoebe S. Kropp analyzed this tension between Spanish and Mexican identification in her study of Olvera Street in *California Vieja: Culture and Memory in a Modern American Place* (Berkeley: University of California Press, 2006), 227–228.

30. Wilson, *Myth of Santa Fe*.

31. McWilliams, *North from Mexico*, 29.

32. David Gebhard, "The Spanish Colonial Revival in Southern California (1895–1930)," *Journal of the Society of Architectural Historians* 2, no. 2 (1967): 131–147; Abigail A. Van Slyck, "Mañana, Mañana: Racial Stereotypes and the Anglo Rediscovery of the Southwest's Vernacular Architecture, 1890–1920," *Gender, Class, and Shelter,* ed. Elizabeth Collins Cromley and Carter I. Hudgins (Knoxville: University of Tennessee Press, 1995), 95–108.

33. The San Francisco Historical Photograph Collection, in the San Francisco Public Library, has some photos of these events in the "S.F. Districts-Mission-1930s" folder, including AAB-9528, AAB-9527, and AAB-4671.

34. Francisco E. Balderrama and Raymond Rodriguez, *Decade of Betrayal: Mexican Repatriation in the 1930s* (Albuquerque: University of New Mexico Press, 1995).

35. Luis Cervantes, interview by author, San Francisco, April 2, 2003.

36. Gutiérrez, *Walls and Mirrors,* 134. Also see Mae M. Ngai, *Impossible Subjects: Illegal Aliens and the Making of Modern America* (Princeton, NJ: Princeton University Press, 2004), 132.

37. Eduardo Obregón Pagán, *Murder at the Sleepy Lagoon: Zoot Suits, Race, and Riot in Wartime L.A.* (Chapel Hill: University of North Carolina Press, 2003); Luis Alvarez, *The Power of the Zoot: Youth Culture and Resistance During World War II* (Berkeley: University of California Press, 2008).

38. Austin, *Around the World*, 92.

39. Bill Morgan marked the physical presence of the Beats in North Beach in *The Beat Generation in San Francisco: A Literary Tour* (San Francisco: City Lights, 2003).

40. José Ramón Lerma, interview by author, Oakland, CA, January 5, 2001.

41. Summers Sandoval pointed to development around Chinatown as one factor that changed the ethnic makeup of the neighborhood. Summers Sandoval, *Latinos at the Golden Gate*, 80–81.

42. The Bay Bridge started construction in 1933 and was completed in November 1936. See Richard H. Dillon, Thomas Moulin, and Don DeNevi, *High Steel: Building the Bridges Across San Francisco Bay* (Millbrae, CA: Celestial Arts, 1979); Peter Stackpole, *The Bridge Builders: Photographs and Documents of the Raising of the San Francisco Bay Bridge, 1934–1936* (Corte Madera, CA: Pomegranate Artbooks, 1984).

43. Francisco Camplís, interview by author, San Francisco, March 12, 2003. Camplís's research on the history of this community is visible in his two short films, *Unmined Treasures* (2000) and *The Mexican Presence in San Francisco, 1930–1950* (2001). Ralph Maradiaga and Emilia "Mia" Galaviz de Gonzalez also had family rooted in the South of Market area. Galaviz de Gonzalez, interview by author, San Francisco, February 5, 2003. Also see Godfrey, *Neighborhoods in Transition* and Summers Sandoval, *Latinos at the Golden Gate*.

44. Unnamed resident, interview by filmmakers, *The Mexican Presence in San Francisco, 1930–1950*, directed by Francisco Camplís, San Francisco, 2001.

45. *Mexican Presence* interview; Camplís, interview, 2003; Galaviz de Gonzalez, interview, 2003. One article referred to a "Little Mexico" in the Mission District in 1926: "Tenement Fire Imperils Homes of Five Families," *Oakland Tribune*, September 17, 1926, D27.

46. Dale Adams, "Saludos Amigos: Hollywood and FDR's Good Neighbor Policy," *Quarterly Review of Film and Video*, 24 (3): 289–295. Also see Darlene J. Sadlier, *Americans All: Good Neighbor Cultural Diplomacy in World War II* (Austin: University of Texas Press, 2012).

47. Charles Ramírez Berg, *Latino Images in Film: Stereotypes, Subversion, Resistance* (Austin: University of Texas Press, 2002), 31–32.

48. Alberto Sandoval-Sánchez, *José, Can You See?: Latinos On and Off Broadway* (Madison: University of Wisconsin Press, 1999), 24.

49. Ted Friend, *Ted Friend's Guide to San Francisco* (San Francisco: Sierra Press, 1950); *Guest Informant: The 1960–61 Mark Hopkins Hotel Edition* (Los Angeles: Pacific Hotel Publications, 1960); Helen M. Abrahamsen, *What to Do, See, Eat in San Francisco* (Palo Alto, CA: Pacific Books 1952).

50. Advertisements showed the Marimba Club's location at 831 Broadway in 1941. A notice in *Billboard*, March 28, 1942, announced a new Marimba Club in the Richelieu Hotel in 1942, likely with the same management, since it featured the same Hurtado Brothers performances. The San Francisco Public Library photograph of Casino Pan America suggests it took over the 831 Broadway location in 1942 for an unknown period of time.

51. The San Francisco Historical Photograph Collection at the San Francisco Public Library provides images of the Hurtado Brothers at the Marimba Club in 1941 (AAB-1219) and the Richelieu Casino in 1942 (AAB-1253). One source noted the rarity of Hurtado Brothers performances outside their Marimba Club contract: "Marimba Band Will Perform at Fiesta on Thursday Night," *The Stanford Daily*, March 30, 1943; Also see Andrés Amado, "The Fox Trot in Guatemala: Cosmopolitan Nationalism Among Ladinos," *Ethnomusicology Review* 16 (2011); John Storm Roberts, *The Latin Tinge: The Impact of Latin American Music on the United States* (1979; repr., New York: Oxford University Press, 1999), 53–55.

52. Two significant downtown nightclubs were Luz Garcia's Sinaloa and the Papagayo Room in the Fairmont Hotel. Friend, *Ted Friend's Guide*; *Guest Informant: Mark Hopkins Hotel*. Delia Martinez, "the Cuban Bombshell," performed regularly at the Sinaloa. Jesse Varela, "Desde La Bahia," *Latin Beat Magazine*, February 2004, 10. Another female group at the Sinaloa was Los Caramelos Cubanos (the Cuban Lollipops), which featured Yolanda Macias, who later married Benny Velarde. Jesse Varela, "Viva Velarde," *Latin Beat Magazine*, December 2002, 26.

53. Austin described 831 Broadway as the Centro Español, "where the leading organizations maintain club rooms, among them the Union Española de California, the Sociedad Española de Beneficencia Mutua, the Cooperative Española, and the Centro Andaluz." Activities included English language classes, Americanization classes, and Spanish history. Austin, *Around the World*, 94.

54. According to Nan Alamilla Boyd, the Beige Room moved from downtown to 831 Broadway in 1951. On the history of José Sarria and the Beige Room, see Nan Alamilla Boyd, *Wide-Open Town: A History of Queer San Francisco to 1965* (Berkeley: University of California Press, 2003). San Francisco city directories show the Copacabana at 831 Broadway from 1957 to 1967. See *Polk's San Francisco* (San Francisco: R. L. Polk, 1957) and *Polk's San Francisco* (San Francisco: R. L. Polk, 1967).

55. Henri Murger, *The Bohemians of the Latin Quarter*, trans. Ellen Marriage and John Selwyn (Philadelphia: University of Pennsylvania Press, 2004); Albert Parry, *Garretts and Pretenders: A History of Bohemianism in America* (New York: Covici-Friede, 1933; repr., New York: Dover, 1960); Elizabeth Wilson, *Bohemians: The Glamorous Outcasts* (New Brunswick, NJ: Rutgers University Press, 2000); Nancy J. Peters, "The Beat Generation and San Francisco's Culture of Dissent," in *Reclaiming San Francisco: History, Politics, Culture*, ed. James Brook, Chris Carlsson, and Nancy J. Peters (San Francisco: City Lights, 1998), 199–215.

56. *Your Guide to San Francisco and Its Nearby Vacationlands* (San Francisco: Californians, 1950); Hansen, *San Francisco*, 224.

57. Susan D. Greenbaum, "Marketing Ybor City: Race, Ethnicity, and Historic Preservation in the Sunbelt," *City and Society* 4, no. 1 (1990): 58–76; Gerald W. McFarland, *Inside Greenwich Village: A New York City Neighborhood, 1898–1918* (Amherst: University of Massachusetts Press, 2001); Christine Stansell, *American Moderns: Bohemian New York and the Creation of a New Century* (New York: Metropolitan Books, 2000).

58. Leonard Austin described an annual flamenco event as "the most popular of the foreign folk festivals in San Francisco and brings out all the vividness and emotion of Spanish life." *Around the World*, 93. Joann Gewertz Harris provided a brief overview of the flamenco scene in *Beyond Isadora: Bay Area Dancing 1915–1965* (Berkeley: Regent Press, 2009), 88–91. Anthony Dumas offers more detail in "(Re)Locating Flamenco: Bohemian Cosmopolitanism in Northern California" (PhD diss., University of California, Davis, 2012). Various advertisements and tourist books confirmed the popularity of flamenco, as did a telephone interview of Maruja Cid by the author, October 22, 2004.

59. *Guest Informant: Mark Hopkins Hotel*; *San Francisco Hotel Greeters Guide* (Frentrup, August 1963). Also see Barnaby Conrad, *Name Dropping: Tales from My Barbary Coast Saloon* (New York: HarperCollins, 1994).

60. Michelle C. Heffner, "Bailando la Historia/Flamenco Bodies in History and Film" (PhD diss., University of California, Riverside, 1998), 20–21.

61. Harris, *Beyond Isadora*, 88–92; Dumas, "(Re)Locating Flamenco." Maruja Cid helped elaborate the scene. Cid, interview by author.

62. Rand Richards, *Historic Walks in San Francisco: Trails Through the City's Past* (San Francisco: Heritage House, 2008), 181–182.

63. Harley Spiller pointed to an abundance of Forbidden City competitors and imitators in San Francisco in "Late Night in the Lion's Den: Chinese Restaurant-Nightclubs in 1940s San Francisco," *Gastronomica*, 4, no. 4 (2004): 94–101. Also see Anthony W. Lee, *Picturing Chinatown: Art and Orientalism in San Francisco* (Berkeley: University of California Press, 2001) 237–285; Trina Robbins, *Forbidden City: The Golden Age of Chinese Nightclubs* (Cresskill, NJ: Hampton, 2009); *Forbidden City USA*, directed by Arthur Dong, Deep Focus Productions, 1989.

64. Christiane Bird, *The Da Capo Jazz and Blues Lover's Guide to the U.S.*, 3rd ed. (Cambridge, MA: Da Capo Press, 2001), 419. A sizable mural at Columbus and Broadway visually documented the many jazz clubs that graced North Beach. The Say When and Fack's also served as popular jazz joints. Ted Gioia, *West Coast Jazz: Modern Jazz in California, 1945–1960* (New York, NY: Oxford University Press, 1992), 65. However, Tom Stoddard has documented the presence of a strong but small jazz community prior to World War I in Stoddard, *Jazz on the Barbary Coast*. In fact, Stoddard, through his interviews of Sid LeProtti, located many of the "Negro dance clubs" (Purcell's,

Charlie Coster's, Sam King's, The So Different Saloon, and Louie Gomez's, also known as the West Indian Club) on Pacific and Broadway Streets, in an area later consolidated with North Beach. The Barbary Coast jazz scene ended with a religious crusade against the dancehalls, 1915–1917.

65. Jesse Varela, "Sonaremó el Tambo: The Life and Times of Armando Peraza: Part Two," *Latin Beat Magazine*, May 2004, 22–23.

66. Ibid. Ted Gioia noted that San Francisco was "one of the last major cities to perpetuate segregated musicians' unions, not merging Local 6 and Local 669 until April 1960." *West Coast Jazz*, 62.

67. Varela, "Sonaremó el Tambo." Raúl Fernandez refers to singer "Juanita Puente," not Silva, in *From Afro-Cuban Rhythms to Latin Jazz* (Berkeley: University of California Press, 2006), 104. A photograph of the Afro-Cubans printed in the *San Francisco Chronicle* shows a glimpse of Juanita "la chiquita" Silva holding maracas with her back to the camera. See Joel Selvin, "Armando Peraza to Play at Yoshi's" *San Francisco Chronicle,* May 26, 2009.

68. Fernandez, *Afro-Cuban Rhythms to Latin Jazz*, 68. Varela and Scott Yanow put Peraza in San Francisco in 1950–1951; Varela, "Sonaremó el Tambo"; Yanow, *Afro-Cuban Jazz* (San Francisco: Miller Freeman Books, 2000).

69. Sherry Tucker, *Swing Shift: "All-Girl" Bands of the 1940s* (Durham, NC: Duke University Press, 2000).

70. "Benny Velarde: Bay Area Latin Jazz Master," accessed October 30, 2016, http://www .salsacrazy.com/salsaroots/bennyvelarde.htm. According to John Storm Roberts, Tjader played for six months at the Macumba Club. Roberts, *Latin Jazz: The First of the Fusions, 1880s to Today* (New York: Schirmer Books, 1999), 97. The club inspired Cal Tjader's "Mambo Macumba." According to Jesse Varela, Velarde played at the Copacabana from 1960 to 1969. Varela, "Viva Velarde."

71. Varela, "Viva Velarde."

72. However, Velarde also played with his group The Panamanians in the early 1950s at the California Hotel in Oakland, "which catered to a largely African American clientele." Jesse Varela, "Desde la Bahia," *Latin Beat Magazine*, November 2003.

73. Zina Escovedo, "My Father," *Pete Escovedo: Music & Art,* http://peteescovedo.com/escovedo -family/pete.

74. Joel Selvin, *San Francisco: The Musical History Tour* (San Francisco: Chronicle Books, 1996), 27–28.

75. Roberts, *Latin Tinge*, 127–128. Raúl Fernandez reproduced a poster for Pérez Prado playing the San Francisco Civic Auditorium in *Afro-Cuban Rhythms to Latin Jazz*, 59, which may be the event Roberts described. Fernandez also discussed "mambo mania."

76. Roberts, *Latin Tinge*, 130. Sandoval-Sánchez, *José, Can You See?* 31.

77. Varela, "Sonaremó el Tambo."

78. Many more sources detailed the East Coast music scene, with the Palladium Ballroom, which opened in 1942, as the heart of a new American rhythm. See Max Salazar, *Mambo Kingdom: Latin Music in New York* (New York: Schirmer Trade Books, 2002); Roberts, *The Latin Tinge*; Ed Morales, *The Latin Beat: The Rhythms and Roots of Latin Music from Bossa Nova to Salsa and Beyond* (Cambridge, MA: Da Capo Press, 2003). Useful sources for the West Coast include Steven Loza, *Barrio Rhythm: Mexican American Music in Los Angeles* (Chicago: University of Illinois Press, 1993); Fernandez, *Afro-Cuban Rhythms to Latin Jazz.*

79. Roberts, *Latin Tinge*, 184.

80. Roberts, *Latin Jazz*, 80, 97.

81. Quoted in S. Duncan Reid, *Cal Tjader: The Life and Recordings of the Man Who Revolutionized Latin Jazz* (Jefferson, NC: McFarland), 31; Peraza corroborated this influence in an interview by Martin Cohen, January 17, 2007, available on YouTube at https://www.youtube.com/watch?v =un0sGsS7p_4.

82. Morales, *The Latin Beat*, 58, 175; Fernandez, *Afro-Cuban Rhythms to Latin Jazz*, 76, 78; Roberts, *Latin Tinge*, 143, 200; Scott Yanow, *Afro-Cuban Jazz*, 139; Gioia, *West Coast Jazz*, 100–104.

83. "Benny Velarde."

84. John Santos, "Salsa and Latin Jazz: A Native Son's Perspective," JazzWest.com, accessed July 5, 2005, http://www.jazzwest.com/archive/articles/archives/santos_1.html. Of Gasca, Fernandez wrote, "During his career, Chicano trumpeter Luis Gasca played Latin jazz with Cal Tjader and Mongo Santamaría, straight-ahead jazz with noted bandleader and vibraphonist Lionel Hampton, Cuban music for Pérez Prado's mambo orchestra, and rock and roll for Van Morrison and Janis Joplin. He was also one of the founders of the Latin rock group MALO and is credited with introducing Carlos Santana to jazz, making Gasca an important figure in Chicano musical history." *Afro-Cuban Rhythms to Latin Jazz,* 110.

85. Robert D. Putnam, *Bowling Alone: The Collapse and Revival of American Community* (New York: Simon and Schuster, 2001).

86. The Condor Club bore a plaque designating June 19, 1964 as the launch date for San Francisco's Red Light district—the day that Carol Doda threw off her bra (without pasties). See Harry F. Waters with Mark Starr, Richard Sandza, and Tony Clifton, "The Squeeze on Sleeze," *Newsweek,* February 1, 1988, 44; Josh Sides, *Erotic City: Sexual Revolutions and the Making of Modern San Francisco* (Oxford: Oxford University Press, 2009), 45–82.

87. Dennis Reed, "Los Locos del Ritmo," "Califa": My Mainly Musical Autobiography, last modified September 21, 2016, http://dmreed.com/autobio-1960s.php.

88. Peters, "The Beat Generation," 211. Peter Christensen, "There's Still Some Italy Left in North Beach," *Sunset,* November 1986, 12–16.

89. Santos, "Salsa and Latin Jazz." Virginia Sanchez Korrol dated the Puerto Rican Club to "as early as 1911, followed by the Liga Puertorriqueña de California, which was founded in 1923." Korrol, "In Their Own Right: A History of Puerto Ricans in the U.S.A.," *Handbook of Hispanic Cultures in the United States: History,* ed. Alfredo Jiménez (Arte Público Press, 1994), 281–301 (286). San Francisco city directories place the Club Puertorriqueño at 605 Columbus in 1913, then 596 Athens Street starting in 1929, then 3247–3249 Mission in the mid-1970s.

90. Jim McCarthy, with Ron Sansoe, *Voices of Latin Rock: The People and Events That Created This Sound* (Milwaukee, WI: Hal Leonard, 2004), 28.

91. Galaviz de Gonzalez, interview, 2003.

92. Quoted in McCarthy, *Voices of Latin Rock,* 50.

93. Al Young, "Behind the Fantasy Label." *California Living: The Magazine of the San Francisco Sunday Examiner and Chronicle,* June 29, 1975. Also see Gioia, *West Coast Jazz,* 63–65.

94. Gioia, *West Coast Jazz,* 65.

95. Ibid.

96. Juana Alicia provided this recollection when she allowed me to record her class, "Art History of La Raza," at San Francisco State University on October 21, 2002. Juana Alicia also did a mural on the 855 Treat Avenue building to represent its use as the home of the San Francisco Mime Troupe and its history as the former site of Fantasy Records.

97. Scott Yanow provided overviews of some of the recordings done for Fantasy Records in *Afro-Cuban Jazz.* The studio showcased diverse talents, including in jazz (Tjader, Gerry Mulligan, and Chet Baker), gospel and blues (Odetta, Sonny Terry, and Brownie McGhee), and poetry and comedy (Lawrence Ferlinghetti, Allen Ginsberg, and Lenny Bruce). In 1967, Saul Zaentz engineered a buyout of the Weiss brothers and in 1968 he hit gold with its Creedence Clearwater Revival recordings. The company's mission to expand its catalogues led to its acquisitions of an impressive archive of jazz, soul, gospel, and rhythm and blues recordings. See Gioia, *West Coast Jazz,* 62. The company later moved to the East Bay, but remained an integral component of the Bay Area (Latin) music scene.

98. Patricia Rodriguez, interview by author, San Francisco, March 27, 2003.

99. McCarthy, *Voices of Latin Rock,* 4.

100. Ibid., 105. Gabriella Delariva, "Congas: A Legal or Cultural Question," *El Tecolote,* November 1975, 3; Juan Gonzales, "Pelando el Ojo," *El Tecolote,* April 1976, 2; "Commentary: Conga Fight Is a Serious Matter," *El Tecolote,* September 1976, 2; Juan Gonzales, "Pelando el Ojo, *El Tecolote,* January 1977, 2.

101. Fernandez, *Afro-Cuban Rhythms to Latin Jazz,* 68.

102. Ibid., 75.

103. Timothy Gray, *Gary Snyder and the Pacific Rim: Creating Countercultural Community* (Iowa City: University of Iowa Press, 2006), 232.

Chapter 2. Freedom in the Beats

1. Luis Cervantes worked for the McRoskey Airflex Mattress Company until 1992 when he retired. Cicero A. Estrella, "Luis Cervantes—Muralist Who Inspired Generations of Artists," *San Francisco Chronicle*, May 2, 2005, B3.

2. Luis Cervantes, interview by author, San Francisco, April 2, 2003.

3. Ernie Palomino, interview, Fresno, CA, October 8, 1983, uncorrected transcript from Califas videotapes 146–150, transcribed by Philip Brookman and Amy Brookman, Califas Book 5, 13, in *Califas Conference Final Report*, Archives of American Art, Smithsonian Institution (here on, AAA).

4. According to Thomas Albright, after a 1957 reading by Ginsberg and Kerouac participants at the Six Gallery "destroyed a piano and many of the art works on display." The action also mimicked the increasing spontaneity of jazz. Albright, "The California School of Fine Arts, c. 1945–1960," in *Reflections: Alumni Exhibitions, San Francisco Art Institute, January 1981* (San Francisco: San Francisco Art Institute, 1982), 22. Raphael "Ralph" Ortiz (1934–), a Mexican American avant-garde artist in New York, gained fame for his performances in the Destructive arts movement, particularly for his "Piano Destruction Concert" televised on the BBC, ABC, and NBC, in 1966. In 1969, he founded El Museo del Barrio. See Jacinto Quirarte, *Mexican American Artists* (Austin: University of Texas Press, 1973), 99–101; Michael Kimmelman, "The Return of the Well-Trampled Clavier," *New York Times*, January 3, 1997, B30.

5. Steven Watson provided the etymology of the term *Beat* in *The Birth of the Beat Generation: Visionaries, Rebels, and Hipsters, 1944–1960* (New York: Pantheon Books, 1995), 3–4.

6. Nancy J. Peters, "The Beat Generation and San Francisco's Culture of Dissent," in *Reclaiming San Francisco: History, Politics, Culture*, ed. James Brook, Chris Carlsson, and Nancy J. Peters (San Francisco: City Lights Books, 1998), 212.

7. Albright, "The California School of Fine Arts," 21.

8. Chon Noriega, "From Beats to Borders: An Alternative History of Chicano Art in California," in *Reading California: Art, Image, and Identity, 1900–2000*, ed. Stephanie Barron, Sheri Bernstein, and Ilene Susan Fort (Berkeley: University of California Press, 2000), 355, exhibition catalog; also see Chon Noriega, "Why Chicanos Could Not Be Beat," *Aztlan* 24, no. 2 (1999): 1–11. Also helpful are A. Robert Lee, "Chicanismo's Beat Outrider? The Texts and Contexts of Oscar Zeta Acosta," in *The Beat Generation: Critical Essays*, ed. Kostas Myrsiades (New York: Peter Lang, 2002), 263; and Manuel Luis Martinez, *Countering the Counterculture: Rereading Postwar American Dissent from Jack Kerouac to Tomás Rivera* (Madison: University of Wisconsin Press, 2003).

9. Caroline A. Jones, *Bay Area Figurative Art: 1950–1965* (Berkeley: University of California Press, 1990). Numerous monographs on Richard Diebenkorn, Elmer Bischoff, Manuel Neri, Nathan Oliveira, Theophilus Brown, Joan Brown, and others also illuminate this important Bay Area movement.

10. José Ramón Lerma, interview by author, Oakland, CA, December 29, 2000, and January 5, 2001; Luis Cervantes letter to author, early 2005.

11. Women participated in Beat culture, but a lack of historical records contributed to their absence. See Brenda Knight, *Women of the Beat Generation: The Writers, Artists and Muses at the Heart of a Revolution* (Berkeley, CA: Conari, 1996); Richard Peabody, ed., *A Different Beat: Writings by Women of the Beat Generation* (London: Serpent's Tail, 1997); Nancy M. Grace and Ronna C. Johnson, eds., *Breaking the Rule of Cool: Interviewing and Reading Women Beat Writers* (Jackson: University Press of Mississippi, 2004); Ronna C. Johnson and Nancy M. Grace, eds., *Girls Who Wore Black: Women Writing the Beat Generation* (New Brunswick, NJ: Rutgers University Press, 2002). In my research, certain female artists stand out for their Spanish surnames, such as Estelle Chaves, also

known as Stella Mary Chaves (1929–2000). *Artforum* marked some of her shows in San Francisco galleries in the early 1960s and occasionally provided condescending reviews: *Artforum* 1 no. 2 (1962): 10; *Artforum* 1, no. 3 (1962): 38; *Artforum* 2, no. 4 (1963): 15; and *Artforum* 2, no. 7 (1964): 48. More information exists for Annita Delano (1894–1979), who taught art for many years at the University of California Los Angeles (UCLA), but who periodically showed art in San Francisco. Delano refers to herself as a white outsider in her travels to portray Native Americans of the Southwest, but also makes reference to her "Spanish" grandmother from Mexico in an oral history; see Annita Delano, "Southwest Artist and Educator, Annita Delano," interviewed by James V. Mink, Oral History Program, UCLA, 1976, vol. 1, 3, 268, 277, 283.

12. Susan Landauer described the wave of Korean War veterans enrolling at the California School of Fine Arts in 1953 as a significant factor in launching a cultural renaissance. Landauer, *The San Francisco School of Abstract Expressionism* (Berkeley: University of California Press, 1996), 124; Albright wrote, "The GI Bill brought in a new breed of students, mostly men in their middle or later twenties, of a maturity—sometimes hardened by experiences in the war—that was largely without precedent among such a large number of art students," in "The California School of Fine Arts," 14.

13. Nan Alamilla Boyd, *Wide-Open Town: A History of Queer San Francisco to 1965* (Berkeley: University of California Press, 2003), 25–29.

14. Alan Bérubé, *Coming Out Under Fire: The History of Gay Men and Women in World War Two* (New York: Plume, 1991); Susan Stryker and Jim Van Buskirk, *Gay by the Bay: A History of Queer Culture in the San Francisco Bay Area* (San Francisco: Chronicle Books, 1996); Boyd, *Wide-Open Town*, 2003.

15. Josh Sides, *Erotic City: Sexual Revolutions and the Making of Modern San Francisco* (Oxford: Oxford University Press, 2009), 83.

16. Between 1953 and 1966, San Francisco lost 9,000 manufacturing jobs, or 14 percent of the total. Businesses that left cited the lack of space, high rents, high taxes, and parking problems, as well as the "character of the labor force." Presumably, this last remark reflected antipathy among manufacturers toward labor's strength in the city. The statistic is from Marjorie Heins, *Strictly Ghetto Property: The Story of Los Siete de la Raza* (Berkeley, CA: Ramparts Press, 1972), 25. Heins cited the City Planning Department's report, "San Francisco Industrial Trends," October 1968. The city's 1934 general strike by laborers, planned in the Mission's American Federation of Labor Building, affirmed representations of the city as a stronghold for labor unions and likely contributed to the movement of heavy industry away from the city. For more on the "character of the labor force," see Bruce Nelson, *Workers on the Waterfront: Seamen, Longshoremen, and Unionism in the 1930s* (Urbana: University of Illinois Press, 1988); David F. Selvin, *A Terrible Anger: The 1934 Waterfront and General Strikes in San Francisco* (Detroit: Wayne State University Press, 1996); Richard Edward DeLeon, *Left Coast City: Progressive Politics in San Francisco, 1975–1991* (Lawrence: University Press of Kansas, 1992).

17. David Sterritt, *Mad To Be Saved: The Beats, the 50s, and Film* (Carbondale: Southern Illinois University Press, 1998).

18. Peters, "The Beat Generation," 209.

19. Ibid., 210. Peters wrote that "press coverage finally brought young people to North Beach from all over the country; they dressed as hipsters and tried to be beats; they were followed by tourists who came to see beatniks; and finally, commodities were created to sell to both beatniks and tourists."

20. René Yañez, interview by author, San Francisco, February 18, 2003.

21. Jerry Stoll, *I Am a Lover* (Sausalito, CA: Angel Island, 1961).

22. Nina Serrano, interview by author, Oakland, CA, April 16, 2003.

23. Nina Serrano, *Heart Songs: The Collected Poems of Nina Serrano, 1969–1979* (San Francisco: Editorial Pocho-Che, 1980), 56.

24. José Montoya, "Russian Cowboys, Early Berkeley and Sunstruck Critics: On Being a Chicano Writer," *Metamorfosis* 3, no. 1 (1980): 50. Translations by the author.

25. Tomas Ybarra-Frausto, introduction to Raúl Salinas's *Un Trip Through the Mind Jail Y Otras Excursions* (Houston: Arte Público, 1999).

26. Rupert García, Oral History interviews by Paul J. Karlstrom, Oakland, CA, September 7, 1995, November 10, 1995, and June 24, 1996, AAA, http://www.aaa.si.edu/collections/interviews /oral-history-interview-rupert-garcia-13572.

27. Allen Ginsberg's participation also gave prominence to a bisexual Jewish American male in Beat culture. For more on Ginsberg's Jewishness, see Jonathan Gill, "The Promised Land Blues: Allen Ginsberg and LeRoi Jones/Amiri Baraka," *European Contributions to American Studies* 42 (1999): 241–249. More broadly, white masculinity is a trope of the movement. In William Lawlor's *The Beat Generation: A Bibliographical Teaching Guide* (Lanham, MD: Scarecrow, 1998), William S. Burroughs, Allen Ginsberg, and Jack Kerouac are the focus of a chapter each, while the mention of anyone else is consolidated in "Other Beats," and even then the overwhelming majority are Anglo American males. James Campbell's work begins in 1944 with the "coming together of three principal characters"—Kerouac, Ginsberg, and Burroughs—in *This Is the Beat Generation: New York— San Francisco—Paris* (London: Secker and Warburg, 1999), ix. These representations are changing, particularly in recognizing the dependency of the movement on African American culture. Lorenzo Thomas wrote that "the Beats found fuel for their intensity in jazz music, experimentation with drugs, and an imitation of what they thought was a Black lifestyle," in Thomas, "'Communicating by Horns': Jazz and Redemption in the Poetry of the Beats and the Black Arts Movement," *African American Review* 26, no. 2 (1992): 291–298. Lee also discusses the expanded dimensions of Beat scholarship in Lee, "Chicanismo's Beat Outrider?"

28. Watson, *Birth of the Beat Generation*, 5.

29. On the oppositional nature of zoot suit culture, see Luis Alvarez, *The Power of the Zoot: Youth Culture and Resistance During World War II* (Berkeley: University of California Press, 2008).

30. Robert Holton, "Kerouac Among the Fellahin: *On the Road* to the Postmodern," in *Jack Kerouac's On the Road*, ed. Harold Bloom (Philadelphia: Chelsea House, 2004), 78.

31. Martinez, *Countering the Counterculture*, 28.

32. *Chicano Beat: An Interview with José Lerma*, directed by Ana Montano, ArtBeat Gallery, 1996. Various Beat shows have included Lerma's work in their exhibitions and discussions. Nathan Oliveira stated, "José Lerma embodied what the 50's and the Beat Generation were about." Quoted in "José Ramón Lerma, Paintings, Collages & Constructions, A Retrospective: 1954–2000," exhibition pamphlet, Intersection for the Arts, San Francisco, June 14–July 22, 2000, 2. In an interview with the author, Cervantes found art reviewer John Coplans's application of the term "beatnik" condescending. Cervantes, interview, 2003.

33. Lerma, interview, 2000.

34. Cervantes, letter to author, 2005.

35. Cervantes, interview, 2003.

36. See John Lardas, *The Bop Apocalypse: The Religious Visions of Kerouac, Ginsberg, and Burroughs* (Urbana: University of Illinois Press, 2001), 180; Howard Campbell, "Beat Mexico: Bohemia, Anthropology and 'the Other,'" *Critique of Anthropology* 23, no. 2 (2003): 209.

37. Juan Felipe Herrera, "Ferlinghetti on the North Side of San Francisco Poem," *Metamorfosis* 3, no. 2 and 4, no. 1 (1980/1981): 35.

38. Ed Morales, *Living in Spanglish: The Search for Latino Identity in America* (New York: St. Martin's, 2002), 24–25. George J. Sánchez discussed Chicanos as the "invisible minority" in *Becoming Mexican American: Ethnicity, Culture, and Identity in Chicano Los Angeles, 1900–1945* (New York: Oxford University Press, 1993), 225–226. Ilan Stavans pointed to the absences in the development of Latino literature in *The Hispanic Condition: The Power of a People* (1995; repr., New York: HarperCollins, 2001), 233. A variety of texts have discussed the absence of Latinos in the media: Lisa Navarrete and Charles Kamasaki, *Out of the Picture: Hispanics in the Media: The State of Hispanic America, 1994* (Washington, DC: Policy Analysis Center, Office of Research Advocacy and Legislation, National Council of La Raza, 1994); *Network Brownout: The Portrayal of Latinos in Network Television News* (Washington, DC: National Association of Hispanic Journalists, 2003).

39. Martinez, *Countering the Counterculture*, 4. Also see José Limón, *American Encounters: Greater Mexico, the United States, and the Erotics of Culture* (Boston: Beacon, 1998); and Américo

Paredes, *Folklore and Culture on the Texas-Mexican Border*, ed. Richard Bauman (Austin: Center for Mexican American Studies, University of Texas, 1993).

40. Watson, *Birth of the Beat Generation*, 4; Peters, "The Beat Generation," 211.

41. Manuel Neri, a Mexican American, was born in Sanger, California, in 1930. He studied at San Francisco City College, served in Korea, then returned to study at the California College of Arts and Crafts in Oakland and the California School of Fine Arts. Many sources discuss Neri's work, including Quirarte, *Mexican American Artists*, 87–92; George W. Neubert, *Manuel Neri, Sculptor* (Oakland, CA: Oakland Museum, 1976), exhibition catalog; and Price Amerson, *Manuel Neri: Early Work, 1953–1978* (New York: Hudson Hills, 1996). Peter Rodriguez was born in Stockton, California in 1926 to Mexican parents. In the 1950s, Rodriguez was showing his work in the Central Valley (the Skylight Gallery, the Haggin Museum, and the Crocker Art Museum), San Francisco (Lucien Labaudt Gallery, Gumps Gallery, De Young Museum, and the California Legion of Honor), and Guadalajara, Mexico (Museo del Estado). See Amalia Mesa-Bains, Tomás Ybarra-Frausto, et al., *A Life in Color: The Art of Peter Rodriguez, A Fifty Year Retrospective Exhibition* (San Francisco: Mission Cultural Center, 1993); Quirarte, *Mexican American Artists*, 75–78; and Albright, *Art in the San Francisco Bay Area: 1945–1980, an Illustrated History* (Berkeley: University of California Press, 1985). Louis Gutiérrez, also Mexican American, was born in Pittsburgh, California, in 1933. Both Gutiérrez and Jorge Castillo showed at the Fredric Hobbs Gallery in the Marina/Cow Hollow corridor. *Artforum* 1, no. 1 (June 1962): 4; *Artforum* 1, no. 7 (December 1962): 46; *Artforum* 1, no. 12 (June 1963): 50; and Quirarte, *Mexican American Artists*, 92–96. Jorge Castillo was born in Spain, raised mostly in Argentina, and later became a resident of New York. Ricardo Gomez (1942–) studied at the San Francisco Art Institute in the early 1960s. *Artforum* 2, no. 2 (August 1963): 22. Victor Moscoso was born in Spain, came to San Francisco in 1959, made his home near North Beach, and shortly thereafter attended the Art Institute. In the late 1960s, he found his calling with rock and roll posters and comic book art. See *Artforum* 1, no. 9 (March 1963): 15; Albright, *Art in the San Francisco Bay Area*, 171–172 and 300; Victor Moscoso, *Sex, Rock & Optical Illusions* (Seattle: Fantagraphics Books, 2005). Alex Gonzales was born in Superior, Arizona, in 1927 and studied at the San Francisco Art Institute, Oakland's College of Arts and Crafts, and San Francisco State University. He moved to Monterey, California, in 1962, where he joined the Carmel Art Association. Gary Stanley, "Alex Gonzales Biography," Carmel Art Association Archives, http://www.askart.com /biography.asp?ID=110281. According to Harriette von Breton, "Mark Tobey has selected Gonzales as one of the most creative artists of the Monterey Peninsula." *Artforum* 1, no. 8 (February 1963): 44. Also see *Artforum* 2, no. 5 (November 1963): 51; and *Artforum* 1, no. 11 (May 1963): 16. Little published information exists on Juan Sandoval. Originally from New Mexico, he received an MFA from the San Francisco Art Institute in 1962. See John Natsoulas, *The Spatsa Gallery: 1958–1961* (Davis, CA: Natsoulas/Novelozo Gallery, 1991), 27; and David J. Carlson, "Juan Sandoval Biography," Carlson Gallery, http://www.askart.com/biography.asp?ID=127519. Anthony Prieto (1913–1967) came to San Francisco from Spain in the early 1940s. According to Albright, "He was an important force behind the growth, if not the direction, of the Bay Area ceramics movement, two of whose most influential figures, Robert Arneson and Charles McKee, studied under him." Albright, *Art in the San Francisco Bay Area*, 306. Rolando Castellón was born in Managua, Nicaragua, in 1937 and came to California in 1956. "His early paintings on paper contained ghost-like images of pyramids, suns, and moons, and were built in transparent, overlapping pastel colors to suggest the layered surfaces of old walls." From Albright, *Art in the San Francisco Bay Area*, 267. Some artists have names that suggest a Latino identity: Sacramento-based artist Archie Gonzales showed at the Hobbs Gallery and San Francisco Art Center. *Artforum* 1, no. 12 (June 1963): 50; *Artforum* 2, no. 7 (January 1964): 15; *Artforum* 2, no. 9 (March 1964): 4. Other names give no indication of ethnicity, but country of origin is suggestive: Henry Brandon was born in Cuenca, Ecuador, in 1934, attended CCAC in the late 1950s and early 1960s, and developed his painting in the figurative style. Ann Adair was born in Coscosolo, Panama, in 1936, attended UC Berkeley and the San Francisco Art Institute, developed a series of ceramic alligators, and married Peter Voulkos; see Albright, *Art in the San Francisco Bay Area*, 264, 257.

42. Ruth Asawa (1926–), George Miyasaki (1935–), Arthur Monroe (1935–), Win Ng (1935–), Arthur Okamura (1932–), Carlos Villa (1936–), Leo Valledor (1936–), and Gary Woo (1928–) are just a few of the Asian American and African American artists working in 1950s San Francisco. See Albright, *Art in the San Francisco Bay Area*, 257–323.

43. Ibid., 107.

44. Dorothy Seiberling, "Jackson Pollock: Is He the Greatest Living Painter in the United States?" *Life*, August 8, 1949, 42–45.

45. See Steven Naifeh and Gregory White Smith, *Jackson Pollock: An American Saga* (New York: Clarkson Potter, 1989).

46. Landauer, *San Francisco School*, 17.

47. Clyfford Still's "contradictions contributed to the larger-than-life image that made Still the man-of-the-hour during most of the four years he taught at CSFA, personifying—as did his paintings—just what the times and many of the students demanded." Albright, "The California School of Fine Arts," 17.

48. Jones, *Bay Area Figurative Art.*

49. Ibid. Also see Peter Selz, *Funk* (Berkeley: University of California, Berkley, 1967); Albright, *Art in the San Francisco Bay Area*, 111–134.

50. Quoted in "Lerma Retrospective," Intersection for the Arts, 9.

51. Jonah Raskin, *American Scream: Allen Ginsberg's Howl and the Making of the Beat Generation* (Berkeley: University of California Press, 2004).

52. José Ramón Lerma papers, collection of the author.

53. Cervantes, interview, 2003.

54. Natsoulas, *The Spatsa Gallery*, 8; Landauer, *San Francisco School*, 124.

55. A number of important galleries had found a home in North Beach, including The Place, The Anxious Asp, Miss Smith's Tea Room, Vesuvio, the Co-Existence Bagel Shop, and the Dilexi (above the Jazz Workshop). Albright, "The California School of Fine Arts," 21.

56. Chapter 1 focuses on the commodification of North Beach.

57. Seymour Howard, John Natsoulas, Rebecca Solnit, Michael McClure, Bruce Nixon, John Allen Ryan, and Jack Foley, *The Beat Generation: Galleries and Beyond* (Davis, CA: John Natsoulas Press, 1996).

58. Natsoulas, *The Spatsa Gallery*, 8.

59. Quoted in Natsoulas, *The Spatsa Gallery*, 2. Also see Landauer, *San Francisco School.*

60. Chris Swiac, ed., *Fodor's San Francisco 2005* (New York: Fodor's Travel Publications, 2005) 150: "Tony Union Street and the nearby Marina are where you find singles bars that attract well-dressed and well-to-do crowds in their twenties and thirties."

61. Natsoulas, *The Spatsa Gallery*, 9.

62. Ibid., 4.

63. Albright added that the gallery "displayed work by Ron Davis, William Geis, Carlos Villa, and other emerging artists associated with the SFAI and the North Beach underground." *Art in the San Francisco Bay Area*, 267.

64. Cervantes, interview, 2003.

65. Peters, "The Beat Generation," 210.

66. Cervantes, interview, 2003.

67. John Coplans, "Panama Canal Anniversary Exhibition," *Artforum* 1, no. 5 (October 1962): 42.

68. Susan Kelk Cervantes, interview by author, San Francisco, February 23, 2003. Also see Coplans, "Panama Canal Anniversary Exhibition," 42; "Richard Van Buren: New Mission Gallery," *Artforum* 1, no. 7 (December 1962): 46; "Manuel Neri: New Mission Gallery," *Artforum* 2, no. 3 (September 1963): 45; "Seymour Locks: New Mission Gallery," *Artforum* 2, no. 7 (January 1964): 9; HG, "Vorpal Gallery," *Artforum* 11, no. 1 (July 1963): 11.

69. Cervantes, interview, 2003.

70. Ibid.

71. Ibid.

72. Ernie Palomino, interview, Califas Book 5, 6. Around the same time, Palomino published a book of his drawings, *In Black and White: Evolution of an Artist* (Fresno, CA: Academy Library Guild), 1956. Notably, June Muller's preface stated, "Palomino insists his pictures are not a protest of the conditions under which he was born and lived, for 'it would do no good to protest.' Rather, he says, they are a mirror, a reflection of the times."

73. Ibid.

74. Ibid.

75. *My Trip in a '52 Ford*, directed by Ernie Palomino, Cine Go, 1966.

76. Ibid.

77. *Artforum* 1, no. 5 (October 1962): 43.

78. *Artforum* 1, no. 12 (June 1963): 44; Ernie Palomino, letter to author, June 1, 2016.

79. Philip Brookman, "California Assemblage: The Mixed Message," in *Forty Years of California Assemblage* (Los Angeles: Wight Art Gallery, University of California, 1989), 83.

80. Tomás Ybarra-Frausto, "Rasquachismo: A Chicano Sensibility," in *Chicano Art: Resistance and Affirmation, 1965–1985*, ed. Richard Griswold del Castillo, Teresa McKenna, and Yvonne Yarbro-Bejarano (Los Angeles: Wight Art Gallery, University of California, 1991), 155–162.

81. For brief descriptions of the film, see Noriega, "From Beats to Borders," 358–360; Quirarte, *Mexican American Artists*, 97–98.

82. Ernie Palomino to author, October 8, 2014.

83. Ernie Palomino, artist's statement, n.d., collection of the author.

84. Ernie Palomino, telephone conversation with the author, May 16, 2016.

85. Quirarte, *Mexican American Artists*, 96; Noriega, "From Beats to Borders." David G. Gutiérrez discussed the use of *gabacho* in *Walls and Mirrors: Mexican Americans, Mexican Immigrants, and the Politics of Ethnicity* (Berkeley: University of California Press, 1995), 185: "In the idea of Aztlán the young activists presented a quasi-nationalist vision of the Chicano people which extolled a pre-Columbian, native ancestry while diminishing or even rejecting their connection with American culture and society. In so doing they also dismissed traditional notions of Americanization and assimilation as nothing more than *gabacho* (a derisive term for Anglo) attempts to maintain hegemony over Chicanos by destroying their culture."

86. Shifra M. Goldman, "How, Why, Where, and When It All Happened," in *Signs from the Heart: California Chicano Murals*, ed. Eva Sperling Cockcroft and Holly Barnet-Sanchez (1990; repr., Albuquerque: University of New Mexico Press, 1993), 41.

87. Lerma, interviews, 2000 and 2001.

88. Quoted in "Lerma Retrospective," Intersection for the Arts, 2.

89. Jim Scully described Lerma's "Coast #1" (1961) as a "collage made of wrapping tissue . . . a striking example of his ability to render landscape as experience. . . . The dizzying outside-inside *feel* of full-bore sun, sand, ambient yellow-orange light and sea light is brought on . . . by a motley chorus of black-rimmed solar afterimages appearing and half-appearing in the varying depths of the sky." Jim Scully, "José Ramón Lerma @ Intersection in the Year 2000," Intersection for the Arts, April 22, 2000.

90. Lerma, interviews, 2000 and 2001.

91. Ibid.

92. Ibid.

93. "Lerma Retrospective," Intersection for the Arts, 2.

94. Gilberto Osorio, "José Lerma Retrospective Covers a Long and Distinguished Career," *New Mission News*, June 2000, 11.

95. Oscar Zeta Acosta, *Autobiography of a Brown Buffalo* (1972; repr. New York: Vintage Books, 1989), 47.

96. *Artforum* I: 1,1, no. 1 (June 1962): 41. Another painting of the period, formerly owned by Luis Cervantes, depicted a cross "on a field of blood red." See, "Lerma Retrospective," Intersection for the Arts, 9.

97. Lerma, interviews, 2000 and 2001. Acosta also described Lerma as forever scarred by his mother's extramarital affair. Acosta, *Autobiography*, 47.

98. Ann Eden Gibson, *Abstract Expressionism: Other Politics* (New Haven, CT: Yale University Press, 1997), xxviii. For the classic account of the "triumph" of abstract expressionism, see Irving Sandler, *The Triumph of American Painting: The History of Abstract Expressionism* New York: Praeger, 1970). Also see the writings of Clement Greenberg, including *Art and Culture: Critical Essays* (Boston: Beacon, 1961).

99. *Chicano Beat: An Interview with José Lerma.*

100. Cervantes, letter to author, 2005.

101. Luis Martínez Cervantes, "Be an Artist," in *Luis Cervantes: 1923–2005,* exhibition booklet, transcribed by Susan Cervantes (San Francisco: SOMArts Gallery, November 11–29, 2006), 6.

102. Ibid., and Cervantes, interview, 2003.

103. Ibid.

104. Luz Cervantes, "Golden Consciousness: The Art and Life of Luis Cervantes," in *Luis Cervantes: 1923–2005,* 8.

105. W. Jackson Rushing, "Ritual and Myth: Native American Culture and Abstract Expressionism," in *The Spiritual in Art: Abstract Painting, 1890–1985* (Los Angeles: Los Angeles County Museum of Art, 1986), 273–295.

106. Albright, *Art in the San Francisco Bay Area*, 267.

107. Cervantes, interview, 2003.

108. Ibid.

109. Ibid.

110. Cervantes, "Be an Artist," 6.

111. Cervantes, interview, 2003.

112. Landauer, *The San Francisco School*, 124; Albright, "The California School of Fine Arts," 14.

113. Natsoulas, *The Spatsa Gallery*, 27.

114. Estrella, "Luis Cervantes—Muralist." For more about Palomino, see Quirarte, *Mexican American Artists*, 98; Goldman, "How, Why, Where, and When," 41.

115. David Craven, *Abstract Expressionism as Cultural Critique: Dissent During the McCarthy Period* (Cambridge: Cambridge University Press, 1999), 17. Also see Craven's article, "Abstract Expressionism and Third World Art: A Postcolonial Approach to 'American' Art," *Oxford Art Journal* 14, no. 1 (1991): 44–66.

116. Cervantes, interview, 2003.

117. Lerma, interviews, 2000 and 2001.

118. Scully, "José Ramón Lerma," emphasis in original.

119. Other Latino painters struggled with this tension, including Carlos Loarca, Jerry Concha, and Rolando Castellón. The latter curated *Mano a Mano: Abstraction/Figuration, 16 Mexican-American & Latin-American Painters from the San Francisco Bay Area* (Santa Cruz: The Art Museum of Santa Cruz County and University of California, Santa Cruz, 1988). The goal of the exhibit was "to rectify, at the regional level, the lack of recognition given to existing abstractionist tendencies in Chicano and Latin-American art." (6).

120. Albright wrote, "Back in the mid-'50's, everyone was talking about San Francisco as the center of a new Renaissance—of literature, art, and jazz. . . . Ten years later, the action shifts from Grant Avenue to Haight Street, and history seemingly repeats itself, but more so. . . . Almost everyone seems to take for granted a certain link between the 'Beat' era of the '50s and the 'Hip' generation of today, if only for the sake of contrast." Albright, "San Francisco's Rolling Renaissance," in *San Francisco Underground Art in Celebration: 1945–1968,* 2nd ed. (San Francisco: Intersection, Center for Religion and the Arts, 1976), 3.

Chapter 3. La Raza Unida

1. Yolanda López, Conference Session 1, UC Santa Cruz, April 16, 1982, transcript, Califas Book 1, 45, in *Califas Conference Final Report,* Archives of American Art, Smithsonian Institution (here on, AAA).

2. Shifra Goldman, *Dimensions of the Americas: Art and Social Change in Latin America and the United States* (Chicago: University of Chicago Press, 1994), 164.

3. Rolando Castellón, "Mano a Mano: Abstraction/Figuration," in *Mano a Mano: Abstraction/ Figuration: 16 Mexican-American & Latin-American Painters from the San Francisco Bay Area* (Santa Cruz, CA: Art Museum of Santa Cruz County, 1988), 14n1.

4. I have capitalized *Raza* as an ethnic label akin to *Chicano* or *Latino*, except when quoting others. Tomás F. Summers Sandoval Jr. pointed out that the 1930s newspaper *El Imparcial* was "the weekly paper of la raza, by la raza, and for la raza" in *Latinos at the Golden Gate: Creating Community and Identity in San Francisco* (Chapel Hill: University of North Carolina Press, 2013), 96. "El Plan de Aztlán" uses "La Raza de Bronze [*sic*]" in *Documents of the Chicano Struggle* (New York: Pathfinder, 1971), 6.

5. Chicano activists produced "El Plan de Aztlán" at the National Chicano Youth Liberation Conference in Denver, Colorado, in 1969. *Documents of the Chicano Struggle,* 6.

6. The preface to the 1991 CARA exhibition catalog stated, "A distinct art arose from the dynamic interdependent relationship between the Movimiento (the Chicano civil rights movement of the 1960s and 1970s) and a significant segment of the artistic community of Americans of Mexican descent, and that this art has been identified by its creators and participants as 'Chicano.'" Also in the catalogue, Shifra Goldman and Tomás Ybarra-Frausto loosely define Chicano art as having "political and ethnic themes," in *CARA,* 83–95. Also see Sylvia Gorodesky, *Arte Chicano como Cultura de Protesta* (*Chicano Art as Protest Culture*) (Mexico City: Universidad Nacional Autónoma de México, 1993); Manuel J. Martínez, "The Art of the Chicano Movement and the Movement of Chicano Art," in *Aztlán: An Anthology of Mexican American Literature,* ed. Luis Valdez and Stan Steiner (New York: Knopf, 1972), 349–353; Alicia Gaspar de Alba, *Chicano Art: Inside/Outside the Master's House: Cultural Politics and the CARA Exhibition* (Austin: University of Texas Press, 1998); and Cheech Marin, *Chicano Visions: American Painters on the Verge* (New York: Bulfinch, 2002).

7. Malaquías Montoya and Lezlie Salkowitz-Montoya, "A Critical Perspective on the State of Chicano Art," *Metamorfosis* 3, no. 1 (1980): 3–7.

8. Various grassroots service organizations began to appear in the Mission, including Mission Rebels in Action (1964–2005), Horizons Unlimited (1965–), Arriba Juntos (1965–), the Mission Coalition Organization (1967–1974), the Mission Hiring Hall (1971–), the Mission Language and Vocational School (1962–), and the Mission Neighborhood Health Center (1970–). See Mike Miller, *A Community Organizer's Tale: People and Power in San Francisco* (Berkeley, CA: Heyday Books, 2009), especially 49–50; Summers Sandoval, *Latinos at the Golden Gate*; and Manuel Castells, *The City and the Grassroots: A Cross-Cultural Theory of Urban Social Movements* (Berkeley: University of California Press, 1983). San Francisco State also targeted the Mission with a "Community Involvement Program." See William Barlow and Peter Shapiro, *An End to Silence: The San Francisco State College Student Movement in the '60s* (New York: Pegasus, 1971), 62–75.

9. Members included Julio Benitez (Guatemalan), Ester Chioffalo (Argentinean), Domingo Díaz (Dominican), Luis Echegoyen (Salvadoran), Waldo Esteva (Chilean), Carlos Loarca (Guatemalan), Carlos Solorio (Guatemalan), Maria Rosa Tranquilli (Argentinean), José Alberto Velasquez (Salvadoran), and José Wigdor (Argentinean). Later, the group included Pedro Cáceres (Mexican), Francisco Camplís (Chicano), Rolando Castellón (Nicaraguan), Maruja Cid (Galician/Spanish American), Zoanne Harris (Anglo American), Leland Mellot (Anglo American), Isa Mura (Spanish Andalusian), Emilio Osta (Spanish Castellano), Tere Osta (Spanish Castellano), Carlos Pérez (Chicano), Carol Lee Sanchez (Native American), Pilar Sanchez (multiethnic Latino), Don Santina (Irish American), Maria "China" Tello (Peruvian), and Osvaldo Villazon (Bolivian). This list is far from complete, but does reflect the diversity of the membership, sourced from: Carlos Loarca, interview

by author, San Francisco, April 8, 2003; Don Santina e-mail to author, October 1, 2004; Santina e-mail to author, August 15, 2005; Maria Tello e-mail to author, August 17, 2005; Loarca e-mail to author, August 18, 2005.

10. *Latino Youth Art Workshop*, c. 1969, Santina archive. Casa Editorial was launched in 1973 and published several books, including Amílcar Lobos, *Quetzal: Poemas Representabalés del Barrio San Francisco,* and Leland Mellott, *Ceremony for a Chicano Community Wedding,* a double volume (1973); Pilar Sanchez, *Symbols* (1974); Carol Lee Sanchez, *Conversations from the Nightmare* (1975); Amílcar Lobos, *Portal a la Californiana: Prosopoemario* (1975); Dorinda Moreno, *La Mujer Es la Tierra: La Tierra da Vida* (1975); and Rafael Jesús Gonzalez, *El Hacedor de Juegos (The Maker of Games)* (1977). Galería de la Raza has long claimed responsibility for the first public celebration of Día de los Muertos. The history of this event is discussed in Chapter 8.

11. Don Santina wrote, "Casa has been lost in the official (such as they are) histories of the period." Santina, e-mail to author, October 7, 2004. His claim does not seem far-fetched. References in secondary sources to Casa Hispana are scarce. Goldman makes passing reference to Casa Hispana in "How, Why, Where, and When It all Happened: Chicano Murals of California," in *Signs from the Heart: California Chicano Murals,* ed. Eva Sperling Cockcroft and Holly Barnet-Sanchez (1990; repr., Albuquerque: University of New Mexico Press, 1993), but no references appeared in Goldman's *Dimensions of the Americas* or the CARA exhibition. I am indebted to Don Santina for copies of his personal archive of Casa Hispana materials. (Here on, the Santina Archive.)

12. Gaspar de Alba, *Chicano Art,* 8, emphasis in original.

13. Casa Hispana de Bellas Artes marketing/information materials, Camplís collection, CEMA, Box 1/3.

14. Loarca, interview, 2003.

15. Carlos B. Córdova, "The Mission District: The Ethnic Diversity of the Latin American Enclave in San Francisco, Calif.," *Journal of La Raza Studies* 2, no. 1 (Summer/Fall, 1989): 21–32; Brian J. Godfrey, *Neighborhoods in Transition: The Making of San Francisco's Ethnic and Nonconformist Communities* (Berkeley: University of California Press, 1988); Manuel Castells, *The City and the Grassroots: A Cross-Cultural Theory of Urban Social Movements* (London: Edward Arnold, 1983); Raúl Homero Villas, *Barrio-Logos: Space and Place in Urban Chicano Literature and Culture* (Austin: University of Texas Press, 2000); Mike Davis, *Magical Urbanism: Latinos Reinvent the U.S. City* (New York: Verso, 2000).

16. Godfrey, *Neighborhoods in Transition,* 97. As noted in Chapter 1, census figures typically undercount Latinos.

17. Ibid., 150. According to Godfrey, Hispanics were 45 percent of the total Mission District population but 52 percent of the "Mission District core." Manuel Castell's Mission District demographics vary slightly: "Latins" composed 42 percent of the total district and 55 percent of the "inner Mission." Castells, *City and Grassroots,* 352. Raúl Homero Villas provided a more general description of this process of "barrioization" in *Barrio-Logos,* 4–5.

18. Castells, *City and Grassroots,* 407n79: "In 1975, 85 percent of Inner Mission residents were renters."

19. Marjorie Heins, *Strictly Ghetto Property: The Story of Los Siete de la Raza* (Berkeley, CA: Ramparts, 1972), 25.

20. Ibid.

21. Rudy Espinosa, "A Glow of Community Spirit Marks El Día de La Raza," *San Francisco Sunday Examiner and Chronicle,* October 31, 1971, 9. According to Laurie Kay Sommers, "Since the late 1960s, San Francisco has witnessed the creation of several Latino festivals that can be seen as a direct response to increasing Latinization of the community." See "Inventing Latinismo: The Creation of 'Hispanic' Panethnicity in the United States," *Journal of American Folklore* 104, no. 411 (Winter 1991): 38.

22. Rebecca Earle argued that "the date of Columbus' 1492 arrival in the West Indies, had by the early twentieth century been declared an official holiday in many Spanish American countries . . . in an implicit assertion that the Spanish American 'race' had an Iberian origin." See "'Padres de la

Patria' and the Ancestral Past: Commemorations of Independence in Nineteenth-Century Spanish America," *Journal of Latin American Studies* 34, no. 4 (November 2002): 775–805. Carlos Morton argued, "It is interesting to note that in Latin America October 12, Columbus Day, is celebrated as El Día de la Raza (The Day of the Race), or the day when all of the races started 'mixing,' hence the origin of the term, 'mestizaje.' We do not honor the elitist 'conquistador,' but rather celebrate La Raza (The Family) as a whole." See "Celebrating 500 Years of *Mestizaje*," *MELUS* 16, no. 3 (Fall 1989–1990): 20.

23. Espinosa, "A Glow of Community Spirit." An article announcing the Sixth Annual Raza/Hispanidad festival included the "Latinamerican Folkloric Festival of Dance, Song, and Poetry," an "anthropological exhibit from Mexico entitled 'The Sacred Well of Chichen Itza,'" and "Arte del Barrio por Ninos." See "Raza/Hispanidad," *El Tecolote,* December 8, 1971, 2; "La Raza/Hispanidad Festival," *City* 6 (September 4–17, 1974): 44–45.

24. See Laurie Kay Sommers, "Symbol and Style in Cinco de Mayo," *Journal of American Folklore* 98 (October 1985): 476–482. She reproduced some of this discussion with more analysis of Carnaval and the 24th Street Festival in "Inventing Latinismo," 32–53.

25. The program for "Día de las Animas," 1971, Santina archive, represented this approach, with separate narrators discussing national customs.

26. See Chapter 1; also based on a telephone interview with Maruja Cid by author on October 22, 2004.

27. Loarca, interview, 2003.

28. Casa Hispana information sheet, n.d.; and *Casa Hispana de Bellas Artes Newsletter*, n.d., both in the Camplís collection, CEMA, Box 1/3. Titles of the works by Lorca and Darío are unknown. By Casona, Casa Hispana performed *Farsa y Justicia del Corregidor* (Farce and Justice of the Magistrate) and *Fablilla del Secreto Bien Guardado* (Fable of the Well-Guarded Secret). Both Casona plays can be found in *El Caballero de las Espuelas de Oro; Retablo Jovial*, in Spanish (1965; repr., Madrid: Colección Austral, Espasa-Calpe, S.A., 1982).

29. Arturo Barea wrote of Lorca that, "though he played with the most esoteric forms of modern art, he became, not the poet of a 'high-brow' set, but a poet of the Spanish people." In Barea, *Lorca: The Poet and His People*, trans. Ilsa Barea (London: Faber and Faber, 1944), 11. For more on Alejandro Casona, see Ruth C. Gillespie's "Introduction," for his *La Sirena Varada* (New York: Appleton-Century-Crofts, 1951); and Juan Rodriguez-Castellano's "Nota Biográfica" (in Spanish) for his *La Dama Del Alba* (New York: Scribner's, 1947).

30. David Whisnant wrote, "From the mid-1960s onward, the Somoza regime's efforts to co-opt and domesticate Darío's image for its own ends were increasingly at odds with those put forth with growing vigor by the FSLN." In "Rubén Darío as a Focal Cultural Figure: The Ideological Uses of Cultural Capital," *Latin American Research Review* 27 (1992): 29.

31. Francisco Alarcón won the "Rubén Darío" Latin-American Poetry prize from Casa Nicaragua in 1981 for his solidarity poems. Salvador Rodriguez del Pino, "Francisco Xavier Alarcón," *Dictionary of Literary Biography,* vol. 122, *Chicano Writers, Second Series*, ed. Francisco A. Lomeli (Farmington, MI: Gale, 1992), 3–7; the image of Rubén Darío in the "Homage to Siqueiros" mural is discussed in Chapter 5; and Jack Hirschman, Nina Serrano, and Alejandro Murguía honored Rubén Darío's birthday in 1985 with a "Bilingual Reading of Darío's Poetry," *San Francisco Chronicle,* January 18, 1985, 74.

32. "Homenaje a Neruda," program, c. 1972, Santina archive; Bernard Weiner, "Julian's Look at Political Suffering in Latin America," *San Francisco Chronicle*, July 2, 1988, C6; "La Hora de los Hornos," poster, n.d., c. 1970, Santina archive; Press Release, "Teatro Campesino to Perform in Raza/Hispanidad Festival," October 16, 1973, Santina archive; "Raza/Hispanidad," *City*, 44.

33. Francisco Camplís, interview by author, San Francisco, March 12, 2003. Camplís described how the relationship between Loarca and Benvenuto, which coincided with the creation of the NAP, was a catalyst for obtaining exhibition space at the Arts Festival.

34. "21st Annual San Francisco Art Festival," poster, September 20–24, 1967, Camplís collection, CEMA, Box 1/10; Martin Snipper, interview by Suzanne B. Riess, in *The Arts and the Commu-*

nity Oral History Project: San Francisco Neighborhood Arts Program, Berkeley, CA, Regional Oral History Office, Bancroft Library, 1978, 12.

35. Casa Hispana information sheet, Camplís collection, CEMA, Box 1/3.

36. The period was rife with expression of inner city frustration, such as the riots in Watts in 1965, Chicago in 1966, and Detroit in 1967. See Gerald Horne, *Fire This Time: The Watts Uprising and the 1960s* (Cambridge, MA: Da Capo, 1997); and Thomas J. Sugrue, *The Origins of the Urban Crisis: Race and Inequality in Postwar Detroit* (Princeton, NJ: Princeton University Press, 1996).

37. The history of the Performing Arts Center debate emerged from multiple sources, including Nora Gallagher, Ken McEldowney, Michael Singer, and Henry Weinsten, "Art for Harold's Sake: How Big Business Manipulates the Arts in San Francisco," *The San Francisco Bay Guardian*, November 21, 1975; Ceci Brunazzi, "On the Performing Arts Center," *The Arts Biweekly*, July 27, 1976, 3–4; and a series of oral history interviews collected by UC Berkeley's Regional Oral History Office: *The Arts and the Community Oral History Project: San Francisco Neighborhood Arts Program*, 1978. I am indebted to Michael Nolan for the use of his personal archive on this subject, which includes a variety of published and unpublished sources. Of particular note was Kathleen Connolly's report, "San Francisco Performing Arts Center: Some Reflections on a White Elephant" (San Francisco: San Francisco Study Center, 1973).

38. Snipper, interview, 1978, 4.

39. Regina Mouton, "Let a Thousand Flowers Grow: An Interview with June Gutfleisch," http://temp.sfgov.org/sfac/CAE/about_us/; Alice Goldfarb Marquis chronicles the rise of the National Endowment for the Arts in her book *Art Lessons: Learning from the Rise and Fall of Public Arts Funding* (New York: Basic Books, 1995).

40. Snipper, interview, 1978, 12.

41. Casa Hispana members link its demise in 1983 to the defunding of arts programs around the country under President Ronald Reagan. Santina, e-mail to author, October 1, 2004; Tello, e-mail to author, September 25, 2004. Also see Marquis, *Art Lessons*.

42. Camplís, interview, 2003.

43. Ibid.

44. Ibid.

45. Loarca, interview, 2003; Cid, telephone interview, October 22, 2004.

46. 1968 calendar, *Casa Hispana de Bellas Artes Newsletter*, n.d., Camplís collection, CEMA, Box 1/3.

47. Camplís, interview, 2003.

48. Don Santina, e-mail to author, October 7, 2004.

49. Emma Pérez, *The Decolonial Imaginary: Writing Chicanas into History* (Bloomington: Indiana University Press, 1999), 7.

50. Cid, telephone interview, 2004.

51. Ibid.

52. Francisco Flores, "Roberto Vargas: The Intersection of Personal Growth and Community Activism," *El Tecolote*, April 2001, 14–15.

53. Cid, interview by Suzanne B. Riess, in *The Arts and the Community Oral History Project: San Francisco Neighborhood Arts Program*, Berkeley, CA, Regional Oral History Office, Bancroft Library, 1978, 27.

54. Cid, interview, 1978, 39.

55. Ibid.

56. Espinosa, "A Glow of Community Spirit"; John P. Larner discussed the shifting image of Columbus in "North American Hero? Christopher Columbus 1702–2002," *Proceedings of the American Philosophical Society* 137, no. 1 (March 1993): 46–63; also see Gerald Vizenor, "Christopher Columbus: Lost Havens in the Ruins of Representation," *American Indian Quarterly* 16, no. 4 (Autumn 1992): 521–532.

57. Joseph A. Rodríguez, "Becoming Latinos: Mexican Americans, Chicanos, and the Spanish Myth in the Urban Southwest," *Western Historical Quarterly* 29, no. 2 (Summer 1998), 165–185;

McWilliams, *North from Mexico*; William Deverell, *Whitewashed Adobe: The Rise of Los Angeles and the Remaking of Its Mexican Past* (Berkeley: University of California Press, 2004); Chris Wilson, *The Myth of Santa Fe: Creating a Modern Regional Tradition* (Albuquerque: University of New Mexico Press, 1997).

58. Little documentation of Casa Hispana art is available to affirm this generalization. However, interviews with Loarca and Camplís and familiarity with later artwork of other associated artists suggest this generalization is fair: Loarca, interview, 2003; Camplís, interview, 2003. Loarca has in general shown a proclivity for abstract figuration, and Camplís initially taught figure drawing: Alfred Frankenstein, "Things Artists Don't Overlook," *San Francisco Chronicle*, December 11, 1978, 60; José Jorge Vazquez Tagle, "Gustavo Rivera y Carlos Loarca Reafirman su Calidad Pictórica," *El Occidental*, May 20, 1980, D1; and Edgar Sanchez, "Free Art Class Seeks Raza Pupils," *El Tecolote*, December 8, 1971, 8. Waldo Esteva developed unique figurative ceramics, such as *Blue Heron*, pictured in Billie Sessions, "Ripples: Marguerite Wildenhain and Her Pond Farm," *Ceramics Monthly*, December 2002, 44–49 (48); Don Santina, e-mail to author, July 13, 2005; Rolando Castellón's appreciation for abstraction is visible in his art and his curation of exhibits. See Castellón, *Mano a Mano*.

59. *Casa Hispana de Bellas Artes Newsletter*, n.d., Camplís collection, CEMA, Box 1/3.

60. Rupert García noted that the "Liberation Art Front" refers to the "Liberation Front of Vietnam." Rupert García, Oral History interviews by Paul J. Karlstrom, Oakland, CA, September 7, 1995, November 10, 1995, and June 24, 1996, AAA, http://www.aaa.si.edu/collections/interviews/oral -history-interview-rupert-garcia-13572.

61. Michael Denning, *The Cultural Front: The Laboring of American Culture in the Twentieth Century* (New York: Verso, 1998).

62. René Yañez, interview by author, San Francisco, February 18, 2003.

63. Ibid.

64. Tomás Ybarra-Fraustro [sic], "The Legacy of La Galería de la Raza/Studio 24," unpublished manuscript, 1996, Ybarra-Fausto collection, AAA, Box 9/GDLR '92 95. The misspelling of Ybarra-Frausto's name and corrections throughout suggests that someone else typed the manuscript.

65. "Mexican American Liberation Art Front: La Raza Nueva," *Bronce* 1 (March 1969): 6–7.

66. Rupert García, interview, Oakland, CA, October 14, 1983, uncorrected transcript from Califas videotapes 155–158, transcribed by Philip Brookman and Amy Brookman, Califas Book 5, 12, in *Califas Conference Final Report*, AAA.

67. Camplís, addendum to interview, 2003.

68. Camplís, interview, 2003.

69. Ibid.

70. *Casa Hispana de Bellas Artes Newsletter*, May 1969, Camplís collection, CEMA, Box 1/3; On La Causa, refer to "The Legacy of La Galería."

71. "The Photography of Francisco Campliz [sic]: Exploding a Taboo in Chicano Art," *El Tecolote*, May 10, 1972, 8. According to Camplís, the CARA exhibit committee declined his submission of nude photographs, asking if he had anything else. Camplís, interview, 2003.

72. Nicholas De Genova and Ana Y. Ramos-Zayas, *Latino Crossings: Mexicans, Puerto Ricans, and the Politics of Race and Citizenship* (New York: Routledge, 2003), 38–39.

73. Francisco X. Camplís, "Towards the Development of a Raza Cinema," in *Chicanos and Film: Representation and Resistance*, ed. Chon A. Noriega (Minneapolis: University of Minnesota Press, 1992), 284–302. Originally published in the Mission District's *Tin Tan* 2 (June 1, 1977): 5–7.

74. Rosa-Linda Fregoso, *The Bronze Screen: Chicana and Chicano Film Culture* (Minneapolis: University of Minnesota Press, 1993), xv.

75. Camplís, interview, 2003; *Los Desarraigados/The Uprooted*, directed by Francisco Camplís, Coatlicue Productions, 1974. Camplís, e-mail to author, August 17, 2005. The film also featured Maria Rios (then wife of artist Mike Rios), Ricardo Diaz (also an artist at that time, and later husband of Maria Rios), Carlotta Jaramillo, Miguel Quiros, Armando Vasquez, Dolores Vasquez, David Martinez, Roger Hollis, Jaime Lopez, and Jack Bourne. Francisco Camplís's sisters Zenaida Camplís and Josephine Hollis, along with his mother Josephine Petrini, were also in the cast.

76. "Mexican American Liberation Art Front," 6–7.

77. Carlos Muñoz Jr., *Youth, Identity and Power*, rev. ed. (New York: Verso, 2007), 76.

78. Rosa-Linda Fregoso, "The Representation of Cultural Identity in 'Zoot Suit' (1981)," *Theory and Society* 22, no. 5 (October 1993): 662. Fregoso adds that "the major ambivalence of the cultural project of nationalism centered on its systemic elision of women as subjects of cultural discourse," 663.

79. For more about Dorinda Moreno, see Yvonne Yarbro-Bejarano, "Female Subject in Chicano Theatre: Sexuality, 'Race,' and Class," *Theatre Journal* 38, no. 4 (December 1986): 397.

80. Ibid.

81. René Yañez, interview, San Francisco, October 29, 1982, transcribed by Philip Brookman and Amy Brookman, Califas Book 2, 1–2, in *Califas Conference Final Report*, AAA.

82. Yañez, interview, 2003.

83. Goldman, *Dimensions of the Americas*, 168; Eva Sperling Cockcroft and Holly Barnet-Sanchez, *Signs from the Heart: California Chicano Murals* (1990; repr., Albuquerque: University of New Mexico Press, 1993), 27.

84. Goldman, *Dimensions of the Americas*, 168.

85. Tere Romo, "A Spirituality of Resistance: Día de los Muertos and the Galería de la Raza," in *Chicanos en Mictlán: Día de los Muertos in California* (San Francisco: The Mexican Museum, 2000), 33; William Wilson, "Art of Barrios in East L.A.," *The Los Angeles Times*, part 4, p. 1 and 7.

86. "Listing of Events," Camplís collection, CEMA, Box 1/3.

87. Camplís, interview, 2003.

88. Francisco Camplís, "Conversations with Myself: Art & Racism," c. 1972, Galería de la Raza collection, CEMA, Box 1/6. In this article, Camplís provided an informal survey of Latinos in San Francisco museums. According to Camplís, as of November 1972, "San Francisco Museum of Art: 40 positions, no Raza; De Young Museum of Art, 68 positions, 1 Raza; Legion of Honor, 28 positions, 1 Raza; San Francisco Art Institute: No full-time Raza faculty; San Francisco Art Commission: 2 Raza members, no full-time Raza employees."

89. Goldman, "How, Why, Where, and When," 27.

90. Goldman, interview, Pasadena, CA, August 9, 1983, uncorrected transcript from Califas videotapes 102–105, transcribed by Philip Brookman and Amy Brookman, Califas Book 3, 8, in *Califas Conference Final Report*, AAA.

91. Ibid.

92. Recruiting letter from Camplís, "California Wide Mexican American and Latin American artists exhibition to be held in Bay Area in October [1969]," Camplís collection, CEMA, Box 1/3. Wilson, "Art of Barrios in East L.A."; Thomas Albright, "A Wide Range in Latin Art," *San Francisco Chronicle*, September 12, 1970, 33. Confirmation of the exhibition in Fresno and Tulare is documented in a letter to Francisco Camplís from Mario Montenegro, March 10, 1970, Camplís collection, CEMA.

93. Camplís, "California Wide Mexican American and Latin American artists exhibition."

94. Camplís, interview, 2003.

95. Ibid.

96. Albright, "Wide Range in Latin Art."

97. Thomas Albright, "The California School of Fine Arts, c. 1945–1960," in *Reflections: Alumni Exhibitions, San Francisco Art Institute, January 1981* (San Francisco: San Francisco Art Institute, 1982), 21.

98. William Wilson. "Art of Barrios."

99. "Mexican Uprising," document, June 1969, Camplís collection, CEMA, Box 2/9.

100. "Mexican Uprising"; Camplís, interview, 2003.

101. "Mexican Uprising."

102. García, interview, AAA.

103. Artes 6 poster, Camplís files, Camplís collection, CEMA, Box 1/4. Show is also listed on Rupert García exhibit histories, Ybarra-Frausto collection, AAA, Box 10.

104. García, interview, AAA.

105. "Mexican Uprising," Camplís collection, CEMA, Box 2/9; Rupert García exhibit poster, June 1970, Camplís collection, CEMA, Box 1/4.

106. Camplís, interview, 2003.

107. Rolando Castellón, Jerry Concha, Carlos Loarca, and Gustavo Rivera (group interview), San Francisco, October 16, 1983, uncorrected transcript from Califas videotapes 158–162, transcribed by Philip Brookman and Amy Brookman, Califas Book 5, 1, in *Califas Conference Final Report*, AAA.

108. Thomas Albright, *Art in the San Francisco Bay Area, 1945–1980: An Illustrated History* (Berkeley: University of California Press, 1985), 285: "Hobbs organized the San Francisco Art Center, a complex of exhibition and studio space on 14th Street in the Mission district, and directed it through most of the 1960s." Camplís recalled that Hobbs benefited from the arrangement not just in terms of rent, but also from a grant to make his space accessible. Camplís, interview, 2003.

109. The number of artists who founded Galería de la Raza is murky, if only because the artists maintained varying levels of involvement. Maradiaga recalled the involvement of up to twenty-five artists: Maradiaga, interview, part 2, San Francisco, October 29, 1982, transcribed by Philip Brookman and Amy Brookman, Califas Book 2, 1, in *Califas Conference Final Report*, AAA. Thomas Albright reviewed the first show and referred to the work of Esteban Villa (not included), Luis Gutierrez, and Luis Cervantes. See his review, "New Galería de la Raza," *San Francisco Chronicle*, July 15, 1970. Another article, published in *El Tecolote* at the end of the year, recognized fourteen participating members: Camplís, Castellón, Loarca, Maradiaga, McNeill, Ojeda, Pérez, Rivera, Rodriguez, Romero, Ruiz, Luis Valsoto, and Yañez: Anita Martinez, "Raza Art," *El Tecolote*, November 30, 1970. Loarca wrote in an e-mail to the author that Valsoto was not one of the original founders, August 31, 2005; Tere Romo emphasizes the importance of only six members: Camplís, Castellón, García, Maradiaga, Rodriguez, and Yañez: Romo, "A Spirituality of Resistance," 34; Sal Güereña gives an extensive list: Camplís, Campusano, Graciela Carrillo, Castellón, Cervantez [*sic*], Concha, García, González, Loarca, Maradiaga, Rivera, Rodriguez, Villamor, and Yañez. See "Galería de la Raza Guide to the Archives, 1969–1999: Organizational History," http://www.oac.cdlib.org /findaid/ark:/13030/tf267nb24r/. I have not included Graciela Carrillo because most accounts describe the gallery's formation as an all-male affair. She and other female artists demanded inclusion and obtained some recognition in the first women's show, February 5–March 5, 1971, according to *El Tecolote*, February 23, 1971, 2. In my interview with Camplís, he recalled the steady presence of his brother-in-law, Campusano, along with Maradiaga, Mike Rios, and Spain Rodriguez. He also referred to José (Joe) Ramos as the local "Gestetner master." Camplís, interview, March 12, 2003.

110. Yañez, interview, 2003.

111. Ibid.; Camplís, interview, 2003.

112. Anita Martinez, "Raza! Arte! Raza! Arte!" *El Tecolote*, September 7, 1970, 3. The artist is unnamed in the article.

113. Rubén Salazar, "Who Is a Chicano? And What Is It the Chicanos Want?" *Los Angeles Times*, February 6, 1970, B7.

114. Angelina Grimke, "Chicano Art Finds Home in Mission Galería," *People's World*, August 8, 1970.

115. García, interview, October 14, 1983, Califas Book 5, 16.

116. García, interview, AAA.

117. Ybarra-Fraustro [*sic*], "The Legacy of La Galería." José Vasconcelos, *The Cosmic Race: A Bilingual Edition* (1948; repr., Baltimore, MD: Johns Hopkins University Press, 1997). Vasconcelos's essay was originally published in 1925.

118. García, interview, AAA. Musician Poncho Sanchez had a parallel experience: "Poncho Sanchez, a [Cal] Tjader protégé who now leads one of the finest Latin jazz bands around, recalls that during his own apprenticeship in the music, he was considered insufficiently 'Latin' for the Latin music community, even though he was a Chicano. 'They wouldn't even let me sit in,' Sanchez says of the Cuban musicians in Los Angeles. 'Are you Chicano?' they'd ask. 'Yeah, I'm Chicano and I play

congas.' 'Get outta here. Chicanos don't know how to play.' " In Ted Gioia, *West Coast Jazz: Modern Jazz in California, 1945–1960* (New York; Oxford: Oxford University Press, 1992), 100.

119. The *People's World* reviewer declared, "See what happens when the artist and the revolution are one and the same . . . it's pretty damned fine." Grimke, "Chicano Art Finds Home."

120. Thomas Albright, "A Powerful Look at Rio's Barrios," *San Francisco Chronicle*, May 15, 1971, 33.

121. Rubén Salazar and Mario T. García, *Border Correspondent: Selected Writings, 1955–1970* (Berkeley: University of California Press, 1995).

122. Ibid.; *CODEX Newsletter*, Galería de la Raza, September 1973, 1–2.

123. Albright, "Wide Range in Latin Art." Albright, "The Sensual Moods of Nature," *San Francisco Chronicle*, January 23, 1971, 34.

124. See Karen Mary Davalos's compilation of this history in *The Mexican Museum of San Francisco Papers, 1971–2006* (Los Angeles: UCLA Chicano Studies Research Center Press, 2010).

125. Camplís, interview, 2003.

126. Jerome Tarshis, "San Francisco," *Artforum*, October 1970, 82–83.

127. Albright, "New Galería de la Raza"; Martinez, "Raza! Arte!"

128. Castellón, group interview, October 16, 1983, Califas Book 5, 11.

129. Loarca, interview, 2003.

Chapter 4. The Third World Strike and the Globalization of Chicano Art

1. San Francisco State College became San Francisco State University in 1974. For more about the strike, see William Barlow and Peter Shapiro, *An End to Silence: The San Francisco State College Student Movement in the '60s* (New York: Pegasus, 1971); Helene Whitson, "Introductory Essay," San Francisco State College Strike, San Francisco State University Archives, http://jpllweb.sfsu.edu/about /collections/strike/essay.html; Jason Michael Ferreira, "All Power to the People: A Comparative History of Third World Radicalism in San Francisco, 1968–1974" (PhD diss., University of California, Berkeley, 2003); Angie Y. Chung and Edward Taehan Chang, "From Third World Liberation to Multiple Oppression Politics: A Contemporary Approach to Interethnic Coalitions," *Social Justice* 25, no. 3 (Fall 1998): 86. Other sources on the event include Kuregiy Hekymara, "The Third World Movement and Its History in the San Francisco State College Strike of 1968–1969" (PhD diss., University of California, Berkeley, 1972); Stacey Ann Cook, "Power and Resistance: Berkley's Third World Liberation Front Strikes" (EdD diss., University of San Francisco, 2001); Harvey Dong, "The Origins and Trajectory of Asian American Political Activism in the San Francisco Bay Area" (PhD diss., University of California, Berkeley, 2002); William H. Orrick, *Shut It Down! A College in Crisis: San Francisco State College, October 1968–April 1969* (Washington, DC: U.S. Government Printing Office, 1969); Dikran Karaguezian, *Blow It Up! The Black Student Revolt at San Francisco State College and the Emergence of Dr. Hayakawa* (Boston: Gambit, 1971); and Robert Smith, Richard Axen, and DeVere Edwin Pentony, *By Any Means Necessary: The Revolutionary Struggle at San Francisco State* (San Francisco: Jossey-Bass, 1970).

2. Whitson, "Introductory Essay." As Johnnetta B. Cole pointed out, "Programs in Afro-American Studies existed at other white institutions before 1968; for example, Cornell University had a functioning program in 1967." In "Black Studies in Liberal Arts Education," in *Transforming the Curriculum: Ethnic Studies and Women's Studies*, ed. Johnnella E. Butler and John C. Walter (Albany: State University of New York Press, 1991) 133. Cole's point is important, but the visibility and momentum of the Third World Strike proved critical to the expansion of the field of Ethnic Studies across the nation.

3. Juan Fuentes, interview by author, San Francisco, March 13, 2003.

4. Erika Doss wrote, "Their canny attention to visual authority made the Panthers' mode of self-representation *the* image of 1960s radicalism," in " 'Revolutionary Art Is a Tool for Liberation': Emory Douglas and Protest Aesthetics at the *Black Panther*," in *Liberation, Imagination, and the Black*

Panther Party: A New Look at the Panthers and Their Legacy, ed. Kathleen Cleaver and George N. Katsiaficas (New York: Routledge, 2001), 178; Joshua Bloom and Waldo E. Martin Jr., *Black Against Empire: The History and Politics of the Black Panther Party* (Berkeley: University of California Press, 2013); Clayborne Carson, *In Struggle: SNCC and the Black Awakening of the 1960s* (1981; repr., Cambridge, MA: Harvard University Press, 1996).

5. Carol Wells points out that, "just as the UFW is inseparable from the history of the U.S. and Mexican labor movements . . . so are Chicano posters inseparable from the diverse struggles mobilized for human rights over the past forty years." See Carol A. Wells, "La Lucha Sigue: From East Los Angeles to the Middle East," in *Just Another Poster? Chicano Graphic Arts in California*, ed. Chon A. Noriega (Santa Barbara: University Art Museum, University of California, 2001), 173.

6. Elizabeth E. Guffey, *Posters: A Global History* (London: Reaktion Books, 2015), 125; Shifra M. Goldman, *Dimensions of the Americas: Art and Social Change in Latin America and the United States* (Chicago: University of Chicago Press, 1994), 162–176; Chon A. Noriega, ed., *Just Another Poster?*; Ralph Maradiaga, curator, *The Fifth Sun: Contemporary/Traditional Chicano & Latino Art* (Berkeley: University Art Museum, 1977); and Richard Griswold del Castillo, Teresa McKenna, and Yvonne Yarbro-Bejarano, eds., *Chicano Art: Resistance and Affirmation, 1965–1985* (CARA), (Los Angeles: Wight Art Gallery, UCLA, 1991).

7. George Lipsitz, "Not Just Another Social Movement: Poster Art and the Movimiento Chicano," in Noriega, *Just Another Poster?*, 85, 84.

8. George N. Katsiaficas, *The Imagination of the New Left: A Global Analysis of 1968* (Boston: South End Press, 1987), 41.

9. Mark Kurlansky, *1968: The Year that Rocked the World* (New York: Random House, 2005); Charles Kaiser, *1968 in America: Music, Politics, Chaos, Counterculture, and the Shaping of a Generation* (New York: Grove Press, 1988); Jules Witcover, *The Year the Dream Died: Revisiting 1968 in America* (New York: Warner Books, 1997); Donald J. Mabry, *The Mexican University and the State: Students Conflicts, 1910–1971* (College Station, Texas A&M University Press, 1982); Elena Poniatowska, *Massacre in Mexico* (1975; repr., Columbia: University of Missouri Press, 1991); Daniel Singer, *Prelude to Revolution: France in May 1968*, 2nd ed. (Cambridge, MA: South End Press, 2002). Michael Denning dated the global New Left from 1955 to 1956 on, "from the Khrushchev revelations to the uprising in Budapest, from the battle of Dien Bien Phy to that of Algiers, from the Suez crisis to the Bandung conference, from the Montgomery bus boycott to the Sharpeville massacre, from the CND marches to the Anpo protests, from the independence of Ghana to the charismatic guerilla revolution in Cuba." See Denning, *Culture in the Age of Three Worlds* (New York: Verso, 2004), 8.

10. Whitson, "Introductory Essay."

11. As Barlow and Shapiro noted, "A group of black students had gone to protest the *Gater's* coverage of [Black Student Union] activities, but their specific grievances reflected a situation which had been building for over two years." The visit erupted in at least six black students physically attacking the editor. The college's suspension of nine black students photographed in the attack contributed fodder for multiple protests in the fall of 1967. Barlow and Shapiro, *An End to Silence*, 112; "Gater Editor Beaten," *The Gater*, November 7, 1967, 1; and on race relations more generally, see Maurice Isserman and Michael Kazin, *America Divided: The Civil War of the 1960s* (New York: Oxford University Press, 2000).

12. Chung and Chang, "From Third World Liberation," 97n6; Barlow and Shapiro, *An End to Silence*, 155; Orrick, *Shut It Down!* 77–90.

13. Information on Martinez and campus organizations taken from Orrick, *Shut It Down!*, 100, 104; Chung and Chang, "From Third World Liberation," 86; Barlow and Shapiro, *An End to Silence*, 156–159, 167–168, 224; Whitson, "Introductory Essay"; Karen Umemoto, "'On Strike!' San Francisco State College Strike, 1968–1969: The Role of Asian American Students," *Amerasia Journal* 15, no. 1 (1989): 3–41. Orrick wrote, "Third World student leaders all agree that whites, moderate and radical, played a large role in visibly supporting the strike and its picket lines, but a negligible one in terms of planning strategy," *Shut It Down!*, 104.

14. For more on the meaning of "Third World," see Cynthia A. Young, *Soul Power: Culture, Radicalism, and the Making of a U.S. Third World Left* (Durham, NC: Duke University Press, 2006); Laura Pulido, *Black, Brown, Yellow, and Left: Radical Activism in Los Angeles* (Berkeley: University of California Press, 2006); Ferreira, "All Power to the People"; Allan M. Gordon, "On Understanding Third World Art," in *Other Sources: An American Essay*, Carlos Villa, curator (San Francisco: San Francisco Art Institute, 1976), 17; Chung and Chang, "From Third World Liberation." Barlow and Shapiro discuss the influence of Frantz Fanon's writings on imperialism in *An End to Silence*, 155; Edward W. Said provided a broader discussion of cultural imperialism in *Culture and Imperialism* (New York: Vintage Books, 1993).

15. Chung and Chang, "From Third World Liberation," 87. Chung and Chang wrote, "The TWLF explicitly challenged the fundamental premises of California's Master Plan for Higher Education, which had been designed in 1960 to restrict admissions to San Francisco State College to 'quality' students and to centralize power in the hands of 21 political and corporate leaders," "From Third World Liberation," 86; Barlow and Shapiro, *An End to Silence*; "A 'Master Plan' that Prevents Colleges from Fighting Racism," *People's World*, January 11, 1969, 2.

16. Orrick, *Shut It Down!* 76.

17. Barlow and Shapiro, *An End to Silence*, xiv.

18. Ibid., 206–218; Orrick, *Shut It Down!* 34–36.

19. Barlow and Shapiro, *An End to Silence*, 218–221; Orrick, *Shut It Down!* 37–38.

20. Barlow and Shapiro, *An End to Silence*, 238–239; Orrick, *Shut It Down!* 51–54.

21. Barlow and Shapiro, *An End to Silence,* 242; Orrick, *Shut It Down!* 51–55.

22. Barlow and Shapiro, *An End to Silence*, 256. Also see Orrick, *Shut It Down!* 55–59.

23. Cole, "Black Studies in Liberal Arts Education," 140. As the editors of *Multicultural Teaching in the University* state, "Most Women's Studies, African American Studies, and other ethnic studies programs and departments in universities in the United States emerged because of the lack of this content in other arenas of the university." See David Schoem, Linda Frankel, Ximena Zuniga, and Edith A. Lewis, eds., *Multicultural Teaching in the University* (Westport, CT: Praeger, 1995), 3; Howard Ball, Stephen D. Berkowitz, and Mbuelelo Mzamane, *Multicultural Education in Colleges and Universities: A Transdisciplinary Approach* (Mahwah, NJ: Lawrence Erlbaum, 1998); Cameron McCarthy and Warren Crichlow, *Race, Identity, and Representation in Education* (New York: Routledge, 1993); and Louis Heath, *Red, Brown, and Black Demands for Better Education* (Philadelphia: Westminster, 1972).

24. Smith, Axen, and Pentony, *By Any Means Necessary*, 301.

25. Barlow and Shapiro, *An End to Silence*, 247–321; Orrick, *Shut It Down!*, 63–70.

26. Smith, Axen, and Pentony, writing in 1970, largely viewed the strike as a failure because it did not achieve all student demands and because the repressive tactics of the administration had such a destructive impact on community organizing. *By Any Means Necessary*, 300–316.

27. Marjorie Heins, *Strictly Ghetto Property: The Story of Los Siete de la Raza* (Berkeley, CA: Ramparts, 1972), 123.

28. Ibid., 130.

29. Schoem et al., *Multicultural Teaching*; Butler and Walter, *Transforming the Curriculum*; Ball, Berkowitz, and Mzamane, *Multicultural Education*; McCarthy and Crichlow, *Race, Identity, and Representation*; Heath, *Red, Brown, and Black*.

30. Rubén Donato, *The Other Struggle for Equal Schools: Mexican Americans During the Civil Rights Era* (Albany: State University of New York Press, 1997); Jeanett Castellanos and Lee Jones, eds., *The Majority in the Minority: Expanding the Representation of Latina/o Faculty, Administrators and Students in Higher Education* (Sterling, VA: Stylus, 2003); Jonathan Kozol, *Savage Inequalities: Children in America's Schools* (New York: Crown, 1991); Charles Wollenberg, *All Deliberate Speed: Segregation and Exclusion in California Schools, 1855–1975* (Berkeley: University of California Press, 1976); and Guadalupe San Miguel Jr., *"Let All of Them Take Heed": Mexican Americans and the Campaign for Educational Equality in Texas, 1910–1981* (Austin: University of Texas Press, 1987).

31. Yolanda M. López, interview by author, San Francisco, March 25, 2003.

32. Ibid.

33. Ibid.

34. Ibid.

35. Ibid.

36. Ibid.

37. Ibid. Karen Mary Davalos covered more of López's life and art history in her monograph *Yolanda M. López* (Los Angeles: UCLA Chicano Studies Research Center Press, 2008). The analysis of López's work presented in this chapter stems from my dissertation, completed prior to the release of this valuable resource.

38. Quoted in Betty LaDuke, *Women Artists: Multi-Cultural Visions* (Trenton, NJ:, Red Sea, 1992), 102.

39. López, interview, 2003.

40. Ibid.

41. Heins, *Strictly Ghetto Property.*

42. López, interview, 2003.

43. Emily Gurnon, "Enduring Legacy of 'Los Siete'; 30 Years Ago, Cop Killing, Trial Unified S.F. Latinos," *San Francisco Examiner*, April 30, 1999, A-1.

44. Ibid. Gurnon quoted Oscar Rios, the brother of one of the defendants: "It was very rough [for Latinos] in the Mission. . . . If you were hanging around, riding around, [the police] would stop you. Whatever they felt like doing to you, they would do it." Rios later became mayor of Watsonville. Michael Kennedy, a lawyer for one of the defendants, declared, "The Mission was an armed camp at that time. . . . It was being run like a police state, every bit as much as the dictatorships of Somoza and Batista. Any Latino on the street was subject to police pressure and harassment," quoted in David McCumber, "Pushing the Porn Envelope: The Mitchell Brothers Test the Limits of the Law," *San Francisco Examiner*, October 19, 1992. Mission District activists took issue with the media's willingness to characterize the accused as "hoodlums" and "Latin hippie types," and the mayor's description of the seven men as "a bunch of punks," while the police were represented as "idealists." See Research Organizing Cooperative, *Basta Ya! The Story of Los Siete de la Raza* (San Francisco: Author, 1970); Heins, *Strictly Ghetto Property*; Ferreira, "All Power to the People"; Tomás F. Summers Sandoval Jr., *Latinos at the Golden Gate: Creating Community & Identity in San Francisco* (Chapel Hill: University of North Carolina Press, 2013); Brian J. Brian J. Godfrey, *Neighborhoods in Transition: The Making of San Francisco's Ethnic and Nonconformist Communities* (Berkeley: University of California Press, 1988).

45. Huey P. Newton, *War against the Panthers: A Study of Repression in America* (New York: Harlem River, 1998); David Hilliard and Lewis Cole, *This Side of Glory: The Autobiography of David Hillard and the Story of the Black Panther Party* (Boston: Little, Brown, 1993); and Charles R. Garry and Art Goldberg, *Streetfighter in the Courtroom: The People's Advocate* (New York: Dutton, 1977). Some general sources on the Chicago Seven (or Eight) trial include David J. Langum, *William M. Kunstler: The Most Hated Lawyer in America* (New York: New York University Press, 1999); James Tracy, *Direct Action: Radical Pacifism from the Union Eight to the Chicago Seven* (Chicago: University of Chicago Press, 1996). Ian F. Haney-López covered the impact of the blowout trials on racial identity in East Los Angeles in *Racism on Trial: the Chicano Fight for Justice* (Cambridge, MA: Harvard University Press, 2003).

46. Eduardo Obregón Pagán, *Murder at the Sleepy Lagoon: Zoot Suits, Race, and Riot in Wartime L.A.* (Chapel Hill: University of North Carolina Press, 2003); Luis Alvarez, *The Power of the Zoot: Youth Culture and Resistance During World War II* (Berkeley: University of California Press, 2008).

47. López, interview, 2003.

48. Heins, *Strictly Ghetto Property,* 162–165.

49. Summers Sandoval, *Latinos at the Golden Gate*, 178.

50. López, interview, 2003.

51. Bobby Seale, "Foreword," in *Black Panther: The Revolutionary Art of Emory Douglas*, ed. Sam Durant (New York: Rizzoli, 2007), 13.

52. Emory Douglas said his drawings of police as pigs developed in conversation with Huey Newton, as documented in David Hilliard's autobiography, Hilliard and Cole, *This Side of Glory*, 150–151.

53. López, interview, 2003.

54. Stew Albert, "White Radicals, Black Panthers, and a Sense of Fulfillment," in Cleaver and Katsiaficas, *Liberation, Imagination, and the Black Panther Party* 189.

55. Erika Doss put it this way: "Douglas shaped a protest aesthetic with which the Black Panther Party aspired to revolutionize the black masses." "Revolutionary Art Is a Tool," 184.

56. López, interview, 2003; *Black Panther* (newspaper), September 20, 1969, 1.

57. According to Davalos in *Yolanda M. López*, the poster was inserted into *Basta Ya!* no. 3, 1969. The poster also appeared on the front cover of *Basta Ya!* no. 6, incorrectly labeled as no. 5, 1969. For protest photos, see Research Organizing Cooperative, *Basta Ya! La Historia*, or Heins, *Strictly Ghetto Property*.

58. Karen Mary Davalos, "The Print Culture of Yolanda M. López," in *West of Center: Art and the Counterculture Experiment in America, 1965–1977*, ed. Elissa Auther and Adam Lerner (Minneapolis: University of Minnesota Press, 2012), 197.

59. In a telephone conversation with the author, February 21, 2005, López stated that Emory Douglas picked up the flag as prison iconography from her work..

60. Ibid.

61. Ibid.

62. First known as La Raza Silkscreen Center, the organization later changed its name to La Raza Graphics. See Sal Güereña et al., "Linda Lucero Collection on La Raza Silkscreen Center/La Raza Graphics," CEMA, January 14, 2005, http://www.library.ucsb.edu/special-collections/cema/lucero. Also see *Images of a Community: An Exhibit of Silkscreen Posters and Graphic Works from 1971 to 1979*, Galería de la Raza collection, Box 19/12, CEMA; National Collection of Fine Arts, *Images of an Era: The American Poster, 1945–1975* (Washington, DC: Smithsonian Institution, 1975).

63. Holly Barnet-Sanchez, "Where Are the Chicana Printmakers: Presence and Absence in the Work of Chicana Artists of the Movimiento," in Noriega, *Just Another Poster?*, 122.

64. López, interview, 2003.

65. Ibid.

66. Yolanda López, "Artist's Statement," in *Yolanda M. López, Works: 1975–1978* (La Jolla, CA: Mandeville Center for the Arts, 1978).

67. Greg Grandin, *Empire's Workshop: Latin America, the United States, and the Rise of the New Imperialism* (New York: Metropolitan Books, 2006); Walter LaFeber, *Inevitable Revolutions: The United States in Central America* (New York: Norton, 1983); Juan González, *Harvest of Empire: A History of Latinos in America* (New York: Penguin Books, 2011); John Perkins, *Confessions of an Economic Hit Man* (San Francisco: Berrett-Koehler Publishers, Inc., 2004).

68. Yolanda López, *Cactus Hearts/Barbed Wire Dreams: Media Myths and Mexicans* (San Francisco: Galería de la Raza, 1988), Yolanda Lopez collection, CEMA, Box 3/10.

69. As Lipsitz noted of López's work, "Building insurgent consciousness entails speaking back to power, subverting its authority, and inverting its icons as a means of authorizing oppositional thinking and behavior." See Lipsitz, "Not Just Another Social Movement," 76.

70. Peter Selz, "Rupert García," (San Francisco: Harcourts Gallery, 1985). Also reprinted in Peter Selz, "Rupert García: The Artist as Advocate," in *Beyond the Mainstream: Essays on Modern and Contemporary Art* (Cambridge: Cambridge University Press, 1998).

71. Rupert García, Oral History interviews by Paul J. Karlstrom, Oakland, CA, September 7, 1995, November 10, 1995, and June 24, 1996, Archives of American Art (AAA), Smithsonian Institution, http://www.aaa.si.edu/collections/interviews/oral-history-interview-rupert-garcia-13572.

72. Ibid.

73. Ibid.

74. Rupert García, "Rupert García," *Toward Revolutionary Art* 2, no. 2 (1975): 20.

75. Jean Franco, "Rupert García," in *Juan Fuentes y Rupert García: Posters, Drawings, Prints* (San Francisco: Galería de la Raza, 1975), Tomás Ybarra-Frausto collection, AAA, Box 10.

76. García, interview, AAA.

77. Ramón Favela, *The Art of Rupert García: A Survey Exhibition* (San Francisco: Chronicle Books and the Mexican Museum, 1986), 19.

78. García, interview, AAA.

79. Favela, *The Art of Rupert García*, 9.

80. Alfred Frankenstein referred to García as a Marxist in "When Politics and Art Do Mix," *San Francisco Chronicle*, March 15, 1978, 54; García, interview, AAA.

81. Quoted in Favela, *The Art of Rupert García*, 9.

82. Wells, "La Lucha Sigue," 175.

83. García, interview, AAA.

84. Ibid.

85. Ibid.

86. Rupert García, interview by Ralph Maradiaga, *The Fifth Sun,* 27–30.

87. Favela provided the image's origins: "The clippings used for this collage were taken from a black-and-white illustration in *Alero*, a cultural magazine published by the University of San Carlos, Guatemala, and a high-contrast reproduction found in a Spanish language newspaper published in the United States." Favela, *The Art of Rupert García*, 13.

88. Ibid., 7.

89. García, interview, *The Fifth Sun*, 30.

90. Rupert García, Califas interview, Oakland, CA, October 14, 1983, uncorrected transcript from Califas videotapes 155–158, transcribed by Philip Brookman and Amy Brookman, Califas Book 5, 10, in *Califas Conference Final Report*, AAA.

91. The United States banned DDT in 1972, ten years after Rachel Carson published her famous book *Silent Spring* indicting the chemical's impact: Rachel Carson, *Silent Spring*, 40th ann. ed. (New York: Houghton Mifflin, 1962; repr., New York: Mariner Books, 2002). The United Farm Workers played a fundamental role in the banning; see Susan Ferriss and Ricardo Sandoval, *The Fight in the Fields: Cesar Chavez and the Farmworkers Movement* (New York: Harcourt Brace, 1997), 221–247; Lorena Parlee, Lenny Bourin, prod., *The Wrath of Grapes*, VHS video, narrated by Mike Farrell, with Cesar Chavez, Dolores Lopez, and Connie Rosales (Keene, CA: United Farm Workers of America, 1986), documentary. Use of DDT persisted elsewhere, especially as an effective preventative of malaria. As a reporter for *Forbes* argued in 2004, "A reluctance to use DDT, often justified by reference to the Precautionary Principle, is now having really bad effects in the Third World. DDT may well be the cheapest and most effective way of combating the mosquitoes that cause malaria." Cass R. Sunstein, "Safe and Sorry," *Forbes*, July 5, 2004, 48.

92. García, interview, *The Fifth Sun*, 27. For more on Chicano iconography, see Tomás Ybarra-Frausto and Shifra Goldman, "The Political and Social Contexts of Chicano Art," in Castillo, McKenna, and Yarbro-Bejarano, *Chicano Art*, 83–95; Tere Romo, "Points of Convergence: The Iconography of the Chicano Poster," in Noriega, *Just Another Poster?*, 91–115; Sylvia Gorodesky, *Arte Chicano Como Cultura de Protesta* (*Chicano Art as Protest Culture*) (Mexico City: Universidad Nacional Autónoma de México, 1993); Manuel J. Martínez, "The Art of the Chicano Movement and the Movement of Chicano Art," in *Aztlán: An Anthology of Mexican American Literature*, ed. Luis Valdez and Stan Steiner (New York: Knopf, 1972), 349–353; Alicia Gaspar de Alba, *Chicano Art: Inside/Outside the Master's House: Cultural Politics and the CARA Exhibition* (Austin: University of Texas Press, 1998); and Cheech Marin, *Chicano Visions: American Painters on the Verge* (New York: Bulfinch, 2002).

93. Hoover, quoted in Akinyele Omowale Umoja, "Repression Breeds Resistance: The Black Liberation Army and the Radical Legacy of the Black Panther Party," in Cleaver and Katsiaficas, *Liberation, Imagination and the Black Panther Party*, 8.

94. García, interview, AAA.

95. García, interview, *The Fifth Sun*, 28.

96. García, interview, AAA.

97. Angela Davis, "On the Art of Rupert García," in *Rupert García*, MARS Artspace Program, October 5–30, 1987, Tomás Ybarra-Frausto collection, AAA, Box 10/Rupert García file.

98. Ibid.

99. Ibid.

100. "Where Is Justice," *El Tecolote*, September 21, 1970, 2.

101. José Montoya, "The Source Is the Force," unpublished article, Tomas Ybarra Frausto collection, AAA, Box 10/Rupert García file.

102. Frankenstein, "When Politics and Art Do Mix."

103. García, "Rupert García," 20.

104. García, interview, AAA.

105. Peter Selz, *Rupert García: New Pastel Paintings*, Galerie Claude Samuel, Paris, March 3-April 4, 1987, Tomás Ybarra-Frausto collection, AAA, Box 10/Rupert García file.

106. Rupert García, handwritten remarks for a lecture, Galería de la Raza collection, CEMA, Box 1/6.

107. Thomas Albright, "Rupert García: Radical Political Portraitist," *San Francisco Chronicle*, April 28, 1983, 60; Donna M. De Salvo, Paul Schimmel, Russell Ferguson, and David Deitcher, eds., *Hand-Painted Pop: American Art in Transition, 1955–62* (Los Angeles: The Museum of Contemporary Art, 1993).

108. Favela, *The Art of Rupert García*, 11.

109. García, interview, AAA.

110. "Buscando América," Galería Esquina Libertad, La Raza Graphics Center and Mission Gráfica, November 15–December 31, 1986, Tomás Ybarra-Frausto collection, AAA, Box 19.

111. Fuentes, interview, March 13, 2003.

112. Ibid.

113. Ibid.

114. Ibid.

115. Jane Mansbridge, "The Making of Oppositional Consciousness," in *Oppositional Consciousness: The Subjective Roots of Social Protest,* ed. Jane Mansbridge and Aldon Morris (Chicago: University of Chicago Press, 2001), 4–5. Also see Chela Sandoval, "U.S. Third World Feminism: The Theory and Method of Oppositional Consciousness in the Postmodern World," *Genders* 10 (1991): 1–24.

116. Fuentes, interview, 2003.

117. Ibid.

118. Ibid.

119. Ibid.

120. Ibid.

121. Katsiaficas, *The Imagination of the New Left*; Michael Denning, *Culture in the Age of Three Worlds*, 5.

122. Fuentes, interview, 2003.

123. Ibid.

124. López also has described Putzker as a helpful teacher. López, interview, 2003.

125. Fuentes, interview, 2003.

126. For more about Malaquías Montoya as an artist inspired by the TWLF, see Wells, "La Lucha Sigue," 176–186; quote from Fuentes, interview, 2003.

127. Fuentes, interview, 2003.

128. As Carol Wells stated, "The importance of Cuban posters in the development of the Chicano poster cannot be overstated." "La Lucha Sigue," 177–178.

129. J. P. Bone, "Mindfield interviews Juan Fuentes," *Mindfield*, November 1997.

130. In the mid-1980s, Mission Gráfica merged with La Raza Silkscreen Center. Fuentes discussed the process of cataloguing this archive in his article, "Mission Gráfica," in *Corazon del Barrio* (San Francisco: Mission Cultural Center, 2003), not paginated.

131. Fuentes, interview, *Mindfield*.

132. René Castro, "Mission Gráfica: Un Taller Humilde en el Barrio de la Mission," in *Corazon del Barrio: 25 Years of Art and Culture in the Mission*, Mission Cultural Center, February 2003; and in *Voices on Paper: 25 Year Retrospective of Posters and Prints by Mission Gráfica* (San Francisco: Galería Museo, Mission Cultural Center for Latino Arts, 2002), 4.

133. Jos Sances, "Mission Gráfica," in *Voices on Paper*, 6.

134. Fuentes, interview, 2003.

135. Shelley Sommer, *John F. Kennedy: His Life and Legacy* (New York: HarperCollins, 2005), 127.

136. Juan Fuentes, "Viva Vietnam," *El Tecolote*, May 28, 1975, 8.

137. Marifeli Pérez-Stable, *The Cuban Revolution: Origins, Course, and Legacy* (Oxford: Oxford University Press, 1999), 53.

138. Translation mine; "Recordando el 26 de Julio," *El Tecolote*, July 1976, 9.

139. "200 Years of 'Progress,'" *El Tecolote*, July 1976, 6–7.

140. Carlos B. Córdova, "The Mission District: The Ethnic Diversity of the Latin American Enclave in San Francisco, Calif.," *Journal of La Raza Studies* 2, no. 1 (Summer/Fall, 1989): 29; Jean Molesky, "Amnesty for Qualified Immigrants in the San Francisco Bay Area: The Implementation of the Immigration Reform and Control Act of 1986," *Journal of La Raza Studies* 2 (Summer/Fall, 1989): 16–20.

141. Tim Drescher, *Progress in Process* (San Francisco: Galería de la Raza, 1982). Tomás Ybarra-Frausto collection, AAA, Box 9.

142. Ibid, 18.

Chapter 5. Hombres y Mujeres Muralistas on a Mission

1. Alejandro Murguía, *The Medicine of Memory: A Mexica Clan in California* (Austin: University of Texas Press, 2002), 118. For an earlier version of this chapter, see Cary Cordova, "Hombres y Mujeres Muralistas on a Mission: Painting Latino Identities in 1970s San Francisco," *Latino Studies* 4, no. 4 (2006): 356–338.

2. Neil Smith, *New Urban Frontier: Gentrification and the Revanchist City* (London: Routledge, 1996), 37–38. For more about the Mission, see Brian J. Godfrey, *Neighborhoods in Transition: The Making of San Francisco's Ethnic and Nonconformist Communities* (Berkeley: University of California Press, 1988); Manuel Castells, *The City and the Grassroots: A Cross-Cultural Theory of Urban Social Movements* (London: Edward Arnold, 1983); Rebecca Solnit and Susan Schwartzenberg, *Hollow City: The Siege of San Francisco and the Crisis of American Urbanism* (London: Verso, 2000).

3. Eva Sperling Cockcroft, John Pitman Weber, and Jim Cockcroft, eds., *Toward a People's Art: The Contemporary Mural Movement* (Albuquerque: University of New Mexico Press, 1998), 1–5; 7–8; Alan W. Barnett, *Community Murals: The People's Art* (Philadelphia: Art Alliance Press, 1984), 50–55; James Prigoff and Robin J. Dunitz, *Walls of Heritage, Walls of Pride: African American Murals* (San Francisco: Pomegranate, 2000), 24–30.

4. John Pitman Weber, *Politics and Practice of Community Public Art: Whose Murals Get Saved?* (Los Angeles: The Getty Conservation Institute, 2004), e-book. Shifra Goldman pointed out that David Alfaro Siqueiros' 1932 mural, *Tropical America,* on Olvera Street in Los Angeles, also set an earlier precedent for exterior murals. Goldman, *Dimensions of the Americas: Art and Social Change in Latin America and the United States* (Chicago: University of Chicago Press, 1994), 87–100; Shifra M. Goldman, interview, Pasadena, CA, August 9, 1983, uncorrected transcript from Califas videotapes 102–105, transcribed by Philip Brookman and Amy Brookman, Califas Book 3, 3, in *Califas Conference Final Report*, AAA.

5. Barnett, *Community Murals*; Cockcroft, Weber, and Cockcroft, *Toward a People's Art,* 230; Eva Cockcroft and Holly Barnet-Sanchez, eds., *Signs from the Heart: California Chicano Murals* (1990; repr., Albuquerque: University of New Mexico Press, 1993); Timothy Drescher, *San Francisco Murals: Community Creates Its Muse, 1914–1994* (St. Paul, MN: Pogo, 1994); Annice Jacoby, ed., *Street Art San Francisco: Mission Muralismo* (New York: Abrams, 2009).

6. Rupert García documented Oscar Caraveo's creation of *Atardecer de un Imperio (The Interruption of Empire)* in El Azteca Restaurant in 1963. García stated that Rubén Guzman created the first exterior mural in the summer of 1971, and noted his participation in a 1967 Latino youth project sponsored by Casa Hispana de Bellas Artes to paint the exterior of a bus. Rupert García, "Chicano-Latino Murals of California, 1963–1970: A Period of Accommodation and Protest," paper submitted for Peter Selz's "Art of the 1960s" class, 1979/1980, Tomas Ybarra-Frausto Collection, Archives of American Art, Smithsonian Institution (hereafter AAA), Box 10; García, "Commercial Popular Mural Art of the 1960s: An Enduring Mexican Folklore in California," paper for Chicano Studies and Department of Architecture, University of California at Berkeley, Ybarra-Frausto Collection, AAA, Box 10. Susan Cervantes recalled painting a mural inside Coffee Dan's establishment in 1965: Susan Cervantes, interview by author, February 23, 2003; Barnett, *Community Murals*, 126; Shifra Goldman, "How, Why, Where, and When It All Happened: Chicano Murals of California," in Cockcroft and Barnet-Sanchez, *Signs from the Heart*, 36; Rolando Castellón, Jerry Concha, Carlos Loarca, and Gustavo Rivera, group interview, San Francisco, October 16, 1983, uncorrected transcript of Califas videotapes 158–162, transcribed by Philip Brookman and Amy Brookman, Califas Book 5, 18, in *Califas Conference Final Report* AAA.

7. Roberto Vargas, NAP associate director, in *City Magazine*, November 25, 1975, quoted in Paul Kleyman and Barbara Taylor-Sharp, "The Seeds of Creative Community: A Report on the San Francisco Arts Commission's Neighborhood Arts Program and Its Development of the CETA Arts Program as a National Model from 1974–1976," 1976. My appreciation to Paul Kleyman for this report.

8. Victoria Quintero, "A Mural Is a Painting on a Wall Done by Human Hands," *El Tecolote,* September 13, 1974, 6; "Mural Transforms a Wall into a Thing of Beauty," *Mission District News*, June 13, 1974, 7; Rupert García, "This Mural Is Not for the Bankers, It's for the People," *El Tecolote*, June 10, 1974, 11; "In a Monumental Mural Latin Artists Working," *El Mundo*, June 12, 1974, 1; "Mission Grads Enrich B of A Office," *Mission District News,* June 13, 1974, 1; "Mission Murals in the Mexican Manner," *San Francisco Examiner*, June 8, 1974, 5; Thomas Albright, "Three Remarkable Latin Murals," *The San Francisco Chronicle*, June 4, 1974, 48; Ira Kamin, "Come On In, Bring Your Paint." *Pacific Sun*, May 30–June 5, 1974, 11–12; "Mural Tour of the Mission District in San Francisco," *Sunset Magazine*, July 1975, 26C. Insert does not appear in all editions.

9. Lynda Gledhill, "Mission Mural Now a Whitewashed Wall," *San Francisco Chronicle*, August 5, 1998, A13; Weber, "Politics and Practice."

10. Manuel Castells, *The City and the Grassroots: A Cross-Cultural Theory of Urban Social Movements* (Berkeley: University of California Press, 1983)., 110.

11. Ana Montes, "The Mission Redevelopment Plan," *El Tecolote*, February 28, 1975, 3.

12. Research Organizing Cooperative, *Basta Ya! The Story of Los Siete de la Raza* (San Francisco: Author, 1970).

13. Juan Cruz and G. Roginsky, "Mission Fires: Urban Renewal Made Simple?" *El Tecolote*, April 1977, 1; Peter Claudius and Chris Collins, "Mission Mourns Victor Miller," *New Mission News*, September 2002, 1.

14. Castells, *City and Grassroots*, 109; Mike Miller, *A Community Organizer's Tale: People and Power in San Francisco* (Berkeley, CA: Heyday Books, 2009); Tomás F. Summers Sandoval Jr., *Latinos at the Golden Gate: Creating Community & Identity in San Francisco* (Chapel Hill: University of North Carolina Press, 2013).

15. Castells, *City and Grassroots*, 117; Tom Wolfe chronicled corruption in this flourishing community service movement in *Radical Chic & Mau-Mauing the Flak Catchers* (1970; New York: Bantam Books, 1999).

16. Jason Michael Ferreira, "All Power to the People: A Comparative History of Third World Radicalism in San Francisco, 1968–1974," (PhD diss., University of California, Berkeley, 2003), 188, 197.

17. In an informal conversation, Alejandro Murguía described Roberto Vargas as another important force in the plan to make CETA amenable to artists. For more about CETA, see Peter Barnes, "Fringe Benefits of a Depression: Bringing Back the WPA," *The New Republic*, March 15, 1975, 19–21; and "The Public Artist Returns," *Manpower*, October 1975, 18–21. Thanks to Michael Nolan for a copy of the proposal, composed and typed by J. D. Kreidler, "Proposed Artists in Residence Project," October 17, 1974. Also see the short film, *Art Works*, directed by Optic Nerve (an eight-person collective), 1975.

18. Barnett, *Community Murals*, 126. Shifra Goldman also gave the earliest date of creation to the Horizons Unlimited mural, in "How, Why, Where, and When," 36.

19. Castellón, Concha, Loarca, and Rivera, group interview, 1983.

20. Barnes, "Fringe Benefits of a Depression," 20.

21. Campusano estimated the total payment in Albright, "Three Remarkable Latin Murals."

22. Bank of America Mission, 23rd Street Office, "Suggested Format for Press Conference," June 4, 1974, Emmy Lou Packard Papers, Box 7, Bank of America files, AAA. At the time, banks commissioned murals as a means of securing a new client population. Rupert García noted the Pan American National Bank's engagement of Mexican muralist José Reyes Meza to produce the "emblematic and conventional" "Our Past, Our Present, and Our Future" in Los Angeles in 1965. García, "Chicano-Latino Murals of California," 9–10, citing "Meza to Paint Pan American Nat'l Bank Murals," *Mexican American Sun*, October 14, 1965.

23. Cover tagline for Michael Sweeney's article, "From Dustbowl to Saigon: The 'Peoples Bank' Builds an Empire," *Ramparts*, May 1970, 24, 37–45. Also see Malcolm Gault-Williams, *Don't Bank on Amerika: The History of the Isla Vista Riots of 1970* (Santa Barbara, CA: Author, 1987); Robert A. Potter and James J. Sullivan, *The Campus by the Sea Where the Bank Burned Down; a Report on the Disturbances at UCSB and Isla Vista, 1968–1970, Submitted to the President's Commission on Campus Unrest at the Request of Joseph Rhodes, Jr.* (Santa Barbara, CA: Faculty and Clergy Observer's Program, 1970).

24. The bank burning was a formative moment for UCSB students Kathleen Soliah (a.k.a. Sara Jane Olson) and James Kilgore, both of whom later joined the radical Symbionese Liberation Army. Twila Decker reports how Soliah's family "traces the onset of her radicalization" to the bank burning in "Unbroken: When Sara Jane Olson Was Arrested in 1999, It Seemed Her Conversion from SLA Revolutionary to Soccer Mom Was Complete. Not Quite," *Los Angeles Times*, August 5, 2001, 16.

25. When César Chávez was a child, his family lost their home in a bank foreclosure. As an adult, César Chávez and spouse Helen Chávez fought discriminatory bank loan policies by creating a credit union that loaned "more than $5.5 million to farmworker families by the mid-1980s." See Susan Ferriss and Ricardo Sandoval, *The Fight in the Fields: Cesar Chavez and the Farmworkers Movement* (New York: Harcourt Brace, 1997), 75, 117, 253; Carey McWilliams, *Factories in the Field: The Story of Migratory Farm Labor in California* (Boston: Little, Brown, 1939; repr., with new text added, Berkeley: University of California Press, 2000), 233, 238; Peter Matthiessen, *Sal Si Puedes: Cesar Chavez and the New American Revolution* (New York: Random House, 1969; repr., Berkeley: University of California Press, 2000), 20.

26. Chester W. Hartman, *City for Sale, The Transformation of San Francisco,* rev. ed. (Berkeley: University of California Press, 2002), 293; Brian J. Godfrey, "Urban Development and Redevelopment in San Francisco," *Geographical Review* 87, no. 3 (July 1997): 309–333; Bruce Brugmann and Greggar Sletteland, eds., *The Ultimate Highrise: San Francisco's Mad Rush Toward the Sky* (San Francisco: San Francisco Bay Guardian, 1971), 194, 217–218.

27. Jesús Campusano, Michael Rios, and Luis Cortázar, *Tres Muralistas,* 1974. Interview pamphlet given to the public at mural opening. My appreciation to Michael Nolan for a copy of this document. Nolan was the uncredited interviewer of the three muralists. Excerpts also appeared in *El Tecolote*, June 10, 1974.

28. Carlos Francisco Jackson, *Chicana and Chicano Art: ProtestArte* (Tucson: University of Arizona Press, 2009), 46. Also see Desmond Rochfort, *Mexican Muralists: Orozco, Rivera, Siqueiros* (Mexico City: Laurence King, 1993); Laurence P. Hurlburt, *The Mexican Muralists in the United States* (Albuquerque: University of New Mexico Press, 1989); Goldman, *Dimensions*, 87–117; and Lizzetta LeFalle-Collins and Shifra M. Goldman, *In the Spirit of Resistance: African-American Modernists and the Mexican Muralist School* (New York: American Federation of Arts, 1996).

29. Eloise Dungan, "Drawn Back to the City," *San Francisco Examiner and Chronicle,* April 1, 1973, 6.

30. Joan McKinney, "An Artist with a Mission," *Oakland Tribune,* clipping, no date, in Packard papers, Box 8, printed material, AAA.

31. Campusano, Rios, and Cortázar, *Tres Muralistas.* For more about Packard see Pat Pfeiffer, "Emmy Lou Packard's Palette of Paints and Politics," *California Living, San Francisco Sunday Examiner and Chronicle,* May 2, 1982, 26; and Geri DePaoli, *Emmy Lou Packard, 1914–1998* (Davis, CA: John Natsoulas Gallery, 1998).

32. John W. Wood, to Emmy Lou Packard, July 8, 1974. Packard papers, Box 7, Bank of America files, AAA.

33. Emmy Lou Packard, "KPFA Radio Transcript: Emmy Lou Packard Interview Conducted by Lewis Hill," June 13, 1957, Packard Papers, Box 5, AAA; and Pfeiffer, "Emmy Lou Packard's Palette of Paints and Politics," 26–33.

34. Emmy Lou Packard to Helen O'Gorman, August 12, 1974; and Packard to Pablo and Maria O'Higgins, August 20, 1974. Packard Papers, Box 5, Diego Rivera and Frida Kahlo files (13/80), AAA.

35. Campusano's name appeared regularly in Packard's later calendars, often in relation to Mission District events: Emmy Lou Packard, Notebook/Diaries 12–23, 1983–1985, Packard Papers, Box 4, AAA.

36. Michael Denning, *The Cultural Front* (New York: Verso, 1998).

37. Roberto Vargas, "La BoA," *El Tecolote,* June 10, 1974, 11.

38. Campusano, Rios, and Cortázar, *Tres Muralistas,* 1974.

39. Geoff Brouillette, "Subjects in Mural at BofA Branch Reflect Free Reign Given Spanish-Speaking Artists," *American Banker,* June 7, 1974.

40. Cockcroft, Weber, and Cockcroft, *Toward a People's Art*, 230.

41. Quoted in Goldman, *Dimensions*, 213.

42. Cervantes, interview, 2003.

43. Mujeres Muralistas, "Latino America," inauguration poster, May 31, 1974. I am grateful to René Yañez for a copy of this poster.

44. Mujeres Muralistas statement, May 31, 1974, Emmy Lou Packard papers, Box 7, Bank of America files, AAA; María Ochoa also notes this replication in *Creative Collectives: Chicana Painters Working in Community* (Albuquerque: University of New Mexico Press, 2003), 35.

45. Patricia Rodriguez, interview by author, San Francisco, March 27, 2003.

46. Many sources indicate people criticized the work for being apolitical (i.e., Quintero, "A Mural Is a Painting"). However, little has been printed that describes the work as apolitical. Terezita Romo suggested that the Mujeres Muralistas art required "an expanded definition of 'political art' that included aspects of nature, culture, and the family." See Romo, "A Collective History: Las Mujeres Muralistas," in *Art/Women/California: Parallels and Intersections, 1950–2000,* ed. Diana Burgess Fuller and Daniela Salvioni (Berkeley: University of California Press, 2002), 180; Guisela Latorre also discussed this simplification of politics in *Walls of Empowerment: Chicana/o Indigenist Murals of California* (Austin: University of Texas Press, 2008), 187–188.

47. Goldman, "How, Why, Where, and When," 40.

48. Amalia Mesa-Bains, "Quest for Identity: Profile of Two Chicana Muralists, Based on Interviews with Judith F. Baca and Patricia Rodriguez," in Cockcroft and Barnet-Sanchez, *Signs from the Heart,* 76.

49. Ibid.

50. Eva Sperling Cockcroft and Holly Barnet-Sanchez titled a reproduction of the work "Latinoamérica," alongside an essay by Amalia Mesa-Bains, in Cockcroft and Barnet-Sanchez, *Signs from the Heart*, 73. Shifra Goldman referred to the work as the "Panamerica" mural (Goldman, *Dimensions,* 1994, 213), as did "Chicano Art: Resistance and Affirmation" (CARA) in *Chicano Art: Resistance and Affirmation, 1965–1985,* ed. Richard Griswold del Castillo, Teresa McKenna, Yvonne Yarbro-Bejarano (Los Angeles: Wight Art Gallery, UCLA, 1991). Patricia Rodriguez used the title "Panamerica" in conversation (Rodriguez, interview by author, 2003). Tim Drescher used the name "Latinoamerica" without the accent (Drescher, *San Francisco Murals*, 22), as did María Ochoa, *Creative Collectives,* 10; Romo used "Latinoamérica" in "A Collective History," 177.

51. Ray Delgado, "Sprightly Mission Mural Now Just a Wall: 'Lilli Ann' Work Whitewashed with No Warning," *San Francisco Examiner*, August 7, 1998, A6.

52. Campusano, et al. v. Robert J. Cort Trust, C98-3001-MJJ (N.D. Cal 1998). This is often referred to as the "Lilli Ann Mural Case."

53. Patricia Rodriguez, interview by author, 2003.

54. Patricia Rodriguez, interview by Ralph Maradiaga, curator, in *The Fifth Sun, Contemporary/ Traditional Chicano and Latino Art* (Berkeley: University Art Museum, 1977), 14.

55. San Francisco was a center for underground comix in the 1960s (*comix* is used to identify an underground or alternative genre of comics). Local artists, such as Manuel "Spain" Rodriguez, Michael Rios, and Robert Crumb, encouraged murals in the comix style with their influential murals for Horizons Unlimited and the Mission Rebels: see Drescher, *San Francisco Murals,* 19; Sepideh Ghadishah, "Strip Shows," *Métier*, Summer 1987, 7.

56. Cynthia Lecount provided a useful discussion of the history of the diablada in Oruro in "Carnival in Bolivia: Devils Dancing for the Virgin," *Western Folklore* 58, no. 3/4 (1999): 231–252. Julia Elena Fortun also discussed the devil dance, as well as argued for the importance of the *morenada* dance as an expression of African culture in Bolivia, in *La Danza de los Diablos* (La Paz: Ministerio de Educación y Bellas Artes, Oficialía Mayor de Cultural Nacional, 1961). For a discussion of the Africanist presence in carnival, see Daniel J. Crowley, *African Myth and Black Reality in Bahian Carnaval* (Los Angeles: Museum of Cultural History, UCLA, 1984); Daniel J. Crowley, "The Sacred and the Profane in African and African-Derived Carnivals," *Western Folklore* 58, no. 3/4 (1999): 223–228; Luis Arturo Domínguez, *Diablos Danzantes en San Francisco de Yare* (Los Teques, Venezuela: Biblioteca de Autores y Temas Mirandinos, 1984).

57. Wilma Pearl Mankiller and Michael Wallis, *Mankiller: A Chief and Her People* (New York: St. Martin's, 1993), 100.

58. Ochoa, *Creative Collectives*, 49.

59. Patricia Rodriguez, interview by author, 2003.

60. Alternatively, María Ochoa argued for the many unintentionally androgynous figures featured in the work, specifically pointing to the figures in the *zia* and the masked devil figures. See Ochoa, *Creative Collectives*, 50.

61. Patricia Rodriguez, interview by author, 2003; Romo, "A Collective History," 182.

62. Exterior community murals, like any public art, must accord with the surrounding community or face possibly destructive consequences. See Cockcroft, Weber, and Cockcroft, *Toward a People's Art*; Barnett, *Community Murals*.

63. Romo, "A Collective History"; Mesa-Bains, "Quest for Identity"; Quintero, "A Mural Is a Painting."

64. Quintero, "A Mural Is a Painting."

65. Patricia Rodriguez, interview, San Francisco, October 30, 1982, uncorrected transcript from Califas videotapes 58–61, transcribed by Carlos Palado, Califas Book 2, 6, *Califas Conference Final Report*, AAA.

66. Quintero, "A Mural Is a Painting."

67. Rochfort, *Mexican Muralists*, 192; includes partial interview with Siqueiros originally published in *El Tiempo*, Mexico City, August 31, 1951.

68. Barnett, *Community Murals*, 144.

69. David L. Kirp, *Just Schools: The Idea of Racial Equality in American Education* (Berkeley: University of California Press, 1982), 46.

70. Latorre reads BART as a positive image in *Walls of Empowerment*, 47.

71. Hurlburt, *The Mexican Muralists*, 163.

72. A bank manager tipped me to this story in May 2003, stating he believed the cell originally contained a symbol of the Symbionese Liberation Army. In a telephone conversation on December 3, 2003, Michael Rios suggested the story might be true, even that the cell might have contained a "seven-headed serpent" image, but he did not wish to confirm or deny the story.

73. César Chávez, "Plan of Delano," 1966, cited in Barnett, *Community Murals,* 141. For the full text, see *The Words of César Chávez*, ed. Richard J. Jensen and John C. Hammerback (College Station: Texas A&M University Press, 2002) 16–20.

74. Goldman, *Dimensions*, 87–100; Phoebe S. Kropp, *California Vieja: Culture and Memory in a Modern American Place* (Berkeley: University of California Press, 2006), 255–257; Latorre, *Walls of Empowerment,* 38–45. The muralists also might have echoed another Siqueiros painting, *Por Una Seguridad Completa Para Todos los Mexicanos* (*For the Complete Security of All Mexicans*), 1952–1954, in the Hospital de la Raza. The mural shows a man issuing from a conveyor belt head first, or upside down. My appreciation to Holly Barnet-Sanchez for this example, which suggests the muralists may have been alluding to Siqueiros's work more broadly.

75. Campusano, Rios, and Cortázar, *Tres Muralistas.*

76. Latorre described only "the positive effects of medical discovery on the community" in *Walls of Empowerment*, 46.

77. Patricia Rodriguez, quoted in Maradiaga, *The Fifth Sun*, 14. For more on the *maguey,* see Chon A. Noriega and Wendy Laura Belcher, eds., *I am Aztlán: The Personal Essay in Chicano Studies* (Los Angeles: UCLA Chicano Studies Research Center Press, 2004), 20–21; and María Herrera-Sobek, *Santa Barraza, Artist of the Borderlands* (College Station: Texas A&M University Press, 2001). Ramon Favela noted that Rupert García completed *Maguey de la Vida* shortly after his first trip to Mexico, but the image was based on a photograph by Edward Weston reproduced in Anita Brenner's *Idols Behind Altars* (New York: Payson and Clarke, 1929). See Ramón Favela, *The Art of Rupert García: A Survey Exhibition* (San Francisco: Chronicle Books and the Mexican Museum, 1986), 18, 43. James Oles discussed the *maguey* as "a symbol of Mexico" in Brenner's and Weston's work in Oles, *South of the Border: Mexico in the American Imagination: 1914–1947,* trans. Marta Ferragut (Washington, DC: Smithsonian Institution, 1993), 149. The modernist emphasis on the *maguey* later circulated through the work of filmmaker Sergei Eisenstein, as Zuzana M. Pick documents in *Constructing the Image of the Mexican Revolution: Cinema and the Archive* (Austin: University of Texas Press, 2010), 98–124.

78. Quintero, "A Mural Is a Painting."

79. Campusano, Rios, and Cortázar, *Tres Muralistas.*

80. Emilia "Mia" Galaviz de Gonzalez, interview by author, San Francisco, February 5 and 12, 2003.

81. Ibid.

82. "PLACA," *Community Murals Magazine*, Fall 1984.

83. Ralph Maradiaga to Zellerbach Family Fund, October 28, 1983. This fundraising letter was a cover for Ray Patlán's more expanded request for support for the project, dated October 25, 1983. It is worth noting that neither letter clearly declared the political orientation of the project. Galería de la Raza archive, Box 10, Folder 5, CEMA, University of California Santa Barbara.

84. Judy Bell, Tim Drescher, Nicole Emanuel, and Paul Rossman, "New Murals Bloom in Balmy Alley," *People's World*, September 8, 1984; Drescher, *San Francisco Murals*, 26–27.

85. Goldman, *Dimensions*, 34.

86. Juana Alicia, class recording, San Francisco State University, October 21, 2002.

87. Juana Alicia, "Remember the Mission," unpublished manuscript, September 20, 2007, collection of the author.

88. Cervantes, interview by author, 2003.

89. Hurlburt, *The Mexican Muralists*, 11.

90. Greg Grandin, *Empire's Workshop: Latin America, the United States, and the Rise of the New Imperialism* (New York: Metropolitan Books, 2006); Mark Danner, *The Massacre at El Mozote: A Parable of the Cold War* (New York: Vintage, 1994).

91. Jorge Mariscal, "Left Turns in the Chicano Movement, 1965–1975," *Monthly Review* 54, no. 3 (2002): 59.

Chapter 6. The Mission in Nicaragua

1. Alejandro Murguía, *The Medicine of Memory: A Mexica Clan in California* (Austin: University of Texas Press, 2002), 126–127.

2. Roberto Vargas, *Nicaragua: Yo Te Canto Besos, Balas y Sueños de Libertad* (San Francisco: Editorial Pocho-Che, 1980), 22.

3. On internationalism, also see George Mariscal, *Brown-Eyed Children: Lessons from the Chicano Movement, 1965–1975* (Albuquerque: University of New Mexico Press, 2005), and the work of B. V. Olguín, especially "Barrios of the World Unite! Regionalism, Transnationalism, and Internationalism in Tejano War Poetry from the Mexican Revolution to World War II," in *Left of the Color Line: Race, Radicalism, and Twentieth-Century Literature of the United States*, ed. Bill V. Mullen and James Edward Smethurst (Chapel Hill: University of North Carolina Press, 2003), 107–140.

4. Nina Serrano, *Heart Songs: The Collected Poems of Nina Serrano (1969–1979)* (San Francisco: Editorial Pocho-Che, 1980), 102–103.

5. Serrano's poetic declaration, "Pinochet, Romero, y Somoza Son La Misma Cosa," echoed Rupert García's 1977 pastel on paper, *Mexico, Chile, Soweto . . .* (Fig. 4.8). Their similar approach conveys how cultural workers in the late 1970s linked separate regimes into a transnational struggle for human rights. Carol A. Wells discussed this global solidarity in her article "La Lucha Sigue: From East Los Angeles to the Middle East," in *Just Another Poster? Chicano Graphic Arts in California*, ed. Chon A. Noriega (Santa Barbara: University Art Museum, University of California, 2001).

6. Lubna Z. Qureshi, *Nixon, Kissinger, and Allende: U.S. Involvement in the 1973 Coup in Chile* (Lanham, MD: Lexington Books, 2009).

7. Gina M. Pérez, Frank A. Guridy, and Adrian Burgos Jr., *Beyond El Barrio: Everyday Life in Latina/o America* (New York: New York University Press, 2010), 4.

8. Murguía, *Medicine of Memory,* 125.

9. Juan Felipe Herrera provided one of the few accounts of San Francisco's Raza literature in "Riffs on Mission District Raza Writers," in *Reclaiming San Francisco: History, Politics, Culture*, ed. James Brook, Chris Carlsson, and Nancy Peters (San Francisco: City Lights, 1998), 217–230. Several anthologies have represented the Nuyorican poetry scene, including Miguel Algarín and Miguel Piñero, eds., *Nuyorican Poetry: An Anthology of Puerto Rican Words and Feelings* (New York: Morrow, 1975); Miguel Algarín and Bob Holman, eds., *Aloud: Voices from the Nuyorican Poets Café* (New York: Henry Holt, 1994). However, Urayoán Noel critiqued some of the exclusions framing these earlier representations with *In Visible Movement: Nuyorican Poetry from the Sixties to Slam* (Iowa City: University of Iowa Press, 2014).

10. Vargas, *Nicaragua,* 16; Carlos B. Córdova, interview by author, San Francisco, March 5, 2003; Carlos B. Córdova, *The Salvadoran Americans* (Westport, CT: Greenwood Press, 2005), 62; Brian J. Godfrey, *Neighborhoods in Transition: The Making of San Francisco's Ethnic and Nonconformist Communities* (Berkeley: University of California Press, 1988), 140.

11. Ernesto Cardenal, *Las Ínsulas Extrañas: Memorias 2* (Madrid: Editorial Trotta, 2002), 475.

12. Godfrey, *Neighborhoods*, 111, 138. For information regarding the 1965 Immigration Act, see George J. Sanchez, "Race, Nation, and Culture in Recent Immigration Studies," *Journal of American Ethnic History* 18, no. 4 (Summer 1999): 66–84.

13. Arturo Arias, *Taking Their Word: Literature and the Signs of Central America* (Minneapolis: University of Minnesota Press, 2007), xxiii.

14. George Black, *Triumph of the People: The Sandinista Revolution in Nicaragua* (London: Zed Press, 1985), 59.

15. Alejandro Murguía, "El Movimiento de Solidaridad en San Francisco, 1974–1979," *Barricada Internacional*, July 8, 1989, 39.

16. "Bay Area Support Group Aids FSLN Cause," *El Tecolote*, June 27, 1975, 8. The *CODEX Newsletter* for the Galería de la Raza, September 1973, 1–2, referred to a benefit for earthquake victims. Galería meeting minutes also included plans to contact the Mechicano [*sic*] Art Center in Los Angeles, RCAF in Sacramento, and East Bay Raza artists. See Carol Lee Sanchez, Minutes, Galería de la Raza General Membership Meeting, February 7, 1973, Box 1/6/ Galería de la Raza, CEMA, UC Santa Barbara.

17. Stuart A. Kallen, *The Aftermath of the Sandinista Revolution* (Minneapolis: Twenty-First Century Books, 2009), 26.

18. Ibid., 33. Thomas Walker, *Nicaragua: Living in the Shadow of the Eagle*, 4th ed. (Boulder, CO: Westview Press, 2003), 31, 33.

19. Matilde Zimmermann, *Sandinista: Carlos Fonseca and the Nicaraguan Revolution* (Durham, NC: Duke University Press, 2000), 210.

20. Carlos Fonseca, quoted in Black, *Triumph of the People*, 90.

21. Daniel Ortega Saavedra, Victor M. Tirado López, and Humberto Ortega Saavedra, "Why the FSLN Struggles in Unity with the People," *Latin American Perspectives* 6, no. 1 (Winter, 1979): 108–113. According to *Latin American Perspectives*, "This document was published both in English and the original Spanish by *Gaceta Sandinista*, III (July–August 1978), in San Francisco."

22. James Brook, Chris Carlsson, and Nancy Peters, eds., *Reclaiming San Francisco: History, Politics, Culture* (San Francisco: City Lights, 1998); Richard Edward DeLeon, *Left Coast City: Progressive Politics in San Francisco, 1975–1991* (Lawrence: University Press of Kansas, 1992); Nan Alamilla Boyd, *Wide Open Town: A History of Queer San Francisco to 1965* (Berkeley: University of California Press, 2005).

23. Wilma Pearl Mankiller, *Mankiller: A Chief and Her People* (New York: St. Martin's Press, 1993), 152.

24. Cardenal, *Las Ínsulas Extrañas*, 475.

25. Nina Serrano, interview with author, April 16, 2003. Murguía also describes the creation of NIN in *Medicine of Memory*, 135.

26. Cynthia Gorney, "San Francisco: When the Golden Gate Leads Home," *The Washington Post*, March 25, 1984.

27. Cardenal, *Las Ínsulas Extrañas*, 476.

28. Walter Ferrety [*sic*], "From Guerrilla Commander to Top Cop," in Phillip Zwerling and Connie Martin, *Nicaragua: A New Kind of Revolution* (Westport, CT: Lawrence Hill, 1985), 5–6.

29. Francisco Flores, "Roberto Vargas: The Intersection of Personal Growth and Community Activism," *El Tecolote*, April 2001; Murguía described the presence of these high-profile figures in *Medicine of Memory*, 130–146.

30. Ferrety, "From Guerrilla Commander to Top Cop," 5–6.

31. The quote is widely translated as "inside the monster," or in "the belly of the beast," and in Spanish as "*en las entrañas del monstruo.*" For instance, the title of one collection of Martí's work is *Inside the Monster: Writings on the United States and American Imperialism*, trans. Elinor Randall, ed. Philip S. Foner (New York: Monthly Review Press, 1975), notably published the same year as Vargas's call for help. Similarly, "*en las entrañas del monstruo*" is widely associated with Martí, as in the work of Susana Rotker, "The (Political) Exile Gaze in Martí's Writing on the United States," in *José Martí's "Our America": From National to Hemispheric Cultural Studies*, ed. Jeffrey Grant Belnap and Raúl A. Fernández (Durham, NC: Duke University Press, 1998), 63. The actual quote is "*Viví en el monstruo, y le conozco las entrañas—y mi Honda es la de David,*" in his 1895 letter to Manuel Mercado. See Roberto Fernández Retamar, "José Martí en los orígenes del antimperialismo latinoamericano," in *From Romanticism to Modernismo in Latin America*, ed. David William Foster (New York: Routledge, 1997), 247–248.

32. Jose Martí, "Our America," reprinted as an appendix in Julio Ramos, *Divergent Modernities: Culture and Politics in Nineteenth-Century Latin America,* trans. John D. Blanco (Durham, NC: Duke University Press, 2001), 295.

33. "Bay Area Support Group," 8.

34. "Nicaragua: Its People, History, Politics and Economy," *El Tecolote*, June 27, 1975, 5–7.

35. Vargas, *Nicaragua,* 8.

36. Ibid., 10.

37. Audio recordings of Murguía and other poets are housed at the Freedom Archives in San Francisco.

38. Ernesto Che Guevara and John Gerassi, *Venceremos! The Speeches and Writings of Che Guevara* (New York: Macmillan, 1968), 398.

39. Mariscal, *Brown-Eyed Children*, 100.

40. Judson L. Jeffries briefly discussed the influence of Che Guevara on Black Panther leader Huey Newton, particularly how "the Black Panther Party was guided by a feeling of love," in *Huey P. Newton: The Radical Theorist* (Jackson: University Press of Mississippi, 2002), 33. Also see Rychetta Watkins, *Black Power, Yellow Power, and the Making of Revolutionary Identities* (Jackson: University of Mississippi, 2012) 62–64.

41. Murguía, *Medicine of Memory*, 122.

42. Flores, "Roberto Vargas"; Michelle Maria Boleyn, "Two Writers in the Mission," *North Mission News*, March 1987, 15.

43. Editorial Box, *Gaceta Sandinista,* San Francisco, December 1975.

44. Nina Serrano, "Un Sandinista en San Francisco: Recuerdos de Walter Ferretti," *Barricada Internacional*, July 8, 1989, 42.

45. Herrera, "Riffs on Mission District"; Roderick Anthony Hernandez, "Pocho-Che and the Tropicalization of American Poetics" (PhD diss, Stanford University, 2000).

46. Murguía, curriculum vitae, collection of the author; Murguía, *Medicine of Memory*, 118–125.

47. Janice Mirikitani, ed. *Time to Greez! Incantations from the Third World* (San Francisco: Glide, 1975); Pocho-Che Editorial publications included José Montoya, *El Sol y los de Abajo and Other R.C.A.F. Poems* (San Francisco: Ediciones Pocho-Che, 1972); Vargas, *Nicaragua*; Serrano, *Heart Songs*; Raúl Salinas, *Un Trip Through the Mind Jail y Otras Excursions* (San Francisco: Editorial Pocho-Che, 1980).

48. Herrera, "Riffs on Mission District"; Hernandez, "Pocho-Che."

49. Murguía, *Medicine of Memory*, 130.

50. Murguía, "Movimiento de Solidaridad," 39.

51. Murguía, "A Chicano Sandinista in Nicaragua," *Uno Magazine*, December 1, 1981, n.p.

52. Ibid.

53. Stephen Kinzer, "Sandinistas Mark Raid That Presaged Victory," *New York Times*, January 7, 1985, A4.

54. Zimmermann, *Sandinista*, 210–211.

55. Murguía, *Medicine of Memory*, 134. Murguía described this event as the first rally held for Nicaragua in the Mission and recalls it as prompted by an FSLN action in December of 1974. Poster scholar Lincoln Cushing reports, in an e-mail to the author on June 17, 2016, that an unknown artist at La Raza Silkscreen Center produced 1,000 of these posters for a January 4, 1975 march. However, the photograph of Murguía and Vargas did not appear in *El Tecolote* until June of 1975 ; see "Bay Area Support Group," *El Tecolote*, 8.

56. Serrano, "Un Sandinista en San Francisco," 42.

57. See Nora Gallagher, Ken McEldowney, Michael Singer, and Henry Weinsten, "Art for Harold's Sake: How Big Business Manipulates the Arts in San Francisco," *San Francisco Bay Guardian*, November 21, 1975; Ceci Brunazzi, "On the Performing Arts Center," *Arts Biweekly*, July 27, 1976, 3–4; and a series of oral history interviews collected by UC Berkeley's Regional Oral History Office: *The Arts and the Community Oral History Project: San Francisco Neighborhood Arts Pro-

gram, 1978, https://archive.org/stream/sfneighborartpro00riesrich/sfneighborartpro00riesrich _djvu.txt.

58. Murguía, curriculum vitae; Gilberto Osorio, "Fight for a Mission Cultural Center," *El Teco-lote,* July 1976, 8; Paul Kagawa, "Mission Shaff-ted," *Arts Biweekly,* February 15, 1977, 3–4; Scott Riklin, "Galería Museo: Mirror of the Mission," *Arts Biweekly,* November–December, 1977, 3–4.

59. Nina Serrano, conversation with author, May 10, 2003.

60. Ibid.

61. Serrano, interview, 2003. Serrano also described this encounter in her article on Walter Ferreti. See Serrano, "Un Sandinista en San Francisco," 42.

62. "Ernesto Cardenal in the Barrio," *Tin-Tan,* 2, no. 5 (1977): 13. Not coincidentally, Cardenal accepted *Tin-Tan*'s invitation to join the publication as a contributing editor, further cementing literary ties between San Francisco and the Sandinista cause.

63. Herrera, "Riffs on Mission District," 225.

64. Ibid.

65. "U.S. People in Solidarity with Nicaragua/La Solidaridad del Pueblo EE.UU hacia Nicaragua," *Bocay Suplemento Especial,* n.d., circa 1987, 4.

66. Emily K. Hobson, *Lavender and Red: Liberation and Solidarity in the Gay and Lesbian Left* (Berkeley: University of California Press, 2016), 111.

67. "Week of Solidarity with the People of Nicaragua," poster, October 1978, collection of Romeo Gilberto Osorio.

68. Murguía, *Medicine of Memory,* 137; also Murguía, "Movimiento de Solidaridad," 39.

69. Murguía, *Medicine of Memory,* 137.

70. Roxanne Dunbar-Ortiz, *Blood on the Border: A Memoir of the Contra War* (Cambridge, MA: South End Press, 2005), 42; Romeo Gilberto Osorio, interview by author, July 10, 2006.

71. Alejandro Murguía, *Southern Front* (Tempe, AZ: Bilingual Press/Editorial Bilingüe, 1990), 7.

72. Murguía, *Southern Front,* 13.

73. Ibid., 15.

74. Murguía, "Chicano Sandinista."

75. Michelle Chase stated, "Throughout the 1960s, Che's iconic photograph seemed to be everywhere, representing both revolution and a particular brand of masculinity" in *Revolution within the Revolution: Women and Gender Politics in Cuba, 1952–1962* (Chapel Hill: University of North Carolina Press, 2015), 45.

76. Serrano, interview, 2003.

77. Serrano, *Heart Songs,* 29.

78. Ibid.

79. Ibid.

80. *Después del Terremoto (After the Earthquake),* directed by Lourdes Portillo and Nina Serrano, 1979.

81. Rosa Linda Fregoso, ed., *Lourdes Portillo: The Devil Never Sleeps and Other Films* (Austin: University of Texas Press, 2001), 50–51. *Después del Terremoto* was part of Portillo's MFA work at the San Francisco Art Institute.

82. Fregoso, *Portillo,* 207.

83. Ibid.

84. Ibid.

85. Fregoso, *Portillo,* 50–51.

86. Juan Gonzales, "Powerful FSLN Documentary Premieres," *El Tecolote,* March 1979, n.p.

87. Fregoso, *Portillo,* 58.

88. Murguía, "Movimiento de Solidaridad," 39. Translation by author.

89. Tim Drescher, "The Brigada Orlando Letelier," *Community Murals,* Fall 1981, 5.

90. Ibid.

91. David Kunzle, *The Murals of Revolutionary Nicaragua, 1979–1992* (Berkeley: University of California Press, 1995), 12.

92. Susan Greene, "Artists Brigade to Nicaragua," *Community Murals Magazine*, Fall 1984.

93. Serrano, interview, 2003.

94. Dunbar-Ortiz, *Blood on the Border*, 77.

95. Gary Prevost and Harry E. Vanden, *The Undermining of the Sandinista Revolution* (New York: St. Martin's, 1999), 2.

96. Ibid., 2–3; Serrano, interview, 2003.

97. Murguía, *Medicine of Memory*, 146.

98. David R. Farber, *Taken Hostage: The Iran Hostage Crisis and America's First Encounter with Radical Islam* (Princeton, NJ: Princeton University Press, 2005), 10.

Chapter 7. The Activist Art of a Salvadoran Diaspora

1. Martivón Galindo uses many spellings of her first name. I use the name that appears on her book *Retazos*. However, other spellings include Marta Ivón and Martivonne. In her dissertation with the University of California, Berkeley, she uses Marta Ivonne.

2. Galindo, interview with author, 2007.

3. María Cristina García, *Seeking Refuge: Central American Migration to Mexico, the United States, and Canada* (Berkeley: University of California Press, 2006).

4. Cecilia Menjívar, *Fragmented Ties: Salvadoran Immigrant Networks in America* (Berkeley: University of California Berkeley, 2000), 6. Susan Bibler Coutin, *Nations of Emigrants: Shifting Boundaries of Citizenship in El Salvador and the United States* (Ithaca, NY: Cornell University Press, 2007), 8. Carlos B. Córdova discussed the unreliability of the 1990 and 2000 censuses in his book, *The Salvadoran Americans* (Westport, CT: Greenwood, 2005), 72–73.

5. Norma Chinchilla and Nora Hamilton documented the migration of radical politics in Los Angeles in "Changing Networks and Alliances in a Transnational Context: Salvadoran and Guatemalan Immigrants in Southern California," *Social Justice* 26, no. 3 (Fall 1999): 8–9.

6. Ana Patricia Rodríguez, *Dividing the Isthmus: Central American Transnational Histories, Literatures, and Cultures* (Austin: University of Texas Press, 2009), 167–168.

7. Menjívar, *Fragmented Ties*, 9.

8. For migrants in Los Angeles, see Nora Hamilton and Norma Stoltz Chinchilla, *Seeking Community in a Global City: Guatemalans and Salvadorans in Los Angeles* (Philadelphia: Temple University Press, 2001). "The Great Migration" usually refers to the mass migration of African Americans from the U.S. South to the North in the early twentieth century, as employed by Nicholas Lehman in *The Promised Land: The Great Black Migration and How It Changed America* (New York: Vintage, 1992). This event's transformative history models the ramifications of Central American migration in the last half of the twentieth century.

9. Córdova, *Salvadoran Americans*, 58.

10. "Hispanic Population Data for the Central City Area: San Francisco, CA PMSA" and "Hispanic Population Data for the Metropolitan Statistical Area," in *Metropolitan Racial and Ethnic Change—Census 2000*, Lewis Mumford Center for Comparative Urban and Regional Research, the University at Albany, SUNY, in collaboration with the Initiative on Spatial Structures in the Social Sciences at Brown University, http://mumford.albany.edu/census/HispanicPop/HspPopData.htm. Also see Córdova, *Salvadoran Americans*, 80; Brian J. Godfrey, *Neighborhoods in Transition: The Making of San Francisco's Ethnic and Nonconformist Communities* (Berkeley: University of California Press, 1988), 111, 138.

11. Renny Golden and Michael McConnell describe the origins and trajectory of this "new underground railroad" in *Sanctuary: The New Underground Railroad* (Maryknoll, NY: Orbis Books, 1986).

12. Córdova, *Salvadoran Americans*, 44.

13. Ana Patricia Rodríguez, "Refugees of the South: Central Americans in the U.S. Latino Imaginary," *American Literature* 73, no. 2 (2001): 389.

14. Alejandro Portes and Alex Stepick featured the conservative Nicaraguan population in Miami in their book, *City on the Edge: The Transformation of Miami* (Berkeley: University of California Press, 1993).

15. Arturo Arias, *Taking Their Word: Literature and the Signs of Central America* (Minneapolis: University of Minnesota Press, 2007); Claudia Milian, *Latining America: Black-Brown Passages and the Coloring of Latino/a Studies* (Athens: University of Georgia Press, 2013); Rodríguez, *Dividing the Isthmus*.

16. Osorio, interview by author, 2006.

17. Ibid.

18. Ibid.

19. Paul Almeida, *Waves of Protest: Popular Struggle in El Salvador, 1925–2005* (Minneapolis: University of Minnesota Press, 2008), 86–87. Carlos Córdova offered the number of those killed in *la matanza* in *Salvadoran Americans*, 10.

20. Osorio, interview, 2006.

21. Ibid.

22. Ibid.

23. I am grateful to Héctor Perla for informing me of the east/west orientation of the two plazas. Informal conversation, Austin, Texas, February 24, 2012.

24. The transnational, transcultural organizing for solidarity as Latinos on the left proved inspirational for Osorio. Osorio, interview, 2006.

25. Héctor Perla pointed out that Felix Kury was instrumental in the founding of the Progressive Salvadorans Committee. See his article, "Si Nicaragua Venció, El Salvador Vencerá: Central American Agency in the Creation of the U.S.-Central American Peace and Solidarity Movement," *Latin American Research Review* 43, no. 2 (2008): 146. For more on El Comité Civíco Pro Liberación de Nicaragua, see Chapter 6.

26. "Editorial," *El Pulgarcito*, August–September, 1977, 2.

27. Almeida, *Waves of Protest*, 161.

28. Osorio, interview, 2006.

29. Such reports on the dead and missing appeared repeatedly in *El Pulgarcito*. For example, "San Salvador: Exclusive Report," *El Pulgarcito*, April/May, 1977, 7; "Amnesty International Campaign for the Abolition of Torture," August/September, 1977, 3.

30. Quoted in "Jornada de Solidaridad con El Salvador en SF," *El Pulgarcito*, August/September 1977, 1.

31. Osorio, interview, 2006; George Draper, "El Salvador Protest [in] S.F.: FBI Assault Team Seizes 3," *San Francisco Chronicle*, April 6, 1978.

32. Edgar Sanchez, "Palmetto Museum," *El Tecolote*, June 27, 1975, 5. Sanchez provided the address as 630 Palmetto, not far from San Francisco State University.

33. Osorio, interview, 2006.

34. Oscar Maciel, e-mail to author, June 14, 2016.

35. Osorio, interview, 2006.

36. Ibid.

37. Ibid.

38. Ibid.

39. Ibid.

40. Ronald Reagan, "Address to the Nation on United States Policy in Central America," May 9, 1984, in *Public Papers of the Presidents of the United States: Ronald Reagan, 1981–1989*, vol. 4, bk.1 (Washington, DC: Government Publishing Office, 1986), 661.

41. Greg Grandin, *Empire's Workshop: Latin America, the United States, and the Rise of the New Imperialism* (New York: Metropolitan Books, 2006); Walter LaFeber, *Inevitable Revolutions: The United States in Central America* (New York: Norton, 1983); Juan González, *Harvest of Empire: A History of Latinos in America* (New York: Penguin Books, 2011).

42. United Nations Office of Public Information, "United Nations. Comision de la Verdad Para El Salvador / From Madness to Hope: The Twelve-Year War in El Salvador: Report of the Commission on the Truth for El Salvador," 1993, accessed on February 17, 2012, http://www.derechos.org/nizkor/salvador/informes/truth.html.

43. Victor Cartagena, interview by author, August 7, 2007.

44. For instance, Nicaragua, Cuba, and the Soviet Union did offer financial support to Salvadoran guerrillas in response to U.S. funding of the Contras. As Sara Steinmetz noted, "Whereas Nicaragua's new leaders had previously refrained from extending large-scale assistance to Salvadoran guerrillas in order to maintain peaceable relations with the Carter administration, they increased their assistance after Reagan's election." Sara Steinmetz, *Democratic Transition and Human Rights: Perspectives on U.S. Foreign Policy* (Albany: State University of New York, 1994), 120.

45. García, *Seeking Refuge*, x.

46. Susan Bibler Coutin, *Legalizing Moves: Salvadoran Immigrants' Struggle for U.S. Residency* (Ann Arbor: University of Michigan Press, 2000).

47. Galindo, interview, 2007.

48. Martivón Galindo, *Retazos* (San Francisco/San Salvador: Editorial Solaris, 1996), 41. Galindo recalled publishing "El Shopping Center" in *El Tecolote* in the mid-1980s. Galindo, interview, 2007.

49. Galindo, interview, 2007.

50. Héctor Perla Jr., "Si Nicaragua Venció, El Salvador Vencerá: Central American Agency in the Creation of the U.S.-Central American Peace and Solidarity Movement," *Latin American Research Review* 43, no. 2 (2008): 148.

51. Ibid., 137–138.

52. Marta Ivón Galindo, Cecilia Guidos, Joaquín Domínguez Parada, CODICES statement, Tomás Ybarra Frausto Archives, Archives of American Art, Smithsonian Institution, Box 15, Mission II file.

53. Shifra Goldman, *Dimensions of the Americas: Art and Social Change in Latin America and the United States* (Chicago: University of Chicago Press, 1994), 232.

54. Martivón Galindo, *Between Shadow and Space: Martivón Galindo, Watercolors and Prints,* brochure for an exhibit at the Piñata Art Gallery, October 10–November 12, 2005, collection of the author.

55. Goldman, *Dimensions,* 232.

56. Galindo, interview, 2007.

57. Ibid.

58. Ibid.

59. Richard Montoya, Ricardo Salinas, and Herbert Siguenza, *Culture Clash: Life, Death, and Revolutionary Comedy* (New York: Theatre Communications Group, 1998), xii.

60. Galindo interview 2007.

61. Montoya, Salinas, and Siguenza, *Culture Clash*. Cary Cordova, "Culture Clash," in *Latino History and Culture: An Encyclopedia*, ed. David J. Leonard and Carmen R. Lugo-Lugo (Armonk, NY: Sharpe Reference, 2010).

62. Galindo, interview, 2007.

63. In an unrecorded statement to the author, Galindo expressed the narrative's personal connection to her experience. Galindo, interview, 2007; Martivón Galindo, "Armas," *Humanizarte* (literary supplement of *El Tecolote*), Summer 1986, vol. 7, no. 1, 6.

64. Translation by John Mckiernan-González.

65. Galindo, "Armas." Translation by John Mckiernan-González.

66. Galindo, interview, 2007.

67. Marta Ivonne Galindo, "Soñando una Nación y Creando una Identidad: Poesía Salvadoreña Durante los Años de Guerra" (PhD diss., University of California, Berkeley, 1998).

68. Córdova, *Salvadoran Americans,* 17. Also see Menjívar, *Fragmented Ties.*

69. Ana Patricia Rodríguez, "'Departamento 15': Cultural Narratives of Salvadoran Transnational Migration," *Latino Studies* 3, no. 1 (April 2005): 19–41.

70. Andrés Torres, *Latinos in New England* (Philadelphia: Temple University Press, 2006), 162.

71. Victor Cartagena, interview by author, August 7, 2007.

72. Ibid.

73. Ibid.

74. Ibid.

75. Ibid. For more on Diego Rivera's popularity in the Mission, see Chapter 5. For information about the Frida Kahlo revival, see Chapter 8.

76. Cartagena, interview, 2007. The founding of Tamoanchán is hard to establish because it started organically through relationships at CODICES. One article stated it began in 1990, but it is apparent these artists were working together before that date. "Tamoanchán Regresa a su Patria" (Tamoanchán Returns to Home Country), *La Prensa Grafica*, July 14, 1998, 63.

77. Kimberly Chun, "Tender Mercies," *San Francisco Chronicle*, September 10, 1999, 1.

78. Quoted in "Introduction," *Frontiers: A Journal of Women Studies* 18, no. 1 (1997): v.

79. Chun, "Tender Mercies," 1.

80. Cartagena, interview, 2007.

81. Ibid.

82. Ibid.

83. Ibid.

84. Ibid.

85. Ibid. The altar also is featured in *El Corazón de la Muerte: Altars and Offerings for Days of the Dead* (Oakland: Oakland Museum of California, 2005), 58–59.

86. Cartagena, interview, 2007.

87. Ibid.

88. Galindo, interview, 2007.

89. Ibid.

90. Cartagena, interview, 2007.

91. Ibid.

Chapter 8. The Politics of Día de los Muertos

1. Richard Rodriguez, *Days of Obligation: An Argument with My Mexican Father* (New York: Viking, 1992), 40.

2. Edward Guthmann, "AIDS Artists Remembered/The Faces Behind the Statistics," *San Francisco Chronicle*, December 7, 1986. Statistics from San Francisco Department of Health Aids Office, Seroepidemiology and Surveillance units, "AIDS Cases Reported through October 1995," *AIDS Surveillance Report*, October 31, 1995, 1, in Michelle Cochrane, *When AIDS Began: San Francisco and the Making of an Epidemic* (New York: Routledge, 2004), 139. Also see Randy Shilts, *And the Band Played On: Politics, People, and the AIDS Epidemic* (New York: St. Martin's, 1987); Benjamin Heim Shepard, *White Nights and Ascending Shadows: An Oral History of the San Francisco AIDS Epidemic* (London: Cassell, 1997).

3. In 1985, while covering an effort to halt deportations and prevent prosecutions of participants in the sanctuary movement, Susan Sward and William Carlsen reported that "San Francisco was chosen as the site for the court battle because it is the capital of the nation's church sanctuary movement sheltering Salvadorans." Sward and Carlsen, "Salvadorans in U.S. Live in Fear," *San Francisco Chronicle*, May 3 1985, 25. For related demographics in San Francisco, see Carlos B. Córdova, "The Mission District: The Ethnic Diversity of the Latin American Enclave in San Francisco, Calif.," *Journal of La Raza Studies* 2, no. 1 (Summer/Fall, 1989); Jean Molesky, "Amnesty for Qualified Immigrants in the San Francisco Bay Area: The Implementation of the Immigration Reform and Control Act of 1986," *Journal of La Raza Studies* 2, no. 1 (Summer/Fall, 1989): 16–20. For more on the sanctuary movement, see Robert Tomsho, *The American Sanctuary Movement* (Austin: Texas Monthly Free Press, 1987); Susan Bibler Coutin, *The Culture of Protest: Religious Activism and the*

U.S. Sanctuary Movement (Boulder, CO: Westview, 1993); Ann Crittenden, *Sanctuary: A Story of American Conscience and the Law in Collision* (New York: Weidenfeld and Nicolson, 1988); and Renny Golden and Michael McConnell, *Sanctuary: The New Underground Railroad* (Maryknoll, NY: Orbis, 1986).

4. Christian Smith, *Resisting Reagan: The U.S. Central America Peace Movement* (Chicago: University of Chicago Press, 1996); Noam Chomsky, *Chomsky Reader,* ed. James Peck (New York: Pantheon, 1987). Also see Shilts, *And the Band Played On*; Benjamin Heim Shepard and Ronald Hayduk, *From ACT UP to the WTO: Urban Protest and Community Building in the Era of Globalization* (New York: Verso, 2002); and Sarah Schulman, *My American History: Lesbian and Gay Life in the Reagan and Bush Years* (New York: Routledge, 1994).

5. Study cited in Ronald E. Powaski, *Return to Armageddon: The United States and the Nuclear Arms Race, 1981–1999* (Oxford: Oxford University Press, 2000), 18; Ronald E. Powaski, *March to Armageddon: The United States and the Nuclear Arms Race, 1939 to the Present* (New York: Oxford University Press, 1989); and Frances FitzGerald, *Way Out There in the Blue: Reagan, Star Wars and the End of the Cold War* (New York: Simon and Schuster, 2000).

6. Ibid.

7. Roberto Berdecio and Stanley Appelbaum, *Posada's Popular Mexican Prints: 273 Cuts* (New York: Dover, 1972); and Patrick Frank, *Posada's Broadsheets: Mexican Popular Imagery, 1890–1910* (Albuquerque: University of New Mexico Press, 1998).

8. Not only was Posada's work in general circulation, but San Francisco's Galería de la Raza held an important exhibit of his work in 1974 (September 15–27, 1974). "Galería de la Raza," 1972–1976 schedule, Tomás Ybarra-Frausto collection, Archives of American Art (AAA), Box 9.

9. Many texts focus on the history and rites of Día de los Muertos. Regina M. Marchi provided an excellent overview of the U.S. celebration, including some of the political dimensions of the event in *Day of the Dead in the USA: The Migration and Transformation of a Cultural Phenomenon* (New Brunswick: Rutgers University Press, 2009). Also see Elizabeth Carmichael and Cholë Sayer, *The Skeleton at the Feast: The Day of the Dead in Mexico* (Austin: University of Texas Press, 1991); René H. Arceo Frutos, *Día de los Muertos: A Celebration of This Great Mexican Tradition Featuring Articles, Artwork, and Documentation from Mexico, Across the United States and Chicago* (Chicago: Mexican Fine Arts Center Museum, 1991); Bobbi Salinas-Norman, *Indo-Hispanic Folk Art Traditions II: A Book of Culturally-based, Year-round Activities with an Emphasis on the Day of the Dead* (Albuquerque, NM: Piñata, 1990). Several texts have a Bay Area focus: Suzanne Shumate Morrison, "Mexico's 'Day of the Dead' in San Francisco, California: A Study of Continuity and Change in a Popular Religious Festival" (PhD diss., Graduate Theological Union, Berkeley, CA, 1992); Tere Romo, curator, *Chicanos en Mictlán: Día de los Muertos in California* (San Francisco: Mexican Museum, 2000). Also see *La Ofrenda*, directed by Lourdes Portillo and Susana Muñoz, Xochitl Films, 1989. In addition, Bay Area residents Zoe Harris and Yolanda Garfias Woo produced a children's book about the Day of the Dead informed by Bay Area practices: Harris and Garfias Woo, *Piñatas and Smiling Skeletons: Celebrating Mexican Festivals* (Berkeley, CA: Pacific View, 1998). Lara Medina and Gilbert R. Cadena provide a meaningful discussion of the religious significance of the Los Angeles procession; see Medina and Cadena, "Días de los Muertos: Public Ritual, Community Renewal, and Popular Religion," in *Horizons of the Sacred: Mexican Traditions in U.S. Catholicism*, ed. Timothy M. Matovina and Gary Riebe-Estrella (Ithaca, NY: Cornell University, 2002). The altars have provoked analysis for their spiritual resonance: Amalia Mesa-Bains, *Ceremony of Memory: Nature and Memory in Contemporary Latino Art* (San Francisco: Mexican Museum, 1993); Kay Turner, *Beautiful Necessity: The Art and Meaning of Women's Altars* (New York: Thames and Hudson, 1999). Also see the general bibliography compiled by Salvador Guereña and Raquel Quiroz, with assistance from Luis Leal, in *Día de los Muertos: An Illustrated Essay and Bibliography* (Santa Barbara, CA: Center for Chicano Studies and Colección Tloque Nahuaque University Library, 1983).

10. Saucedo quoted by Tomás Ybarra-Frausto in "Recuerdo, Descubrimiento, Voluntad: Mexican/Chicano Customs for the Day of the Dead," in Arceo Frutos, *Día de los Muertos*, 28.

11. Ibid., 26.

12. Not all Latin American celebrations limit Día de los Muertos to November 1 and 2. Many still follow ancient indigenous calendars.

13. Amalia Mesa-Bains distinguished between altars and *ofrendas* as follows: "The difference between an altar and an *ofrenda* is that a home altar is the permanent, ongoing record of the family's life. So if someone dies in the war their little medals are put there; when babies are born, their booties are put there; when people get married, their corsages are put there. . . . The *ofrenda* is a temporal offering that is only done on the Day of the Dead and only for the remembrance of the soul departed." Amalia Mesa-Bains, quoted in Anne Barclay Morgan, "Interview: Amalia Mesa-Bains," *Art Papers*, March and April 1995, 24–29. Jennifer A. González used this public/private distinction to separate Mesa-Bains' altar installations from the altars in Day of the Dead exhibitions in *Subject to Display: Reframing Race in Contemporary Installation Art* (Cambridge, MA: MIT Press, 2008). Tomás Ybarra-Frausto observed the public/private dimensions of *ofrendas* in Mexico versus the United States: "The *ofrendas* in Mexico are usually family affairs. . . . In Mexican/Chicano communities, the *ofrendas* tend to be collective commemorations created by artists in public spaces such as art centers, galleries or museums." Ybarra-Frausto in "Recuerdo, Descubrimiento, Voluntad," 28. Both Mesa-Bains and Ybarra-Frausto described the more public orientation of the *ofrenda*, at least in the United States. However, most artists did not make this distinction between *altar* and *ofrenda*. The two terms are often used interchangeably in the United States and in this text.

14. These features of the *ofrenda* have a long-standing history in Mexico, though they also vary by region and individual preference. See Carmichael and Sayer, *The Skeleton at the Feast*, 18–24.

15. Laurie Kay Sommers wrote, "Mexican-Americans throughout California began to use a newly self-conscious sense of ethnicity as a strategy to achieve group solidarity and social change. Shared cultural forms—such as festivals, dance, music, and foodways—and a shared history as an oppressed internal colony of white America, were the tools employed by Movement leaders to galvanize group emotions and affirm group identity." Sommers, "Symbol and Style in Cinco de Mayo," *Journal of American Folklore* 98, no. 390 (1985): 478.

16. For instance, Carolina Ponce de Leon, director of Galería de la Raza, followed tradition in attributing the first public celebration to Galería de la Raza (Carolina Ponce de Leon, "Día de los Muertos y La Misión," in Romo, *Chicanos en Mictlán*, 20. Most Bay Area newspaper articles on Día de los Muertos have been consistent with this attribution. Others, such as Suzanne Shumate Morrison, have been more hesitant to ascribe credit to Galería de la Raza (Morrison, "Mexico's 'Day of the Dead,'" 344). Shifra Goldman observed that René Yañez "made his first altar in 1967, and instituted Day of the Dead celebrations by 1972 in the Galería de la Raza." Goldman, *Dimensions of the Americas: Art and Social Change in Latin America and the United States* (Chicago: The University of Chicago Press, 1994), 230.

17. Yolanda Garfias Woo, interview by author, Daly City, CA, May 14, 2003.

18. Carmen Lomas Garza, interview, San Francisco, October 30, 1982, uncorrected transcript from Califas videotapes 56–58, transcribed by Carlos Palado, Califas Book 2, 1, in Califas Conference Final Report, AAA.

19. Rafaela Castro, "The Day of the Dead Celebrates Life in a Multicultural Society," *San Francisco Chronicle*, October 31, 1993, A17.

20. When Sinclair withdrew his support, the project folded, but the footage reappeared in a variety of films. Sinclair gave Eisenstein's footage to director Sol Lesser, who produced *Thunder Over Mexico* (1933) and two shorts: *Eisenstein in Mexico* (1934) and *Day of the Dead* (1934). Grigori Alexandrov later reclaimed and edited the film according to his best recollection of Eisenstein's intent, producing *Que Viva Mexico* in 1979.

21. Alexander Girard, *The Magic of a People/El Encanto de un Pueblo: Folk Art and Toys from the Collection of the Girard Foundation* (New York: Viking, 1968); Frank Duane, "Hemisfair '68," Handbook of Texas Online, https://tshaonline.org/handbook/online/articles/lkh01; Henry Glassie, *The Spirit of Folk Art: The Girard Collection at the Museum of International Folk Art* (New York: Abrams, 1989).

22. Octavio Paz, *The Labyrinth of Solitude,* trans. Lysander Kemp, Yara Milos, and Rachel Phillips Belash (1950; repr., New York: Grove, 1985), 57–58.

23. Juanita Garciagodoy, "Contemporary Attitudes Toward Death," *Digging the Days of the Dead: A Reading of Mexico's Dias de Muertos* (Niwot: University Press of Colorado, 1998), 173–195.

24. Richard P. Cimino and Don Lattin, *Shopping for Faith: American Religion in the New Millennium* (San Francisco: Jossey-Bass, 1998).

25. Garfias Woo, interview, 2003.

26. Ibid.

27. Harriet Swift, "Day of the Dead Rises across the Border," *The Oakland Tribune,* November 1, 1990, G1–G2.

28. René Yañez, interview by Ralph Maradiaga, curator, in *The Fifth Sun: Contemporary/Traditional Chicano & Latino Art* (Berkeley: University Art Museum, 1977), 32.

29. Chloë Sayer, *Mexico: The Day of the Dead: An Anthology* (Boston: Shambhala, 1993), 10; Carmichael and Sayer, *The Skeleton at the Feast*, 18–24.

30. Sybil Venegas, "The Day of the Dead in Aztlán: Chicano Variations on the Theme of Life, Death, and Self-Preservation," in Romo, *Chicanos in Mictlán*, 42–53.

31. Gronk, Oral History interviews by Jeffrey Rangel, Los Angeles, January 20 and 23, 1997, for the AAA, Smithsonian Institution, http://www.aaa.si.edu/collections/interviews/oral-history-interview-gronk-13586.

32. Emilia "Mia" Galaviz de Gonzalez, interview by author, February 5 and 12, 2003

33. Ralph Maradiaga credited Garfias Woo with providing "a traditional way of doing a Day of the Dead altar, since we've had these shows"; Ralph Maradiaga, Slide Presentation, UC Santa Cruz, April 17, 1982, transcript from videotape 6B, Califas Book 1, 108, in *Califas Conference Final Report*, AAA.

34. "Día de los Muertos," Galería de la Raza, San Francisco, October 25–November 12, 1983, Galería de la Raza collection, CEMA, Box 16/8.

35. For more on Casa Hispana festivals and the origins of Día de la Raza, see Chapter 3.

36. "El Patronato del Sexto Festival Annual de la Raza/Hispanidad 71 Presenta Día de las Animas," Casa Hispana de Bellas Artes, November 2, 1971. Don Santina personal archive.

37. Ibid.

38. Osorio, quoted in Scott Riklin, "Galería Museo: Mirror of the Mission," *The Arts Biweekly,* November/December 1977, 3–4.

39. Ibid.

40. Maria Pinedo, "Galería de la Raza," *KPFA Folio*, 28, no. 2 (February 1977).

41. Marta Sanchez, "DeadCalm: Galería de la Raza Brings Intimacy to Day of the Dead Tradition," *New Mission News*, October 1993, 11.

42. "Homenaje a Frida Kahlo/Homage to Frida Kahlo," Galería de la Raza, San Francisco, November 2–December 14, 1978, Galería de la Raza collection, CEMA.

43. Timothy Drescher, "The Galería de la Raza/Studio 24 Culture and Community," article draft, no date, Tomás Ybarra-Frausto Collection, AAA, Box 9.

44. Raquel Tibol, *Frida Kahlo: Cronica, Testimonios y Aproximaciones* (Mexico: Ediciones de Cultura Popular, 1977); Raquel Tibol, *Frida Kahlo: Una Vida Abierta* (1983; repr., Mexico: Editorial Oasis, 1987); Hayden Herrera, *Frida, a Biography of Frida Kahlo* (New York: Harper and Row, 1983); Edward J. Sullivan, "Frida Kahlo in New York," in *Pasión por Frida: Museo Estudio Diego Rivera, De Grazía Art and Cultural Foundation 1991–1992*, ed. Blanca Garduño and José Antonio Rodríguez (Mexico: Instituto Nacional de Bellas Artes, 1992), 182–184.

45. Goldman, *Dimensions*, 181; *Frida Kahlo, 1910–1954* (Chicago: Museum of Contemporary Art, Chicago, 1978). The *Frida Kahlo* catalogue featured an essay by Hayden Herrera, who was in the early stages of writing her influential biography, *Frida, a Biography of Frida Kahlo.*

46. Ramon Favela emphasized the role that Galería de la Raza played in the Frida Kahlo revival in "The Image of Frida Kahlo in Chicano Art," in Garduño and Rodríguez, *Pasión por Frida*, 185–189.

Yañez discussed San Francisco art institution prejudices aimed at Kahlo in an interview with author, 2003.

47. Amalia Mesa-Bains, "Art/Chicano Movement," in *Activists Speak Out: Reflections on the Pursuit of Change in America,* ed. Cieri Marie and Claire Peeps (New York: Palgrave, 2000), 215.

48. Carmen Lomas Garza, "California Arts Council Evaluation Form," San Francisco: Galería de la Raza, 1980–1981. Galería de la Raza collection, CEMA, Box 6/2.

49. The 1983 program firmly stated, "Día de los Muertos in San Francisco started with an idea discussed by René Yañez and Ralph Maradiaga in August, 1972" and "Museums and other galleries have created Día de los Muertos exhibitions based on the concept originated by Galería de la Raza in 1972." "Día de los Muertos," Galería de la Raza, San Francisco, October 25–November 12, 1983, Galería de la Raza collection, CEMA, Box 16/8.

50. Garfias Woo, interview, 2003.

51. Ibid.

52. Ibid.

53. Laura Elisa Pérez, *Chicana Art: The Politics of Spiritual and Aesthetic Altarities* (Durham, NC: Duke University Press, 2007), 88.

54. "Herminia Romero: El Arte de Hacer Altares," *Segundamano,* November 16–30, 1993, 1.

55. Claire Bishop, *Installation Art: A Critical History* (New York: Routledge, 2005); Hugh M. Davies and Ronald J. Onorato, *Blurring the Boundaries: Installation Art, 1969–1996* (San Diego, CA: Museum of Contemporary Art, 1997); Nicolas de Oliveira, Nicola Oxley, Michael Petry, *Installation Art in the New Millennium: The Empire of the Senses* (New York: Thames and Hudson, 2003) ; and Mark Rosenthal, *Understanding Installation Art: From Duchamp to Holzer* (London: Prestel, 2003).

56. Amalia Mesa-Bains, "Altar as an Art Form" statement, n.d. Tomás Ybarra-Frausto collection, AAA, Box 14/Mesa-Bains.

57. Kay Turner and Pat Jasper, "Day of the Dead: The Tex-Mex Tradition," in *Halloween and Other Festivals of Death and Life,* ed. Jack Santino (Knoxville: The University of Tennessee Press, 1994), 133–151.

58. Yvonne Yarbro-Bejarano, "Turning It Around: Chicana Art Critic Yvonne Yarbro-Bejarano Discusses the Insider/Outsider Visions of Ester Hernández and Yolanda López," *Crossroads* 31 (May 1993), 15.

59. Amalia Mesa-Bains, "The Art of Provocation: Works by Ester Hernández," Gorman Museum, UC Davis, October 10–November 17, 1995, 3.

60. Día de los Muertos artist applications for Ester Hernandez, Jack Heyman, Jos Sances, and René Castro, 1983. Galería de la Raza collection, CEMA, Box 16/7.

61. Ibid.

62. Ibid.

63. For more on the Balmy Alley murals, see Chapter 5.

64. Enrique Chagoya, e-mail to author, July 7, 2016.

65. Ibid.

66. Ibid.

67. Moira Roth, "Interview," in *Enrique Chagoya: When Paradise Arrived* (New York: Alternative Museum, 1989), 6.

68. Shilts, *And the Band Played On,* 90.

69. Ibid., 188, 209.

70. Ibid., 284.

71. Silvana Paternostro, *In the Land of God and Man: Confronting Our Sexual Culture* (New York: Dutton, 1998); David Román, *Acts of Intervention: Performance, Gay Culture, and AIDS* (Bloomington: Indiana University Press, 1998); Sander L. Gilman, *Disease and Representation: Images of Illness from Madness to AIDS* (Ithaca, NY: Cornell University Press, 1988); and Susan Sontag, *Illness as Metaphor* and *AIDS and Its Metaphors* (New York: Picador USA, 2001).

72. Guthmann, "AIDS Artists Remembered," 1986.

73. Juan Pablo Gutiérrez, e-mail to author, October 15, 2014.

74. Ibid.

75. For instance, Christina B. Hanhardt noted how Josh Sides characterized "the response to antigay violence during the 1970s as a struggle between straight Latinos and white gays in the Mission and Castro" in *Safe Space: Gay Neighborhood History and the Politics of Violence* (Durham, NC: Duke University Press, 2013), 114. See Josh Sides, *Erotic City: Sexual Revolutions and the Making of Modern San Francisco* (Oxford: Oxford University Press, 2009), 159–161. Sides drew on late-1970s media coverage, which encouraged simplistic representations of these communities, especially following a series of homophobic physical assaults in the Mission.

76. Horacio N. Roque Ramírez, "Gay Latino Histories / Dying to Be Remembered: AIDS Obituaries, Public Memory, and the Queer Latino Archive," in *Beyond El Barrio: Everyday Life in Latina/o America*, ed. Gina M. Pérez, Frank A. Guridy, and Adrian Burgos Jr. (New York: New York University Press, 2010), 110.

77. Shilts, *And the Band Played On*, 491–492.

78. Ibid., 569.

79. Román, *Acts of Intervention*; Shepard, *White Nights and Ascending Shadows*; Marita Sturken, *Tangled Memories: The Vietnam War, the AIDS Epidemic, and the Politics of Remembering* (Berkeley: University of California Press, 1997); Diana Taylor, *Disappearing Acts: Spectacles of Gender and Nationalism in Argentina's "Dirty War"* (Durham, NC: Duke University Press, 1997); David Rimanelli, "Time Capsules, 1986–1990," *Artforum*, April 2003.

80. Garfias Woo, interview, 2003.

81. "Rooms for the Dead" press release, Mission Cultural Center, San Francisco, November 2, 1990. Personal papers of René Yañez.

82. José Antonio Burciaga, "Rooms for Los Muertos," n.d./c. 1990. Personal papers of René Yañez; Gary Gach, "Expunging Death: Rooms for the Dead at Galería Museo," *Artweek* 21, no. 39 (1990): 13.

83. Burciaga, "Rooms for Los Muertos."

84. Dawn Garcia, "Mexican Day of Dead Revived," *San Francisco Chronicle,* November 2, 1990, 4.

85. Gach, "Expunging Death," 1990.

86. Swift, "Day of the Dead Rises Across the Border," 1990.

87. Turner and Jasper, "Day of the Dead," 134.

88. "Lively Times in Latino San Francisco," *Sunset*, October 1989, 32–37.

89. Lon Daniels, "The Day of the Dead: Mission District Celebrates Ancient Aztec Festival," *San Francisco Examiner*, November 3, 1990, A1.

90. Warren Hinckle, "Halloween '81—For Gays, a Night to Stay Home," *San Francisco Chronicle*, November 2, 1981, 6. Turner and Jasper discuss the conflation between Día de los Muertos and Halloween in "Day of the Dead," 135.

91. Jack Kugelmass wrote, "Greenwich Village has a long, albeit erratic, history of impromptu Halloween celebrations, and there is undoubtedly a link between the recent emergence of such carnivalesque celebrations and the increasingly public nature of gay culture." See Kugelmass, "Wishes Come True: Designing the Greenwich Village Halloween Parade," in Santino, *Halloween and Other Festivals of Death and Life*, 194; Kugelmass, "Imagining Culture: New York City's Village Halloween Parade," in *Feasts and Celebrations in North American Ethnic Communities*, ed. Ramón A. Gutiérrez and Geneviève Fabre (Albuquerque: University of New Mexico Press, 1995), 141–157.

92. Cynthia Robins, "The Spirits of San Francisco," *San Francisco Examiner,* October 31, 1982, Scene/Arts 1.

93. Georgie Dennison, "The Beginning of the Spiral Dance: It Was 20 Years Ago," *Reclaiming Quarterly* (1999), http://www.reclaimingquarterly.org/web/spiraldance/spiral4.html.

94. George Franklin, "Ten Years of Needle Exchange in San Francisco," *GroundWork*, 1998, accessed October 21, 2004, http://www.groundworknews.org/commun/commun-harm.html.

95. "Día de los Muertos," in "Mission Life," in the *S.F. Independent*, October 1993, 16.

96. Susan Ferriss, "The Mission Celebrates the Dead," *San Francisco Examiner*, November 1, 1993, A3.

97. Garfias Woo, interview, 2003.

98. Alejandro Murguía, *This War Called Love: 9 Stories* (San Francisco: City Lights, 2002), 62.

99. Mike Davis, *Magical Urbanism: Latinos Reinvent the U.S. City* (New York: Verso, 2000), 41.

Epilogue

1. Rio Yañez, interview with author, San Francisco, August 6, 2007.

2. Ibid.

3. "Rio Yañez," *The Great Tortilla Conspiracy,* http://tortillaconspiracy.wordpress.com/artists/.

4. René Yañez described prospective investors viewing his building in Rebecca Solnit and Susan Schwartzenberg, *Hollow City: The Siege of San Francisco and the Crisis of American Urbanism* (London: Verso, 2002), 113. Yañez explained, "My building is for sale, and people come through every day. I'm trying to buy it, but it's a half-million dollars." In the 2001 documentary film *Boom: The Sound of Eviction*, directed by Francine Cavanaugh, A. Mark Liiv, and Adams Wood, Yañez is practically in tears over his pending eviction. Residents stopped those proceedings but have lived with the threat of eviction for more than a decade.

5. Joseph Grubb, "Rent Board Annual Report on Eviction Notices," Rent Stabilization and Arbitration Board, April 20, 2000, http://sfrb.org/annual-eviction-reports. Marisa Lagos, "Evictions Surge as Market Heats Up," *San Francisco Chronicle*, November 5, 2013, A1, A7; Jessica Kwong, "Supply, Demand and Evictions," *San Francisco Examiner*, November 15, 2013, 4.

6. Delene Wolf, "Rent Board Annual Report on Eviction Notices," Rent Stabilization and Arbitration Board, April 13, 2010, and March 11, 2014, http://sfrb.org/annual-eviction-reports.

7. Anti Eviction Mapping Project, http://antievictionmappingproject.net/.

8. Blanca Torres, "San Francisco Median Home Hits $1 Million," *San Francisco Business Times,* May 17, 2013, http://www.bizjournals.com/sanfrancisco/blog/real-estate/2013/05/median-home-price-hits-1-million-in.html?s=print.

9. Lagos, "Evictions Surge."

10. George Avalos and Pete Carey, "Bay Area Apartment Rents Set Record," *San Jose Mercury News*, April 15, 2014.

11. Michael Helft, "Google's Buses Help Its Workers Beat the Rush," *New York Times*, March 10, 2007, A1.

12. Tech companies do not share their transit routes and stops, but Stamen Design mapped routes using observational data, city reports, and online corporate data. Stamen Design, "The City from the Valley," commissioned by Zero1 and presented with support of the James Irvine Foundation, 2012, http://v1.stamen.com/zero1/ and http://stamen.com/work/the-city-from-the-valley/. Also see Geoffrey A. Fowler, "Map Reveals Corporate Bus Routes Tech Workers Take," *Wall Street Journal*, October 10, 2012.

13. Erin McElroy, "No-Fault Evictions and Tech Bus Stops," Anti-Eviction Mapping Project, http://www.antievictionmappingproject.net/techbusevictions.html.

14. Jennifer Baires, "Google, Facebook Pay for Shuttles to Use San Francisco Bus Stops," Reuters, August 1, 2014.

15. "Battle Over Buses: San Francisco to Charge Tech Companies Fees for Shuttles," CBS News, January 22, 2014, http://www.cbsnews.com/news/battle-over-buses-san-francisco-to-charge-tech-companies-fees-for-shuttles/.

16. Stephen Pitti, *The Devil in Silicon Valley: Northern California, Race, and Mexican Americans* (Princeton, NJ: Princeton University Press, 2003), 199.

17. Laura Sydell, "What It's Like to Live on Low Pay in a Land of Plenty," NPR, December 18, 2013, http://www.npr.org/blogs/alltechconsidered/2013/12/17/251992536/security-guards-at-big

-tech-companies-struggle-with-low-pay; Adam Satariano, "Google Buses Fuel Inequality Debate as Boom Inflates Rents," Bloomberg, February 25, 2014, http://www.bloomberg.com/news/2014-02-25 /google-buses-fuel-inequality-debate-as-boom-inflates-rents-tech.html.

18. Baires, "Google, Facebook Pay for Shuttles."

19. Kristina Shevory, "Twitter's New Home Is Helping Revive a Seedy San Francisco Neighborhood," New York Times, November 2, 2013, B1. Several of the tech companies signed "community benefit agreements," or CBAs, expressing commitments to contribute positively to the neighborhood, but with little concrete objectives. See Angela Johnston, "The New Gold Rush: What Impacts Are Tech Companies Really Having on San Francisco's Mid-Market District?" KALW.org, April 4, 2014, http://kalw.org/post/what-impacts-are-tech-companies-really-having-san-francisco-s-mid -market-district.

20. Rebecca Bowe, "Corporate Welfare Boom: SF's Business Tax Breaks Jump to $14.2 Million Annually," San Francisco Bay Guardian, September 16, 2013.

21. Evelyn Nieves, "In Old Mission District, Changing Grit to Gold," New York Times, January 21, 1999, A11.

22. Steve Henn, "Is Silicon Valley Automating Our Obsolescence," NPR, December 16, 2013, http://www.npr.org/blogs/alltechconsidered/2013/12/16/251645736/is-silicon-valley-automating -our-obsolescence.

23. San Francisco Human Services Agency (SF HSA), "San Francisco's Widening Income Inequality," May 2014, accessed September 27, 2016, http://www.sfhsa.org/asset/ReportsDataResources /FamEconSuccessForum_IncomeInequality.pdf.

24. John Ritter, "San Francisco Hopes to Reverse Black Flight," USA Today, August 28, 2007.

25. Rigoberto Hernandez, "Latinos Make Gains Everywhere Except the Mission," June 23, 2011, Mission Local, http://missionlocal.org/2011/06/latinos-make-gains-everywhere-except-in-the -mission/.

26. PolicyLink and PERE USC Program for Environmental and Regional Equity, An Equity Profile of the San Francisco Bay Area Region, 2015, 23–24, http://www.policylink.org/sites/default /files/documents/bay-area-profile/BayAreaProfile_21April2015_Final.pdf.

27. Heather Knight, "Income Inequality on Par with Developing Nations," SFGate.com, June 25, 2014, http://www.sfgate.com/bayarea/article/Income-inequality-on-par-with-developing-nations -5486434.php.

28. Heather Mack, "'Royalty' of the Mission Art Scene Faces Eviction," MissionLocal, October 2, 2013.

29. Guillermo Gómez-Peña, "A Heartfelt Letter to René Yañez & the SF Arts Community," Tirado, September 2013, http://tirado.tumblr.com/post/62588866162/a-heartfelt-letter-to-rene-yanez -the-sf-arts.

30. Mack, "'Royalty.'"

31. Quoted in Solnit and Schwartzenberg, Hollow City, 113.

32. Mack, "'Royalty.'"

33. Isabel Angell, "In San Francisco, Rent Control Gets Personal," KALW.org, March 13, 2014, http://kalw.org/post/san-francisco-rent-control-gets-personal; Jim Forbes, "The Birth of Rent Control in San Francisco," San Francisco Apartment Magazine, June 1999, 12–13.

34. See comments, Mack, "'Royalty.'"

35. Lynne Shallcross, Andra Cernavskis, Alexandra Garreton, and Heather Mack, "Live: Anti-Evictions Protest on 24th Street," MissionLocal, October 12, 2013, http://missionlocal.org/2013/10 /live-anti-evictions-protest-on-24th-street/.

36. Lauren Smiley, "The Downtrodden Landlord," The New Yorker, March 12, 2014, http://www .newyorker.com/business/currency/the-downtrodden-landlord.

37. See comments, Mack, "'Royalty.'"

38. Ibid.

39. "Mission No Eviction," Brava Theater, San Francisco, October 2013.

40. Nancy Raquel Mirabal, "Geographies of Displacement: Latina/os, Oral History, and the Politics of Gentrification in San Francisco's Mission District," *Public Historian* 21, no. 2 (May 2009): 19.

41. Gray Brechin, *Imperial San Francisco: Urban Power, Earthly Ruin* (Berkeley: University of California Press, 1999).

42. "Mission No Eviction."

43. Ibid.

44. Ibid.

45. Ibid.

46. Ibid.

47. Ibid.

Index

Page numbers in italics refer to figures.

Acknowledgments

I could not have written this book without the kindness of so many people who shared their time, stories, art, and archives. For one of my earliest oral histories for this book, I met with Emilia "Mia" Galaviz de Gonzalez at her Encantada Gallery on Valencia Street. We barely knew each other, but that day, surrounded by beautiful, colorful art, Mia entrusted me with an abundance of precious memories. Our time passed quickly, and by the end of the day, we had accumulated close to five hours of tape. A week later, we followed up with another three hours of recorded reflections. I marvel at how much we laughed, and I learned. Not all interviews lasted as long, but Mia's generosity illustrates how much time and energy she and others shared with me in the process of making this work. From the start, this book depended as much on people as on archives, so I have many to thank.

Many people welcomed me into their homes, sat with me for hours at a time, and generously consented to share their memories. These recollections informed my research and shaped my writing. Thus, I am very grateful to Cesar Ascarrunz; Marta Ayala; Francisco Camplís; Victor Cartagena; Luis Cervantes; Susan Cervantes; Carlos B. Córdova; Daniel del Solar; Martha Estrella; Juan Fuentes; Martivón Galindo; Yolanda Garfias Woo; Mia Galaviz de Gonzalez; Juan Gonzales; José Ramón Lerma; Andrés López; Yolanda López; Carlos Loarca; Alejandro Murguía; Michael Nolan; Romeo Gilberto Osorio; Joe Ramos; Patricia Rodriguez; Peter Rodriguez; Nina Serrano; Roberto Vargas; René Yañez; and Rio Yañez. Juana Alicia gave me permission to audit her class at San Francisco State and permitted me to record a meaningful discussion of her work. I also benefited from oral histories I conducted with Mary Anchondo, Maya Gonzalez, and Harriet Rohmer as part of my research on the origins of Children's Book Press in the Mission. And I am grateful for the oral histories collected by the Archives of American Art, Smithsonian Institution and the Regional Oral History Office at the University of California Berkeley, which significantly expanded the scope of my research.

Many others offered guidance in shorter conversations, phone calls, e-mails, and letters, including Isabel Barraza; Carlos Baron; Lorenza Camplís; Maria

Tello Carty; Maruja Cid; Enrique Chagoya; Lydia Chavez; Lawrence "El" Colación; Anita De Lucio; Lou Dematteis; Tim Drescher; Judy Drummond; Lorraine Garcia-Nakata; Juan Pablo Gutiérrez; Jud Hart; Georgiana Hernández; Francisco Letelier; Mike Miller; Ernie Palomino; Ray Patlán; Elise Phillips; Michael Rios; Don Santina; Robert C. Tjader; and Linda Wilson. I especially am indebted to Francisco Camplís; Victor Cartagena; Susan Cervantes; Tim Drescher; Carlos Loarca; Michael Nolan; Don Santina; and René Yañez for sharing archival materials. My appreciation for the generosity of this community is boundless.

Procuring images for this book presented a multitude of challenges. A number of people helped me in this process, including Donna Amador; Miranda Bergman; Andres Campusano; Sandra Campusano; Victor Cartagena; Susan Cervantes; Irene Christopher; Lincoln Cushing; Wolfgang Dietze; Emory Douglas; Tim Drescher; Jennifer Feeley; Juan Fuentes; Martivón Galindo; Rupert García; Yolanda Garfias Woo; Juan Pablo Gutiérrez; David Harvey; Marjorie Heins; Blair Helsing; Ester Hernandez; Jed A. Jennings; Mark Johnson; John Leaños; Yolanda López; Alfonso Maciel; Oscar Maciel; Robin MacLean; Consuelo Mendez; Romeo Gilberto Osorio; Ernie Palomino; Ray Patlán; Joe Ramos; Isis Rodríguez; Patricia Rodriguez; Peter Rodriguez; Si Rosenthal and Emily Brewton Schilling; Don Santina; Mats Stromberg; Robert C. Tjader; René Yañez; and Rio Yañez. Cathy Osorio and Elise Phillips deserve special mention for their phenomenal assistance locating and reproducing key images. And I want to emphasize how grateful I am to Elise Phillips and Jim Edson for their selfless efforts to document and preserve the art of José Ramón Lerma, and to José and his family for their generous support.

Several organizations and institutions played a fundamental role in my ability to access information and images. I extend my profound gratitude to the archivists and archives that make research like this possible. My thanks to Georgiana Hernández and Linda Wilson at Acción Latina / *El Tecolote*; to Liza Kirwin and Joan Lord at the Archives of American Art (AAA), Smithsonian Institution; to Christina E. Barber and the Bloom Alternative Press Collection at Amherst College; to Liz Kurtulik Mercuri and the Artists Rights Society; to Rena Bransten, Trish Bransten, and China Langford at the Rena Bransten Gallery; to Susan Grinols and the Fine Arts Museums of San Francisco; to Christina Moretta and the San Francisco History Center at the San Francisco Public Library; to Salvador Güereña and Mari Khasmanyan at the California Ethnic and Multicultural Archives at University of California, Santa Barbara; to Kristin Law and Special Collections at the University of Texas, San Antonio; and of course, to Linda Gill, Margo Gutierrez, and Adrian "AJ" Johnson at the Benson Library at the University of Texas at Austin.

As a scholar, I have benefited from fellowships and other forms of institutional support that have helped me pursue my research. I wish to thank the Archives of American Art, Smithsonian Institution; the Center for Mexican American Studies at the University of Texas at Austin; and the California Ethnic and Multicultural Archives at the University of California, Santa Barbara. Of course, these institutions are nothing without the people that guide them, and in particular, I would like to highlight my appreciation for Liza Kirwin for propelling my work as an oral historian for the Archives of American Art; for Deborah Paredez, who advanced my work with her mentorship and her generosity as interim director of the Center for Mexican American Studies; and to Salvador Güereña, whose eye for collecting has helped save archival material for generations to come. In addition, the publication of this book is indebted to generous financial support from the President's Office at the University of Texas at Austin and from the Art History Publication Initiative through the Mellon Foundation.

Institutionally, intellectually, I have to acknowledge the formative impact of my mentors and colleagues at the University of Texas at Austin. This book could not have been written without the opportunities advanced to me by Steven D. Hoelscher; Janet M. Davis; Shelley Fisher Fishkin; Jeffrey L. Meikle; Mark C. Smith; and Shirley E. Thompson. I cannot possibly thank this team of scholars enough for the kindness, patience, and advocacy they have expressed on my behalf; if I held an award ceremony, they would each deserve individual celebration and a giant plaque of honor. My giant gold star award would go to Steven Hoelscher and Janet Davis for their many acts of kindness and support. I also want to thank my larger circle of American Studies colleagues for their support and grace, including Robert H. Abzug; Elizabeth Engelhardt; Nicole Guidotti-Hernández; Lauren Gutterman; Nhi Lieu; Karl Hagstrom-Miller; Randolph Lewis; Stephen H. Marshall; Maurie McInnis; Julia L. Mickenberg; and A. Naomi Paik.

My colleagues at the University of Texas at Austin have shaped my development as a scholar. I emulate the grace and fortitude of my mentor in public history, Martha Norkunas; the ethical leadership of Frank A. Guridy; and the model mentorship of Arturo Arias, Luis E. Cárcamo-Huechante, and David Montejano. My work also has drawn from a campus rich in conversations about the objectives of Mexican American and Latino studies. Thus, I would like to express my appreciation for the people who have shared in these expansive conversations, including Mary Beltrán; James H. Cox; Richard R. Flores; Gloria González-López; David L. Leal; José E. Limón; Martha Menchaca; Jim Mendiola; John Morán González; Charles R. Hale; Domino Renee Perez; Robin Moore; Maggie Rivas-Rodriguez; Angela Valenzuela; and Emilio Zamora. I

also want to acknowledge the faculty of the newly minted department of Mexican American and Latina/o Studies, especially C. J. Alvarez; Rachel V. González-Martin; Laura G. Gutiérrez; Julie Minich; and Deborah Para-Medina, for their work building new spaces for Latino studies.

Certain spaces and places played fundamental roles in my research, thanks to the communities that welcomed me. My time at the University of California, Davis, made a lasting imprint on my scholarship, thanks to Sergio de la Mora; Richard S. Kim; Kimberly Nettles-Barcelon; Julie Sze; and Carolyn Thomas. While at Dickinson College, in addition to working alongside excellent colleagues in American studies, such as Amy E. Farrell; Sharon J. O'Brien; Jerry Philogene; and Cotten Seiler, I benefited from a wonderfully social and supportive community of scholars, including Shawn Bender; Christopher Bilodeau; Adrian Cruz; Ebru Kongar; Kazuyo Kubo; Amanda Moras; Guillermo Rebollo-Gil; and Chris Talbot. And though my stay at the University of Illinois, Urbana-Champaign was brief, it was formative thanks to Teresa Barnes; Adrian Burgos Jr.; Antoinette Burton; Kirstie Dorr; Julie A. Dowling; Rayvon Fouché; Kristin L. Hoganson; Frederick Hoxie; Jonathan Xavier Inda; Korinta Maldonado-Goti; Isabel Molina-Guzmán; Alicia P. Rodriguez; Richard T. Rodriguez; Gilberto Rosas; Darrel Wanzer-Serrano; and Edna Viruell-Fuentes.

As much as these key sites have informed my scholarship, so, too, has an expansive universe of friends and scholars. In particular, I would like to thank Luis Alvarez; William S. Bush; Richard Cándida-Smith; Dolores Carrillo Garcia and Gilberto Cardenas; Maritza E. Cardenas; Jason Casellas; Dolores Inés Casillas; Ernesto Chavez; Christina Cogdell; Eduardo Contreras; Kency Cornejo; Eric Covey; Michael Cucher; Jason Ferreira; Kirsten Silva Gruesz; Robb Hernandez; Emily K. Hobson; Michael Innis-Jiménez; Jenny Kelly; Josh Kun; Marisol Lebron; Alexis M. McCrossen; Claudia Milian; Nancy Raquel Mirabal; Natalia Molina; Fred Nadis; Marisol Negrón; Suzanne Oboler; Alexander Nemerov; William Anthony Nericcio; Ben V. Olguín; Gina M. Pérez; Laura Pérez; Stephen Pitti; Raúl A. Ramos; Pablo Ramirez; Alex Rogers Pittman; Horacio N. Roque Ramírez; Jess Rigelhaupt; Ana Patricia Rodríguez; A. Joan Saab; Sonia Saldivar-Hull; George J. Sanchez; Tomás F. Summers Sandoval; Roberto Tejada; and Wilson Valentín-Escobar. Many people impacted this book from afar through their writing, art, and actions, including José Antonio Burciaga; Eva Cockcroft; Holly Barnet-Sanchez; Shifra Goldman; Guillermo Gómez-Peña; Ralph Maradiaga; Amalia Mesa-Bains; Chon A. Noriega; Tere Romo; and Tomás Ybarra-Frausto. And much of my work has benefited from the push of amazing students, who have inspired me with their passion and enthusiasm, especially Anneleise Azua; José Centeno-Meléndez; Andrew J. Friedenthal; Chris-

tina Garcia Lopez; Irene Garza; Brendan C. Gaughen; Amanda Gray; Andrew Hamsher; Kerry Knerr; Caroline Pinkston; Susan J. Quesal; Tatiana Reinoza; Sherri Sheu; Jacqueline M. Smith; Luis Vargas Santiago; and Natalie Zelt.

I experienced a number of unexpected and destabilizing challenges while conducting this research, but have felt fortunate to count on some incredibly fierce and brilliant people as my friends and support network, including Luis Cárcamo-Huechante; Jax Cuevas; Patricia M. García; Caroline Herring; Richard Heyman; Stephanie Kaufman; Robin Li; Nhi Lieu; Yolanda López; Jen Margulies; Anne M. Martinez; John Morán González; Julie Minich; Juan and Maria Morales; Gretchen Murphy; A. Naomi Paik; Virginia Raymond; Lilia Rosas; Sheree Scarborough; Stephanie Schipper; Cherise Smith; Nicole Stanton; Julie Sze; Christine Tam; Carolyn Thomas; Siva Vaidhyanathan; Sam Vong; and Grace Wang. I am especially thankful to my editor, Robert Lockhart, for the patience and support he showed me through this time; I thank him with all my heart for seeing the value of this work. I also owe much thanks to Sandra Spicher and to my anonymous readers for their excellent edits and advice and to Eileen Quam for compiling the index. I am humbled by the community that helped me forge this research and by the many amazing friendships this work sparked. My dearest friends know all the more how hard it was for this book to see light. Their support made all the difference, and in return, all I can do is express my love and gratitude for Alicia Barber; Joel Dinerstein; Julie Dowling; Mia Galaviz de Gonzalez; Yvonne Guu; Kim Hewitt; Frances Jones; Kimberly Nettles-Barcelon and Aaron Barcelon; Michael Nolan; Marina Parrera Small; and Jennifer Wilks.

When my father fell ill, I did not think I could bring this book to completion, and yet he is such a part of why I wrote this book. Though this book is not about my parents, it is inextricably the result of their worlds colliding through me. My father, Solomon Cordova Jr., grew up mostly in Albuquerque, New Mexico, in the 1930s and 1940s. Foreseeing a draft notice in the 1950s, he enlisted in the U.S. Navy and sailed around the world, transporting soldiers and goods during the Korean War. When he returned to Albuquerque, he had trouble finding work. In the late 1950s he took a huge leap, moving away from his family and friends to a city where he had no roots. San Francisco promised work and a life different from where he was raised. While he made his career as an electrician, in his heart, my father was a beat, and an artist, and a scholar.

In the late 1960s, my father spied my mother at a party and later asked his friend, José Ramón Lerma, if he could fix them up on a date. José knew my mother's best friend Nancy Eichler, and these two coconspirators put my life in motion. Thanks to them, my father met Jennifer Feeley, a woman who craved

some semblance of stability after growing up in the avant-garde community of Bennington College, where her father Paul Feeley taught art. When my mother moved to San Francisco, she sought some distance from this small community and some desire to find her own path. I can see how my parents gravitated to each other because they were so different. Their love affair did not last, but they raised me to move between profoundly different worlds, to care about art, and to think about San Francisco as a meeting ground for many different people. This book has nothing and everything to do with my parents, two people so different from each other that it often felt like only San Francisco could have brought them together. I cannot help but be grateful for the worlds they opened to me and for the love they have given to me.

There is poetry in this history, since one of the people who introduced my parents is one of the artists discussed in this book. When I was growing up in San Francisco, José and Nancy were part of my San Francisco family, along with Ed and Anna Everett, Howard and Rena Foote, Ellen Kernaghan, and Jane Oka. My memories of these bright, creative, offbeat folks certainly influenced my understanding of art and history and undoubtedly played a role in this work. Indeed, this book is as much a product of growing up in San Francisco as it is a product of all the people who helped me think about this place over many years and with many kindnesses. For those I have not listed here, I hope I can express my thanks in spirit, if not in name.

My grandmothers, Marcelina Cordova and Helen Webster Feeley Wheelwright, taught me how to create art out of the everyday. Through them, and with the support of my family, this book was imaginable. Thus, along with my parents, I thank Richard and Helen Cordova; Camille Cordova; Mark Cordova; Carla Cordova and Roy Mirabal; Luke Cordova and Paula Maxim; Yvonne Gordon; Gillian Feeley-Harnik and Alan Harnik; Vanessa Harnik and Leon Powell; Paul Harnik and Morgan Elmore; Aleyda González Mckiernan; Eileen Mckiernan González; and Larry Mckiernan González and Judy Mckiernan Jurado.

That this book does exist is thanks especially to John Mckiernan-González, who supported me in too many ways too count. His feedback consistently made this work stronger. He pushed me to reach for the finish line when all I wanted to do was collapse. Living with someone as smart, compassionate, and energetic as John made a lot of life's challenges just a little easier to handle. John and our beautiful son Feliciano have delivered profound joy to my world. I thank them both for so much happiness in the midst of so much struggle. Son mi amor y my corazón.